FUGITIVE VISION

FUGITIVE VISION

SLAVE IMAGE AND BLACK IDENTITY IN
ANTEBELLUM NARRATIVE

MICHAEL A. CHANEY

INDIANA UNIVERSITY PRESS
Bloomington & Indianapolis

This book is a publication of

Indiana University Press
601 North Morton Street
Bloomington, IN 47404-3797 USA

http://iupress.indiana.edu

Telephone orders	800-842-6796
Fax orders	812-855-7931
Orders by e-mail	iuporder@indiana.edu

First paperback edition 2009
© 2008 by Michael A. Chaney
All rights reserved

The paper used in this publication meets the minimum requirements
of American National Standard for Information Sciences—Perma-
nence of Paper for Printed Library Materials, ANSI Z39.48-1984.

Manufactured in the United States of America

Library of Congress Cataloging-in-Publication Data

Chaney, Michael A.
 Fugitive vision : slave image and Black identity in antebellum nar-
rative / Michael A. Chaney.
 p. cm. — (Blacks in the diaspora)
 Includes bibliographical references and index.
 ISBN-13: 978-0-253-34944-6 (cloth)
 1. American literature—19th century—History and criticism.
2. Slavery in literature. 3. American literature—African American
authors—History and criticism. 4. Visual perception in literature.
5. Abolitionists—United States—Intellectual life. 6. Art and litera-
ture—United States—History—19th century. 7. African Americans
in literature. 8. African Americans—Intellectual life. I. Title.
 PS217.S55C47 2007
 809'.93355—dc22

 2007030507

 ISBN 978-0-253-22108-7 (pbk.)

2 3 4 5 6 14 13 12 11 10 09

CONTENTS

ILLUSTRATIONS

ACKNOWLEDGMENTS

During the writing of this book, I experienced the generosity and collaborative verve that propels intellectual endeavor even in a discipline renowned for individual writing efforts. Of course, I also acclimated to the usual scenes of isolation, but did so accompanied by the internalized comments, questions, conversations, laughter, and the occasional scowl of a number of blithe spirits who have helped me enormously along the way.

For those who helped me when this was merely an idea, I owe special debts of direction and support to my dissertation committee. Eva Cherniavsky, whose inspiring theoretical insights spring from an equally limitless supply of patience, guided me through the process of research, organization, and articulation. I am still in awe of the way she somehow manages to encompass intricacies of culture, gender, and power with clarity even in casual conversation. John Eakin, another model of erudition and pedagogy, encouraged me to pursue the difficult alchemy of transforming the ore of personal esoterics into the precious metal of transactional prose. In Fred McElroy's classes and office hours I had fortunate opportunities to apply my interests to the larger contexts of African American intellectual traditions. Another source of inspiration, Ray Hedin's readings were always cogent and prodding.

At Indiana University, I had the pleasure of learning from a number of amazing scholars. George Hutchinson's continued mentorship has been invaluable. Jonathan Elmer shaped my thinking on figures of literature and theory falling outside the scope of this book but informing it nevertheless. Margo Crawford, Tom Foster, Linda Charnes, and Shane Vogel were together and separately tremendously influential as mock interviewers. Their penetrating questions led to important reconceptualizations on the two-lane road from dissertation/grad student to book/professor. Kathy Smith, David Nordloh, Richard Nash, Valerie Grim, and Nick Williams proffered various maps and compasses to navigate that road as well. The influence of graduate peers in this work is both subtle and direct. Thanks go out especially to Victoria Elmwood, for being a careful respondent, relentless questioner, and such a good friend.

I can imagine no better institution than Dartmouth College for encouraging the professional development of junior faculty. In particular, I want to thank the institutional support of the Burke Award Fellowship and the Leslie Humanities Center (directed by Jonathan Crewe), which funded a stellar

manuscript review that significantly altered the book, bringing two excellent scholars to campus: William L. Andrews and Marcus Wood spread wisdom with grace, care, and intelligence, for which I am forever in their debt.

Dartmouth's institutional resources are matched only by the phenomenal support of my colleagues in the English Department. The gravitas of Donald Pease as a scholar is in direct proportion to his generosity as a friend and mentor. J. Martin Favor encouraged me to think about the links between this project and my other work in twentieth-century convergences of race and representation. Although I finally decided to emphasize the antebellum period here, his advice lingers still. Guided, likewise, by the sage advice of Ivy Schweitzer and Gretchen Gerzina, who prod me to be not just a better thinker but a better teacher and colleague, I have striven to develop the ideas presented here in a manner worthy of their support. Lou Renza and Patricia McKee helped me to better understand what I was trying to get across with the panorama and questions of materiality. Their direction and pointed inquiries gave sustenance to this project at a key moment of transition. And no departmental thanks would be complete without acknowledging the kindness, relentless humor, and infinite wisdom of Bill Cook, who regaled me with tales of history, literature, and wonder. For their general support, Tom Luxon, Peter Travis, Colleen Boggs, Jeffrey Santa Ana, Ana Merino, Bed Giri, Mishuana Goeman, George Edmondson, and Sam Vasquez all deserve gratitude.

At Indiana University Press, I found an advocate in Bob Sloan, who offered immediate and gratifying feedback on the project. Thanks also to Dan Pyle, a patient wizard of graphic production, and to Brian Herrmann, a conscientious and careful project editor. Readers John McCluskey, Jr., and Ezra Greenspan staged interventions that have made this a much better book.

On a more practical but no less instrumental note, I thank the incredible librarians without whose contribution this book would not exist: Laura Braunstein, Dartmouth's literature specialist, Sarah Hartwell, Rauner reading room supervisor, and Joshua Shaw, Rauner's technology coordinator. Curator Jill Beute Koverman, of the Mckissick Museum, was also a significant help in securing images. The editors of *African American Review* gave permission to reprint an expanded version of a previously published article. Ellen Driscoll deserves thanks for permitting the reproduction of her inspiring installation. And I would like to thank, most especially, my students who constantly invigorate the scholarly process in ways they are sometimes unaware of and more often in ways for which they are most immediately responsible but not so easily credited as individuals in the space allotted here.

Finally, I want to thank my two families, the one cast physically adrift in time and space, the other always nearby. It is with a strange but fitting "mix" of sadness, nostalgia, and pride that I think back to my years growing up

the white-looking one in a family of black, brown, and white, bearing the heavy load of two heritages impossibly, yet ever so faintly, (dis)articulated in my bearing. There is my Oma, an abundance of experience, understanding, and love, and my two grandfathers: one a commanding but fleeting presence, the proud descendent of slaves; the other related only by law is always there, though a world apart, modeling love beyond the vexations of blood and resemblance. Also, for my brother, my hero, even when we were two abandoned kids no one thought would amount to much (here's some "much"); and for my stepfather, the man I called Dad despite the racial incongruities that scrunched up the faces of others upon hearing it; and for my mother, who was raised, from her perspective, as the only *Mischling* in a country fervently second-guessing the implications of Aryan purity—no scholarship comes close to the meta-complexities of racialization she dissected over so many dinner tables of my childhood. For them I dedicate this book to my daughter Heike, who expresses life's most pellucid blessings, and to Sara, whose intellectual companionship and life partnership have enriched my existence beyond words.

FUGITIVE VISION

Introduction: Looking Beyond and Through the Fugitive Icon

In the August 11, 1854, issue of the *Frederick Douglass' Paper,* an anonymous reviewer cites the following advertisement from the Southern press:

> SLAVE DEPOT, 133 Baronne Street. The undersigned has on hand, and will keep constantly for sale, for either Cash or City Acceptances, a full assortment of slaves, consisting of Mechanics of all descriptions, House and Field Servants, etc. Having leased the large and commodious three story dwelling. No 133 Baronne Street, near the Carrollton Depot, he is prepared to accommodate Transient Traders and their Slaves, on as reasonable terms as can be obtained in the city, having accommodations for between two and three hundred Negroes, and the advantages of a large and fine yard. . . . *Independent*

Entitled "A Significant Picture," the editorial passes over the content of the text in order to "call attention to the picture that prefaces every such advertisement." For this writer, Independent, the implied picture fails to approximate the context of the "large and fine yard," being the same specimen type (fig. 1) that sold for eighteen cents to adorn runaway slave advertisements. The discrepancy between the icon of fugitivity and the described enclosure of the depot stirs the writer to interrogate the counterintuitive master logic of slave iconography. Just what does the image of the single black figure in stride signify when placed in the commercial context of a slave warehouse? With mounting exasperation, the writer poses several possibilities: "The alacrity of the slave to do his work? Or his hurry to escape from the slave depot? Or his eagerness to quit his present master, on the principle that he cannot be worse off? Or his general disposition to run away?" Neither consumer desire nor vendor self-protection accounts for the mismatch: "Do slave dealers consider swiftness of foot a special recommendation of a negro, and the point to be made prominent in an advertisement? Or is this an honest caveat to purchasers as to the migratory character of such property?" Building toward caustic crescendo, the writer eschews the picture altogether to proffer more suitable alternatives:

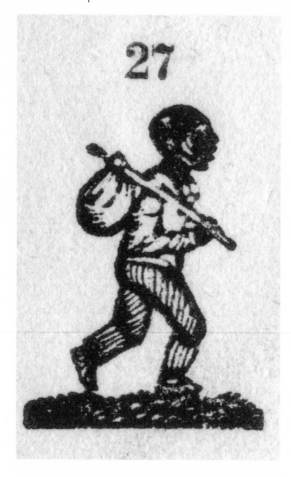

Figure Intro.1. Specimen Type of Fugitive Slave from *Specimen of Printing Types from the New England Type Foundry,* 1834

We would suggest a picture that should convey some idea of permanence; say a man chained by his hands and feet, or two chained by the neck, or a naked woman planting under the lash of the overseer; or if slavery is a blessed institution a peaceful cabin with Uncle Tom and Aunt Chloe sitting lovingly at the door, while the "little niggers" romp freely with Massa's children. By all means let the system have a symbol that looks like permanence!

The editorial exemplifies a rhetoric of acrimony thinly veiled by humor and hyperbole, achieving its coup de grace as the slaveholding imagination proves ineffectual even in matters of slaveholding. By contrast, the antislavery activist is shown to be more capable of producing pictures that are not just more accurate and thus more damning but also more ameliorative, suggesting a few that brighten the whole affair by casting the institution in the light of domesticity to which its defenders often recur. This trick of "Puttin' on Ole Massa," of doing a better job of being the master by putting on

the master's mask and seeing the world through his eyes, is a double-coded strategy. It insults the slaveholder as improper to capitalism, less poised for the game of property acquisition and profit than even a former article of property, while recasting the slaveholder's identity as a role vulnerable to speculation and aggressive takeover. For his part, Frederick Douglass could not resist the sham of sympathy for the vulgar slaveholder. In his letter to William Lloyd Garrison concerning the vicissitudes of his passage on board the *Cambria,* Douglass implicitly pretends to a patriotic dignity in being a slave, only to claim embarrassment at the outrageous behavior of crude and indecorous masters: "I declare, it is enough to make a slave ashamed of the country that enslaved him, to think of it." Such rhetorical tricks also always turn on pretensions to class, as the former slave denounces the system with an élan that cuts slaveholders for having inferior morality and etiquette. Also an act of redress, the wit that cuts recalls the slave system's treatment of the captive body, cuts inflicted on the flesh and reproduced at the cultural disjuncture of symbolic knowledge and racial experience.

The symbolic potential in pictures to advertise slavery as an international crisis drove Douglass's fondness for the cartoons published in the British periodical *Punch.* In 1848 Douglass praised the periodical in his *North Star* for its prescient ability to "notice the 'Model Republic'" and illustrate the tragic American ethos of "profession versus practice." The picture described matches one of the scenes suggested by the editor of "A Significant Picture," showing a "whipping-post, with the emaciated form of a miserable slave tied to it, over whose naked shoulders a figure of Liberty, in a dress ornamented with stars and stripes, is brandishing a cat-o'-nine-tails" (Dec. 15). Another description of a *Punch* cartoon (fig. 2) published nearly a year earlier (Jan. 14, 1848) in the *North Star* best articulates the purpose of these visual archetypes of abolition: "It is not impossible that we may wring from a sense of shame what we have been unable to gain from American sense of justice." Collectively, these meditations on the iconography of slavery perform a national counterintelligence, embracing British satirical cartooning as a means to address the suitability and substance of slavery's public display. Obsessively returning to primal scenes of brutality, these cartoons stage the splitting of U.S. constitutional liberty upon slavery's rapacious torture of the naked, chained, and often female black body. For many black abolitionists, to recommend these nightmare visions is to dissect, deploy, and divert the loaded politics of looking studied in this book.

Fugitive Vision joins these early critics in broadly asking what a more appropriate symbol of either the slave or slavery would look like for many ex-fugitives of the antebellum period. To pose such a question entails negotiations between symbol systems, or what Anne Elizabeth Carroll in reference to a later period of African American cultural production calls "abrupt

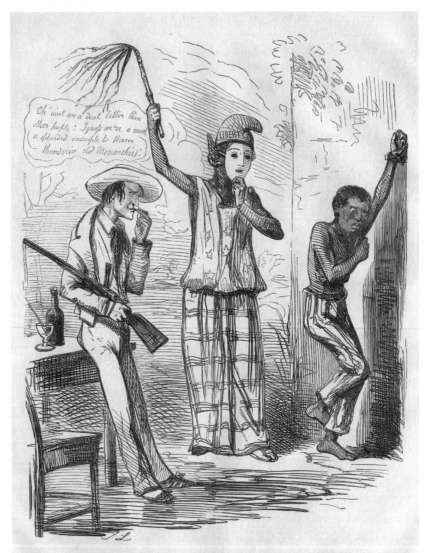

LIBERTY, EQUALITY, FRATERNITY.

DEDICATED TO THE SMARTEST NATION IN ALL CREATION.

Figure Intro.2. From *Punch* 14 (Jan.–June 1848)

juxtapositions" of visual and verbal representation.[1] Despite the ironic demand for "a symbol that looks like permanence," the iconography attending the writing of black abolitionists appears in states of ephemerality and fugue, exerting denotative but also subversive pressures on the texts this iconography illustrates.

The purpose of this book is to investigate the claims, however impermanent, purported by the selection and look of particular illustrations of black identity. It aims to discover in points of connection and disparity between texts and images the constitution of a racialized seeing subject that looks back at the systemic structures that occlude it. In mapping the alternative visual field called forth by the depictive practices of former slaves, the runaway slave icon is a useful starting place, orienting us to the prevailing cultural screens on which black bodies were projected and against which the looking relations investigated in this book arise. I borrow the word "screen" from Kaja Silverman to name a network of imagery and image associations functioning as both a cultural grammar for making the pictorial domain intelligible as well as the porous ground of relations on which subjects project themselves into being.[2]

In the early decades of the nineteenth century, the screen of the runaway crystallized repressive ideological forces that predicated the black body to be an object of display, commodification, and exchange. The relation of the pictured slave to any actual person remained as blurry as the besmeared contours so often accompanying the advertisement's imprint in periodicals on both sides of the Mason-Dixon Line. Less than a handful of these silhouetted figures in midstride shouldering a "bindle stick" (fig. 1) were used to represent fugitives individuated in textual descriptions of such details as height, weight, personality, vocal tone, complexion, scars, burn marks, and amputations. In *Blind Memory,* Marcus Wood persuasively illuminates the ensuing clash between the interchangeability of the runaway image and the torturous particularity of abuses in the text of runaway advertisements.[3] As abolitionists were wont to exclaim, here was proof from the slave masters themselves of the human uniqueness of slaves elsewhere argued to possess nothing more than a brute-like, and thus enslavable, nature.

The indistinct character of the typical image speaks to the ideological, as opposed to the mimetic, portrayal of African American identity in the nineteenth century. As Henry Louis Gates, Jr., has explained, no presumption of individuality was ceded to blacks whom many white Americans believed to be devoid of subjectivity. Lacking the self-abstracting capacities inherent to literacy, the typical slave had no means of communicating personhood in syntax intelligible to white authority, stranding the slave in the ontological non-space of chattel.[4] To picture the slave, therefore, was to envision precisely what the runaway block or engraving hastily designated: fu-

gitive property, flesh run astray. As such, even the blotted appearance of the icon captured a likeness, in more ways than one, of the denigrated cultural form it proposed to diagram. Yet as a mechanism of repossession, the runaway advertisement also always envisions the denial of its own proscription, suspending the figure in a visual field of stasis and density that belies the likelihood that anything so inert and cumbersome could escape, let alone move, in the first place.

Even while depicting the slave as a generic truncation, such ads and the paradoxes of exhibition that underwrite them helped to activate competing representations. Many prominent black abolitionist leaders at midcentury returned to the scene of the fugitive promulgated by the ads to reroute and recharge the directionless posture of the runaway, as demonstrated in the opening example here. Abolitionist counterimages, however, threatened to recompose the slave body for scopophilic voyeurism. Is the whipping-post image any less reductive for ossifying blackness under the sign of martyrdom? Even if the pictured martyr is a more appropriate object of victimization, what, after all, obviates it from becoming—to extrapolate from the editorial—a *permanent* subject of subjection?

Indeed, if the format of the standard slave narrative were not routine enough, the iconography of abolitionism offered no variety of expression. Countless images of tree-climbing slaves escaping dogs and Elizas leaping over ice cakes circulated the culture, emblazoned on everything from the pages of newspapers and books to plate ware, toys, and pillows.[5] Paradoxically, these proliferating scenes presumably marketed to denounce slavery's dehumanization of the African American body replicated and amplified the process by which the slave was reduced to an object of commodification, becoming nothing more than a marketplace signifier of self-dispossession. Nineteenth-century black writers such as Frederick Douglass, William Wells Brown, Harriet Jacobs, and William Craft expressed resistance to the devaluations of the imaged black body to which their identities were intransigently wedded. Although many joined the abolitionist cause and adopted its signifying practices, they also adapted these practices, recoding conceptualizations of the slave through hyperboles, ironies, and metonymies that exceeded the abolitionist norm. Many of the most prolific black writers of this period seek in the old and familiar plantation tableaux new and estranging modes of sight, and it is toward these excesses of visuality, ways of seeing unaccountable to and unaccounted for by abolition, that *Fugitive Vision* embarks.

The urge of this book is to reevaluate, to borrow from Fred Moten, the "radical materiality and syntax that animates black performances"[6] between representational modes. At this crucial intersection, a process of ekphrastic writing often patches over disturbing blind spots and flickering investments

endemic to the visual field. W. J. T. Mitchell usefully addresses the disso-
nances of verbal and visual representation through an analysis of ekph-
rasis, the name for the genre of literature that describes a picture and the
conceptual problem of interartistic interpretation.[7] In opposition to what
he defines as ekphrastic hope is Mitchell's notion of ekphrastic fear, that
aversion to ambivalences that sunder crucial antinomies such as verbal/vi-
sual, black/white, subject/object, spectator/image.[8] Resisting the principle
of supplementarity governing word-image relationships, the figures studied
here show evidence of being motivated by aesthetics forged in experiences
of dehumanization, fugitivity, and natal (particularly maternal) alienation,
wherein the space of the pictorial, the visual field, and the object of visual
and haptic sensation become sites of subjective redirection.

Fugitive Vision analyzes images of slavery alongside and against cor-
responding literary texts to discover whether their uneasy convergence
produces schemas of subjectivity different from those available in either
the visual or the verbal text alone. Mining the intertext of mediation, the
following chapters recontextualize the longstanding argument that slaves
could only attain subject status through literacy or by re-negotiating the
terms of their commodification.[9] Posing the visual as an alternative means
to cultural authority, this book explores the interface of visual and liter-
ary texts, and the vexed dynamics of race and gender embodiment elicited
there. The interpretative fieldwork *Fugitive Vision* undertakes into these
blind spots of representation necessitates a reexamination of the relation-
ship between constructions of alterity and the visual field. In addition to
scholarship on race and slave narrative, theories of psychoanalysis, gender
studies, art history, and film criticism provide valuable, if unavoidable, tax-
onomies for talking about looks, lookers, and the gaze.

Broadly, the gaze functions to acknowledge and refuse agency during
moments of seeing and being seeing. A metonym of the visual field, the gaze
described by Jacques Lacan and endlessly elaborated by others gives rise to
a scene of subject formation, wherein the annihilation of the seeing subject
follows acts of being seen, or being caught as the object of another's view
in a "scopic field" predicated on desire.[10] Lacan's gaze, therefore, has more
to do with all that is beyond the bearer of vision, comprising the complex
screen within which formations and transformations of identity occur, and
where the subject takes initial shape, in Kaja Silverman's reading of Lacan,
as a stain upon the screen.[11] Although Lacan's inspiringly complex theory
has engendered diverse applications in twentieth-century film and gender
analysis, the scholarly account of abolitionist iconography has yielded a sti-
fling consensus on the regulatory priorities entailed by visualizations of the
stain that was the slave.

Particularly in treatments of African American subjectivity, the Laca-

nian implication of the gaze in master/slave dialectics subtends the notion that even when former slaves access the visual field as a means to asserting humanity, the result is an a priori extension of patriarchal institutions of racialization. Karen Sanchez-Eppler maintains that the abolitionist concern for putting on view the disenfranchised bodies of blacks and women became a double-coded strategy of political critique, exposing through intersecting rhetorics of sentimentalism and abolition the white maleness that consolidated social power by masking its own embodiment.[12] The power to conceal or abstract from the body is further theorized in Hortense Spillers's influential account of the slave's metaphysical expulsion from the body altogether. For Spillers, the slave configures flesh, the not-yet-body bereft of the cultural accoutrements required for assignations of gender. Stranded in this vestibular zone separating unacculturated flesh from the social and gendered descriptors of the body, the cuts and wounds of the slave's vestibular flesh are displayed for the pleasure of subject-viewers, who are, in turn, reassured of their own protective prophylaxes in the law.[13] Likewise, Saidiya Hartman contends that even scenes of slave enjoyment and jollity reinforce white privilege by recalling the pained expression of the black body and thus associating blackness with subjection and terror.[14] Moten explains that Hartman's critique of the terror-haunted scene of subjection is itself haunted by an originary performance of spectacular torture witnessed by Douglass in the whipping of his Aunt Hester. Expounding upon Hartman, Moten claims that the accession of humanity is always an entry into subjection that summons again what he calls the cut, the brutal clamoring that originally accompanies humanity's negation and thereafter echoes in the acoustic aesthetics of black art.[15] Updating bell hooks's path-finding *Black Looks,* Moten's intervention into the genealogy of criticism on the black look maps a detour around the ocularcentrist economies of the gaze posited by Lacan. Rather than exploring avenues toward "a reversal or inclusion within the agencies of looking," Moten attunes his analytic of black looking relations to the salutary trace of aurality, the improvised blessings of sound that bestow alternative conditions of possibility to Lacan's mirror stage and the circumscriptions of its gaze.[16] By discovering in the writings of black writers the sonic eruption of forms exceeding Lacan's "assumed economy of visually and spatially determined meaning and difference," Moten generates a model for the black gaze based on the nonexclusion of orality and aurality.[17] Moten's synaesthetic field of visible music bypasses the limiting conditions of subjectivity conceived of in Eurocentric terms and conducts "the eruptive content of a transferred history."[18]

The following chapters take up Moten's specific challenge to see aurality and to hear the visible fluctuations of African American presence. Yet, it is rather the implication of his analytic more than his concern for musicality

that informs this book. My overriding interest is to explore the alternative dynamics of vision and race animated in the chiasmus between writing and seeing. *Fugitive Vision* proposes that in the liminal gap between the visual and the verbal forms deployed by ex-fugitive authors and artists lay self-representational possibilities for overcoming cultural stereotypes, reductions, and essentialist collapses. In this gap, those figures who were themselves undergoing ontological translation—actively performing themselves as having shifted from a state of property to one of proprietary self-possession—project a deconstructive fantasy to break down and open up boundaries of self and other.

By investigating such intersections, *Fugitive Vision* reciprocates that gesture of opening up characteristic of its objects of analysis in order to posit not just new kinds of artifacts for inclusion in the archive of African American creation but new kinds of seeing. Throughout, I trace unconventional modes of ocular knowledge in the multimediated texts of nineteenth-century African Americans that defer the discursive ground of relations inherent to slave subjectivity. The master/slave dialectic, the delimitative racial coordinates of black and white raciality, the linear temporality that abjures the middle time for origins and ends, the exclusion of the sense of touch from the domain of the visible, the determinative assignation of an either/or gender coding—all are discursive grounds of knowledge and subject formation which the intertexts pursued here refuse to resolve. And the vision necessary to glimpse the instabilities that erupt around ephemeral moments of verbal and visual collision, as the title of this work suggests, is fugitive. In using the term, I mean to connote the contraband condition of juridical and cultural alienation faced by the writers under review here, as well as the renegade indeterminacies and boundary breakdowns that their expressive practices set in motion. Thus *Fugitive Vision* focuses on the intertextual insurgencies of ex- and current slave creators in whose works we find the subtle but meaningful trace of a visual field contrary to the one established by the twin hegemonies of abolition and slavery. Impermanent, volatile, and elusive, the visual practices explored in this study register the limitations as well as the horizons of possibility afforded by an alternative though outlawed way of envisioning racial identity.

Joining a large body of scholarship that focuses on African American subjectivity, I consider how something akin to a black look takes shape alongside and within the production of a black identity recorded for prurient, sympathetic, thrilled, and terrified white audiences. In doing so, I am deeply indebted to the prevailing theories of African American subject formation proposed by Henry Louis Gates, Jr., and Houston Baker, Jr., which consider the ways that slaves were forced to trade personhood for literacy and commodity status, respectively.[19] Yet I depart from their interpretative

points of focus by turning attention to issues of materiality and vision, maternality and memory, mobility and commodification. The figures discussed here, I argue, translate the blind spots constitutive of an antebellum visual field of captive embodiment into the mercurial ground of self-making.

When invoking the notion of the visual field, I am talking about both the sensory data of visual perception and the frameworks that coordinate visual data with pre-existing and contradictory cultural meanings. Crucial to my engagement with the status of visuality during the period leading up to Emancipation is Jonathan Crary's impressive cultural history of vision. According to Crary, the proliferation of a marketplace iconography along with the rise of optometric devices of illusion such as the stereoscope eroded the presumed equivalence of vision and knowledge.[20] To see was no longer to know or to experience the immaterial sensorium extended into the knowable world, but to risk buying into seductive fallacies of commodity replication and to be led astray by the infidelities of the eye. It is during this dissolution of the eminence of the eye that former slaves inscribed themselves in lifewriting and projected themselves visually, through frontispieces, illustrations, portraits, and as orators, into the Northern marketplace. In their various bids for humanity these writers repurposed the commodity form of literacy and abolitionist celebrity in accordance with the instabilities of the visual field, perhaps not so much in search of a sustainable subjectivity but rather to preserve a space of subjective deferral often in opposition to the declamatory strivings and self-assertions found in their written texts.

As with slave narratives, within whose rhetorical ruptures, as William L. Andrews instructs, the germ of black self-expression may be discerned only through critical "creative hearing," what can be "creatively heard" in the marginal interludes resonating between signifying systems here is no less generative.[21] Memorialization, ancestral contact, and the urge to throw off, at least temporarily, the stultifying trappings of identity centralized in markers of race, gender, and sexuality all occur during these interludes. Space and time, too, find loosened coordinates in them. As Sharon Patricia Holland has shown, the space of "unspeakable things unspoken" in African American culture often entails a necromantic conversation with the dead.[22] Through this converse, the unhinging metaphysics of death, which align black subjects with the spectral marginalities of invisibility, offer the tragic potential to empower those who return from the space of death to seize categories of status previously denied.[23] Less absolute than death, however, the semantic interfaces of verbal and visual representation also transpire around metaphors of the scar, the punitive stamp of slave exchangeability which, as Hartman shows, reveals the theatrical nature of power in relation to captive embodiment.[24] Similarly, Carol Henderson links the iconic

force of the slave's scar to political action, which "rested not only on *seeing* the body in pain but also on *being* the body in pain because it is this rhetorical use of pain that marks the slave body and makes it visible."[25] Black writers importunately return to the scene of the scar—the cut that Moten originates with Douglass's witnessing of Hester's beating. It is there that the private captive body merges with "an acknowledgement of communal pain" but does so (and here is where I hope to extend the conversation) in meditative spaces that exceed the bounds of print or illustration alone, exhausting to the point of collapse the modes and technologies common to antebellum representations of vision.[26]

The organization of the book is meant to encompass the emergence of an alternative field of antebellum visuality deployed by slaves and ex-fugitives according to mode and technology. The first part analyzes the gendered and filial dimension of the ironizing modalities of the slave look. The second part examines the way this look becomes operational in three of the period's premier technologies of visual production: the panorama, the camera obscura, and the utilitarian craft object. This is not to imply, however, that the first part ignores technological specificity. Indeed, each of the three chapters in part 1 deals with signifying structures that could be seen as technologies for picturing slaves. Taking up ethnographic illustration, the public exhibition, and the frontispiece, the first part of *Fugitive Vision* concerns a more pressing division of signification emblematic in the opening examples in this introduction, namely, the equation of slave visibility either to the victimological blackness of the maternal wound or to the whitewashed status of patriarchal exemplarity associated with the bourgeois ascendancy of former slaves turned abolitionist celebrities. Such transformations were perpetuated by frontispiece portraits and their conventional framing of authorship by the trappings of middle-class Victorianism. A unifying claim here is that the stain of pre-identity that is on but that also is the screen of culture calcifies around the sight of the black mother in the self-inscriptions of ex-fugitive writers. To be a slave is ultimately to be this ironic site of the reproduction of both blackness and other slaves, of course, but also the transformative whiteness that helps, for example, Frederick Bailey the slave become Frederick Douglass the author. For ex-fugitive authors, I argue, to be seen is to re-see this maternal stain and to become, in part, the visible slave of torture who is always shadowed by the feminine, mobilizing the female-inness that Hortense Spillers attributes to black masculinity.[27] Yet to be seen is also, as I shall argue, to be neither reducible to this slave mother nor to render that figure in ways commensurate with determinate scripts of black femininity. This book builds on Spillers to show how the visual claims of the slave mother become a transformative field of

representation for nineteenth-century black writers, wherein legacies of ancestry, memory, and race enact a look that makes fugitive the ideological codes that allow race and gender to be visible at all.

In part 2, I am interested in the engagements of writers and artists with available visualizing technologies, and their revision of them. I focus on three technologies rarely discussed together in relation to the slave: the panorama, the camera obscura, and the utilitarian craft object. Brown relies upon the illusory effect of mastery endemic to the totalizing view of the panorama in order to forcefully juxtapose the subjection of the black body. While this subjected form of embodiment elicits a tragic sense of immobility, particularly in comparison with the moving pictures of the panorama, Brown invests the stillness of the disruptive exhibit of the iron collar worn by one of the female slaves pictured in the panorama with a power to move—in the emotional sense, to stir viewers to political action, and in an aesthetic sense, to move from the conventional stasis of subjection toward a productive form of displaced embodiment. Similar to the panorama, the camera obscura allowed the observer to visually master perceived phenomena, except in a way that de-emphasized the observer's bodily interaction with the external world. Jacobs in her garret, so like the darkened chamber of the camera, seems to reprise the god-like vision idealized in the camera obscura, but without turning away from the body. I contend that, unlike the image of Dion Boucicault's Zoe on the auction block, Jacobs's implied theory of vision insists upon the particularity of her immured bodily experience and militates against the aftereffect of racial gazing that makes the black woman a paradoxical site for the reproduction of whiteness. Finally, the book culminates with the work of Dave the Potter, a slave who designed some of the largest earthenware vessels built in the nineteenth century to hold the signifying tensions explored throughout *Fugitive Vision,* between enslavement and freedom, word and image, sight and touch, commodification and identity. Beyond linking Dave's jars to the prior slave narrators' aesthetics of looking, this chapter also furnishes an alternative to the woes of self-commodification found in Jacobs. Where Jacobs seeks to decommodify herself, to occupy a liminal space neither outside nor inside her role as a slave or commodity, Dave seeks status in hypercommodification, focusing attention to his transformation, effected in the interstices of the proverbs and the signature written on his jars, from commodity to commodity creator to commodity logo. In becoming a trademark rather than a tradesman, Dave thus transcends the predicament of exchangeability that forecloses humanity in prior visualizations of the slave.

As a whole, this project complicates the argument that slaves could only ascend to the status of humanity as a commodity-object or through literacy. Here literacy operates in dialectical relation to the visual and the performa-

tive. In tracing the way ex-slaves negotiate authority through multimedia representations, *Fugitive Vision* argues that the interface of visual and verbal texts produces a space of hybridity. Rather than pursue this space as an abstraction, however, the following chapters focus on the *material* incarnations of such spaces. Jacobs's garret, a cited illustration of Ramses for Douglass, a caricature of a slave woman and an iron collar for Brown, Dave the Potter's iconographic gaps and spaces allegorizing diasporic absences, the antebellum railway platform for the Crafts—all of these sites become staging areas for reconceptualizing the complex ways that slave and ex-slave authors represent themselves into being.

PART 1
FUGITIVE GENDER

Black Mothers, White Faces,
Sanguine Sons

1

Racing and Erasing the Slave Mother: Frederick Douglass, Parodic Looks, and Ethnographic Illustration

> My mother then turned to him and cried, "Oh, master, do not take me from my child!" Without making any reply, he gave her two or three heavy blows on the shoulders with his raw hide, snatched me from her arms, handed me to my master, and seizing her by one arm, dragged her back towards the place of sale. . . . as we advanced, the cries of my poor parent became more and more indistinct—at length they died away in the distance, and I never again heard the voice of my poor mother. Young as I was, the horrors of that day sank deeply into my heart, and even at this time, though half a century has elapsed, the terrors of the scene return with painful vividness upon my memory.
>
> Charles Ball, Slavery in the United States: A Narrative of the Life and Adventures of Charles Ball

A chief difference between Frederick Douglass's first autobiographical project, *Narrative of the Life of Frederick Douglass, An American Slave, Written by Himself* (1845), and his second, *My Bondage and My Freedom* (1855), is the representation of his mother. Douglass describes her in *Narrative* with alarming stolidity. Tellingly, the personal, "My mother and I were separated when I was but an infant," dissolves to type in the very next sentence: "It is a common custom, in the part of Maryland from which I ran away, to part children from their mothers at a very early age."[1] In *Narrative*, maternal absence prepares the way for Douglass's more pressing indictment of slavery.

But in *My Bondage and My Freedom,* the figure of the mother is not the same void carved out by the horrors of slavery; she no longer signifies the author's alienation from dominant cultural and linguistic tropes. On the contrary, she signals and—to borrow Henry Louis Gates, Jr.'s, term for repetition with a difference—"signifies on" the author's mastery of literary

and extra-literary devices of characterization.[2] Douglass not only textually describes her in fuller detail, he even informs the reader that he has come across a picture, an illustration in James C. Prichard's fully illustrated text of historical ethnography, *The Natural History of Man* (1848), which fondly reminds him of his mother's appearance. The picture's features, Douglass explains, "so resemble those of my mother, that I often recur to it with something of the feeling which I suppose others experience when looking upon the pictures of dear departed ones."[3] In this significant act of citation, Douglass establishes a rapport with his readers based upon a shared relationship to pictures. Though he does not possess an image of his mother, it would seem that the accretion of mass market images in mid-nineteenth-century America affords him a likeness of her just the same, which in turn allows him to take part in a visually activated form of sentimental consumption familiar to his audience.

Yet, upon locating the cited volume and page of Prichard's book, one encounters a most unexpected sight. Instead of the slave woman suggested by Douglass to be quite dark, we discover an engraving of Ramses II. Oddly, it is an image of a bearded, quite white, mythical man (fig 1.1).

Douglass's citation of this engraving as a maternal image is shocking, in part because it defies the usual validating power ascribed to the sentimental portrait, displaying no mimetic correlation between the beloved singularized in the text and the figure presented in the image. And although the peculiar citation of this picture may be a mystifying response to slavery's trauma, it is no less communicative, for in it we glimpse Douglass in the very act of self-creation. His allusion to the picture acknowledges and perhaps even parodies anxieties of race, ancestry, and identity—first by courting the fictional trope of sentimental nostalgia and then by flouting the expectation of phenotypic verisimilitude that underpins traditional conceptions of racial illustration, popularized by nineteenth-century ethnography.

As many scholars of historical anthropology have noted, in taxonomizing difference, "American School" ethnographers (ca. 1820–1870) were drawing and policing the borders of Anglo-American racial identity, enumerating prescriptive markers for a dominant cultural identity in the process of isolating and classifying the markings of the other.[4] Johannes Fabian summarizes this hierarchical formation of identity in the following manner: "When modern anthropology began to construct its other in terms of topoi implying distance, difference, and opposition, its intent was above all, but at least also, to construct ordered Space and Time—a cosmos—for Western society to inhabit, rather than 'understanding other cultures,' its ostensible vocation."[5] What has not been fully considered by revisionist scholarship on American formations of identity is the way in which slave narratives contributed to and problematized the shaping of a homogenized white culture

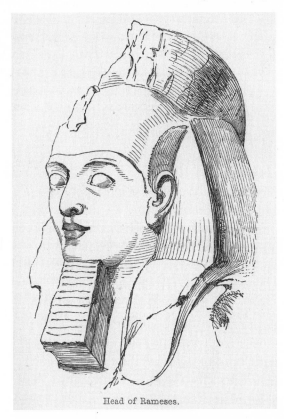

Head of Rameses.

Figure 1.1. Ramses II
Engraving from *Natu-
ral History of Man*

for an antebellum readership by mimicking and disrupting ethnographic
endeavors to classify subject peoples into discreet typologies. Through the
strange reference to a pharaohic mother, Douglass participates in the same
descriptive observation of difference and thus reveals an epistemological
similarity between early nineteenth-century autobiography (slave narra-
tives) and ethnography (especially American School ethnography). That is
to say, the same evidentiary rhetoric in both discourses supplements and
establishes the authority of a central "self" and that self's spectatorship and
literal seeing of otherness.[6]

The irregular referentiality of the picture also suggests that Douglass
does not appropriate the ethnographic eye without challenging the raced
and gendered assumptions that motivate it. Like other ex-fugitives, Dou-
glass's critical appraisal of the appearance of black, mainly maternal slave
figures strategically employs a form of racial looking and observation that
had come to be associated with ethnographic discourse. The resulting coun-
ter-ethnography subverts the presuppositions inherent to mid-nineteenth-
century American schools of ethnography founded upon correlations of

blackness and ignominy, appearance and essence, and, most significantly, objective visible perception and knowledge. By deploying contradictory images of black women and slave mothers in both their narratives and visual texts, Douglass and, as will be discussed later, William Wells Brown and William Craft dislodge the black female body from associations with passivity, lasciviousness, and fixity. More pressing in Douglass's appropriation of the ethnographic gaze is the negation of the black slave mother as a cipher of the very modifiers that constitute her. For Douglass, she is neither black nor slave; neither mother nor female, yet still in symbolic possession of those properties of reproductivity and ancestral connection that both ethnography and abolition accorded to the slave mother with varying degrees of threat and thrill.

The false assumption that the slave narrative is rhetorically disconnected from ethnography dissolves as Douglass blends contemporaneous socio-political controversy with autobiography to make the turbulent debate over the ethnology of the "Negro" another one of the noticeable differences that distinguishes his second autobiographical project from his first, *Narrative of the Life*. Between the years 1845 and 1855 the slavocracy's racial justification for human enslavement received pseudoscientific credibility with the publication of Josiah Nott's *Types of Mankind* (1850), further complicating the self-definition of ex-slaves in the North. While many of these former slaves entered the debate over ethnicity and racial origins in established abolitionist or religious platforms, Douglass combated racist ideologies by returning once again to his autobiography and therein mythologizing for himself a racial origin that debunks both the arguments and methods of American School ethnography—even while seeming to rely on ethnographic strategies of observation to do so. In the manner of a trickster, then, Douglass conflates and disrupts his autobiographical role as participant and observer of slavery, and as William L. Andrews notes, refuses "to identify himself wholly or finally with either insider or outsider but only with the freedom to move back and forth across the margin."[7]

Central to Douglass's antagonistic appropriation and dismissal of the dominant ways of envisioning and (de)valuing black persons is his comparable performance of an alternative, radically subjective form of seeing. This new form of seeing crystallizes in what at first seems to be only a casual citation of an ethnographic illustration reminiscent of his mother, but which suggests an overarching critical agenda to dismantle the rationale of an emergent science. For Douglass, this project of disturbing the objectifying visual regimes of dominant culture is tied to acts of re-imagining and re-membering the slave mother, a figure Hortense Spillers theorizes to be integral in mediating kinship networks for slaves and in giving rise to a partly androgynous subject formation for black slave sons: "The African

American male has been touched, therefore, by the mother . . . [who] breaks in upon the imagination with a forcefulness that marks both a denial and an 'illegitimacy.' Because of this peculiar American denial, the black American male embodies the *only* American community of males which has had the specific occasion to learn *who* the female is within itself."[8]

This chapter analyzes one such instance of a son who dramatizes the slave mother's forceful breaking "in upon the imagination" and records how being touched with her forbidden knowledge informs his revision of dominant modes of visualizing black subjects. Spillers's invocation of the black male's uniquely androgynous perspective helps to frame the ambiguities and contradictions observable in the metaphorical and literal pictures of the slave mother that Douglass offers. In *My Bondage,* the picture that Douglass references as reminiscent of his mother as well as his alteration of her heroic importance in his early life comprise both an academic citation and a sentimental revision. As citation, the picture allows Douglass to compete discursively against established ethnographers such as Josiah Nott, James Prichard, and Robert Knox for the authority to taxonomize Africanicity, both ancient and diasporic. In his second autobiography, therefore, Douglass achieves a form of presentational irony, reversing the usual order of observer-other to become the autoethnographer of a white American other to otherness itself, a son whose racial identity and existential coordinates fail to map onto the reflective anchor that the image of the mother was presumed to be.

However, because Douglass's ethnological principles seem to reinforce Euramerican cultural dominance, some literary historians (Waldo Martin, Peter Walker, Wilson Moses) have overlooked Douglass's particular triumph in challenging and reversing those modes of visually framing blackness practiced by American School ethnography. Thus, Douglass uncovers the racial subjectivities involved in seeing blackness. He avers that blackness, as a category of racialized and cultural marginality, can only be seen by white eyes, using a mode of viewing that both appropriates and subverts the gaze, and he acknowledges that the black subject sees blackness differently, through tactics of looking back to slavery and looking beyond racialist colorism.[9] In assuming the role of an ethnographer, a role not usually available to a person of color, Douglass also appropriates the ethnographer's gaze, if only to draw attention to its despicable and sometimes ludicrous tyranny in presuming to see blackness, particularly black femininity.

The Anti-Sentimental Mother

In the first narrative (*Narrative of the Life of Frederick Douglass*), distance from the mother establishes a compelling parallel to slavery's exile of

slaves from structures of kinship and natal intimacy. Douglass stresses the infrequency of contact with his mother without providing affective commentary on this distance, rather noting that their separation exemplifies slavery's denigration of those family relationships valorized in sentimentalism. To be sure, the figure of the mother is uniformly romanticized in sentimental literature of the nineteenth century, and the heart-rending absence of the mother in many antebellum slave narratives often serves the abolitionist's objective to inculpate slavery's vicious defilement of the "Empire of the Mother"—a contradictory ideal constructed by Northern writers of conduct manuals, sentimental literature, and popular women's magazines that ennobled women while narrowly delimiting their power. Although George Fredrickson does not explicitly connect abolitionist contempt for slavery's dehumanization to slavery's obliteration of the Empire of the Mother, he notes that the Christian fervor of abolitionist propaganda often led to a defense of "human nature as self-regenerating" in general and to an indictment of the "peculiar institution," not permanent racial attributes, as the cause for the moral depravity of slaves.[10]

Even if ethnographers rarely expatiated upon the domestic behaviors of plantation slaves, they often implied that permanent physiological differences precluded slaves from ever fully appropriating European morality. The British physician Robert Knox, for example, delineates morality and sentiment as exclusive characteristics of Saxons, "which distinguish [them] from all other races of men."[11] Like so many Southern planters and slave traders who opposed abolitionist criticisms by staunchly denying the humanity of slaves, Knox straightforwardly denies that the "black races" may ever become civilized. "Their future history," he says, "must resemble the past."[12] In Knox's view, as with Nott, Morton, and Gliddon, the incommensurability of European notions of civilization, such as morality, arts, science, even filial kinship, with uncivilized subjects is only minutely evidenced by skin color; thus, the initiate observer may entertain "wild, visionary, and pitiable theories . . . respecting the colour of the black man, as if he differed only in colour from the white races; but he differs in everything as much as in colour . . . He is no more a white man than an ass is a horse or a zebra."[13] According to antebellum ethnography, access to the culturally white faculties necessary for feeling filial love was biologically impossible for figures like Douglass.

Many ethnographers of this period invoke fallacious cause-effect logic to account for observed slave or Native American depravity. In "Claims of the Negro," Douglass critiques this false rationale: "The evils most fostered by slavery and oppression are precisely those which slaveholders and oppressors would transfer from their system to the inherent character of their victims."[14] Post-oppression behaviors are routinely cited as indicative of

deep-rooted racial characteristics without considering these behaviors as effects of, instead of causes for, oppression. Expounding the demise of Native Americans, Nott reflects the faulty causality that haunts so much ethnographic discourse of this period:

> It is clear as the sun at noon-day, that in a few generations more the last of these Red men will be numbered with the dead. We constantly read glowing accounts, from interested missionaries, of the civilization of these tribes; but a civilized full-blooded Indian does not exist among them. We see every day, in the suburbs of Mobile, and wandering through our streets, the remnant of the Choctaw race, covered with nothing but blankets, and living in bark tents, scarcely a degree advanced above brutes of the field, quietly abiding their time.[15]

It would not be unreasonable to infer that Douglass or his abolitionist allies kept such fallacious observations in mind when conceptualizing his first autobiography. In order to correct such racist cause-effect logic, Douglass dramatizes the salient lack of sentimentality in the life of a slave, but justly assigns this lack to slavery instead of predetermined attributes in the slave.

Douglass may have been attracted to sentimentalism because of its universalizing of human experience and moral development along an axis of gender rather than race. In identifying the origin of morality in human beings, sentimental discourses stressed feminine agency in modeling children's behavior regardless of skin color. Though typical stories and poems were almost all related to white mothers and infants, sentimentalism, like abolitionism and religious discourses in general, always implied a universal application. As Mary P. Ryan points out, antebellum constructions of motherhood "conferred upon women the function of transforming infant human animals into adult personalities."[16] Because slavery typically removed slave mothers from impressionable infants, as Douglass's first narrative lamentably attests, the institution could be clearly faulted for the moral condition of so many motherless adults. Read in this way, the representation of the mother in the first autobiography serves a larger abolitionist purpose.

The presentation of the mother in *Narrative* conforms to Mary Louise Pratt's definition of autoethnography: "Instances in which colonized subjects undertake to represent themselves in ways that engage with the colonizer's own terms.... [which] involves partial collaboration with and appropriation of the idiom of the conqueror."[17] Motherless-ness thus becomes a specimen text of the slave's autoethnography, approximating a type familiar to (and perhaps demanded of) the slave narrative. At a syntactic level, however, Douglass's autobiographical impulses of private self-disclosure—"My mother and I were separated when I was but an infant"—contend with his narrative's autoethnographic agenda—"It is a common custom, in the part of Maryland from which I ran away, to part children from their mothers at

a very early age."[18] The "self" enunciated here remains shackled to an ethno-graphic other, an infinite number of muted and otherwise unlettered slaves for whom the narrator must speak.

The mother, too, is reduced to ethnographic type in *Narrative*. Al-though Douglass hardly adumbrates his mother's personality, he does offer glimpses of her physical appearance. Significantly, what appears to be the most important detail given of her appearance is her skin tone. As if to acti-vate the white antebellum reader's racializing gaze—a reductive kind of vi-sual fascination for blackness that ethnography helped to construct—Dou-glass reports that his mother is darker than his "quite dark" grandparents:

> My mother was named Harriet Bailey. She was the daughter of Isaac and Betsey
> Bailey, both colored, and quite dark. My mother was of a darker complexion
> than either my grandmother or grandfather.[19]

That these lines are a single, unified paragraph within the narrative only heightens the effect of the racialist, autoethnographic description. It is as if this revelation of the comparative skin tones of his maternal family were a necessary prelude to disclosing the troublesome fact of his white paternity in the stark first sentence of the following paragraph: "My father was a white man."[20]

A tension of authenticities arises from the chromatic contrast of mother and father. Houston Baker, Jr., notes that as a spokesman for abolition, "the slave narrator must accomplish the almost unthinkable . . . task of transmut-ing an authentic, unwritten self" and that self is expected, of course, to be black.[21] In order to ensure authentication as a *black* slave, Douglass indulges his reader's scopophilic desire for the spectacle of blackness, particularly the darker than "quite dark" blackness of the forlorn female body, before admitting to a white paternity that carries with it a potential to bedevil his authenticity as a representative black slave. The overly pigmented mother diverts the reader from identifying the unwritten body of Frederick Bailey with that of the white father, whose presumed rhetorical authority seems reflected in the literary acumen of the authorial Frederick Douglass. This nearly Faustian bargain facing all slave narrators—the unthinkable task of voicing blackness in a culturally white language—is also an underlying ten-sion inherent to the "partial collaboration" Pratt detects in autoethnography.

Eventually, the Douglass of 1845 divulges more about his mother: "I never saw my mother, to know her as such, more than four or five times in my life; and each of these times was very short in duration, and at night."[22] The accretion of embedded qualifiers progressively separates the mother from memory, beclouding both her maternity, "as such," and her physical-ity until she recedes invisibly from the narrative in complete darkness, "at night," and death: "Never having enjoyed, to any considerable extent, her

soothing presence, her tender and watchful care, I received the tidings of her death with much the same emotions I should have probably felt at the death of a stranger."[23] It is important to note the autoethnographic fusion of black mother and white mother in this cheerless reaction. Here we observe the "idiom of the conqueror" implemented to express the emotional loss of a mother for whose death there was no emotional loss. The death is stated not as his mother's death but as the death of literary sentimentalism's generalized mother, the "soothing . . . tender . . . watchful" mother who is metaphorically conjoined to the obfuscated mother. And here again arises the contradiction, the double consciousness endemic to slave narrative and autoethnography. Douglass registers his former lack of desire for the sentimental mother as well as his current desire to have "enjoyed" such a mother, if only to grieve her passing properly. By momentarily casting what may be the antithesis of sentimental motherhood, the apathetic mourning of a mother, in terms contiguous with sentimentalism, Douglass establishes autoethnography as a genre that demands the fusion of the colonized experience with the idiom of the colonizer.

The cultural fusion of sentimental tropes with the absence of such constructions in the realities of the slave's experience represents a noticeable device of antithesis throughout *Narrative*. In effect, the tension of collaboration is performed in the text. In *My Bondage and My Freedom,* however, the recognizable tension of partial collaboration seems somehow withdrawn, resolved before the act of writing, as if in the intervening years Frederick Douglass the man has so internalized the cultural capital of white literary America that Douglass the author in 1855 can write about his mother as if she had been a sentimental construction all along. The rift between biographical facts of his relationship with his mother and the tropological fictions of her image is somehow fused prior to her resurrection in the second autobiography. And yet, Sidonie Smith reminds us that this prior internalization is still an effect of the narrated self: "the interiority or self that is said to be prior to the autobiographical expression or reflection is an *effect* of autobiographical story telling."[24] Despite the constructedness of this linguistic interiority effect, Douglass reduces autoethnographic disruptions when presenting his mother a second time.

In the second autobiography's association of mother, citation, and Ramses, we may begin to see Douglass struggling to express a new kind of racial looking, informed by what he has learned from being "touched [. . .] by the mother [and] handed by her in ways that he cannot escape."[25] To see Douglass's remembrance of his mother in the guise of a white man as a response to the conflicting demands of *psychic* and social pressures, is to complicate interpretations of it that focus only on the latter, such as Deborah McDowell's important comment that the Ramses illustration "captures

emphatically the discursive priorities of masculinity and its gendered rela-
tion to the feminine."[26] While this priority cannot be denied, neither can the
probability that it exists in discursive tension with contrary formulations of
gender relation produced in slavery. In light of Spillers's alternative schema,
we may notice how the picture gives voice to what Douglass has learned
in the process of reading the symbolic scars of the mother's body. Such a
reading lesson produces knowledge about the value of the slave mother not
only as a symbol of displaced heritage but also as the site of personhood.
Douglass's refusal to convey the scarring of the mother's body by denying
readers an expected image of that body resonates with Valerie Smith's gloss
on the significance of Hortense Spillers's assertion in "Mama's Baby" that
"our racial and national survival may depend on our learning to read [the
mother's] scarring."[27] One way that Douglass reads that scarring is as an
absence centralized in the conventions of depicting the slave body; not just
his mother's, but his own.

Visual Genealogies of Douglass Depicted

Why does Douglass invite readers to picture him picturing the mother?
What changes in his outlook between 1845 and 1855 shape the way he looks
at slavery, captive embodiment, and the iconicity of ex-slave celebrity in
abolitionist culture? We might look to the other pictorial evidence of Doug-
lass's self-presentation to address these questions. Aside from the embedded
illustration of the author's overdetermined slave mother veiled by citation,
My Bondage sports two other more overt graphics, that of the author in the
frontispiece and that of the narrative itself, converted to an engraving that
piles three paradigmatic scenes from the text like a panoramic totem one on
top of the other. Both of these traditional additions to the image repertoire
of Douglass's authorship should be considered in semiotic relation to the
anomalous image of the mother. Together they provide a broader picture of
the politics of the look and the aesthetics of slave iconicity that contextual-
ize Douglass's provocative citation of the slave mother in Ramses.

Engraved portraits of a slave narrator, like the signatures that fre-
quently escorted them, documented the veracity of the author's literacy and
claims.[28] In light of Robert Stepto's analysis of the degrees of supplemen-
tarity between slave narratives and their ancillary documents (with slave
narratives that successfully integrate their authenticating documents at the
apex of Stepto's taxonomy), author portraits may seem only symptomatic
of abolitionist anxieties regarding the validity of slave accounts.[29] As an au-
thenticating strategy, the author's likeness anchors the text in the real world
of material history and the body, which could otherwise be substituted with
the fantastic body and non-space of the runaway slave icon. But the run-

away, as pointed out in the introduction, was not the only way black subjects were abbreviated in the visual field. The de riguer portrait of the author of the slave narrative also offered visual proof that the specific author existed, having undergone a transformation from slavery to freedom. Ultimately, the burden of reflecting such a transformation rested on the bourgeois hieroglyphics of commodity objects that appear as incidental subjects of the portraits: suits, books, drawing room backdrops. This constructed vision of "freedom" corroborated that of presumed readers and viewers of slave narrative texts, illustrating strong investments in the promise of ontological ascendancy through commodity culture.

As unique set pieces in a cultural screen usually geared to project slaves in predominantly negative ways, frontispiece portraits presented ex-slave writers as unequivocal success stories, dramatizing the aftereffects of the gentrification process. In the case of Douglass's first narrative, there is an observable lightening and softening of the writer; his hands—perhaps representative of physical agency—are significantly blurred (fig 1.2). In fact, much of Douglass's body fades to invisibility. Yet, corporeal invisibility here makes visible the author's relocation of identity, tailoring bodily presence to bourgeois representations of antebellum authorship in much the same way that the cut and style of his apparel matches the trends of the day. The result is less portrait than portraiture, an unmistakable luster of authorship packaged to middle-class tastes of a figure that is unmistakably African American. Thus there arises a contradiction between the respectable aura of the portrait and the benighted subject of the text, a loosening of the presumption of equivalence in autobiography between author and narrator. If the frontispiece is a phenotypical point of reference for the fundamental likeness of author and narrator, then how is it that the propertied bearer of the represented countenance and signature coheres with the narrated bearer of the wounds of slavery? As Lynn Casmier-Paz affirms, the conventional slave narrative "portrait harnessed multiple signs of elite membership . . . to resolve contradictory social relations and to assert the author's understanding, acceptance, and utilization of dominant codes and institutional standards of being."[30] The portrait, in this reading, balances a central tension of intention: it reframes blackness in the guises of propertied whiteness so as to emphasize and resolve the slavocratic equation of blackness and property.

The obvious limitations of the abolitionist approach to the portraits, as occasions to invest commodities with transformative powers of class ascension, would later drive Douglass and other leading ex-fugitives to formulate counterstrategies of visual representation that signaled more complicated relationships to commodity culture. In their reformulation of this visual aesthetic, the black body is not merely represented as a prop for symbolic

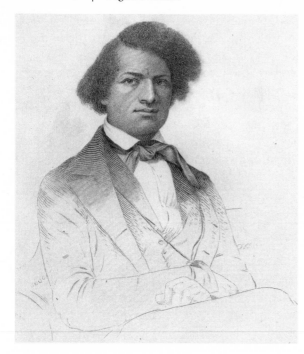

Figure 1.2.
Douglass 1845
Frontispiece;
Engraved Portrait

markers of middle-class arrival. The frontispiece portrait of Douglass's sec-
ond narrative (fig. 1.3) is perhaps the most famous example of this revision,
showing a stronger, more muscular, fist-clenched Douglass. Peter Dorsey
argues that the shift toward this stronger image "signals Douglass's grow-
ing awareness of the performativity of his self-representations and maps
his bolder claim to conventional sources of authority (and authorship) in
antebellum culture."[31] This shift is further linked to concomitant textual
evolutions in Douglass's autobiographies, in which, to borrow from Dorsey,
Douglass "abandons the *Narrative* posture that facts can be transparently
recorded and stresses an awareness of the complex textuality of the self and
society."[32]

Regardless of these postural changes, Douglass's frontispieces display a
consistent strategy of coding the ex-fugitive as having undergone class ag-
grandizement. Again, the commodities surrounding the daguerreotyped,
painted, or drawn subject as well as the fact that the subject is being de-
picted at all are responsible for such visual coding; all are part of an emer-
gent discourse—saliently conveyed through pictures—that helped to define
the middle class during this period. In arguing for the significant inter-
change between discourses of domesticity and individualism in antebellum
culture, Gillian Brown explains how a notion of individualistic domesticity
became commensurate with a model of selfhood that was imagined as being

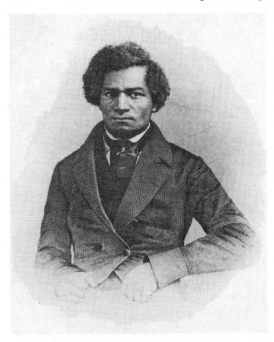

Figure 1.3. Douglass
Frontispiece, 1855

under continual construction by the commodities surrounding it: "And the
materials that became the features of the self—its properties—thus repre-
sent a history of proprietorship and invention, the process of ownership and
production sustaining the self."[33] The type of self that Brown describes is vi-
sually granted to ex-fugitives in frontispiece portraits and daguerreotypes.
As a result, a double-coded significance underlies many slave-narrative
frontispieces. While they seek to widen access to myths of class ascension to
former slaves, their reliance on a narrative of class belonging (despite race
difference) through shared consumer practices sustains the same binary
logic of exclusion and assimilation that informs slavery. In essence, one is
civilized and free because one bears recognizable evidence of civilization
adhering to the standards of the dominant group; similar tautologies may
be found in classic proslavery arguments that saw the African as essentially
fit for slavery because qualities associated with the African were arbitrarily
defined in opposition to those indicating inherent human rights of freedom.

That images become sites for redefining alterity in *My Bondage* is fur-
ther evidenced in two illustrations that correlate the narrative's two-part
division of "Life as a Slave" (fig. 1.4) and "Life as a Freeman" (fig. 1.5). Elabo-
rating upon the first narrative, these engravings by the renowned firm of
Nathaniel Orr confer to Douglass's publication that patina of visual appeal
for which Orr's other engravings were so regarded. With his brother, and
later his son, Nathaniel Orr was one of the most prolific engravers of the

period, and his acclaimed New York firm of N. Orr Company was responsible for cutting the steel and wood plates, primarily from the work of other artists, for popular travelogues, dime novels, and illustrated versions of the work of James Fenimore Cooper, N. P. Willis, Shakespeare, and others. Although Douglass's selection of or control over the engravings cannot be determined, they do echo, if only indirectly, other priorities and additions established in his text. The more expansive prose style of the second narrative in contrast to the flatness of *Narrative* finds resonant parallel in the choice, whether Douglass's or his publisher's, to allow the narrative the semiotic latitude to be illustrated at all. Indeed, the illustrations align the textual contents of the autobiography to those of fiction, being generalized depictions of slave scenes not necessarily connected to the specific incidents that Douglass narrates, but more in keeping with the illustrations of sensational episodes that helped to popularize Harriet Beecher Stowe's *Uncle Tom's Cabin* (1852). Opposing the unadorned presentation of the slave narrative, this tension between the factuality of the content and the appeal of the book and author may have caused alarm in the abolitionist sponsors of the first narrative whom the Douglass of the second takes expressed delight in being without. Moreover, the illustrations indicate the "racial and regional rhetorics of national progress" invoked throughout the text.[34]

Each illustration contains five vignettes, three tiered above one another with two unframed scenes flanking a central oval. Together they rehearse a generic dichotomy of slavery and freedom in an iconographic language that would have been immediately legible to readers of abolitionist literature. However, the two illustrations also function as reciprocal semantic legends or keys, as the composition of one elaborates that of the other. For example, "Life as a Slave" purports a causality of fugitivity based on the corruption of the spheres of education, market and labor, and technology that comes across more clearly in the second set of illustrations in "Life as a Freeman." The lower scene of the first illustration adumbrates the plantation of asymmetrical resources as slavery's schoolroom, the subject of the corresponding bottom scene of the second illustration. The domestication of animal labor to support the bucolic production of agriculture dramatized within the middle oval of the second engraving gets transposed onto the slave in the first, whose sale the flags and distant capitol building proclaim as a national activity. The triumph of mechanical transportation emblematic of the train and canal boat in the second topmost illustration finds a disturbing parallel in the scene of the runaway in the first. Lisa Brawley aptly describes the two illustrations as though they were poised beside one another, noting their shared symmetry of design and discerning the sub-plots proposed by the illustrations, including the disturbing quality of the topmost image in each, the progress of technology, the juxtaposition of leisure and play, opulence

Figure 1.4. "Life as a Slave" from *My Bondage and My Freedom*

Figure 1.5. "Life as a Freeman" from *My Bondage and My Freedom*

and squalor in slavery, and the striking absence of any black face in the second illustration of freedom.[35]

But even while acknowledging their generic relation to the specific scenes in the life of Douglass, we might nevertheless relocate these scenes in dialogue with his text and its many intertexts. The two-part display of the illustrations further supports such a dialogue, echoing that trope of antithesis so characteristic of Douglass's speech. But to what new effect are we to respond to this by-now familiar invocation of the startling difference between slavery and freedom? The answer may be found in the political changes affecting Douglass in the intervening decade between publishing his autobiographies, wherein the political urgencies of the Mexican War and potential annexation of new slave territories tragically highlighted the ineffectuality of Garrison's brand of moral anti-constitutionalism. Opting for a more nuanced negotiation with the spirit of the Constitution, Douglass saw nothing in the founding document, in contrast to Garrison, that endorsed slavery, which led him to declaim slavery as a violation of democracy's founding pact. Therefore, rather than agree to a Garrisonian hard line against the Constitution, and indirectly attest to the racist suspicion that Negroes were ill-suited to participate in a democratic society, Douglass publicized his own constitutional interpretations.

From one perspective, then, the second element of the pictorial antithesis ironically presents a view of progress from the perspective of Douglass's constitutional opponents, one that screens out blackness from the utopian view of a life without or after slavery. According to Brawley, these scenes "depict not his own story but the generic iconography of white nationalism and portray a narrative of progress from which he is excluded."[36] And yet, there is another way to limn their relation, not horizontally but vertically; not as exclusion of blackness but as an evolution of the meaning of whiteness. Just as Douglass eschews Garrison's inflexible linkage between the material Constitution and the spirit of its as yet unrealized effects, he likewise practices a mode of looking that decouples the signifier of white skin from its mythological signified of freedom, radically evacuating its presumed ethnological meaning.

The topmost scene of "Life as a Slave" allows us to glimpse this evolution of whiteness. In addition to outlining the iconic pose of the fugitive, as Brawley suggests, the strange whiteness surrounding this figure also disrupts the landscape, making it seem as if the frantic slave absconds into the ground beneath the tree so forcefully that it displaces the landscape and the teetering tree. The spectral whiteness that attends his burial in the ground emphasizes the religious overtones of the two-part illustration, slipping its meaning through the punctum of the runaway icon to imply a narrative of ascendancy through a totalizing fugitivity, one that destabilizes two kinds

of incorporation, that of property in the body of the slave and that of freedom in the body of the subsequent whites of the next illustration. This is a resurrection not just of the slave into the freeman but of whiteness—that fugitive white haze that threatens to topple the visible physics and rationality of the scene—into a usable ideograph of the condition of freedom and its privileges. This is an ideal freedom whose abbreviated conditions in the second illustration, in what appears to be only the visible embodiment of these conditions as whiteness, are no longer solely indicative of white people, but anagogically available to former slaves. The whiteness of "Life as a Freeman" may thus be seen as freedom's costuming, a prophylactic illustrated as such through a necessary exclusion of black faces. Such an interpretation seems far-fetched only insofar as we continue to impose an assumption of mimetic resemblance onto the second illustration amounting to the same dualist positivism that drove Garrison to reject a material constitution, which Douglass later saw in a different light. Accordingly, the aftermath of punctumous change in the racial aesthetics of the gaze yields an unreal whiteness staged in an unreal space. The flags have been eliminated in an annulment of the nationalist priorities that would claim the space depicted under the aegis of the same military and legal infrastructures that administer distinctions of persons and property. The scene of plantation jollity, resonant with Orr's engravings for popular minstrel tracts such as Byron Christ's *Clown Joke Book,* Charley Fox's *Bijou Songster,* and Harry Pell's *Ebony Songster,* has been replaced with an icon of liberty, embodied as a white woman in keeping with the visual patois used in the period to bespeak the offices and privileges of liberty. The pleasure that finally reduces to subjection, according to Hartman (*Scenes of Subjection*), in the slave dance equates to two correlates here, for there are two levels of signification in the second illustration. On the one hand, liberty is the serene pleasure afforded automatically to the inhabitants of "Life as a Freeman." Liberty is not strictly an antithesis of the scene of labor or sale; she presides over them both in new form. On the other hand, this liberty has become the apogee of compromised slave joy; not analogous to slave dances in an alternative, removed white space of existence, but rather a temporal extension of them achieved only after the slave dance in the plantation space has transpired. Liberty for whites, in this reading, depends upon a transformation of the slave spectacle of plantation jollity into another state of being.

This is not to believe in a de-racinated, un-gendered vision of liberty, despite the obvious characteristics of the symbol and the much critiqued consequences of imagining nations in beneficent female form, but to leave open the possibility that Douglass may have believed in precisely this sort of transformation, particularly in view of the way he re-races and trans-genders other iconic figures elsewhere in the narrative. If this second illustra-

tion were to be interpreted as Douglass's vision of freedom, then it would be hasty to conclude that it merely reflects in order to indict the racist vision that must preclude blacks from inhabiting it. Rather, we might see these scenes as an articulation of a fugitive vision that relocates the United States under the sign of Christianity (whose ciphers in steeples replace federal icons), where technological innovation may be glimpsed without reference to the grim materiality of its counterpart in the runaway slave, and where whiteness functions not to delimit Anglo-Saxons but the freedoms they unjustly monopolize and which they might disincarnate to allow others to occupy. This is a reading of white skin as the shell of privilege that is corroborated by Douglass's other visualizations of a whiteness that blacks may yet transmute or enter into as a political state of being to be veiled behind. Douglass readily accesses this transfigured whiteness in a fugitive field of vision, achieving its partial legibility through double-coded forms of racial exclusion and, as we shall see, through the appropriative discourse of citation.

The Mother's Picture as Citation

Let us return to the Ramses-mother citation. In *My Bondage* Douglass resurrects his mother's image vividly, expands the emotional importance of her maternity, and, in a move that has befuddled scholars and critics, he directs his readers to an exact page in a book where a replica of her face may be found:

> My knowledge of my mother is very scanty, but very distinct. Her personal appearance and bearing are ineffaceably stamped upon my memory. She was tall, and finely proportioned; of deep black, glossy complexion; had regular features and, among the other slaves, was remarkably sedate in her manners. There is in Prichard's *Natural History of Man*, the head of a figure—on page 157—the features of which so resemble those of my mother, that I often recur to it with something of the feeling which I suppose others experience when looking upon the pictures of dear departed ones. (52)

On page 157 of the 1848 edition of Prichard's *Natural History of Man,* which Douglass encountered "in England in the midforties" according to Peter Walker,[37] we are presented with an etching of Ramses II copied from statuary (fig 1.1).

The picture to which Douglass so strangely recurs approaches what Jennifer Fleischner finds in many slave narratives: "a psychologically coded strategy of remembering and representing."[38] The picture catalyzes ideological, social, political, and historical anxieties that are both internal and external to the autobiography—externalized in the casual way that it is men-

tioned and yet intrinsic to Douglass's self-constructed relation to the world, by virtue of the fact that this is, after all, a picture of his mother. In other words, the odd introduction of this picture may be a response to a specific site of trauma where we may isolate Douglass inscribing and mystifying selfhood through the fictional trope of sentimental nostalgia, so quizzically performed, and the academic device of the citation, which is no less odd, at least for the modern reader, since the page number of the original text seems more important for Douglass to report than either the illustration or a description of it. Why would Douglass orchestrate the reference to the picture in a way that recapitulates the bibliographic journey of his thoughts more than the mimetic rationale of his selection? Why is pagination more important than pictorial elaboration? We might argue that it is precisely through the rhetorical structure of the citation that Douglass seeks to access and override the principles of racialized looking that would govern any picture he might choose, negating its specificity at the outset. By emphasizing the process of citation, therefore, Douglass calls attention to the discursive irrelevance of the slave mother's resemblances that precedes his pictorial selection.

As citation, the reference to Ramses inserts Douglass into an ongoing network of scholarly borrowings and commentary taking place in the densely illustrated pages of ethnographic texts eager to weigh in on the racial classification of the Egyptian pharaohs. In Prichard's text, we observe that the picture is accompanied by an ornate description that aptly typifies the rhetoric of ethnography in the period. The language is especially typical of protoscientific and academic discourses in that Prichard generously borrows much of it from an earlier tome, Martin's *Natural History of Mammiferous Animals*:

> In this figure, it is observed that "the general expression is calm and dignified; the forehead is somewhat flat; the eyes are widely separated from each other; the nose is elevated, but with spreading nostrils; the ears are high; the lips large, broad, and turned out, with sharp edges; in which points there is a deviation from the European countenance."[39]

Both the form (citation) and content (ethnographic description) of this quotation merge with the context of Douglass's self-inscription. At the very moment of reference to Prichard's text, Douglass's autobiography enacts a symbolic genealogy that connects it intertextually to a host of other ethnographic texts. Andrews has already noted the heteroglossic novelization in *My Bondage* arising from the four major self-quotations, or "interpolations" as he calls them, from the first autobiography.[40] But few critics have noted the extraverbal interpolation of Prichard's text, and the way in which Douglass uses the image of his mother to insert himself into an otherwise

impermeable conversation among antebellum America's leading ethnographers. Following Andrews, we may better understand how Douglass signifies maternity, while signifyin(g) on ethnography.[41]

As stated, in Prichard's importation of Martin's language a lineage of rhetoric is established in which authority is mutually constitutive. The image of the Egyptian pharaoh and its accompanying description perform scholarly rhetoric: both image and words have been passed along a chain of texts, transferring knowledge between them. In general, citation evacuates the presence of the primary writer through the device of quotation marks, signaling the interruption or overlaying of another voice, usually an established authority, onto the primary writer's language. In this way, citation acknowledges epistemological ancestry. In "The Problem of Speech Genres," Bakhtin theorizes the function of citation more specifically, noting that quotation marks internalize "the change of speaking subjects [and the] boundaries created by this change are weakened . . . The speaker's expression penetrates through these boundaries and spreads to the other's speech, which is transmitted in ironic, indignant, or reverential tones."[42] In traditional scholarship, therefore, the citation is a mechanism of border control, policing boundaries of shared knowledge and speech. Prichard's use of Martin's voice announces his permission to do so; the self-other boundaries between the two men are dissolved and both are constituted as members of a scholarly community that share a common voice, perhaps even a common mouth.

Douglass's reference penetrates the boundaries of this community of exclusive knowledge and reshapes its ways of knowing, transmitting, and patrolling information. Ben Slote, in his discussion of Douglass's interpolations from *Narrative,* notes Douglass's penchant for exerting ownership of words and contexts: "the prior intention, the prior context, even the prior 'mouth' are all Douglass's."[43] In one sense, we may interpret the citation to the picture as a similar move to "own" or claim special kinship with a key piece of ethnographic evidence. Whereas Prichard's borrowed rhetoric of description distances him from the scrutinized image, Douglass's claim of maternal kinship with this image brackets the ethnographer's discursive authority of objectification and emphasizes the equally constructed authority of sentimentalism and autobiography as more viable ways of knowing. This picture of Ramses that is merely a prompt for a proliferation of racialist discourse for Prichard, showing exactly how un-European certain facial angles are, becomes in the hands of Douglass an image of a very European, that is, sentimental, vision of cherished maternity. But this is not to say that this sentimental image no longer represents a darker than "quite dark" slave woman. On the contrary, the fact that it is cherished by a member of the very community of "savages" and "brutes" that ethnography claimed felt no

civilized feelings of domesticity further challenges the authority of ethno-graphic discourses.

Sentimentalism versus Ethnography

To fully appreciate the complexity of Douglass's interrogation of eth-nography, we must recall the peculiar textual circumstances of the picture's reference. As mentioned, in *Narrative* it is Douglass's mother who recedes behind a shroud of darkness, in contrast to the definitive whiteness of the problematic master-father. In *My Bondage* the balance of parental certainty shifts. The whiteness of the father is qualified: "My father was a white man, or nearly white" (52). And he is now "shrouded in a mystery that [Douglass] has never been able to penetrate" (51), while the mother's "personal appear-ance and bearing are ineffaceably stamped upon [his] memory" (52). But the permanence of this stamp's impression is only possible through Prich-ard's text. In effect, Douglass reverses racist stereotypes of black intelligence by acknowledging his mother as the benefactress of his literary acumen. In "Claims of the Negro," Douglass characteristically deracializes this point by drawing an analogy between intelligent Irishmen and mulattos: "an edu-cated man in Ireland ceases to be an Irishman; and an intelligent black man is always supposed to have derived his intelligence from his connection with the white race. To be intelligent is to have one's Negro blood ignored."[44] And just as Douglass demarcates literacy as the pathway to freedom in the *Narrative,* so too does he evidence his continuing love of letters by tracing his mother, the giver of literacy, back to a book, Prichard's *Natural History,* which Douglass thereafter "takes" as his text by identifying his mother in an illustration of an Egyptian.

But we must not be lured too far into speculating over the literal impli-cations of this masculine, and nearly European (as will be shown), image standing in for Douglass's mother, especially considering Douglass's public commitment to colorless and genderless reform politics—Douglass's 1847 newspaper the *North Star* had a masthead claiming "right is of no sex—truth is no color." Walker, on the other hand, interprets this substitution of male for female as an indication of Douglass's repression of his own blackness. Walker anachronistically ascribes to Douglass a mulatto subjectivity that persuades Douglass to think of himself as half-white, which brings Walker to the facile conclusion that "[t]wo cultures, and the claims of each, as well as two persons lived inside Douglass."[45] It is much more illuminating to focus on the figurative and contextual, as opposed to the literal, implications of the picture at this point, especially since a literal reading ignores the possi-bility that Douglass is being facetious. Discussing similar perplexities in the writings of William Wells Brown and Alexander Crummel, Wilson Moses

elucidates the importance of recognizing patterns of sportive indirection: "often one will encounter even a spirit of playfulness, a dark sense of humor, and a capacity for self-satire among those nineteenth-century Afrocentrists."[46] In "The Blackness of Blackness," Gates locates a similar sportiveness in the intertextual construction of signifyin(g): "This parody of forms, or pastiche, is in evidence when one writer repeats another's structure by one of several means, including a fairly exact repetition of a given narrative or rhetorical structure, filled incongruously with a ludicrous or incongruent one."[47] It is clear that the other text implicated in the use of the picture is *Narrative,* and that out of the interplay of maternal differences between the first and second autobiographies Frederick Douglass fashions for himself a rhetorical self-definition that destroys the logic of ethnography through the sentimental revision of his mother. To borrow Spillers's phrasing, being "touched" by the mother enables Douglass to defy culturally dominant modes of envisioning the black mother, to take up a spectator position in relation to the mother not accounted for by dominant culture, one that makes viewing the mother's mental endowment and intellectual legacy a greater priority than viewing her expected skin color or gender markings.

In attributing his literariness to his mother, Douglass makes an overt reference to racialist notions expounded by ethnographers and challenges their assumptions:

> I am quite willing, and even happy, to attribute any love of letters I possess, and for which I have got—despite of prejudices [*sic*]—only too much credit, *not* to my admitted Anglo-Saxon paternity, but to the native genius of my sable, unprotected, and uncultivated *mother*—a woman, who belonged to a race whose mental endowments it is, at present, fashionable to hold in disparagement and contempt. (58)

We may be tempted to read Douglass's list of adjectives, "sable, unprotected, and uncultivated," as autoethnographic; that is, as a partial collaboration with the dominant discourse that always reduces the black mother to a skin color, thereby "epidermalizing"[48] her and the otherness she represents. But Douglass reverses gendered and racialized polarities by proclaiming that the nationless color of sable maternity, "the native genius of my sable . . . mother," is more culturally potent than the colorless nationhood of Anglo-Saxon paternity. Such an assertion sharply contrasts with the "fashionable" belief espoused by Josiah Nott, who claims: "In the broad field and long duration of Negro life, not a single civilization, spontaneous or borrowed, has existed, to adorn its gloomy past."[49] A kind of "spontaneous" literacy is exactly what Douglass ascribes to his mother. In midsentence, Douglass abandons the typicality expected of the native informant of autoethnography, "That a 'field' hand should learn to read, in any slave state, is remarkable,"

in order to proclaim the uniqueness of his mother, which can only be described in miraculous terms: "but the achievement of my mother, considering the place, was *extraordinary*" (58, emphasis mine). Instead of using the discourse of ethnography to report to and evoke pity from a readership of dominant Euromericans (autoethnography), Douglass makes his own life (i.e., his autobiography and his mother) the primary evidence for an interrogation of dominant discourses—using one, sentimentalism, to discredit another, ethnography.

That Douglass's mother could have achieved spontaneous literacy may be partly explained by sentimentalism. As stated earlier, a widely held sentimental belief of this period underscored the agency of the mother in instilling the child with morality. More importantly, the mother was often metaphorized in these discussions as a book that the child reads. An anonymous writer in *Woman's Influence and Woman's Mission* emphasized that the child's first impressions came from its mother in a process of affective reading: "She is its first book, and from her comes all which is to elevate or degrade."[50] The mother was also directly responsible for the political identity of sons. Mrs. A. J. Graves wrote of the influential political power of the mother: "in every son she is entrusted with a being who . . . will exercise a voice in the promotion of measures to operate either for his country's weal or woe."[51] In taking his mother as a text decontextualized from Prichard's text, Douglass seems to be deracializing her, transforming her from the quintessence of slave mothers to the epitome of the culturally white sentimental mother. However, it is not that she is no longer black, as Walker would have it, but that her role as the giver of literacy overrides her role as the giver of pigmentation.

Another reason for the colorless, masculine image is perhaps the most obvious yet least mentioned in criticism. Masculinization of the mother's image forecloses the possibility of an erotic gaze, seeking pleasure analogous to the sexual defilement perpetrated by slavery. Associating female blackness and lasciviousness had already been made popular by descriptions of the Hottentot Venus.[52] But, while linking the mother to Ramses II seems to release her from being the feminized object of white masculine authority, there is some indication to suspect that Douglass's notion of Ramses II may well have been connotative of femininity. Douglass may have read Bayard Taylor's 1854 account of the actual statue of Ramses II lying "on its face with its face in a hole filled with water," though its "countenance [was] said to be very beautiful."[53] Like a Muslim woman in the American traveler's imagination, the statue's face is beautiful but hidden. Nevertheless, Taylor goes on to say that the statue marks the spot of the lost civilization of Memphis, which again points to Ramses II's symbolic connection to ancient culture

in addition to genderless beauty. Thus, paradoxically, the picture may be Douglass's attempt to render his mother's mental endowments rather than her physical appearance, since, as Douglass notes in "Claims of the Negro," the instantaneous spectacle of blackness had already been institutionalized by ethnography: "I think I have never seen a single picture in an American work, designed to give an idea of the mental endowments of the Negro, which did any thing like justice to the subject."[54] And yet the question of race is not circumvented by this attempt to picture black mental endowment in terms of a white image.

Is She Whitewashed, Mulatto, or Egyptian?

If we return to James McCune Smith's preface to *My Bondage,* we witness an undeniable paling of the mother, whose chromatic trajectory begins in the text as "a deep black, glossy complexion" (52) that softens to "sable" (58), and by implication in the preface is referred to as European:

The authors of the "Types of Mankind" give a side view of the same [picture of Ramses] on page 148 [fig 1.6] . . . The nearness of its resemblance to Mr. Douglass' mother rests upon the evidence of his memory, and judging from his almost marvelous feats of recollection of forms and outlines recorded in this book, this testimony may be admitted . . . If the friends of "Caucasus" choose to claim, for that region, what remains after this analysis—to wit: combination—they are welcome to it. They will forgive me for reminding them that the term "Caucasian" is dropped by recent writers on Ethnology . . . The great "white race" now seeks paternity . . . in Arabia . . . Keep on gentlemen; you will find yourselves in Africa, by-and-by. The Egyptians, like the Americans, were a mixed race, with some Negro blood circling around the throne, as well as in the mud hovels. (xxx–xxxi)

Literary historians Peter Walker and Waldo Martin Jr. have registered the difficulties arising from what appears to be Douglass's racial prestidigitation—the perplexing transformation of his father from white to near white, and his mother from quite dark to a mulatto image of Egyptian antiquity. Though Martin seems to find fault with the surety of Walker's psychoanalytical approach to Douglass, his interpretation of Douglass's racial self-conception is less a refutation of Walker than it is a hesitant corroboration of his conclusions. Like Walker, Martin sees the Ramses picture as a testament to Douglass's continued desire to escape the legal bonds of maternal slavery as well as the ancestral marks of blackness: "Perhaps because Frederick later identified so closely with Egypt, he fancied his mother as akin to Egyptian royalty."[55] Martin goes on to speculate that the selec-

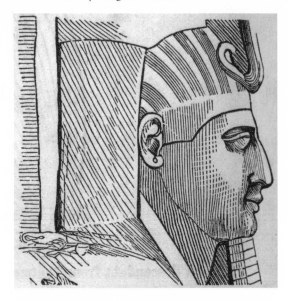

Figure 1.6. Ramses II
Engraving from *Types
of Mankind*

tion of a masculine, light-complexioned picture suggests, "on one level, the
subconscious power of [Douglass's] racial ambivalence [and] [o]n another
. . . the genderless dimension of his catholic vision of a common humanity
transcending sex as well as race."[56] Quoting James McCune Smith, Mar-
tin shows that modern critics are not the first to be flustered by the "in-
tricate racial world view" of Douglass: "James McCune Smith, speaking of
Douglass, stated in an 1848 letter to Gerrit Smith 'that only since his Edito-
rial career has he seen to [*sic*] become a colored man!'"[57] Cued by McCune
Smith, Martin qualifies Douglass's alleged racial ambivalence to account
for Douglass's increased prominence as a race leader in the 1850s. Martin
insinuates that because Douglass sought to portray himself as more repre-
sentatively black at this time, his second autobiography "obscured his white
patrimony and enhanced his black identity at the crucial juncture where he
was fast becoming the representative Negro American and the preeminent
race leader."[58] Thus, the earlier point made about Douglass's racial ambiva-
lence in selecting the Ramses picture is contradicted—how can Douglass be
seen as both ambivalent about his blackness and eager to present himself as
more black in the same autobiography?

While acknowledging Douglass's enhanced black identity in the 1850s,
Martin, like Walker, goes on to make a conclusive case for Douglass's over-
riding identification with mulatto subjectivity: "Douglass's racial vision
reflected his fundamental belief in a composite or mixed American race,
which he, as a mulatto, personified."[59] Frances Smith Foster avers that for
mulatto slave narrators, revealing a mixed parentage "offers an especially

strong potential for the antislavery cause . . . to emphasize the immorality of a system which not only allowed white men to father children by their slaves, but then to own, sell, and often abuse their own children."[60] If mulattoness can only help Douglass's antislavery cause, as it certainly did in the first narrative, as Foster attests, and if mulattoness is central to Douglass's racial vision, as Martin suggests, then why does Douglass obscure his mulattoness in *My Bondage*? All of these commentators seem to read Douglass as a racial performer in a world inhabited by genuine "Negroes" and genuine whites. But in his racial performance, Douglass seems aware of the performativity of race in general. Indeed, we might read Douglass's use of the Ramses illustration as a sign of racial performance. What sort of racial performance does its citation indicate? In what ways does Douglass use it as an occasion to racialize aspects of himself? Further analysis shows that Douglass employs the image not only to subvert ethnographic modes of viewing that presume an emphasis on exteriority but also to re-racialize his literacy and thus his authorial identity.

Let us re-theorize the Ramses picture. To borrow Andrews's terminology from "Towards a Poetics of Afro-American Autobiography," the picture is "constative—i.e., [it] refers to something extrinsic—and performative—i.e., [it] enacts something by its very existence as a text."[61] Martin and Walker belabor the picture's constative implications without seriously considering its performative function as a conduit into elitist ethnographic discourses and as a symbol of Douglass's special kind of highly emotional reading of texts usually approached with detachment. The picture also signals a diasporic gap or a rupture in black ancestry and as such it rejects the historical fixity ethnography assigns to ancient Egypt. It portrays Douglass as a living incarnation of an ancient Egypt while pointing to the ongoing presence of ancient Egypt as a "mulattoness" in contemporary America perpetuated by slavery.[62] In this way, the picture is akin to what Sidonie Smith refers to as dis/identification: "Through tactical dis/identifications, the autobiographical subject adjusts, redeploys, resists, transforms discourses of autobiographical identity."[63] This disidentification agrees with Russ Castronovo's assessment of Douglass's diasporic subjectivity, which causes Douglass "to preserve in the midst of America a set of attitudes and counter-memories garnered, not from a single monolithic culture, but from the spaces between cultures."[64]

That the picture represents a rupture in identity is perhaps also a result of the urge to present an illustration of a face at all.[65] Peter Dorsey has already noted the apparent shift in color tone between the frontispiece pictures of Douglass accompanying the first two autobiographies: "In the earlier version [there is] a pallid . . . Douglass . . . The later work shows a darker, more physically powerful Douglass."[66] And although Dorsey comments that

the stronger image connotes Douglass's evolving consciousness of self-per-formativity, he does not speculate how the "darker" self-representation also achieves this pragmatic shift. I would argue that in Douglass's prosopopoeia of himself and his mother—literally meaning his giving a face to these en-tities—the face presented implies a cultural identity that offsets, reverses, and ironizes the implied cultural identity of Douglass's belletristic rhetoric, that is, the culturally Anglofied rhetoric in *My Bondage* that so many critics have noted.[67] How ironic, then, that the face advertised to be writing these "white" words is darker and more directly engaging than the first paler face, whose eyes wistfully seem to look beyond the gaze of the viewer and whose body disappears into a white void. Compare also the ornate but merely contoured and thus lifeless illustration of Ramses to the muteness Doug-lass ascribes to his mother: "but the image [of her remembered side view] is mute, and I have no striking words of hers treasured up" (57). The wordless mother of the second autobiography therefore is less changed from her mys-terious representation in the first than one might realize. The mother is still a mystery, and her image does not bespeak her face, since there are no words to attach to the face. Instead, her image speaks to and against the ethnogra-phers who have captured her in their pages.

Otherizing White Faces and Picturing Mother Egypt

It is most striking that Douglass alludes to a picture of a drawing that is essentially colorless, passing over a few illustrations in Prichard's text that emphasize skin tones that might have been more comparable to his mother's narrative description. By citing a picture that figuralizes his mother's "side view," her profile and the form of her face, rather than one that illustrates the verbalized shade of her skin, Douglass opposes the order of specular gazing practiced by ethnography, which, as Prichard points out, begins with skin color and hair textures and then moves on to form: "We must, in the first instance, consider accurately the intimate nature of those organic pe-culiarities on which the variety of complexion . . . and of the hair . . . [w]e shall afterwards advert to the varieties of form."[68] Significantly, the Ramses picture allows for no elaborate scrutiny of the hair to which Prichard de-votes entire chapters.[69] Knox obeys the same order of observation practiced by Prichard: "Let it be remembered . . . it is to the exterior we must look for the more remarkable characteristics of animals."[70]

By focusing on the exterior, ethnographers enjoined readers to practice a form of racial, colonizing, and consumerist gazing that had long been per-formed at slave auctions—the instantaneous viewing of black body parts that reduces whole people to anatomized images of frozen primitiveness, salable powerlessness, and brute animality. Even without actual pictures,

ethnographic texts enjoin readers to picture black faces, as when Knox asks, "Look at the Negro, so well known to you . . . Is he shaped like any white person?"[71] And as Douglass argues in "Claims of the Negro," the features most often presented as typically "Negroid" are "lips exaggerated, forehead depressed—and the whole expression of the countenance made to harmonize with the popular idea of Negro imbecility and degradation."[72] The "whiteness" reciprocally constructed by these writings identified a group for whom such spectatorship was a biological right of superiority. Nott describes whites as having "the largest brains . . . theirs is the mission of extending perfect civilization—they are by nature ambitious, daring, domineering, and reckless of danger—impelled by an irresistible instinct, they visit all climes regardless of difficulties."[73] Along with this biological right, therefore, comes a duty of imperialism. Nott's writing often constructs a colonizing gaze so powerful that it easily travels into the heart of "dark" lands to perform a panoptic dissection that takes ownership of entire nations:

> Reader! Let us imagine ourselves standing upon the highest peak in Abyssinia; and that our vision could extend over the whole continent . . . we should descry at least 50,000,000 of Nigritians, steeped in irredeemable ignorance and savagism; inhabiting the very countries where history first finds them . . . Do we not behold, on every side, human characteristics so completely segregated from ours . . . Upon the moral and intellectual traits of such abject types no impression has been made within 5000 years: none can be made.[74]

Even when considering the place of "Negroes" in antiquity, Nott provides ambiguous illustrations of Egyptian slaves and coaches his readers to imagine a past in terms of slavocratic America. No antebellum reader could possibly miss the connection made between the plantation father-master and Egyptian slaveholders in Nott's description of a train of slaves, "among which are some *red* children, whose *fathers* were Egyptians"; nor the disturbing point about the jollity of ancient slaves: "even in Ancient Egypt, African slavery was not . . . always inseparable from the lash and the hand-cuff . . . 'de same ole Nigger' of our Southern plantations could spend his Nilotic sabbaths in salutary recreations."[75] The colonial gazing modeled by ethnographers therefore sought to quell anxieties of the immorality of slavery by historicizing blackness (and even mulattoness), while providing a palliative shared identity of superiority for white Americans.

In "Claims of the Negro," Douglass attacks the unified whiteness constructed in such ethnological writings. Casting himself in the role of the black ethnographer, Douglass argues for essential differences between the white gaze and the black. That blackness is perceived erroneously by white ethnographers to indicate savagery motivates his critique: "The importance

of this criticism may not be apparent to all;—to the black man it is very apparent."[76] Consider how shocking it must have sounded to his antebellum audience in Hudson, Ohio, that a black man sees blackness differently than whites do, that the eye, which the history of Western philosophy and science had purported to be a universal agent of reporting truth, was indeed biased. Almost like one pondering that facile conundrum, "is the same color blue that I see, the blue that you see," Douglass forces his audience to consider the epistemological crisis entailed by his rejection of the universal, truth-telling eye. Extrapolating from Douglass's statement, I argue that Douglass may have chosen a picture so unlike a nineteenth-century reader's image of a black slave woman in order to critique white preconceptions of blackness, to alter and destroy the colonial gaze, to register his refusal to internalize racializing depictions of blackness, and to supplant the colonizing gaze that sees only blackness with his own alternative of seeing, a form of black looking that sees mental endowment, nobility, and heritage without the stigma of color.

In his speech, Douglass goes on to shift his own anxieties of mulattoness onto white America as a whole, pinpointing differences between American and European morphologies: "The lean, slender American, pale and swarthy, if exposed to the sun, wears a different appearance to the full, round Englishman, of clear, *blonde* complexion."[77] In his construction, pure European racial identities are diluted over time as "Englishmen, Germans, Irishmen, and Frenchmen [are converted] into Americans."[78] More effective than this, Douglass subjects the "common portraits of American Presidents" to the same particularizing gaze of ethnography to conclude that the "increasing bony and wiry appearance" of later portraits proves "the greater remove from that serene amplitude which characterizes the countenances of the earlier Presidents."[79] More important than the validity of his proof that faces and people change over time, which rejects the permanent attributes championed by Nott, Douglass demonstrates the absurdity of searching for anything like racial purity in an increasingly heterogeneous nineteenth-century America, while grandly subjecting these eminent American faces to his own form of ocular dissection.

But the need for a shared identity was not limited to a heterogeneous population of white Americans split by geography and mixed European backgrounds; ex-slaves and freed blacks also felt the need to proclaim a shared cultural identity. Douglass was not the first race leader to turn to Egypt for an ancestral homeland whose universally recognized civilization would disprove ethnological claims of African backwardness. In the 1820s David Walker made a similar connection between contemporary mulatto America and ancient Egypt:

Some of my brethren do not know who Pharaoh and the Egyptians were . . . For the information of such, I would only mention that the Egyptians, were Africans or coloured people . . . a mixture of Ethiopians and the natives of Egypt—about the same as you see the coloured people of the United States at the present day.[80]

In 1841 James W. C. Pennington, who witnessed Douglass's first marriage, continues Walker's plea and foreshadows Douglass's methods in the slim but grandiosely titled *A Text Book of the Origin and History of the Colored People*.[81] Although Pennington relies upon a shrewd exegesis of the Bible to substantiate his "true history of the human family," he intimates that he should be believed because of the rhetorical and moral prowess evidenced in his text.[82] This rhetoric-as-evidence formula underlies much ethnography of the period, as George Stocking notes: "parties to the midcentury dispute based themselves for the most part on anecdotal evidence."[83] In spite of Samuel Morton's anthropometric (skull-measuring) advances to the discourse of ethnography, Morton, as William Stanton rightly points out, "was still typical [in that] he was not averse to drawing cultural and aesthetic judgments."[84] What distinguishes Pennington from these protoscientists is his finessing of Biblical history; hermeneutic acumen becomes his primary evidence for establishing a black Egypt, in the same way that autobiographical testimony will later serve as Douglass's proof.

Despite their noble attempt to assert a positive racial origin for American slaves, Douglass, Walker, and Pennington were also offering a dangerous and perhaps inappropriate heritage: Egyptians were a slavocratic society. This tendency to argue for African contributions to the progress of civilization based on an inherently European hegemonic conception of civilization ignored links to existing Africans in favor of a lost race of dynastic Egyptians more akin to Europeans. At the same time, this move implied the need for nineteenth-century blacks to assimilate European models of identity even in their search for African ancestry in order to make this heritage legible to dominant culture. Moses has pointed out the obvious paradox in such a self-conception, since many slaves already identified with the enslaved Hebrews in their songs, "away down in Egypt's land."[85] Moses suggests that this paradox of wanting "to be children of Pharaoh as well as children of Israel" resolves itself in the nature of folk mythology: "it is in the nature of mythologies to reconcile contradictions, for mythologies must accommodate the diverse spiritual goals of complex aggregations of people—not to mention the paradoxes within individual psyches."[86]

In order to make his point about the difference between sympathetic looking and clinical gazing, Douglass mimics the very same sort of ethnographic gaze that he presumably seeks to debunk. There remains evidence

that Douglass was not motivated by a disdain for all ethnography, only American School ethnographers. His continued respect for Prichard marks much of the rhetoric in his 1854 speech. Douglass's toleration for Prichard may have stemmed from the latter's performance of scientific disinterestedness. Even in his corroboration of others' testimony, Prichard exudes a scientific disinterest that borders on suspicion of bias. For Prichard, the authority of the ethnographer and the veracity of his observations lie in his lack of theoretical motivation. Raw observation, according to Prichard, is what gives credence to the eighteenth-century American explorer John Ledyard's perceived similarity between Egyptians and mulattos: "Mr. Ledyard, whose testimony is of more value as he had no theory to support it, says . . ."[87] It is highly probable that Douglass read these passages so near to the cherished picture with interest and probably noted the way Prichard exercises ethnographic authority as a correlative of rhetorical control and perspicacious skill. Like Ledyard, Douglass presents his antebellum readers with a picture of an Egyptian as a stand-in for his mother, and the reasons that such a picture should be accepted as true to her likeness are precisely those that empower Ledyard and Prichard: rhetoric, observation, and, if we recall McCune Smith, memory.

And memory, of course, is the primary mode of referentiality by which any autobiographer gives shape to life experiences. For the slave, however, memory takes on a special importance, as Gates argues:

> deprivation of time . . . signaled [the slave's] status as a piece of property. Slavery's time was delineated by memory and memory alone. One's sense of one's existence, therefore, depended upon memory . . . A slave stood outside of time.[88]

As an extension of individual memory, history is that mode of reference by which a culture, a group of people, or a nation gives shape to the past. In Douglass's autobiographies, the individuation of his life experiences indicates both a turning away from the autoethnographic enterprise—of relating the self as a typical mouthpiece for an otherized community—and a turn toward elaborating that community's cultural history in relation to particularized life experiences. Instead of avoiding a direct confrontation with those who took it upon themselves to taxonomize blackness, as did Pennington, Douglass engaged ethnographic discourse openly throughout the 1850s, and his insistence that the black look conceives of blackness differently than the colonial gaze practiced by white ethnographers marks a fundamental break from autoethnography and antebellum slave narratives.

2

Looking for Slavery at the Crystal Palace: William Wells Brown and the Politics of Exhibition(ism)

> Significantly, this logic of appearance and disappearance, of moving toward
> something only to erase it, describes nostalgic structure. . . . [which] requires an
> absent mother.
>
> LYNNE HUFFER, *MATERNAL PASTS, FEMINIST FUTURES*

That whiteness could be recharged to signify the urgencies of liberty for slaves was not altogether new in antebellum culture. Douglass's re-routing of racial appearance in the Ramses illustration seems less startling when compared to the many white artists and writers with varying leanings for and against the slave trade who regularly inscribed slavery through white figures. Countless writers trying to match the profitable aura of slave sympathy that made Harriet Beecher Stowe a success produced fictional tales of octoroons, white-looking mulattas, and whites without a drop of sable heritage but pressed into slavery through sensational means. These works competed for the attention of midcentury audiences, borrowing and in some cases surpassing the appeal of authenticated testimonials of former slaves. Unlike Douglass's post–Uncle Tom inscription of a dark black "Heroic Slave" (1852) in Madison Washington, the protagonist of his only short story, William Wells Brown struggled to disseminate stories of "white" slaves without relinquishing the authority of experience to do so. In the novel *Clotel; or, The President's Daughter* (1853) and its assorted variations, Brown sought to capitalize on the public demand for the mulatta, making whiteness the vexatious locus of contradictory appeals—for antislavery propaganda and authenticated slave testimonial; for the professionalization of black literature as well as the implicit perpetuation of black stereotypes. Ann

duCille cautions that this use of the "trope of appearance—the metaphor of the mulatta," should not be mistaken as mere surrender to bourgeois reading tastes, as it is through the convention that Brown expresses concern for "the vulnerability and sexual exploitation of black women, which stand in his work as hallmarks of the deep-seated hypocrisy of a world out of joint."[1]

In contrast to Douglass, Brown also departed from print media to broadcast his contradictory, often sensational dissatisfaction with hypocrisy to a divided public via bold excursions into the visual field. In particular, Brown's opposition to what he viewed as an inauthentic representation of whitened slavery during the Crystal Palace Exhibition of 1851 plays out in a war of antagonist images. Annoyed by the popularity of Hiram Powers's statue *The Greek Slave,* Brown made a public spectacle of himself in rejecting the artwork as a sentimental whitewashing of American slavery and its subjugation of black bodies. Significantly, Brown turned to a satirical cartoon, "The Virginian Slave," of a dejected black female as a form of counter-representation to *The Greek Slave,* thereby grounding his resistance to dominant representations of blackness, like Douglass, in an alternative, radically subjective form of seeing black femininity. And although the picture we get of Brown's mother in his *Narrative* of 1847 freezes her into an icon of imminent violation and permanent anguish, his use of such icons of maternal subjugation opposes other ways of envisioning blackness determined to be more politically threatening than systems of objectification alone. Through their engagement with pictorial representations of the slave mother, both Douglass and Brown demonstrate access to what Hortense Spillers refers to as the mother's forbidden knowledge. Although both former slaves epitomize contrary approaches to resisting dominant representations of slavery through parodic counter-representations, their practices also measure the troubling extent to which masculine self-determination necessitates reclaiming maternal or feminine emblems of slavery, whether through symbolic appropriation or evasion.

As Spillers claims, the black male's appropriation of the black mother may not be understood accurately according to European-based models of psychoanalysis since gender and even sexuality may not be conceived of as normative in the historical context of slave relations, in which "only the female stands *in the flesh,* [as] both mother and mother-dispossessed."[2] In other words, the image of the mother for African Americans wields the representational possibility of symbolizing either an actual or an imaginary kinship structure (maternality) and countering the dichotomous, dehumanizing fatherhood represented by the white master and the conspicuous absence of the African father (in the form of the "mother-dispossessed")—both of which, Spillers suggestively argues, may be uniquely embedded in the black male's psychic sense of self: "It is the heritage of the

mother that the African-American male must regain as an aspect of his own personhood—the power of 'yes' to the 'female' within."[3] In what follows I shall argue that, like Douglass, Brown employs the visual to affirm a heritage of brutal dispossession and continued subjection, which the image of the slave mother represents, not just for female slaves but for male slaves as well. Armed with a caricature of the black mother and performing the role of the slave himself, Brown activates a black look that operates according to the psychic economy of fleshing that Spillers describes. He stands in to reveal the statue's negation of both the mother-in-the-flesh and the mother dispossessed, a compound figure that Brown awkwardly stands in for and conjures at the exhibition, where maternal black flesh, according to Brown, has been obliterated by white stone. As we shall see, it is primarily through this fleshing capacity of the visual field to make public unspeakable maternal pain, which slave sons introject as ritual, memory, and selfhood, that enables Brown and Douglass to voice a yes to the female within.

William Wells Brown and The Greek Slave

In the summer of 1851, Brown together with William and Ellen Craft and other leading members of the British antislavery movement staged an attack on American hypocrisy at the Crystal Palace Exhibition, a venue that promised to make the globe itself audience to America's proslavery injustices.[4] Two aspects of the plan will be germane to my purposes here: first, the theatrical actions of Brown's party as signs meant to exacerbate American miscegenation taboos; and second, Brown's use of an editorial cartoon to satirize an appropriative work of high art and thereby rescue the historical significance of black slave women obscured by that work. Both tactics exercise a similar but contrary approach to preserving the meaning of represented slave bodies to that evinced in Douglass's citation of the ethnographic illustration.

With his exhibit of *Original Panoramic Views of Slavery* floundering, Brown turned his attention to promoting antislavery by making a spectacle of himself and his guests at the Great Exhibition. According to William Farmer, who published a record of the incident in Garrison's *Liberator* (June 26, 1851), Brown and his cohorts deliberately paired themselves into interracial couples or groups "in order that there might be no appearance of patronizing the fugitives, but that it might be shown that we regarded them as our equals."[5] The day chosen for their protest, Saturday, promised an audience of fifteen thousand visitors, among them the queen and other royal dignitaries. Also in attendance were slaveholders, whom Brown and the Crafts in turn made exhibits of in identifying them, as Farmer tells us, with "experienced eyes."[6] Before this dignified gathering, the group intended

to incite indignation from American slaveholders only, Farmer cautiously explains, without overstepping the limits of British propriety. One of the ways they meant to carry this out was to avoid initiating verbal contact with visitors: "It would not have been prudent in us to have challenged, in words, an anti-slavery discussion in the World's Convention; but everything that we could with propriety do was done to induce them to break silence upon the subject."[7] Farmer implies that it is far less disquieting for the group to become a picture meant to impugn slaveholding spectators than to make statements explicitly geared to annoy them. Despite including himself and the other whites of their party in the spectacle of miscegenation, Farmer's language singularizes the fugitives as the ones who were to be wholly transformed into exhibits: "under the world's huge glass case, in order that the world might form its opinion of the alleged mental inferiority of the African race, and their fitness or unfitness for freedom."[8]

To become targets of the racist hostility of other exhibit-goers without necessarily accosting anyone directly, it is presumed, would uphold those refined notions of propriety that Brown had been unsuccessful at maintaining—at least to the mind of Mr. J. B. Estlin of Bristol, an exponent of slave narratives in England, who was one of the guests present at the exhibition and host to the Crafts. In the weeks leading up to the international exhibition, Estlin wrote chidingly of Brown's preference for the scandalous and the showy: "We have been endeavoring to improve the tone of Brown and Crafts [sic] Exhibition altering their *showman-like* handbills, and securing a higher position for Ellen. She fully feels the propriety of all we have said and done and is very thankful to us."[9] Evidently, Brown did not share Estlin's insistence on distinguishing showmanship from abolitionist promotions, nor his presumption that mimetic enticement or polemical modes of address were incongruous with propriety. That Estlin connected Brown's problematic tone to the proper treatment of Ellen Craft, however, indicates the degree to which Brown's showman-like tactics (whatever they may be in particular) often made use of women in a manner indecorous to the well-to-do sensibilities of Bristol abolitionism, the strict policing of which (in the name of preserving the virtue of English female readers) led Estlin to bowdlerize some of the slave narratives he supported on prior occasions.[10] As we shall see, not only will Brown be indecorously showman-like, he will also make use of the black female body as counter-display to Hiram Powers's statue, *The Greek Slave*. Regardless of whether Brown's actions at the Crystal Palace evidenced conciliation or blatant disregard for Estlin's concerns, they decidedly underscore the significance of the self-pronouncedly black, American, and (by way of the picture and what Spillers refers to as the slave mother's touch) female slave body, no longer merely the "vehicle by which and through which the slavemaster's power is publicly displayed"

but as a powerful riposte to Powers's statue.[11] Linking a material signifier to an absent signified, Brown, like Douglass, co-opts the visual field in order to articulate an alternative to reigning portrayals of slaves. Whereas Douglass suggests the salutary political effects of racial exchange in visual representation, Brown seeks to obviate the ascendancy of a whiteness that disappears black exteriority.

Considered by many art historians to be the most popular sculpture by an American in the nineteenth century and the first nude to be accepted by fastidious New England sensibilities, Hiram Powers's *The Greek Slave* (fig. 2.1) was one of the most frequented exhibits at the convention. The statue was seen as a reflection of American values in an international context and presented Brown with a rare opportunity to expose American hypocrisy through satire and thereby shatter a portion of "the huge glass case" under which the United States was exhibited to the world. Wrought in marble, the strikingly white female figure stands upon a pedestal. Her face turns to her left with a downward tilt to the head. The profile of the head illuminates the spheroid bun where her hair has been pulled back. Though both wrists are manacled and doubly chained, her right hand rests upon a column draped with tasseled fabric as her left hand obscures her pubic area. Two chains loop across her right thigh. Visible amid the ornamental tassels hangs a cross. A pattern emerges from the important nexus where the cross, tassels, column, and chains nearly merge, correlating the enchained female and the tightly wound drapery encircled with tassels. The cross reorganizes the spectacle according to a conflict between Christian piety, conveyed in the figure's reluctance to face the view of her nudity, and the lechery of her heathen captors. The imagined specter of Turkish captors invoked by Powers in the statue, as Joy Kasson points out, "enabled his audience to participate in the gaze of sensuality and to distance themselves from it simultaneously."[12]

During the exhibition, official interpretations of the life-sized statue emphasized moral rather than aesthetic qualities and sought to define the figure's nudity, perhaps illogically to puritanical Americans, as an allegory of the Christian virtues of modesty and resignation. One exhibit description expatiates on the cross and locket, which "indicate that she is a Christian, and beloved," but then offers a conclusive interpretation of the statue as a whole: "It represents a being superior to suffering, and raised above degradation by inward purity and force of character. Thus *The Greek Slave* is an emblem of all trial to which humanity is subject, and may be regarded as a type of resignation, uncompromising virtue, or sublime patience."[13] Moreover, the statue appropriates that other pervasive emblem of slavery, Wedgwood's antislavery seal, which had been used particularly by abolitionist women as a symbol of defiance rather than resignation to enslavement. As Jean Fagan Yellin points out, "Instead of signifying that woman

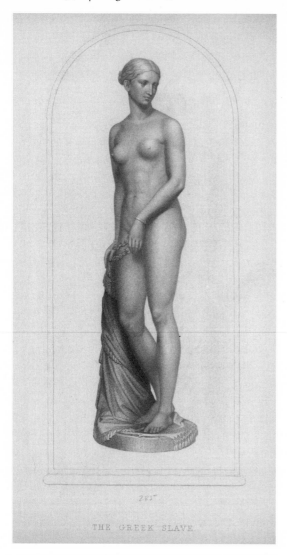

Figure 2.1. *The Greek Slave* by Hiram Powers. Print Collection, Miriam and Ira D. Wallach Division of Art, Prints and Photographs, The New York Public Library, Astor, Lenox and Tilden Foundations.

should engage in public action to end her oppression, in elite texts the icon of the enchained female signifies that the appropriate womanly response to tyranny is resignation."[14]

Brown responded to the statue's denial of redress with radical public action, precisely what the statue opposes. As described by Farmer, Brown and his company first drew a crowd of interested spectators near the statue by openly discussing its resemblance to "The Virginian Slave, Intended as a Companion to Powers' 'Greek Slave'"—an illustration by John Tenniel that had appeared in *Punch, or the London Charivari* (fig. 2.2).

When boisterous comparisons failed to produce in the assembled

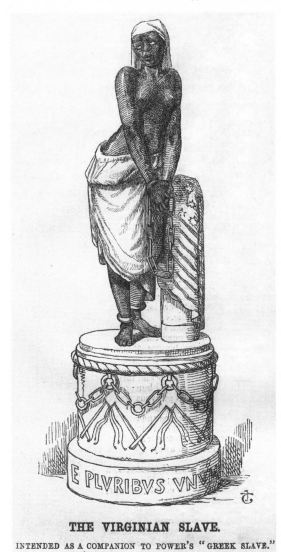

THE VIRGINIAN SLAVE.

INTENDED AS A COMPANION TO POWER'S "GREEK SLAVE."

Figure 2.2. "The Virginian Slave" from *Punch* 20, 1851

Americans "any audible expression of feeling," Brown flamboyantly took the *Punch* illustration and "deposited it within the enclosure by the 'Greek Slave,' saying audibly, 'As an American fugitive slave, I place this 'Virginia Slave' [*sic*] by the side of the 'Greek Slave,' as its most fitting companion.'"[15] Never an apostate to showmanship, Brown dramatically literalizes the subtitle of the *Punch* illustration, physically closing the space between the cartoon and its intended object of satire, and thus returns to view the black female supplicant emblematic of the abolitionism that the statue seems to supplant.

The satirical force of the cartoon's representation of the black slave

woman is difficult to miss. The manacled black female stands with breasts exposed against a column mirroring the design of *The Greek Slave* but altering a few of its key elements. Instead of the tasseled fabric, an American flag covers the column; rather than the faded, understated pedestal, this one is enlarged and decorated with whips and chains in mock tribute to the egalitarianism idealized in the Latin inscription. Most significantly, "The Virginian Slave" readjusts the meaning of two important terms that the statue mystifies: slave and American. The illustration illuminates what it means to be a slave in a contemporary American context. It condemns, borrowing from Yellin, "both the American celebration of the *Greek Slave* as a moral statement disassociated from the issue of American slavery and the claim that America is the land of the free."[16] And combined with Brown's performative act of placing it directly beside its satirical object, the illustration becomes part of a multivalent assault on the very way that blackness and slavery are put on display—or fail to be properly displayed.

Brown's dramatics recontextualize Powers's sculpture as well as its reception by the spectators present. Overlaying the image of the black female slave onto the space of Powers's sentimental captive reconfigures the viewing possibilities of both images within the public space of the exhibition. The mutual dissonance of the images defies the exhibition space in its indirect attempt to create a universal public; the *Punch* cartoon, for example, brings into existence an alternative audience (critics of the exhibit and readers of the periodical press) not accounted for by the exhibit. This makes the conflict in reception, which multiple publics conjure, the centerpiece of the exhibit rather than one image or the other.

In addition to putting these images in uneasy dialogue with one another, Brown's performance calls into question the ethics and efficacies of slave iconography, casting doubt on the possibility of either mode of popular iconography—whether romantic or satirical—to resist ideological forces sustaining slavery. As Farmer's narrative suggests, Brown's ostentatious embrace of the cartoon's satire is only a preliminary gesture. The final act of resistance to the statue's offensive rearticulation of slavery requires Brown to enter into the circuits of representation himself and, in a sense, to speak *over* the inauthentic representation of the slave. His words ("As an American fugitive slave") position him as a representation of slavery equivalent to both the statue and the illustration; all three—American, Virginian, and Greek—yoked together by virtue of slippages in the term "slave," which none seem wholly capable of embodying alone. The insufficiency of Powers's slave as an index of American slavery is made glaringly evident in the *Punch* illustration; but this too proves insufficient to Brown, who must supplement it with his own performative gesture, speech act, and presence (fig. 2.3).[17]

But just how representative is the picture that Brown makes of himself

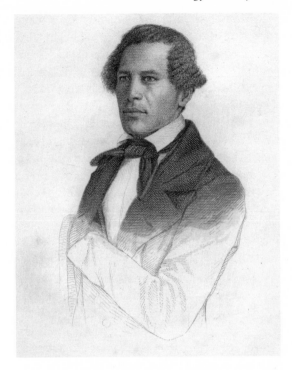

Figure 2.3. Frontispiece
Portrait from Brown's 1847
Narrative

as a spokesman of American slavery? How easy would it have been for spectators to close the conceptual gap created between Brown's professed identity and his appearance as a well-dressed, light-skinned man, gallivanting about the Crystal Palace? In his careful treatment of the incident, William Edward Farrison wryly observes that Brown's performance is ironic since only Craft "could not have been taken for a white person" by onlookers at the scene.[18] Though Farrison usefully emphasizes the partiality of Brown's own signifying presence, he overlooks other contextual factors of the scene. William Craft's more obvious Africanicity might throw into question the presumed whiteness of, at least, the other male member of the party escorting a young white female— Brown, who despite being light enough to pass may yet have been too brown to pass while standing beside a darker man, particularly as both men accompany white women. Indeed, it would be even more difficult to imagine those slaveholders whose presence precipitated Brown's self-reflexive speech to believe him to be white. No matter what race other exhibit-goers believed him to be, Brown took it upon himself to arrogate the public space of the exhibit in the name of silenced black women by speaking "as an American fugitive slave," a performative utterance that transforms the Crystal Palace, for all its spectacular pomp, into a displaced stage of American slavery.

As with Douglass, participation in the conflict of racial memory and national history catalyzes the figure of the slave mother connoted by "The Virginian Slave." To seize control over the visual signification of black femininity, Brown resorts to a countervailing reinscription of maternity. Reducible neither to the memory of Brown's mother in particular or to tormented black womanhood in general, Tenniel's slave woman is foremost a caricature and wields all the more propagandistic power for being so. It addresses through parody what Powers's sculpture conveys and what it conceals, visualizing that absence in a form and on a register conventionally used to impugn and anthropomorphize nations. Just as the ground of the editorial cartoon is the language of national abjection, the maternal becomes a ground for the language of redress. To what extent, we may then ask, does slave maternity have value apart from becoming the ground for a dialogue of masculine agents, whereby the Greek and Virginia slaves silently recede so that Brown, Powers, and America may converse? With what degree of comfort may we say of Brown what Barbara Johnson says of the default relation of mother–poet son: "The mother's curse is thus necessary for the son's apotheosis. The son's ascension is in fact dependent on the mother's abjection[?]"[19]

Whereas maternal figuration often functions as the pivot on which invocations of the mother turn toward idealization or abjection, it is yet possible, in Theresa Krier's reading of Luce Irigaray, "for writers to internalize a notion of the mother as a structure or ground for language and action (mother as object) and yet to acknowledge, or work their way toward, mothers' subjectivities."[20] If the *Punch* cartoon is a means of working toward the slave mother's subjectivity, we may yet wonder for whom does this work tend? Is Brown's act meant to arouse Crystal Palace audiences to work toward the elided slave mother, or, more significantly, to measure simultaneously the work he must do to re-member her? Such questions necessarily refuse absolute answers; however, in asking them I want to point to the issue of Brown's appropriation of the mother as a means to acknowledging his parturition from slave maternity. Krier approaches this issue, in another context, according to the psychological dynamics of the placental economy between mother and fetus that does not reduce to fusion or merger, but to an exchange between two discreet organisms in one that is mediated by the autonomy of the placenta. Released from this economy, a parturition organizes the self-(m)other relation, a space Krier finds running throughout Western literature as a trope of mediation and repression: "It is in *not* acknowledging parturition that fantasies of fusion with an archaic mother arise; not to acknowledge the dynamic distances between mother and infant in birth is itself the loss."[21] We might question if in addition to Brown's theatrical dismissal of Powers's exhibit, he discharges parturition to publicize a fantasy of

"fusion with an archaic mother," or if he is, perhaps like Douglass, attempting to acknowledge his distance from the different condition of enslavement visited upon the black female body. Barbara Johnson makes a similar point in discussing the poetics of maternal relations in the writings of Plath and Baudelaire: "If there is nothing between the self and other, there is no space of separation, no difference, perfect oneness."[22] Rather than imagining oneness, Brown magnifies the space of separation, the gulf between his agentive being in the world and the poignant absence and ongoing erasures of the slave mother. At the Crystal Palace, he achieves this by multiplying the mediators. Put another way, there are simply so many representations that come between that slave maternity finally indicates neither redress for nor through, but a crisis of address piqued but also somehow ameliorated by the multivalence of Brown's performance as spectacle, spectator, and speaker.

Moreover, Brown's multivalent intervention complicates the politics of racial spectatorship that ramify the exhibition principle of the Crystal Palace. Aside from American slavery, the other peculiar institution unbalanced by Brown's commotion is that of the museum, whose nascent procedures of display are reified by the international exhibition on a grand scale. Brown effectively takes the medium of the museum hostage by rearranging the site of the spectacle in a number of complicated ways. His disruption transforms a passive site of viewer consumption into one that makes interactivity and contestation possible, interrogating the way visual information is presented and the kinds of cultural truths that such information can convey. By politicizing *The Greek Slave,* a purportedly apolitical representation of slavery, Brown shifts the possible meaning of every piece at the exhibit, casting in doubt the singular reference to monumental truth to which all of the artifacts aspire. He lays at the feet of one official artifact a sort of counter-fact, and thus he takes possession of the right to tell slave history; at stake is not just the very meaning of slavery but the ethics of its presentation and the ontological priority of blackness as a descriptor of the slave.

From such acts of spectator resistance, we may infer Brown's conviction for the transformative powers of visual intertextuality. Like avant-garde artists of the twentieth century, Brown's aesthetic, far from indicating a political "anesthetic" view of art, stresses an intermediated form of representation. To paraphrase Michel Foucault, Brown emancipates "historical knowledge" from subjection by showing it to be capable of opposition against the coercions of unitary discourse.[23] By defying the exhibit as a truth-telling custodian of cultural knowledge, Brown literally turns around the signification of one of its most celebrated works.

The type of "turning around," or *détournement,* accomplished by Brown is described by Guy Debord as deceptive: "the détournement of an intrinsically significant element, which derives a different scope from the new

context."[24] In essence, Brown turns the statue's signifying context around—from a staging area of romantic escapism to a political space in which national culture, identity, and white hegemony are contested through counter-representation and juxtaposition. Deceptive *détournement*—or what Greil Marcus clarifies as a "theft of aesthetic artifacts from their own contexts and their diversion into contexts of one's own devise"[25]—moves beyond the mere negation of bourgeoisie conceptions of art; it seeks to negate the negation and tends toward a parodic, sublime stage, where, according to Debord, "the accumulation of détourned elements, far from aiming at arousing indignation or laughter by alluding to some original work, will express our indifference toward a meaningless and forgotten original, and concern itself with rendering a certain sublimity."[26] Although Brown may have intended to perform an act of minor *détournement,* scandalizing a paragon of high art with a commonplace illustration, his acts finally reveal the sublime indifference of the gathered crowd to the "forgotten original" referent.[27] The plight of the African female slave indeed becomes as peripheral to the battle of images that Brown wages as Ellen Craft is in Farmer's rendition of the scene. Though white-looking, Ellen Craft was a quadroon fugitive slave woman, and therefore the closest among the group to the subjectivity and historical position distorted by Powers; but her participation, whatever it may have been, is eclipsed by Brown's futile but grandiose gestures to rescue the African female slave from the misrepresentations of dominant culture.

Speaking as an American slave, Brown returns the black American slave, at least temporarily, to the center of a web of mediation surrounding *The Greek Slave* that marginalized African captivity to the fringes of an unacknowledged historical analogy.[28] As an official presenter at the event, however, Brown was not forced to the periphery of the Crystal Palace Exhibition's collections. Far from being merely a crasher of the Powers exhibit, Brown was also a privileged insider with his own works exhibited elsewhere in the palace, which makes him, one might argue, partly complicit in the site's overall presentation of American slavery. Available to visitors at the Crystal Palace were Brown's *Original Panoramic Views of Slavery* alongside an exhibit of Henry "Box" Brown's box. While few of the illustrations of the *Original Panoramic Views* exist, a consistency of expression and symbolism links those that were reprinted as illustrations in his literary and nonfiction prose works with "The Virginian Slave." For example, the cover of Brown's *The Anti-Slavery Harp* (1848)—one of the first collections of African American lyrics—depicts an American eagle capturing a black woman desperately holding her child, while in the background stands the U.S. Capitol building (fig. 2.4). The collection also features Patrick H. Reason's woodcarving plate of a tormented black slave fastened to a pole flying the U.S. flag (fig. 2.5).[29] Such heavy-handed symbolism appears frequently in illustrations that,

Figure 2.4. Frontispiece of *Anti-Slavery Harp*, 1848, by Patrick Henry Reasons; also Front Cover of *Antislavery Almanac*, 1843

like the *Punch* cartoon, were used by Brown to inveigh directly against the American government.

This is not to say, however, that Brown's iconographic vocabulary of protest is ideologically innocent. In many of the illustrations commissioned, published, or otherwise employed by Brown, the iconic figure of the slave risks dehumanizing its various referents by universalizing them. Yet its counterpart, always a vilified icon of America, brandishes hyperbole and association in ways similar to the genre of political cartoon, that microcosmic carnivalesque that routinely censures and lampoons nation-states and sensationalizes political conflict. In one sense perhaps, Brown's *Original Panoramic Views* amplify the biting satire of the political cartoon by projecting it on the grand scale of the panorama.

Although Brown's panorama will be examined in more detail in chapter 4, it is important to note here its political and aesthetic affinities with the *Punch* cartoon. As Farrison explains, the panorama occupied a pivotal place in Brown's armory of weapons against America's slavocratic despotism.[30] Like the highly choreographed presentation of slave narrators before English audiences in the 1850s, Brown's panorama was a strategy of titillation, inciting audiences visually before and after antislavery lectures. According to Farrison, Brown alighted on the idea of presenting "as fair a representation of American Slavery as could be given upon canvas"[31] in the

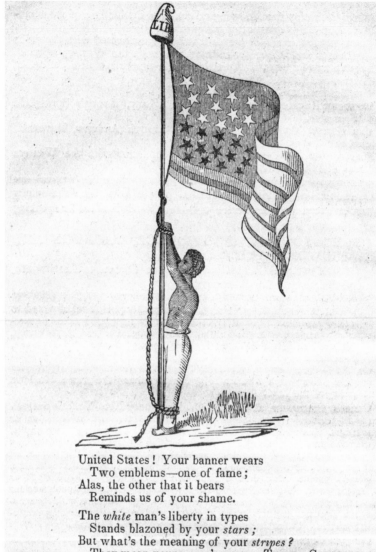

United States ! Your banner wears
 Two emblems—one of fame ;
Alas, the other that it bears
 Reminds us of your shame.

The *white* man's liberty in types
 Stands blazoned by your *stars ;*
But what's the meaning of your *stripes ?*
 They mean your *negro's scars.* THOMAS CAMPBELL.

PIOUS SLAVEHOLDERS.—BY ELIZUR WRIGHT.

"I have no more disposition than I ever had, to demonstrate how much men may dabble with dishonesty, or defile themselves with oppression, and yet be saved—how much men may vocally or silently consent with thieves, and yet be honest—how much they may involve themselves with laws and customs worthy of devils, and yet deserve sympathy and consolation at our hands, as Christians. There *may* be Christian pickpockets, Christian horse thieves, Christian swindlers, for aught I know. I am not profound on this argument. But I think such Christians do no honor to a church ; much less to a pulpit."

Figure 2.5. Back Cover of *Antislavery Almanac*, 1843

summer of 1850 as a means to entice weary British lecture-goers, "lest the public . . . lose interest in his lectures."[32] Brown's panorama was initially an idea prompted in reaction to another panorama that Brown had seen in Boston three years earlier, which presented slavery in a "very mild manner."[33] In addition to emending the pastoral treatment of slavery in this earlier panorama by adding scenes designed to sensationalize the brutality of the "peculiar institution," Brown's *Original Panoramic Views* also reflect modes of ethnographic spectacle popularized in the India Route Panorama on exhibition in London at the time.[34]

Just as the India panorama propagated bourgeois norms of English colonial supremacy, staging its exploitative construction of racial and cultural difference as merely a by-product of geographical curiosity, the *Original Panoramic Views* pandered to similarly circumspect ideologies contrary to anti-racism. The slave experience is almost universally rendered allegorical, as slave iconography equates black people to a state of fleshliness, "pornotroping" blackness for the consumption of viewers. Put simply, pornotroping is a representational process derived from slavery that transforms a person into flesh. It involves putting flesh on display and thereby satisfying voyeuristic desire by reinforcing the viewer's self-perception of bodily integrity in contrast to the view of objectified flesh. In her discussion of pornotroping, Spillers makes a distinction between body and flesh, between culture and cultural exclusion—what Spillers calls "vestibularity."[35] While flesh is the entryway to culture, a condition of being vulnerable to fissures in the body, the body of the public viewer is presumably safeguarded by institutional prophylaxis of the law. To what extent, then, can Brown simultaneously occupy the position of the vestibule and the law by orchestrating such exhibits of the slave as self and other? Is he at once like the slave objects he puts on view and like the spectator who views them at the same time?

Even if Brown's insistence on the presence of black female bodies objects to white supremacy, it nonetheless evidences affinities with patriarchy by translating the feminine into the exploitable raw material of self-making. Producing the *Punch* illustration simultaneously gives occasion to Brown's multiple identification as both outsider (slave, feminized, black) and insider (exhibitor, genteel chaperon to white women, public speaker). Unlike Douglass, who turns away from representing the exteriority of black femininity, pornotroping functions as the complex generative source of Brown's identity construction, which rhetorically hovers between maternal fleshliness and masculine personhood. It is in Brown's narrative that we may understand how the figure of the mother comes to mediate this tenuous sense of personhood for Brown, encoding slavery in primarily visual terms of protracted temporality and maternal subjection that yet give rise to generative identification.

Picturing the Mother in Brown's Narrative

We have seen that Douglass's move to re-gender and deracinate the mother hints at a form of indemnification against the kind of pornotroping best exampled in his first narrative's depiction of Aunt Hester's whipping. With Brown, one may argue, the obverse is true. Here the pornotropic picture that re-racinates the female slave ("The Virginian Slave") counters prevailing modes of picturing slavery based on occlusion, pathos, and displacement. Yet both strategies adhere to limiting assumptions about gender and race congruent with masculine ideologies of their time. Both risk justifying polarizations of race otherwise used to support slavery and assumptions regarding the iconicity of the feminine. To valorize the maternal as a force in excess of rationality and prior to representation risks affirming the compensatory ideology by which women have power in the symbolic inversely proportionate to their lack of it in society. To be sure, the maternal remains the ground of fraught self-making for Brown, but to focus only on the effects of its apparent use-value is to ignore how it comes to have such effects and how it seems to achieve such value, particularly as a locus of visuality, affect, and absolution. What does it mean to speak of the slave body both vicariously and experientially, and how is it that consanguineous witness comes to speak for the collective? These questions are perhaps not resolvable, but tentative responses to their call may be found in tracing Brown's negotiation, as I do in this section, with narrated memories of torture and visions of his mother and sister while on the brink of freedom. I seek to show how the slave mother becomes a symptom of the torture of memory. Though she represents enduring absolution for the son who steals himself to freedom, she also marks an ontological and epistemological chasm, a wound that thereafter aligns the freedom and manhood achieved after escape with the mother forever doomed to captivity.

Brown's 1847 *Life of William Wells Brown* narrates slavery as an inevitable series of whippings doled out by harsh and frivolous masters. Beginning with a childhood account of hearing "every crack of the whip, and every groan and cry of my poor mother" as she is lashed for a minor tardiness, the narrative goes on to catalog other incidents of cruelty with an observable declension of affect.[36] Randall, a powerful yet responsible field hand, is shot for not submitting to a slavebreaker's lash; Brown himself is whipped and smoked (forced to near suffocation in a smokehouse) for a runaway attempt; Aaron, a knife-cleaner in a hotel, is whipped and then doused with rum by Brown, who notes with chilling distance: "This seemed to put him into more agony than the whipping" (24).

The progression from impassioned witness of slave punishment to phlegmatic accomplice plots the extent to which torture ramifies slave life, whether experienced, observed, administered, or merely rumored. To reflect the sinister quality of slavery in St. Louis, for example, Brown draws attention to the equivalent value and cumulative force of various accounts of torture, including those only gleaned from newspaper reports: "During a residence of eight years in this city, numerous cases of extreme cruelty came under my own observation;—to record them all, would occupy more space than could possibly be allowed in this little volume. I shall, therefore, give but a few more, in addition to what I have already related" (28). What follows, however, is not the lengthy citation of newspaper reports familiar to readers of Charles Ball's narrative, but a paragraph of Brown's eyewitness experiences on the taming of another innocent slave and then a return to an account of his intense feelings for his mother.[37] This cyclical progression of affect is significant, for it demonstrates in the maternal a power to localize excesses of spatial, experiential, and evidentiary complexity, resolving the psychic and practical dilemmas inherent to witnessing slavery's injustices. To speak of the maternal, for Brown, is to speak from contradictory locations of authority and to reconcile the conflictual demands of individuality and community, feelings and politics, type and archetype. Like the *Punch* cartoon, maternality here transforms into an absolute symptom of slavery, an evidence-fetish that collapses into itself all of the other cuts to the body that Brown lacks the space (or the experience) to supply. In this way, maternal reproductivity translates into a rhetorical conductivity of testimony, which the son appropriates as a natural right to depose and which, as will be shown, intensifies when articulated in the visual field.

The importance of the figure of the mother (and sister) in Brown's narrative sheds light on his use of illustrations of black slave women. Although he prepares the reader for impersonal digression, Brown spends much of the fourth chapter explaining how domestic affection, symbolized jointly by his mother and sister, anchors him to a condition of slavery, causing him to forego escape while hired out on a steamship. Whenever considering escape, Brown confides, "my resolution would soon be shaken by the remembrance that my dear mother was a slave in St. Louis, and I could not bear the idea of leaving her in that condition" (31). Having sufficient opportunity and cunning to effect his own escape were it not for family ties, Brown conversely presents those trapped within the domestic space of slavery, perhaps unconsciously, as lacking the will, opportunity, or agency to escape. This view is endorsed by Brown's sister in one of the narrative's many exchanges of dialogue, which are prescient in their illustration of the permanence of slavery for women, no matter how stilted in their expression of it:

"No, I will never desert you and mother."

She clasped my hand in hers, and said—

"Brother, you have often declared that you would not end your days in slavery. I see no possible way in which you can escape with us; and now, brother, you are on a steamboat where is some chance for you to escape to a land of liberty. I beseech you not to let us hinder you. If we cannot get our liberty, we do not wish to be the means of keeping you from a land of freedom." (33)

The sister's poignant absolution of Brown from feeling responsible for her enslavement echoes in a similar exculpation speech given by the mother after being imprisoned: "*My dear son, you are not to blame for my being here. You have done nothing more nor less than your duty*" (78, emphasis Brown's). Even as both women insist the contrary, these speeches register Brown's sense of accountability for his different position in slavery. The text accentuates these passages of maternal absolution through a heightening of tone, italicization, and appended poetry ("I half forgot the name of slave / When she was by my side" 79). During these moments, a ritual space of ancestral commemoration and eulogy disrupts the narrative of progress toward liberty, enabling communion between opposing worlds. In contrast to the protagonist-narrator's impending freedom, the mother speaks from the crypt of permanent slavery: "My child, we must soon part to meet no more this side of the grave" (78). While there may be dialogue between them, Brown's narrative of self-recovery requires that he abandon the tragic domestic space of slavery symbolized by his mother.

Moreover, the ties of affection nurtured in this domestic space are tied to primal scenes of torture. Recounting the mother's whipping, Brown paraphrases stories of maternal sacrifice told to him by his mother, "how she had carried me upon her back to the field when I was an infant—how often she had been whipped for leaving her work to nurse me" (31). Family history and childhood identity are literally carried on the back of the mother, a back that also pays for such support with stripes from the master's lash. The dual quality of suffering and love embodied in the mother recalls the narrative's opening scene, where the mother's whipping conjoins mother and child emotionally despite their separation not only in physical space—Brown overhears her whipping from a bed within the plantation house—but also in occupational caste: Brown was a house servant; his mother, a field hand. In both scenes, Brown authorizes himself as a spokesperson of the wrongs of slavery, which culminate in his presentation of them as a senseless, inexorable series of whippings. Because he has only partial knowledge of these whippings, Brown's mother plays the epistemological go-between; her back becomes an extension, so to speak, of Brown's own sensorium. The "few more" observations of "extreme cruelty" that Brown finally offers emerge

as one prolonged, ardent pledge of loyalty to his mother and sister, who top Brown's list of intimates: "Of all my relatives, mother was first, and sister next" (32). Though the cruelty visited upon slaves known only through public accounts may still qualify to Brown as being related to his own experiences as a slave, the cruelty felt by his mother on his behalf overtakes the focus of the chapter as well as the narrative's climax.

Insights derived from the copious scholarship on the whipping of Aunt Hester in Douglass's *Narrative* point to the ways in which black masculine identity achieves coherence in opposition to white masters by repressing identification with black female slaves. To be sure, the protagonist in Brown's narrative mirrors the teleology of Douglass's self-representation: both slave narrators aspire toward autonomy in opposition to the oppression of maternal figures. In her psychoanalytical reading of Aunt Hester's abuse, Gwen Bergner argues that Frederick Douglass identifies with Captain Anthony, whose phallic power is cathected in the whip dominating Hester, the surrogate mother, causing Douglass to experience voyeuristic pleasure in her debasement.[38]

Although Brown's narrative similarly confines black women to vulnerability, Brown does not position himself as spectator to maternal persecution. Rather than repressing identification with the mother, Brown ascribes transcendent power to his mother's pain as the vehicle that traverses the chasm of their separation. The white master is invisible in the scene, even though the "Law of the Father" may be said to imbue the house young William is immured within, since it maintains an a priori division of slave child and mother. Therefore, in Brown's narrative entry through the "blood stained gate" of slavery occurs as an auditory, not a spectatorial, trauma. That Brown's inaugural perception of patriarchal sadism extricates him from the scene is not to say that Brown's narrative or his narrated masculinity is any less haunted by an Oedipal dynamic of voyeurism and prurient fantasy than Douglass's; only that for Brown the primal scenes of maternal abuse, which he defines his self-possession against, are experienced as attenuated memories and nonvisual perceptions. Interestingly, however, these partial sensations of the traumatized maternal focalize into pure vision during the narrative's climax.

Just as Brown prepares to cross slavery's mythical threshold North, the multisensory jumble of emotions related to the women he leaves behind converge memory and anxiety to yield two ominous visions of suspended crises. After making his way to Cairo, Ohio, in chapter 12, that "land of liberty" his sister exhorted him to find, Brown punctuates his thrilling realization of self-possession, "It was that I *should be free!*" (93), with imagery of maternal suffering. He looks forward to the following New Year's Day, when

his newfound life of liberty shall commence, and juxtaposes his progressive mobility against mental images of his mother's and sister's perpetual slavery. I shall quote the final paragraph of the chapter in its entirety:

> During the last night that I served in slavery, I did not close my eyes a single moment. When not thinking of the future, my mind dwelt on the past. The love of a dear mother, a dear sister, and three dear brothers, yet living, caused me to shed many tears. If I could have been assured of their being dead, I should have felt satisfied; but I imagined I saw my dear mother in the cotton-field, followed by a merciless task-master, and no one to speak a consoling word to her! I beheld my dear sister in the hands of a slave-driver, and compelled to submit to his cruelty! None but one placed in such a situation can for a moment imagine the intense agony to which these reflections subjected me. (93–94)

As with Douglass, remembering the slave mother stimulates the discomforting realization of one's own privileged opportunity for escape. For Brown, images of maternal vulnerability to endless ignominy become simultaneous with imagining his own freedom. Tellingly, Brown characterizes himself as unable to conceptualize freedom other than through its opposite, obsessively picturing both mother and sister forever suspended in typical preludes to torture and rape. In his description, the mother is only "followed by" a would-be tormentor, while the sister's crisis intimates a harsher degree of imagined cruelty. Just as he occupies a liminal state between slavery and freedom during these visions, so too do mother and sister take iconic shape at the very limits of life and death. If only they were dead, he muses, their vivid memory would not be so intolerable. That they were alive before his escape makes it impossible for Brown to martyr them or make their transference into the symbolic register of memory more tolerable. Babatunde Lawal connects memory and history in African American performances of the past and sees recollection as a process of reconstruction, in which "memory not only facilitates the transfer of cultural property from one geographical space to another, it is also a catalyst in the construction and negotiation of new identities."[39] Beyond personalizing scenes that had already become visual clichés for depicting the injustice of slavery to black women, Brown's iconic memorial to his mother and sister suggests his new identity in freedom to be visually unimaginable, or categorically illegible, without reference to maternal labor, sacrifice, and subjugation.

Yet identification with female stand-ins is not restricted to mother and sister in the narrative. During a digression, where the intention seems to be to relate yet another atrocity of slavery, Brown describes a beautiful white slave girl "not in chains" (34), who boards the steamship he is hired out to. With "straight light hair and blue eyes" (34), she attracts the notice of other passengers and crewmembers, but, as Brown qualifies, "it was not the white-

ness of her skin that created such a sensation among those who gazed upon her—it was her almost unparalleled beauty" (34). Brown's de-emphasis of whiteness in attributing some non-racialized quality of beauty to a white-looking slave girl mystifies connections between codes of feminine attractiveness and white superiority. One may argue that Brown simply disavows the ideological causes for finding a young white slave girl "unparalleled" in beauty. Regardless of our first critical impressions, Brown withholds further details regarding the mysterious white slave girl, until informing us later that he too is to be hired out to Mr. Walker, the very man who claimed the girl Brown alternatively calls an "article of human merchandise" (34) as his own. Replacing the white slave girl as Mr. Walker's "article," Brown structurally likens himself to her and alludes to the way in which anxieties hovering around the convergence of whiteness, gender, and commodification also structure the strange allure of white slave women.

Erotic associations between complexion and commodity structure the slave master's gaze in much abolitionist literature. Epitomizing the erotizization of the slave son via the mother is Haley's unsettling apprehension of Eliza in Stowe's *Uncle Tom's Cabin* (1852). What makes the scene so disquieting is the voyeuristic exchange established between the child and the mother as erotic objects of examination. Eliza becomes visible, in other words, and sexually alluring insofar as she bears a resemblance to Harry: "There was the same rich, full, dark eye, with its long lashes; the same ripples of silky black hair."[40] The child thus becomes the implicit point of reference for the prurient coalescence of the material and sexual objectification of the black woman in general. Strange, and perhaps adding to the subtextual sexualizing of the child, is the contrast in the way mother and child are shown to react to the appraising gaze of white male authority. While Eliza flushes when seeing "the gaze of the strange man fixed upon her in bold and undisguised admiration," Harry responds with that curious admixture of opposites Stowe repeatedly attributes to him in the opening chapter, "a certain comic air of assurance, blended with bashfulness," which proves, Stowe tells us, "that he had been not unused to being petted and noticed by his master."[41] The ambivalence of little Harry's reaction to the master's gaze gains in clarity only through the equivalences Stowe insists upon in relating mother and child through the practiced eye of the slave trader.

We may infer that the same sexualizing gaze that is "well used to run up at a glance the points of a fine female article" is no less practiced at sizing up the points of the charming young boy whose exploits and performances readers are led to view with relatively no commentary from Stowe regarding the trader's reaction.[42] It is not until the intrusion of Eliza, saving the young child from the trader's view, that we are led to presume that a similarly sexual sizing up had been taking place all along, and that Stowe has strategi-

cally made us unwilling participants in it. The more typical sexualization of the mulatta mother stands in for and obscurely references the sexualization of the child. Reinforcing this association of slave mother and child as twin "articles" of material and sexual desire is the pair in Haley's ironically self-righteous speech about a case when the "real handsome gal" and her child are not desired together: "The fellow that was trading for her didn't want her baby; and she was one of your real high sort, when her blood was up."[43] Aside from casting the trader in a hypocritical light, this speech functions as prolepsis. It looks forward to the realization of the mother-child split that heralds such dangerous fusions of the adult slave woman's anguish of being a sexual target onto the transacted slave child. Entry into the economy of slavery stamps the child with the same currency of eroticization as the slave woman. So it is that anguish that functions as the imprimatur (the name for the face impressed upon coins) that marks the slave's translatability into the commodity form.

Linkages between the commodified sexuality of the white slave girl in Brown's narrative and his feminized role beside Mr. Walker both anticipate and complicate his relation to *The Greek Slave*. Like the white slave girl, Brown may have been found attractive to Walker because of the whiteness of the merchandise that Brown embodied, or like little Harry, because of the substitutive dynamic of the erotic economy of the gaze that organizes slave mother and son in the master's view. Perhaps when insisting on a category of beauty untouched by prejudices of race in 1847, Brown disavows the market value of his light complexion, that near whiteness which must not be the cause of his attractiveness as a slave just as it must not be the reason for the white slave girl's universal appeal. Nor must Brown's near whiteness in 1851 be seen as the ticket that transfers him to more mobile sites of agency than his mother is able to access, such as the Crystal Palace, where his valorous grandstanding as an American slave accrues denunciatory value insofar as it borrows against a fund of martyrdom made visible by two more readily apparent captive bodies, both of which are female. And between the illustration of the black slave woman and her disappearance in Powers's dissimulating white statue stands Brown, whose brown complexion triangulates him in relation to a third female slave body conjured at the site, that of his mother, whose blackness predicates his claim to speak as an American slave. If there is any truth in Farmer's report that slaveholders were spotted with "experienced eyes" at the Powers exhibit, they would bring with them the knowledge of the mother's condition as the defining quality of enslavable status. Even so, the absence of observably black women during Brown's performance charges the caricature he wields with that same pathos that transfixes female relatives in the narrative. While the image of the white female slave in the palace gives rise to articulations of female-inness, in the

narrative it suggests an insufferable paradox: within slavery, Brown's male and mulatto body exonerates him from the brutal experience of darker female bodies with which he identifies so strongly once free.

Indeed, his mother is not the only body surrogate to take lashes for Brown; an illiterate freedman gets tricked into getting whipped when Brown asks him to take a note prescribing punishment to the authorities. Mollifying his petty treachery, Brown blames slavery for making "its victims lying and mean" (57). Though only applied to this incident, Brown's evasion of complicity may also function in the narrative to justify the compromising role Brown is forced to play in service to Mr. Walker. Despite acknowledging the possibility for reconciliation with the duped freedman in the authorial present, Brown surveys the fate of female slaves with less optimism. For example, Cynthia, Mr. Walker's quadroon housekeeper "and one of the most beautiful women [Brown] ever saw" (46), is predicted to have been swallowed up by the intransigent forces surrounding her, becoming the target of Walker's "base offers" and "vile proposals" (47).

Whether Cynthia is the aforementioned slave girl or not (the narrative remains unclear as to the connection), she positions Brown within an erotic network of voyeurism similar to that evoked by the nameless white slave girl and later configured at the Crystal Palace. Brown comforts Cynthia, just as he imagines comforting his mother and sister, after pruriently eavesdropping on her encounter with Walker: "I comforted and encouraged her all I could; but I foresaw but too well what the result may be" (47). The language here echoes Brown's earlier certainty regarding Walker's salacious intentions in providing Cynthia with a separate room. "I had seen too much of the workings of slavery," Brown confides, "not to know what this meant" (47). Based upon this surplus knowledge of slavery gleaned through similar sights, not to mention credible information amassed since attaining freedom, Brown envisions Cynthia's fate in the authorial present as a descent into irrecoverable slavery proportionate to her role as a mother: "Walker has been married, and, as a previous measure, sold poor Cynthia and her four children (she having two more since I came away) into hopeless bondage!" (48).

Coupled with a related incident in which Walker sells a slave woman's child whose crying annoys him, such scenes of slavery's sexual domination of women confer upon Brown "too much" of the spectator's knowledge. The cruel details he deploys as crucial evidence of slavery's evil are perpetrated upon women and only witnessed by him secondarily. He is an indirect victim looped into the circuit of domination by accident of situation and birth and, thereafter, fixed within that circuit through acts of compassion, memory, and representation. Even if excluded as a primary victim of slavery's worst humiliations, Brown serves as the vehicle through which such scenes

of female submission are represented. To borrow the words of his prefacer, J. C. Hathaway, Brown paints himself within "harrowing scenes . . . graphically portrayed" (viii) of female-centered abuse as the self-made man who is "urged on by the consideration that a mother, brothers, and sister, were still grinding in the prison-house of bondage" (ix). In his asides, Brown makes corrective adjustments to any resulting instability in his self-made manhood and draws upon a surplus knowledge of slavery's sexual exploitation of women to annul conceptualizing their resurrection in freedom. Therefore, while the status of Brown's masculinity in slavery emerges in collaboration with maternal sacrifice, rape, and death, his masculinity outside of it, as escaped slave and author, coheres by consigning slave women to the limits of imagination, prohibiting them from any status other than the iconic.

Within slavery, Brown's tenuous agency is parceled out to him by white masters, leaving him in a hazy relation to systems of oppression. Juxtaposed against his mother's bodily degradation, Brown experiences slavery as a dispossession of identity and self. Significantly, even Brown's official legal status is ambiguous to him while working for Mr. Walker: "Although my master had told me that he had not sold me, and Mr. Walker had told me that he had not purchased me, I did not believe them" (40). Under Walker's service, Brown is forced to prepare slaves for market, feeling "heart-sick at seeing my fellow-creatures bought and sold" (42). The imprecise nature of his ownership resonates in his duties to ensure the exchangeability of other slaves, obfuscating their apparent value by embellishing their bodies.

As usual, in describing his participation in the dehumanization of slaves, Brown relies on a careful, though sometimes awkward, selection of pronouns to direct and deflect blame: "I was ordered to have the old men's whiskers shaved off, and the grey hairs plucked out, where they were not too numerous, in which case he had a preparation of blacking to color it, and with a blacking-brush we would put it on" (43). Agency and blame follow a principle of ownership. The materials belong to Mr. Walker, the "he" who forces Brown, now engorged by a subordinate collective "we" (although in later passages Brown alone assists Walker in slave marches), to literally make the older slaves black. And just as the "we" plural pronoun distributes and diffuses Brown's complicity in the final clause, the ambiguous use of the third-person pronoun, "it," confuses the integrity of the slave body. The "it" in the phrase, "he had a preparation of blacking to color it," may name the hypothetical spot either on the slave body in need of blackening or on all the slave bodies as a non-countable entity; but by the end of the same sentence, another "it" designates "blacking" as an antecedent, which further commingles the particularity of the slave body with the materials for producing commodity blackness. Commodity blackness, or the marketable blackness

that motivates objectifying white viewers and consumers, covers over inconsistencies in the variety of Walker's "cargo of human flesh" (42).

We may infer several pertinent distinctions in the valuation of color from this instance of blacking up the slaves. Whereas blackness in slaves connotes youth, commercial visibility, physical competence, and the surety of sale, whiteness in them conveys commercial invisibility, the surety of sexual exploitation, and the prospect of escape. Some measure of invisibility may even be detected in the description of Walker's white clientele, who are screened off from these preparations only to be "dreadfully cheated" (43) as a result of their inability to distinguish what Brown has made indistinguishable in his narrative: black skin from blackening agents.

Whiteness, as Brown and current critical reflections on race configure it, also accrues a value of abstraction.[44] Brown scarcely acknowledges his own lighter complexion when assessing his privileged opportunities for escape and, as shown, renders whiteness an unmentionable criterion of social evaluation. Overlapping with gendered hierarchies, Brown's conception of whiteness further compares to current critical views in that the abstraction it affords plays out most effectively in terms of language. If Brown's sister and mother aver that he should be free because he has always simply said that he would be—a view of language as destiny finally confirmed in Brown's self-realizing assertion, "I would be free"—then we might conclude that black femininity, in Brown's formulation, occupies a linguistic space of selfless prophecy and silence.

Facing the Female Within:
Brown and Douglass Compared

In setting the visual practices of Brown and Douglass side by side, the point, of course, is not to erroneously unify their heterodox orientations toward slave representation. Rather, I want to mine their similarities and differences in order to better understand the conditions of possibility and practice affecting their racialized looks at self and slavery. Nevertheless, some simplification is inevitable in such an undertaking, and I admit placing unconventional emphasis on the deployment of the figure of the slave mother in the works of both in order to make the following comparison possible.

Both Douglass and Brown illuminate the conversion of the mother into the realm of the symbolic. It bears consideration that while the specific mother's transference into maternality creates and sustains identity for both writers, it does so in different contexts and with different intertextual effects. In Douglass's autobiographical supplement, the mother's legacy of

literacy is, in part, amplified via citation beyond the world of the text, where signified in the linear surface of the Ramses illustration she is ostensibly re-gendered and re-raced but also rendered mythically untouchable or un-knowable by conventional modes of racist viewing. Like Douglass, Brown represents his mother as an archetype of plantation slavery, writing her into being as the long-suffering martyr to his own freedom. Whereas Douglass's progenitor endows him with literacy, Brown's bequeaths a related instru-ment of autonomy: the enunciative will to be free. Further, Brown's mother gets translated into the visual without formal disruption of the narrative; he inscribes her not mythically anterior to plantation slavery, as with Douglass, but mythically suffused in it, temporally fixed within the harsh vacuities of its unchangeable tableaux like a runaway slave advertisement. Thus, while Douglass de-familiarizes the mother as well as discourses of ethnographic illustration to which she is compared, Brown over-familiarizes the mother along with antebellum codes for dominating and minimizing the reproduc-tive labor of black women. This is not to say that the figure of the mother is unproductively absent from Brown's critique of racist iconography. Rather, female slave bodies of any kind are *productively absent as historical subjects* in Brown's narrative, highlighting their disappearance in a manner not en-tirely dissimilar to Douglass's tactic of unexpected image reversal. What re-places women as historical subjects is the excessive presence of prostrated female bodies in Brown.

Whether *détourned* or disavowed, the inexorable anguish of the slave mother harvests the ground of self-revision, memory, and tradition for Douglass, Brown, and many African American writers. Either a reanimated persona in revised autobiography or an image taking shape at the boundar-ies of text and intertext, the slave mother and her burdensome legacies of nugatory subjectivity aggregates into a face, a transcendent cipher of en-slavement that haunts beyond the pale of escape. In his examination of the topos of the face as a structuring principle of the African American literary tradition, Kimberly Benston argues that recurring scenes of facing the self or others enact a form of "prosopopoeia, a giving of face to an absent power" and engender a "(re)envisioning of blackness as an immanent locus of ex-pressive emancipation."[45] Intricately constitutive of Brown's emergent sense of freedom, the memory of the mother becomes an image, crystallized in the oppressive torpor of the plantation field. Re-envisioned in "The Virgin-ian Slave," Brown recodes the fixity of the slave maternal to authorize his own active rebuttal to the evacuation of black suffering attributed to the Powers statue. In addition to enabling double-voiced articulations of black identity, the facing topos produces a sense of selfhood through "the shock of one's reflection in the father's or mother's face, the glance of self-discovery or dissociation in the mirror, the confrontation with the face of mastery,

[or] the encounter with some emblem of communal visage."[46] For Brown, facing involves—to borrow from Benston—"the effort to constitute the self in [. . .] relation to the otherness against which that self seems to arise."[47] Put another way, Brown fashions identity by imagining his mother made into a static image to which he is at once external and internal, an insider to slavery, but outsider to the gendered subjection projected onto the mother. His form of prosopopoeia aligns with the use of the trope that Barbara Rodriguez associates with women of color, who propose a "kind of personification that represents an imaginary, absent, or deceased person as speaking or acting" in order to invert the structural relations that would reify racial objectification.[48] As memory-turned-icon, the figure of the mother opens up a visual space in which Brown reifies his own contrary location as the privileged spectator of the mother's objectified struggle. Her blackness and femininity must be made visible, as with the example of the *Punch* cartoon, as guarantors of the privileges afforded to his different class and gender positioning.

At the same time, however, Brown seems to internalize this petrified vision of motherhood in bondage, imprinting on the scene not just as the other of his post-slave identity, but as the symbolic face of the slave community at large. On one hand, this gesture of translation from the historical, embodied mother to the realm of signification, difference, and polysemous meaning recapitulates priorities of manhood. On the other, it elevates the black body ideologically by endowing it to have meaning beyond physicality, releasing it from the discursive constraint of signifying "entirely closed self-referentiality," "the very failure of meaning," and "only a state of obdurate physicality."[49] That Brown narrates his sense of liminal identity as taking shape against obsessive visualizations of his mother, who in turn becomes a cipher of negative embodiment as well as generative community, may account for his strict policing of visual representations of slavery: representing slavery, to him, *was* representing the mother. For Brown, re-envisioning or facing the black plantation-bound mother mediates the conflicting demands of racial memory and community, of speaking as a privileged male ex-slave and speaking for voiceless but visually potent foremothers and sisters who, like "The Virginian Slave," embody the very face of slavery itself, American or otherwise.

Brown's self-revision through facing, we may conclude, reimagines "the communal face" in pictorial terms congruent with visions of his mother's perpetual martyrdom.[50] Contrasting my reading of Brown, Benston characterizes Douglass's description of meeting Sophia Auld in *Narrative* as a different type of facing, one that involves facing mastery in order to surmount its "visual reign."[51] Although Douglass and Sophia are mutually transformed while gazing at each other, Douglass ultimately utilizes the slave mistress's

"face-become-mask" to effect his own liberation from mastery's scopic op-
pression. "By suspending the privileged position of Sophia's countenance,"
Benston explains, Douglass's "narrative releases the hero from entrapment
in the scopic regime that her presence mediates and ensures."[52] Douglass's
scrutinizing of Sophia's face inverts the looking relations invoked between
white mistress and black slave, empowering Douglass to constitute him-
self as the objectifying viewer of her tenuous mastery. Doubtless, codes for
scripting women as objects for male viewing contribute to Douglass's facing
ritual in this instance. Part of what it means to become a man for Douglass
involves assuming a role of surveillance over women. Yet, as we have seen,
part of what it means to be the son of a black slave mother is to abrogate the
possibility of her exposure to this masculine form of visual dominance.

The way that Douglass diverts the public's gaze from his mother's body
and the bodies of slaves that she represents coincides with a tactic of specu-
lar diversion that Carolyn Sorisio attributes to Francis Harper: "Through
the use of temperance rhetoric, Harper turns readers' attention toward de-
racialized or Caucasian characters to challenge damaging beliefs about gov-
ernance, corporeality, and control."[53] A similar diversionary impulse may
inform Douglass's citation (and the Ellen Craft illustration to be discussed
in the next chapter), but a significant difference may be noted between
Douglass and Harper in terms of the ostensible means of their diversions.
If Harper, according to Sorisio, "encourages readers to turn their gaze in-
ward by proposing self-discipline as a liberatory strategy,"[54] Douglass pro-
poses irony, absence, and a lacuna of meaning, as potential disruptors of the
reader-viewer's racial assumptions. In spite of his championing of "The Vir-
ginian Slave" over Powers's deracinated representation, female embodiment
remains for Brown a reflective instrument through which male agents pur-
sue meaning and assert power, becoming subject in the face of female ob-
jectification. bell hooks neatly elucidates the position of the object: "As ob-
jects, one's reality is defined by others; one's identity created by others, one's
history named only in ways that define one's relationship to those who are
subject."[55] But we must remain attentive to the complex ways in which, for
Brown, the subject power attained through the use of the mother's history is
itself a contingency, never wholly capable of conferring to him a subject sta-
tus, predicated as it is on the logic of the slave as absence, a logic that always
in some way includes Brown. The play of difference between presence and
absence that we find in both Brown's and Douglass's pictorial replacements
presumes maternal nostalgia, as Lynne Huffer maintains when analyzing
the "logic of replacement" through the lens of gender: "Significantly, this
logic of appearance and disappearance, of moving toward something only
to erase it, describes nostalgic structure. . . . [and] nostalgia requires an ab-
sent mother."[56] Implied in Brown's resistance to Powers's statue is the view

that slavery, insofar as it is to be visually represented, must be supplemented by intertextuality and hybrid mediations of the absent mother. Douglass's opposing view betrays the discord within abolitionism concerning the preferred degree of direct national reference in antislavery undertakings.

Although abolitionists responded to Powers's alleged whitewashing of slavery with indignation, as evidenced by Brown's actions, some fugitive spokesmen, notably Douglass, celebrated the statue. Stubbornly refusing to consider the statue outside of the antislavery visual context that its chief elements resembled, Douglass wrote a commentary in the *North Star* extolling the educative effects of Powers's artwork:

> This beautiful and lovely creature . . . [teaches the soul] to detest that depravity in man . . . in the act of ENCHAINING, and degrading to the brute level a being of which this magnificent piece of statuary is but a cold and lifeless resemblance.[57]

Clearly, the value of the statue for Douglass derives from its referential capacity to resurrect and personify the female slave as a historical subject by virtue of its own obvious lifelessness. According to Douglass's optimistic reasoning, an exclusive representation (the white slave) signifies inclusively when the represented subject is beyond representation. Taking his defense a step further, Douglass emphasizes the universality of the represented figure in the statue:

> To the feeling heart and discerning eye, all slave girls are GREEK, and all slave masters TURKS, wicked cruel and grateful, be their names Haman, Selin, James, Judas or Henry, their County Algiers or Alabama, Congo or Carolina, the same.[58]

Douglass's logic establishes one extreme ethnic distinction in order to collapse all others. The terms of racial binaries are challenged, but the principles on which they circulate are not. By universalizing those involved on both ends of slavery's chains, the logic of this quotation reinforces one racist dictum in order to deny another.

Why does Douglass take this "high road" to representation and simply absorb Powers's statue, whiteness and all, into the more global project of antislavery? At stake here is a divide not in terms of what the statue means, but in what political goals can be accomplished through its display. Brown deflects his position as an insider of the exhibit while ceremonializing the disappearance of black women, just as his narrated self negotiates the cost of liberation by enshrining the image of the mother's and sister's entrapment in slavery. His scene at the exhibit may have been motivated by selfish reasons, bolstering his role as sponsor and exhibitor of authentic visual images meant to properly declaim American slavery with as little allusiveness

in symbolism as possible. In this regard, Brown's actions may function in ways contrary to his purposes as the icon of "The Virginian Slave" reduces actual female slaves to symbolic bearers of a unified, unvarying meaning. It seems to be this monolithic frame of reference that Douglass wanted to escape in representing his mother obliquely in the Ramses illustration. What is unique in Brown's deployment of a counterimage to Powers, however, is that it hinges upon the rhetorical and representational inclusion of the black woman, a figure commonly excluded from debates over extensions of civil liberty. By writing black women back into history while also producing them as invariant, dehistoricized subjects, Brown attempts to halt that process of patriarchal culture which Michelle Wallace and Barbara Johnson refer to as the negation or exclusion of "the other of the other."[59] In essence, Brown exposes the erasure of black women's labor as the crux upon which notions of antebellum white womanhood—such as those attributed to *The Greek Slave*—get their meaning. In the process, he endorses a notion of blackness as a political category legible within European discourses. Race for Brown is still that ineffaceable quantity without which the issue of slavery becomes irrelevant.

If for only a few moments, Brown makes the Powers exhibit a hybrid site of representational and racial conflict. The kind of participatory spectatorship required of the exhibit while in this state of public intervention rejects the passive consumption encouraged in other exhibits. Brown's actions force viewers to witness Powers's statue as an erasure of black American slavery, in part, perpetuated by aesthetic conventions of allegory and romanticization. By contrast, Douglass's aberrant citation of his mother relies on allusive reference. Consonant with his interpretation of Powers's statue, Douglass pictures American slavery covertly in a whitened, anachronistic image. The ground of slavery on which one may imagine the inclusion of figures like Ramses and a *Greek Slave* takes shape in an international, transhistorical context congruent with the emphasis on inclusivity and global interdependence that characterizes Douglass's policies on the representation of slavery.

There is a distinctly diasporic strain to the reconstitution of the maternal or ancestral in pictures for Douglass and Brown. Evoked in their use of pictures is the African-based masking tradition, in which the mask signifies an immobile, self-contained interiority in contradistinction to the mask-in-motion, or the highly mobile dance that accompanies it. As Henry Louis Gates, Jr., observes, the mask achieves a "'spiritual consolidation' of the race" by exposing and containing the same binary oppositions operative in Brown's reveries of maternal slavery, "the essence of immobility, fused to the essence of mobility, fixity with transience, order with chaos, permanence with the transitory, the substantial with the evanescent."[60] Shuttling

between stasis and flux, the mask-in-motion resembles the ocular mask-in-motion that Brown's visions construct.[61] In Brown's dance of memory, diasporic connections are forged by imagining his mother as the immobilized mask of his own mask-in-motion; his propitious transitory flux between slavery and freedom is mediated by her permanent symbolization in unyielding slavery. However much this arrangement of privilege increases gender imbalances, it also importantly connects Brown to an African tradition of masking, thus becoming not just an expression of masculine transcendence but also a reclamation of an African cultural identity.

This exchange of critical priorities presumes a false binary. To what extent are the African characteristics of the mask, for example, also gendered? And there arises an additional complication—diasporic gender identity operates on a psychic landscape different than the one imagined by Western notions of the Oedipal conflict. In her sophisticated investigations of these differences, Spillers argues that the experience of slavery inculcated black men with the potential for what may be called "female-inness"—a potential for identification with disconnected mothers as typified by Douglass and Brown. Because of slavery's destruction of black family relations, Spillers argues, "the black American male embodies the *only* American community of males which has had the specific occasion to learn *who* the female is within itself [. . .] It is the heritage of the *mother* that the African-American male must regain as an aspect of his own personhood—the power of 'yes' to the 'female' within."[62] From this view, the re-connections with maternal figures seen in Douglass and Brown are not so much violations of female agency as they are vindications of an Afrocentric femininity conceived as being inherent to black masculinity, but repressed and blighted in slavery.

3

The Uses in Seeing: Mobilizing the Portrait in Drag in *Running a Thousand Miles for Freedom*

Get up! You can do the wench no good; therefore there is no use in your seeing her.

WILLIAM AND ELLEN CRAFT, *RUNNING A
THOUSAND MILES FOR FREEDOM*

Although it was not unusual for the publication of antebellum slave narratives to be preceded by illustrations of climactic aspects of the tale, no narrative received more widespread acclaim for a pre-publication illustration than *Running a Thousand Miles for Freedom* (1860). Primarily written by William, William and Ellen Craft's slave narrative recounts the couple's amazing escape to freedom through role reversals, imposture, and disguise. During the escape Ellen performs the role of Mr. Johnson, the white male slave owner of her darker husband, William, who conversely plays valet to his master-wife and comments on the action with droll irony. First published nearly a decade before the narrative reached print, the famous engraving of Ellen Craft by S. A. Schoff (after Edward E. Hale's daguerreotype) circulated widely in newspapers of the 1850s both in England and America, rendering the light-skinned female slave as an enfeebled Southern slaveholder (fig.3.1). While the engraved portrait functioned as exciting testimony for contemporary viewers, it has become a centerpiece in current critical discussions of the vexed workings of race and gender in antebellum America. Vying with William's narrative for representational authority to depict Ellen Craft, the image also acts as a strange attractor of antebellum panic and fantasy, troubling boundaries of race and gender embodiment, progressivist myths of mobility, and the reliability of observation.

Broadly asking what are the uses in seeing the black woman and, more

Figure 3.1. Ellen Craft
Frontispiece Portrait from
Running

particularly, the light-skinned black woman passing as a white man, this chapter investigates the stakes of "seeing" gender and race in both the narrative and the engraved image. The narrative foregrounds the uses in seeing the black woman during an auction scene in which William Craft is denied the privilege of visiting his sister after her unfortunate purchase. Although he was told that there is no use in seeing his sister, William employs the narrative and the image of Ellen Craft to restore value to the act of seeing the slave woman. At the same time, both of these texts also subvert the expected representation of embodied femininity associated with slave women. The moment at which the celebrated image of Ellen Craft most clearly obtrudes upon the action comes at the railway station, where the Crafts are temporarily detained. Here *Running a Thousand Miles to Freedom* momentarily stabilizes the Crafts' identity slippages and exposes the presumed class, gender, and race relations operant in an emergent culture of mechanized bourgeois travel. Because of an integral ambivalence in the construction of whiteness, it is Ellen's mimicry of white masculinity rather than her abil-

ity to produce legal proof of her identity or her ownership of William that enables her to pass on to Philadelphia.[1] The deceptive image of Ellen Craft, I argue, produces a suspended recognition, call it a slave Uncanny, that links anxieties concerning the bodily parameters of whiteness to issues of visibility and mobility such that Ellen Craft's cross-racial and transvestite image attributes to whiteness the same discursive fixity of being trapped in the body that traduces the slave body. Thus Ellen's image approximates a form of colonial mimicry, demonstrating that the condition of bearing meaning only through the body can be co-opted to overturn the intransigency of raced and gendered embodiment.

Ellen Craft—Agency, Literacy, and the Image

As a cultural signifier *in* antebellum America, the illustration of Ellen Craft as a man emphasized the harrowing realities of slavery and the reversals of identity that slavery entails (woman become man, wife turned master, visually white but "Negro" rendered culturally white), which would have been met with outrage by abolitionists and their followers. But as a cultural artifact *of* antebellum America, the image of Ellen Craft in disguise epitomizes what Barbara McCaskill, Marjorie Garber, Eric Lott, and others identify as a national obsession for spectacles of gender and race fluidity.[2] Notwithstanding stylized theatrical performances and occasional literary incidents of identity masquerade in late eighteenth-century America, the culture that the Craft illustration forecasts virtually explodes with such spectacles from the late 1850s to the turn of the century. Examples include characters such as E. D. E. N. Southworth's mannish heroine Capitola Black from *The Hidden Hand* (1859), who masquerades as a man and even challenges a(nother) man to a duel; Edward Wheeler's "ruined" Western heroine Calamity Jane, who sharpshoots her way garbed in masculine buckskin throughout dime novels of the 1860s; the Civil War spy Emma Edmundson, who successfully disguises herself as a male Confederate and sometimes even a male slave; and T. D. Rice's minstrel troupes, who gallivanted to high acclaim costumed as both male and female blacks. This spate of gender- and race-blurring spectacles culminates without gender inversions (or indeed much of any overtures to stigmatized masculinity) in the much-studied literature of the tragic mulatta in the last decades of the nineteenth century.[3] As the opening salvo in a veritable cannonade of similar cultural formations, the image of Ellen Craft constellates as it catalyzes midcentury desires governing the mutability of gender and race.

When differentiating the function of the sketch of Ellen in disguise from that of *Running a Thousand Miles to Freedom* as a whole, the most notable opposition involves issues of agency and authority. The term "agency"

is used in this case to mean a person's capacity to act within and against culturally imposed roles and positions, the ability to mobilize resources to effect social change, attain personal empowerment, or negotiate opposition. This is not to suggest that agency is not also a *product* of social positioning, or (in light of Michel Foucault) an *effect* of a wide array of discourses and practices.[4] Therefore, in discussing William's capacity for agency in authoring and narrating *Running,* or when comparing that against Ellen's agency as a pictorial subject in the image, I am referring to the ostensible agency-effects of each. And when it comes to *Running,* William Craft seems to have acquired through literacy a monopoly of agency-effects.

After all, it is the urbane, often ironic, sometimes indignantly declamatory voice of William that relates the story of the escape. It is his name solely listed on the opening page of the original edition (though Ellen's does appear in most modern editions). And it was his oratorical performances as part of William Wells Brown's abolitionist tour that made the tale popular a decade before its publication for audiences in New England and abroad. To be sure, Ellen plays a significant part in his narration of the escape. Details of the plan to pass as a Georgia planter are hers; but her part is always filtered through and authorized by William. As many critics of the narrative have noted, McCaskill premier among them, in William's text Ellen remains muted and finally circumscribed within a version of domesticity acceptable to elite Northern audiences. Even when occasionally making an entrance and saying a few words to punctuate William's orations during the tour, Ellen's manner is described as demure, restrained, and laconic.[5]

Even if reserved, Ellen does initiate the plan to pass within the narrative, achieving a sensational reversal that nearly every critic who deals with the narrative has championed. John C. Inscoe, for example, praises *Running* for offering more psychological insight than similar narratives "in its treatment of gender and racial role-reversals, of husband-wife and master-slave relations."[6] Although we might be tempted to view these gender role reversals as originating with the unique circumstances surrounding Ellen's disguise, such an interpretation misses the point of Craft's initial assessment of slavery's "anomalous" relations of persons, property, and parentage: "But as the woman and her children are legally the property of the man, who stands in the anomalous relation to them of husband and father, as well as master, they are liable to be seized and sold for his debts, should he become involved."[7] Therefore, despite their carnivalesque manifestation, the many instances in which William slyly observes the social comedy created by his wife's (and his own) disguises are not without pretext in slavery's status quo.[8]

The third paragraph of the narrative establishes such familiar confusions and reversals: "My wife's first master was her father, and her mother

his slave, and the latter is still the slave of his widow" (3). In passing, Ellen acts the part of the master she knew, her father. Exaggerating an Electra complex grown dangerously afoul of Freud's theory of "normal" female sexual development, Ellen Craft literalizes desire for the father's power by *becoming* her father and, in turn, William stands in for Ellen's mother, negotiating any residual castration anxieties resulting from this feminization by flaunting a compensatorily masculine narrative control. That such distortions of identity and conventional family relations are structuring principles of slavery is established from the outset of *Running*.

Though not sufficient in themselves to describe diasporic identity formation, Freud's terms yet give figurative expression to the sort of Uncanny operationalized by the Crafts' masquerade.[9] During scenes of misidentification, William is the only one who fully knows Ellen's essential lackings; he alone knows his master has neither phallus nor property nor literacy. Combining the anguish of first-person testimony with the arch wit of a confidence man and the cynicism of a zealot, William's narrator plays the part of the ignored anti-hero taken by so-called social betters to be inconsequential, so much so that at one point he is even transported as just another article of his master's baggage. He alone sees the totality of the narrative's staged scenes of passage and passing that dupe everyone else. When it comes to questions of agency, William alone seems to wield power as the organizer and narrator of his and his wife's experiences of enslavement and escape.

We may surmise then that Ellen possesses little agency-effect except that which is meagerly allotted to her in the performative dimension of her escape, and none except that which is defined and framed a priori by William, who defies cultural sanctions against black literacy and negotiates an agency for himself as an author within the constrained rhetorical conditions delimiting the slave narrative.[10] Before asking what sort of agency Ellen possesses through the image in becoming a mass-reproduced spectacle of passing, let us first take a closer look at the kind of agency she does not possess—literacy.

In *Figures in Black* Henry Louis Gates, Jr., describes the limiting rhetorical conditions facing slave narrators and famously argues for the centrality of literacy as both a technology and a commodity able to uplift degraded blacks to a status compatible with Enlightenment priorities of subjectivity. "A direct correlation of political rights and *literacy*," Gates argues, "helps us to understand both the transformation of writing into a commodity and the sheer burden of received opinion that both motivated the black slave to seek his or her text and defined the frame against which each black text would be read."[11] That slaves were forbidden literacy by law and considered incapable of it by social and medical discourses demonstrates how the slave is conceptualized as pure object, as property imprisoned within an economic relation

that debars her from the only kind of property (literacy) that would promise escape from the signifying prison of the body. Without literacy blacks had no culturally recognizable means of validating that they too could abstract the mind from the body, completing a process of discorporation which alone satisfies Enlightenment criteria for rational subjectivity.[12] In other words, without literacy the black "subject" exists in the prisonhouse of the body, signifying only visible difference and thereby offering material evidence for perpetual debarment from the very cultural structures that would prove it worthy of signifying anything more than the particularity of the body.

Therefore, by casting the tale of his and Ellen's escape from slavery in print, William figuratively liberates his body from the predicament that leaves Africans in America "grounded in the true prison of particularity, a drastic particularity that separates him or her from the rest of humanity."[13] Nonetheless, we may still question whether his narrative rescues his wife from standing outside of signification in the process. Does Ellen Craft achieve agency by virtue of her husband's narrative? And if not, then what sort of agency may she yet achieve in the image? Phrased in this way, we might notice that a complication arises in the presumed division between verbal and visual media in the preceding questions. Indeed, the fact that the signifying body of Ellen in disguise from the 1850–1851 engraving anticipates William's textual performance of stealing himself through literacy according to a primarily visual paradigm further complicates the empowering work of literacy as it is exercised in the narrative. *Running* is not simply an example of the embodied slave discorporating through literacy; it is also a response to a picture that heralds and shapes this performance of disembodiment.

In addition to having to express a culturally legible black body for both himself and Ellen, William must also take control of the visual representation of Ellen that prefigures his narrative. In refuting the charge that the Negro occupies an ontological situation that is above all bodily, which Thomas Jefferson infamously asserts in *Notes on the State of Virginia* (1781–1782), William Craft, like all slave narrators, faces the excruciating double paradox of having to recoup in the master's language a black subjectivity that is outside of that language, while delicately celebrating the flexible powers of language to effect this rescue mission of the pre- or sub-linguistic black subject. On top of striking this delicate balance, William Craft uses his narrative to seize control of the visual system of bodily signs that Ellen's image leaves indeterminate.

Even though the narrative echoes the racial indeterminacies of Ellen's image by blurring distinctions between bodies marked as black and those privileged as white, it also works against the subtext of Ellen's image, which equates whiteness with power. And part of William's struggle against the

correlation of whiteness and power stems from the dilemma of literacy, for in paying homage to literacy he risks endorsing the very power structures that oppress the black body, as Lindon Barrett points out: "Rather than immediately presenting the reader with descriptions of the conditions and trial of bodies designated as African American, the narrative begins and resolves itself by rehearsing the sometimes insurmountable difficulties of distinguishing white from black."[14] Thus, Craft avoids underwriting oppressive assumptions regarding the inferiority of African Americans, which may follow from celebrating his acquisition of literacy, by deliberately obscuring scopic priorities of racial differentiation. Even if William cannot be said to equate whiteness with literate agency due to his confusing of white and black, his wife's white appearance, rather than her literacy, equates to another kind of power, a visual agency.

In contrast to William's exclusive performance of literacy in his narrative, Ellen remains the exclusive subject of the engraving and thus seems to possess a measure of importance surpassing that of her representation in the slave narrative. As mentioned, copies of the engraving of Ellen in disguise appeared in various British and American periodicals throughout the 1850s. With its prefatory function in mind, we may note how the image foments the desire to consume later cultural texts related to it, such as William Craft's oral performances, as it was commercially designed to do, and William Wells Brown's versions in *Clotel* and *The Escape* (1858). The image is linked commercially in two important ways to the narrative. First, as an advertisement for abolitionist lectures of the early 1850s, copies found their way into periodicals weeks before scheduled lectures. And second, as a poster meant to be consumed without direct relation to an ensuing lecture, copies were advertised alongside other recognizable texts in the abolitionist arsenal of antislavery bestsellers. "[T]he Leeds Anti-Slavery Association sold an illustrated, youth edition of *Uncle Tom's Cabin*," McCaskill observes, "on the same page as a notice for a shilling portrait of Ellen wearing masculine garments" (xvii).

The earliest publications of the engraving cannot be classified technically as illustrations since they do not visualize referents outside of their immediate context. The image does not explain the escape nor seek to depict it in the usual metonymic relationship of illustrated part to a referred-to scene, since the escaping Ellen wears a poultice covering her face and nothing obscures the face of the engraved Ellen. Rather than illustration, the engraved image is a portrait, or better yet an anti-portrait, of Ellen Craft in garb resonant of her escaping self but not necessarily reflective of that self. Interestingly, current reincarnations of the escape rectify this absence of illustration, as seen in Mary O'Keefe Young's drawings for Cathy Moore's

children's book *The Daring Escape* (Carolrhoda Books, 2002), whose cover depicts the poulticed Ellen aided by William in disembarking from a train. Modern illustrations of the escape diverge from the famous engraving of Ellen's disguise and from subsequent portraits of the Crafts, which, as P. Gabrielle Foreman points out, rarely show the celebrated interracial couple together in the same view (fig. 3.2).[15]

To some extent, the engraving of Ellen in disguise even works outside of the economies of racial voyeurism that Sterling Lecater Bland, Jr., compellingly discovers in the narrative. For even if the narrative arranges William and Ellen in what he calls an "exterior self-division," displaying William the slave as the author-observer of Ellen, whose figural "white maleness is indebted [. . .] to the visual presence of and conception of black masculinity," the picture of Ellen significantly excludes William.[16] Tensions between the visual and verbal representations of the Crafts' escape reiterate a gender struggle endemic to ekphrasis. Yet Ellen's transvestitism in the image complicates the "gendered antagonism" James Heffernan observes in the typical ekphrastic "duel" between "male and female gazes, the voice of male speech striving to control a female image that is both alluring and threatening, of male narratives striving to overcome the fixating impact of beauty poised in space."[17] Just as the subject of the engraving deconstructs gender by exposing its constitutive performativity, so too does the context of the engraving's reproduction confound the presumed femininity of the image common to ekphrasis. Without the implicit superintendence of William's lecture or narrative, even the way the engraving was disseminated confers to Ellen a masculine effect of agency never wholly realized in the narrative.

The narrative reigns in the complexities of the image by tying them purposively to a larger project of recovering William's female relatives lost amid slavery's pernicious exchanges. Here again the visual becomes the ground of an emancipatory fleshing of slave maternality that transcends polarities of gender and race, time and space, commemoration and commodification. In explaining the use in seeing enslaved femininity, William compounds his empowered status as author and narrator, repositioning himself textually against the very forces that sundered his family. His explanation also sets up an ordering of slave women, hierarchically distinguished according to degrees of skin tone and kinship. Ultimately, the use in seeing black femininity reveals the asymmetrical power relations predicated in acts of visual observation, where power for the perceiver depends upon the objectification of the seen. Yet, as we shall see, the narrative and the image of Ellen also celebrate the use in *not* seeing black femininity, for it is precisely the convention of urban anonymity—of allowing white persons unimpeded mobility—that allows the Crafts to escape.

WILLIAM CRAFT.

ELLEN CRAFT.

Figure 3.2. The Crafts, Engraved Portraits from William Still, *The Underground Railroad*, 1872

The Uses of Seeing, Anger, and
Types of Black Femininity

Near the start of the narrative, William Craft briefly recounts the financial self-interest motivating his master to sell his father, mother, and brother. Afterward, *Running* spends the next five paragraphs describing a scene of separation on the auction block familiar to any reader of the antebellum slave narrative. Begging to have an "opportunity of bidding [his sister] farewell" (9), sixteen-year-old William is rebuffed by his sister's new master, who hastily prepares to depart with her in a cart. William falls to his knees pleading but is forced by the auctioneer to remain on the platform: "Get up! You can do the wench no good; therefore there is no use in your seeing her" (9).

Beyond personifying the cruelty of slavery, this scene underscores a grievance elsewhere repeated in apocalyptic tones regarding slavery's emasculation, its rendering of enslaved men powerless to protect female dependents: "if there is any one thing under the wide canopy of heaven, horrible enough to stir a man's soul, and to make his very blood boil, it is the thought of his dear wife, his unprotected sister, or his young and virtuous daughters, struggling to save themselves from falling prey to such demons" (7). There is no *use* in his *seeing* the sister, for his vision (as a black man) cannot entail the same implications of possession and knowledge extended to white bearers of the gaze. To see his sister, according to the harsh but, under the circumstances, honest advice of the auctioneer, produces nothing useful because William cannot see another's property in her. Rather, the sight of his sister encodes a permanent lack of agency on his part and an insuperable rift in his knowledge of himself and the world; it becomes a recurring scene of interminable departure and heartrending separation:

> On rising, I saw the cart in which she sat moving slowly off; and, as she clasped her hands with a grasp that indicated despair, and looked pitifully round towards me, I also saw the large silent tears trickling down her cheeks. She made a farewell bow, and buried her face in her lap. This seemed more than I could bear. It appeared to swell my aching heart to its utmost. But before I could fairly recover, the poor girl was gone;—gone, and I have never had the good fortune to see her from that day to this! (9)

Taking on a markedly heightened sentimental register, which differentiates it from the more expository accounts of other separations narrated in *Running,* this passage at first seems to eulogize the slave sister while breaking with the narrative's established temporality. Not unlike Douglass's famous intertwining of disparate temporalities, in which he measures the

gashes on his feet with the pen that writes the past, this passage weaves together multiple temporal threads through the lost sister, who "from that day to this" measures the emotional scars of those who mourn her. However, the passage goes on to conjoin the remembered past and the authorial present with a future reunion financed, in part, by the engraving:

> Perhaps I should have never heard of [my sister] again, had it not been for the untiring efforts of my good old mother, who became free a few years ago by purchase, and, after a great deal of difficulty, found my sister residing with a family in Mississippi. My mother at once wrote to me, informing me of the fact, and requesting me to get her free; and I am happy to say that, partly by lecturing occasionally, and through the sale of an engraving of my wife in the disguise in which she escaped, [. . .] I have nearly accomplished this. It would be to me a great and ever-glorious achievement to restore my sister to our dear mother, from whom she was forcibly driven in early life. (9–10)

Here William Craft discloses the purpose of the engraving in funding his efforts to reunite his family and set aright the broken circle of black matrilineal kinship skewed by slavery. In the process, the figure of the mother replaces William as the dramatically bereft family member, the one who kneels enervated on the platform and for whom the girl's removal signifies absent agency. Craft sloughs off the lack he associates with himself in the separation scene onto the mother and, in the exchange, recodes himself as the sole conqueror of slavery's "greatest indignity"—an able restorer of his family and his own masculine ideal. The use that Craft finally makes of seeing the sister is thus transposed onto the spectacle of Ellen. Ironically, the very engraving that thematizes disappeared black femininity also works to restore a disappeared black female. And in the process Craft metaphorically takes back the power the auctioneer deprives him of and reinvests the act of seeing with a contrapuntal use value calculated to win control over the legal, social, and physical position of his sister. For Craft the picture of Ellen is a retort to the charge that his seeing has no use.

Aside from a financial purpose, the narrative further ascribes an emotional and gendering function to the engraving. Not being able to see his sister makes William angry, and venting anger is one of the ways that masculinity is structured in the narrative. Consequently, another way of reading the auctioneer's response to the young William is that there is no use in William's anger at not being able to alter circumstances beyond his control. I stress the matter here because one of the questions raised by *Running* concerns the use value of black masculine rage. What would have been the use of William's heartfelt farewells to his sister? If solemn words of parting were allowed, then perhaps William would not have been incensed with "red-hot

indignation" (10), which becomes a prime cause for the escape, motivating him to "crave for power to avenge our wrongs!" (10). Even though Craft narrates the traumatic departure scene as if he were crushed beneath "the iron heel of despotism" (10), he also hints that this primal scene of powerlessness gives rise to the escape and underwrites the apocalyptic rhetorical tone that infuses the narrative. Indeed, the narrative intermittently smolders with racial indignation; it impugns slaveholders and "worthless white people" (6) in the South as well as Northern "Yankee prejudice," and ends with an ominous apostrophe to a now more generalized target of Americans, whom Craft addresses from an expatriated perspective in England:

> Oh, tyrant, though who sleepest
> On a volcano, from whose pent-up wrath,
> Already some red flashes bursting up,
> Beware! (69)

Given the narrative's rhetorical foundation in an anger reflective of early antebellum pamphlets like David Walker's incendiary *Appeal* (1829), and given its unique textual partnership with the engraving (the "other matter" William refers to in the preface), we might expect to find a concomitant strain of anger in the engraving.

Nonetheless, while anger has restorative power in Craft's narrative, there is little evidence of it in the engraving, at least not in the facial expression of the depicted figure. Even though Ellen represents a masculine figure, she plays the role in the picture without recourse to overt displays of aggression. The point here is that anger may be a means of rhetorical ablution in the narrative, which cleanses William's fractured masculinity, but it is a discursive option withheld from women—even those masquerading as men. Violent anger is not extended to adult women in *Running* and this effect of gender socialization is shown in the narrative to gravely undermine the ability of slave women to resist lecherous masters.

Craft ascribes the possibility of an instinctual rage to young girls, but denies such a response to women: "But should the bondman, of his own accord, fight to defend his wife, or should his terrified daughter instinctively raise her hand and strike the wretch who attempts to violate her chastity, he or she shall, saith the model republican law, suffer death" (11). In Craft's sardonic reproof of the republican social order, the generic slave wife remains a passive victim, as opposed to instinctively aggressive slave husbands and slave girls. This is significant for two reasons. First, it marks the extent to which slave women are thought to undergo a form of gender socialization that robs them of even the possibility of aggressive redress. And second, the assumed passivity of slave wives mentioned here contrasts the pivotal

role that Ellen Craft plays in the narrative, as she takes on all of the unjust though legally sanctioned privileges pertaining to redress, property rights, and unencumbered mobility which Craft imputes to white oppressors.

If there is no use in seeing black women (black icons) in the narrative, there is certainly a use value accorded to seeing whiter black women (white hieroglyphs).[18] Obliquely, Craft notes a distinction between the forms of resistance available to darker female slaves, like his sister, and those available to near white women, like Ellen or Antoinette, one of "three nearly white, well educated and beautiful girls" (13) sold to a drunken would-be defiler named Hoskens. Before Hoskens is able to "pollute" her chastity, she takes her own life in a scene reminiscent of *Uncle Tom's Cabin* (1852): "The brave Antoinette broke loose from him, pitched herself head foremost through the window, and fell upon the pavement below" (15). Although Antoinette's story typifies abolitionist horror over the abuses of slavery and revalues the "use in seeing" exploited slave women, her valorous suicide highlights her different relation to slavery than that of William's sister or wife. Even as Antoinette stands on the block with her brother and presumably her sister Mary, Craft stresses the pain felt by the brother when Antoinette is "knocked down" or sold: "I cannot give a more correct description of the scene, when she was called from her brother to the stand, than will be found in the following lines" (14). Thereafter, exposition gives way to the lyric accuracy of the auction block, where females are torn from loving male relatives. In William's poem, the brother most keenly feels slavery's grim indifference to family separation, often depicted in abolitionist iconography through maternal loss (fig. 3.3). Not only does he suffer the sister's public removal, but through the device of temporal compression he seems to opine her inevitable violation in private as well. In this way, William Craft revisits his own experience inversely through Antoinette's story, or, more precisely, through that of Antoinette's brother, making revisions along the way that may have at least as much to do with his wife as with his blood relatives. For whereas William's sister does not choose to "suffer death" before permitting her master to "violate her chastity," his wife does, in a sense, suicide her femininity in order to escape a related violation. Beyond suppressing femininity, Ellen's disguise masks the primal scene of separation and rape that William elsewhere feels so poignantly through his sister. Moreover, the narrative allows readers to "see" more of Antoinette's traumatic circumstances than those of Craft's sister, suggesting that in order for black femininity to be something useful to see, it must first resemble something else. And resemblance, we must notice, is not coterminous with essence in the narrative. Merely resembling white masculinity does not afford Ellen the protections of privilege. It rather reveals the incompleteness of their trans-

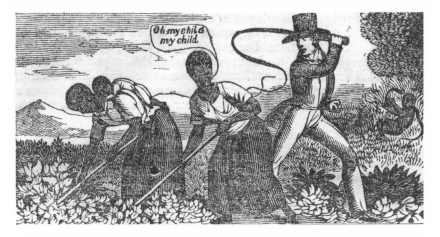

Figure 3.3. From *Antislavery Almanac*, 1840

fer, particularly when Ellen and her husband are nearly detected during the escape.

Regardless of Ellen's resemblance to privileged identity in the engraving, the narrative reveals just how flimsy the deceptions are that help to facilitate a mobility that is always provisional. Barrett astutely analyzes the way scenes of detainment in *Running* function as "revisionary scene[s] of writing" and rework ideologies that associate writing and whiteness with immaterial embodiment and the power to signify through a play of difference: "Understanding that the meaning of and privilege of white bodies resides in their ability to disappear meaningfully, the Crafts deploy the fact that white bodies never signify foremost their own materiality, even in a state that prioritizes attention to that materiality."[19] Were it not for the threat of impasse momentarily interposed between them and other passengers, their passage would not have been so successful nor as ideologically revelatory. Ironically, it is the panic of immobility that greases the wheels of escape for the Crafts more so than counterfeited identity. For example, at the custom house office in Charleston, a "very mean-looking, cheese-coloured fellow" (36) refuses to sell them tickets without proof of Ellen's—the master's—ownership of William. When this momentary impasse "attracted the attention of all the passengers" (37), a military officer steps in to vouch for them without really knowing them, garnering yet more sarcasm from the narrator: "When the gentleman finds out his mistake, he will, I have no doubt, be careful in future not to pretend to have intimate acquaintance with an entire stranger" (37). While the slave owner disguise guarantees for Ellen, at the very least, a casual identification with Southern aristocracy, becoming an obstacle in the flow of the transit of the leisure class is what finally intensifies the pressure

that makes other passengers unwitting accomplices in the sham. If passing suggests a threat to dominant culture, as with Homi Bhabha's notion of the menace of colonial mimicry that exposes the ambivalences of colonial authority, then the menace of Ellen's mimicry is not so much that she passes, but that she may fail to.[20]

The Railroad Station, the Bell, and Failing to Pass

During the climax of the narrative—a moment William calls "the eleventh hour" (44) of their escape—Ellen is again stopped by an "eagle-eyed" (45) customs agent, this time at Baltimore. After Ellen questions the legitimacy of the officer's procedures "with more firmness than could be expected" (45), the officer replies in a language of extreme conditionality: "if we should suffer any gentleman to take a slave past here into Philadelphia; and should the gentleman with whom the slave might be traveling turn out not to be his rightful owner; and should the proper master come and prove that his slave escaped on our road, we shall have him to pay for" (45). Oddly, this triply qualified series of conditionals backfires. Instead of producing authentication of ownership, it arouses the spectatorial interest of other passengers who gather about the detained Crafts.

William explains the crowd's sympathy in a move that seems at first redundant, reasoning that they sympathized "not because they thought we were slaves endeavoring to escape, but merely because they thought my master was a slaveholder and invalid gentleman, and therefore it was wrong to detain him" (46). The passengers' mumblings of "chit, chit" (46) mark a solidarity not necessarily for slaves (as William Craft this far into his narrative need not remind readers) nor even for slaveholders, but for passengers who expect uninhibited passage for any apparent gentlemen regardless of bureaucratic liabilities. By failing to pass, the Crafts make visible the fragility of this presumed mobility.

Unable once again to produce proof of ownership, the Crafts simply do nothing. Yet to call their subsequent inertia before the customs agent and a gathering crowd of passengers unproductive is to overlook what this inertia yields. The "few moments" of "perfect silence" (46) that ensue cause the once bustling commuters to rubberneck the pair, who are now transformed into a silent, motionless spectacle: "My master looked at me, and I at him, but neither of us dared to speak a word, for fear of making some blunder that would tend to our detection" (46). As their delicate ruse seems most ready to give way, the Crafts do nothing more than simply appear, turning their gazes inward and looking only at each other while others look upon them with growing agitation and interest. As spectacles, the Crafts produce

a kind of colonial menace—a catalepsy of pure presence that vegetates progress.

As the crisis of racial passing converges with a crisis of mass transit, William describes their sensations through mixed metaphors of drowning in "deep waters," "being overwhelmed," and alternatively being suspended by a "brittle thread" over the "horrible pit of misery and degradation from which we were straining every nerve to escape" (46). The Crafts are simultaneously engulfed, submerged, and lynched—all while being spectated by others and spectating each other. As with any form of rhetorical catachresis, this moment obtrudes upon the spatial-temporal frame of the scene, disrupting it and locating the Crafts partly beyond the scene itself, partly outside of time. The onrush of mixed metaphors fills in the gap created by the trauma of their imminent detection. However, this is perhaps the moment of their greatest agency as well. Anticipating the protagonist of Ralph Ellison's "King of the Bingo Game," who in pressing the button that spins the wheel of his fate infinitely protracts a moment of deferred opportunity (an opportunity made all the more unsustainable given the persistent constrictions placed on black freedom in 1940s America), the Crafts too seem to stand before the customs official importunately holding the button, refusing to move along. In 1850s America, moreover, they are doubly objectified in the process. In addition to being objects in the sense that they are legal property, they become petrified objects of spectacle, intending to move but immobile, much like runaway slave advertisements.

Amplifying the tension of the scene, the ringing of a bell terminates the Crafts' abrupt torpor: "Just then a bell rang for the train to leave [causing] every eye to flash with apparent interest, and to be more steadily fixed upon us than before" (46–47). Because the sound of the bell finally prods the official to let them pass ("I really don't know what to do; I calculate it is all right"), we may assume that its tolling heralds a rhetorical undoing of the legal knots binding the Crafts and the customs agent to official discourses of antebellum mobility and property rights. In other words, the tension announced by the bell reverberates between two socio-juridical mandates that the Crafts make problematic: to protect the mobility of white subjects and to restrict the illegal transfer of property. While the law requires that no unaccounted for bodies may pass, the bell—and the increasing spectatorial attention that it punctuates—requires a peremptory decision to be made.

The sudden intrusion of the bell audibly marks both the preceding silence of the Crafts' suspended spectacle, in which time seems to be annihilated, as well as the subsequent clamor of the outside world from which the Crafts (and implicitly even the station master) had been cut off. To borrow from Thomas De Quincey's famous gloss of *Macbeth*, the bell precipi-

tates the "re-establishment of the goings-on of the world [. . . and] makes us profoundly sensible of the awful parenthesis that had suspended them."[21] The "awful parenthesis" here marks a disturbing period of stasis and postponement in which arbitrary markers of race and legal ownership are in a state of flux until the disconcerted customs agent permits them leave with perfunctory sympathy: "As he is not well, it is a pity to stop him here" (47). Curiously, it is at this moment that the agent becomes a viewer implicated in the act of inspecting Ellen's bodily signs much like the viewer of Ellen Craft's engraving. Here again, the menace that freights this act of racial gazing centers on the indeterminate meaning of Ellen's white skin, suspending Ellen and her viewers in an interrogation of the ethical and legal meanings of white skin.

The Crafts' paralysis on the platform and outward reversion to an existence of surface revises an earlier platform scene, the slave market where William's sister is sold. As with the auction platform, which also takes place at a similar threshold of community and separation, the scene at the rail depot leaves intact the slave's relation to a voyeuristic white community. However, it significantly transforms the relation between the slave and the slave community, here symbolized by the married couple. William and Ellen share a communal alliance of particular and private trauma hidden from public view that William does not fully share with his sister in the earlier scene. Despite their very different visual impression to onlookers, William and Ellen are together in this moment of crisis in a way that William and his sister are not. In one sense, then, the single moment in the narrative that most forcefully conjures the visual image of Ellen's engraving (in which, we might surmise, the view William has of Ellen closely matches the static quality of the image) also rectifies the scene of traumatic family separation that the image is reportedly meant to counteract. At least from William's perspective, the use in seeing Ellen become image reassures his sense of connectivity and shared prostration in the face of a crisis so overwhelming as to exhaust the limits of coherent verbal expression.

In addition to its submerged critique of the consequent social pressures of America's emergent culture of mass transit, the climax inscribes genteel white masculinity, however fractured or partial as it may appear to be, as the privileged ground of mobility. The reader is enjoined to share William's sentiments on the fortuity of their passing as being the product of Mr. Johnson's visible wretchedness as well as his visible privilege. By implication, the scene also projects social fixity onto stigmatized visible differences of gender and race and thus leaves *Running* open to a prevailing criticism of passing narratives: Ellen's successful seizure of visible gender and race dominance partly serves to *reinforce* existing race hierarchies even while imagining the fluidity of such boundaries. Unlike the more defiant forms

of resistance reserved for male blacks, passing is a covert role of less heroic resistance usually assigned to female characters who remain "fragile and well-bred."[22]

Although the gendered dynamics of passing in *Running* consign Ellen to a state of mute passivity congruent with notions of True Womanhood, the fragile and fractured male that Ellen is taken to be recapitulates the privileges normally accorded to "whole" forms of masculinity all the more.[23] Hence passing in *Running* confirms Hazel Carby's definition of it as a "narrative device of mediation."[24] The caul and sling, Ellen's muffled face and maudlin look, her bespectacled bemusement hanging fire at the sight of passage all function to mediate the tragedy of a masculinity that has been somatically immobilized, but which can be made whole again and metaphorically restored through the utopian promise of mass transit. The domain of the railway, according to the logic of this utopian discourse, *should* be the place where the propertied white male—no matter how physically impeded or injured in body—may attain geographic mobility and progress unobstructed.

Passages immediately following their successful embarkation reinforce the distinctions between William's and Ellen's narrated identities. Whereas Ellen remains passive, allowing her appearance to prompt the agent and others, William allows himself access to qualities of both action and inertia. At first he is active, taking it upon himself to literally transport his master into the railway car and "tumbling" him into his seat. Symbolically, William becomes, like the train itself, an extension of the master's mobility, which strengthens his performance of inferiority to onlookers. However, once their journey is under way, William "tumbles" himself into a baggage car. Having already treated the master as an object of transport, he makes use of the same unusual verb in reference to himself. So while the trip has exhausted both to the point of becoming nothing more than cargo, it is only William who inconsistently occupies both the subject position of the one who does the tumbling as well as the object position of the one who gets tumbled. Even in being an object William outdoes his master-wife. At the end of the trip, William is physically (mis)recognized as baggage and gets hauled to his master while sleeping inside their luggage. As with the engraving viewed without the caption, Ellen's passivity impels the viewer-reader to assign status to her. William, on the other hand, actively and flamboyantly performs double social roles as the most omniscient agent operating behind the scenes as well as the most overlooked object within the scene.

Both Crafts may be said to be engaged in acts of passing, but with different racial and gendered implications. William allows himself a subversive, masculine form of the passer's identity, taking pleasure in multiple and contradictory subject locations. Interestingly, the scene in which he is taken for

baggage, which signifies on Henry "Box" Brown's famous escape through the postal system, epitomizes William's comic penchant for passing as a slave. This scene makes visible a concurrent dramatic interest in which the authorial subject of the slave narrative represents himself less as a slave than as a master in the art of passing as a slave. Even when objectified, William revels in his control of the situation, while Ellen, however masculine in appearance, continues to be passive. Yet this is not to say that her characterization is without subversive effect. Insofar as the reader-viewer depends upon the reliability of the visual field to warrant identity, Ellen's passing constitutes a disruption of the social order that menacingly exposes the susceptibility of white, propertied masculinity to appropriation. Inherent to the couple's disparate roles in the act of passing are two familiar modalities of appropriation that critics have traditionally identified in passing literature: William's positive collapse of boundaries and performance of changeable identity and Ellen's problematic assumption (and thereby upholding) of white masculinity as a site of social dominance and agency.

The bell, moreover, signifies the gap between material, private bodies of passengers and their abstract, public role (at least to the officials of the depot) as cargo, contents expected to be loaded onto and off of the train at specific intervals. Unresolved detainment thus gives rise to a dangerous form of private identification and precludes the railway system from its efficient, routine conversion—announced with every blow of the station bell—of the private to the public, the transmogrification of particular persons into mass subjects. Implied in this protracted moment of crisis is the failure of the bourgeois discourse of mass transit to complete one of its concomitant goals: the annulment of private distinctions between public passengers beyond those already demarcated in the railway system's classifications of compartment assignments. More than coach, baggage, or sleeper, the Crafts are given a limbo status. They are would-be passengers consigned to linger at the platform, a social location visually incongruous with the apparent dignity of the enfeebled Mr. Johnson. At this moment, the Crafts therefore emblematize both the promise and failure of nineteenth-century notions of identity in motion brought into being by the railroad and reflected in contemporary literary texts.

Urban Anonymity and Mobility in *Running* and *The House of the Seven Gables*

An analogous failure of the symbol of the train to separate subjects from the domestic structures that frame them famously occurs in Nathaniel Hawthorne's *The House of the Seven Gables* (1851). Although Clifford and Hepzibah board a train to escape the confining ideologies of the house

(not to mention the corpse) of Jaffrey Pyncheon, Clifford's delirious celebration of the train's production of a new kind of existence, an identity that becomes anonymous in motion, is only fleeting. Commenting on the insubstantiality of property and houses, Clifford decries traditional desires for real estate, that "solid ground to build a house on,"[25] preferring instead the sensations of fluidity and groundlessness brought about by the train ride. At first, Clifford enjoys feeling placeless, but later grows maudlin at the sights afforded by the train of a dizzying world full of new market-based activities fast supplanting the old and familiar. Critics have read Clifford's reaction as a veiled assault on commodity culture. According to Richard Millington, the railroad in Hawthorne is a new and disturbing emblem of market-based community:

> Its fifty strangers, cast into "close relations," form a community on the new model, constructed by the accidents of trade and continually changing its membership. It condenses within its narrow space a kind of economy-in-motion: its denizens are reading the cheap, imported novels and penny papers made available by the newly national publishing industry, and at each stop merchandize-bearing boys work the car, doing business at top speed.[26]

The collapse of distinctions among passengers that Clifford applauds (and toward which Hawthorne's narrator expresses comic derision) proposes a radical democracy of identities in motion that William Craft alludes to with similar humor, but, of course, to different effect than Hawthorne. Distinctions between banker and criminal fuel the same forces of Yankee practicality and prejudice that have imprisoned Clifford, but his glee at their seeming dissolution while riding the train depends upon his uncontested admission to the clan of the privileged. Brimming with excitement for this sudden flight from domestic enclosure, Clifford embarrassingly drifts outside of the impersonal community of train riders when he mistakenly imagines them as a community in the first place. A more cautious approach to identity-in-motion *communitas* is practiced by the Crafts. For self-emancipating African Americans, being in transit effectuates a state of fugitivity that Samira Kawash has shown to productively defer the discursive claims of slavery and freedom.[27] This is not so different from the hybridity perpetuated by newly mechanized forms of travel that temporarily fragment and compress notions of home and destination, decoupling identity from coordinates normally relied upon to give it meaning. If Hawthorne implies the tragic impossibility of this provisional release of identity through Clifford's quixotic mania for an "ascending spiral curve" of human progress, *Running* stresses its incompleteness. It is not so much that Ellen Craft cannot unmoor herself from the binding structures of identity established for her on the Georgia plantation while on the train, but that she *must* present her-

self as the public image of a predetermined identity already assumed to be in motion. Still, Ellen more so than Clifford approximates that assemblage of identity conditioned by bourgeois discourses of travel. She must suppress private markers of difference (as a matter of life or death) in order to participate in the same feeling of placelessness that Clifford feels only briefly. Home cannot remain unstable as a ground of identity for Clifford, but no such structure exists without partiality for the runaway slave.

Even with their differences as models of mass passage, Clifford and Ellen similarly experience the rail system as a convergence of commodity and visual culture. As Clifford embraces placeless locomotion and the microcosmic community it posits, Hepzibah seems to see the house they have just fled everywhere and in everything, even in the novel commodities that overrun the train. Many critics have noted that the train ride presents Hepzibah with a simulacral world of goods for sale only tentatively glimpsed in her earlier efforts to sell Jim Crow pastries from the mansion's store. Linking Hawthorne's representation of Clifford and Hepzibah's journey to commodity fetishism, Alan Trachtenberg writes, "The mirror of unrealities leaps out as the apt emblem of commodity culture, the very agent of reproduction, transforming substance into image in a process that itself mirrors the apparent magic whereby money vanishes into goods and reappears as profit."[28] The self that is constructed in relation to the market so ruinous in Hawthorne contrarily becomes the only means of liberation in *Running*. Just as Hepzibah's conversion of the scenery into a dizzying panorama recalls the judge's false construction of identity, which according to Trachtenberg evidences the way he "sees himself only in the mirror of his market self," so too are the Crafts forced to figure forth market selves in order to survive.[29] While Hawthorne's world ends with a "magic circle against the threat of political economy that reproduces the world as image-commodities,"[30] the world of the Crafts ends in celebration of commodity fetishism. Opposing Hepzibah's discomfort with the spectacle of domestic replication and the routine intrusion of newspaper and magazine vendors through the train cars, the Crafts luxuriate Clifford-like in the destabilizing replication of the visual, embracing an effect of it that perhaps explains Hawthorne's derision, for such replication alienates the value of skin color from its presumed guarantee of racial purity. This alienation reaches its zenith at the train station, where Ellen's white skin becomes a mystified commodity object, disjointed from its production since the black mother's imprint of African heritage is not clearly visible. To borrow from William Pietz, Ellen's social value as an object of spectacle "depends on the specific institutional systems for marking the value of material things."[31]

As commodity object Ellen's body may be seen as a kind of sartorial museum, having been adorned with artifacts of a Southern white masculin-

ity in physical peril. As such she is a specimen type of cultural power and physical decay that is imbued with privileged status at precisely the moment the notion of identity predicated by a nascent culture of display, which presumes the authenticity of signs of the surface, is most called into question as insufficient authentication of private ownership. What the climax narrativizes, then, is a theory of passing that consolidates the status of white masculinity within an emergent social system structured according to the dictates of legal authentication, security, and private property. In this system, authentication transfers from the artifactual value of embodied presence[32] to that of the fetishized document, the signature, promissory note, receipt, or contract.

The legal document becomes the formalized equivalent of evidence that the body alone once signified. The moment of the ringing bell not only heralds the triumph of the passing slave couple, it also tolls resistance to the dehumanization of members of the privileged classes. A complex victory, the climax enables bourgeois identification by militating against the possible reduction of white masculinity to the status of object, on one level, even if heavily enforcing this objectification in Ellen's very act of passing on another. And yet, we should ask whether a similar identification is possible in Ellen's engraved image. In what sense do the same uses of seeing Ellen's passing in the narrative obtain in the image? How does the image of Ellen expose and dismantle whiteness as well as the cultural institutions that support and reproduce it?

The Semiotics of Disguise

Even a cursory analysis of the visual signs of Ellen's engraving forces a recognition of its astounding reversals of gender, class, and racial markers. Closer scrutiny of the image uncovers a different set of priorities than in the narrative structuring Ellen's representation. The whiteness of Ellen's face is decidedly valued in both texts, but whereas the shape of her face is a feminizing liability in the narrative, it is an individuating asset in the engraving. The image thus diverges from the narrative in its reliance on masquerade rather than on masking, in which costuming duplicates masculinity despite Ellen's unmasked face. When plotting Ellen's disguise in the narrative, for example, William admits that the "smoothness of her face would betray her" (24), so Ellen decides on the addition of a facial poultice made from a white handkerchief that would be wrapped around the top of her head and chin. William's reason for the engraving's omission of this obscuring device gains rhetorical emphasis by being delivered in its own single-sentence paragraph: "The poultice is left off in the engraving, because the likeness could not have been taken well with it on" (24). The implication is that an

image of Ellen masked as s(he) was yields a dangerous anonymity, rendering not Ellen in disguise as a man but a faceless mannequin.

To William the engraving eschews the anonymous passer in order to restore the particularity of Ellen's face, its empowering color as well as its feminizing shape. Of course, this face also appears with a body draped in men's clothes, but by implying that the engraving's unimpeded likeness of Ellen's face discloses her gender, William assures viewers of the image that what they are looking at is not a man. Taking control of his narrative's only ancillary supporting document, William seeks to arrest the indeterminacy of Ellen's image from the textual space of the narrative. But does William's interpretation hold Ellen's image steadily within a normative frame of femininity? Or are his efforts to normalize her within the narrative only a response to the apprehension that Ellen's image may fail to signify in the way he wants it to, failing, ultimately, to convey a likeness of femininity?

To William, Ellen's pronominal "she" only playfully and ironically acquires the status of "he." Critics have noted William's anxious affirmations of Ellen's true womanhood—her "state of trepidation" and "violent sobs" (27) and his pronouncement that his "wife had no ambition whatever to assume this disguise" (24) before his imposition of masculinity and mastery onto her. Although William Andrews imputes this reasoning to William's unwillingness to disaffect his white readership by linking Ellen's trickery of unsexing herself to the tradition of the "justified picaro,"[33] these affirmations of Ellen's "true" womanhood also allow William to retain control over her gender signification and to fortify a base of gendered power relations between him and Ellen, even as his narrative topples superstructural power relations between Ellen and others.

Tellingly, William endows her with masculinity from the moment of their departure, "my *master* (as I will now call my wife)" (28), to the moment of their arrival in Philadelphia, "On leaving the station, my master—or rather my wife, as I may now say" (50). As Andrews acknowledges, Craft "actually savors the convincingness of [Ellen's] charade while also suspending [. . .] the equation of mastery and maleness on which societal power in the North and South had been traditionally predicated."[34] Even though Ellen's performance as a "master" dupes various characters into assigning her a masculine gender identity, that status is always consigned to her and managed by William. Her passing allows him to destabilize the assumed uselessness of the black gaze and to seize control of the meanings implied in interracial looking relations, as when he observes privileged white girls casting romantic glances at his wife in drag or when various slave owners inveigh to her against the prospect of liberating slaves supposedly incapable of independence.

Yet exercising hermeneutic and scopic power over whites causes Wil-

liam to construct his wife as a powerless object of scrutiny, and his constant supervision of her reinstalls her within a matrix of gender subordination that "muzzles or suffocates Ellen," as McCaskill claims.[35] While Ellen's passing subverts "the infallibility of the gaze by initially asserting a variousness of blackness that the gaze fails to comprehend," as Sterling Bland postulates, the narrative's muffling of Ellen's subversion is finally ironized by the engraving.[36] Agreeing, McCaskill quips: "Ellen's unmuffled mouth in the frontispiece likeness does not bespeak the fact that William's narrative snaps it shut."[37] Of course, such supervision may have been taken by readers of the narrative as a restoration of black masculine security annulled by slavery. McCaskill speculates that white female viewers of the engraving would "recognize how enslavement divested African women of the protection of fathers, husbands, and sons, and demanded them freakishly to substitute themselves in the labors and decisions that the customs of the day inclined 'naturally' to men."[38] One could argue, by contrast, that the freakishness of this pained substitution is greater in the narrative, for it is there that William stands beside his wife as her slave. Because William is absent in the engraving, along with those other compensatorial markers deflecting any individuation of Ellen's "true" race or gender, the engraving signifies the possibility of suppressing the pain of Ellen's substitution in order to permit viewers to revel in the voyeuristic pleasures of that substitution. Just as the tinted glasses, the facial poultice, and William himself enact supervision in withholding but also alluding to Ellen's subordination in the narrative, the engraving still contains its own policing mechanism in the form of the caption.

Even when unbound from the narrative the engraving regularly appeared in periodicals with an explanatory caption minutely affixed. The caption intervenes upon the referential possibilities of the image, creating a moment of ekphrasis.[39] The uncritical viewer decodes the image in an ekphrastic signifying relationship to the caption. Like a policing device, the caption functions to ground the dangerously interminable range of significations that the picture sets in motion. Among the inevitable information expressed in the caption is the revelation of Ellen Craft's "true" identity. Her sex is indirectly disclosed as feminine in the caption's designation of the pictured subject as "Ellen Craft." Her classed and racial status is either overtly determined or implied, as when the viewer is told that she is only in "her escape disguise" as "an ailing white planter." Through an implicit negation, then, the caption informs the viewer both of the intended interpretation of the signified pictorial subject (the ailing white planter) that the pictured subject (Ellen Craft) approximates.

In an official, preferred decoding of the caption and the image, the viewer is induced to engage in a paradoxical series of closures[40] that seek, on

one hand, to secure the visual reproduction of whiteness but, on the other, to disrupt that reproduction. One discrete act of closure visually associates the signifier "ailing" with the poultice that cross-cuts the image. Another associates "planter" with the sartorial ensemble beneath the poultice, the top hat, raised cravat, tassel, and patterned coat, and with the complexion of the face, the subject's right cheek awash in whitening light. While this line of closure depends upon the gendered and racial ascriptions betokened by the word "planter," another actuated by the terms "disguise," "Ellen," and "escape" unsettles those very ascriptions. Even in this official reading of the image authorized by the caption, the viewer is compelled to reconsider the implications of the whiteness descried upon the subject's cheek and the masculinity that the outfit conspires to construct.

But the caption likewise re-affixes Ellen beneath the veneer of her disguise to the culturally legible body of the female slave. It primarily functions to explain the effect of the image as a visual seizure of the potentially transferable cues of masculine Southern gentility, but finally implies the necessary non-transferability of feminine blackness. Put simply, we can see Ellen become the ailing planter in the image, but the caption acts to terminate this identification by giving away the lie. However, a less deterministic reading is possible, not so much of the image itself, but of the relationship between it and the caption.

One way of conceptualizing Ellen's ekphrasis is as the process of the pictorial polysemous becoming monologic by the caption. Seen in this way, the range of interpretations harbored by the image gets corralled and branded with one interpretation by the caption. Another way to conceive of ekphrasis is as a dialogical process. In this way, the process of signification need not terminate with the caption. Indeed, even in purely spatial terms the relationship of adjacency between the image and its caption favors repeated viewing of the image. The result is a return to the image. After first reading the caption and seeing the image, one possible viewing pleasure is a patterned return to the image with its imagined finality of identity markers constantly under erasure, but always at the ready like a kind of viewing safety valve propitiating any of the viewer's own destabilizing identity fluctuations pursuant to viewing Ellen's. The pleasure thus derived is rooted not simply in the reactivation of Ellen's bodily fluidity, but also in the constant throwing off and reinstallation of a hegemonic structure of identity formation that the viewer seems to control. Like a kaleidoscope, the image and caption of Ellen Craft together comprise a kind of visual toy for the antebellum viewer that affords maneuverable control over the otherwise intractable rules governing the visual realities of chromatic order. In this way, the curious viewer of the engraving gets to play a role exclusive to William in the narrative. The

possibility for participatory acts of knowing and unknowing lends the engraving a kind of agency-effect modeled by William in the narrative.

Perhaps then what is most intriguing about this famous engraving—which may also explain its longstanding popularity as a commodity item among abolitionists on both sides of the Atlantic—is its depiction of exactly what the caption implies about it. The engraving is finally a visual palimpsest of miscegenated androgyny that succeeds in passing for a Southern gentleman. What we should ask is not how this picture configures white masculinity, but how Southern and propertied white masculinity came to configure a subjectivity that is visually both androgynous and miscegenated.

The Slave Uncanny: Feminine Southern Masculinity and Colonial Mimicry

In *Alternative Americas* Anne Norton offers an interesting connection between representations of Southern masculinity and femininity, arguing that Southern national identity developed around a metaphorical incorporation of identities considered antithetical to the national identity of the Northern states as bequeathed to them from Puritan traditions. According to Norton, the South built a political identity that reflected a self-conscious political marginalization from the North, and symbolized Southern national identity by referencing the black, the Indian, and the feminine. An example of the latter occurs in the preoccupation with themes of maternal provision in Southern rhetoric meant to legitimate the South's agrarian economy and plantation culture: "The maternal metaphor expressed the intimate relation of the farmers to the land [and] presented to the Southern mind the possibility of a national corporate identity."[41] Norton gives examples, too numerous to list here, of contemporary depictions of the effeminate Southern gentleman in both Northern and Southern cultural artifacts that were anchored in metaphors of the South as a "Motherland."

This view of Southern character as structured by a deliberately feminine nationalism, however, does not account for the ubiquity of such forms of feminine nationalism, in general. Gender is significant to constructing national narratives and foundational myths, as Paul Gilroy explains, because it is "a sign of an irresistible natural hierarchy that belongs at the center of civic life. The unholy forces of nationalist biopolitics intersect on the bodies of women charged with the continuance of blood lines [so that the] integrity of the nation becomes the integrity of its masculinity."[42] More specifically, in *Imperial Leather* Ann McClintock argues that all nationalisms are strongly gendered, but that gender and race differences are repressed when concep-

tualizing the nation as an imagined community. Although women are typically constructed as symbolic bearers of the nation and reproducers of its citizens, they are also often denied political participation in nation-building. According to McClintock, the dichotomy between women's symbolic importance and political invisibility leads to a series of contradictions at the core of nationalism: while it draws on images of the family to produce a generic narrative of national belonging, families are excluded from national power; while it values nostalgia (through images of domesticity and femininity), it simultaneously valorizes novelty (progressivism, masculinity); and, most significant for our purposes, while it ascribes to women symbolic agency, it also requires them to replace their political relation to the nation with a social relation to the husband.[43]

Analyzing the paradoxes stemming from women's symbolic relation to the nation helps us to uncover more submerged threats to Northern white masculinity in Ellen's engraved appropriation of Southern masculinity. Ellen's picture and the story of her escape make the identity markers of the Southern gentleman functionally equal to the dispossessed but metaphorically appropriated identities that Southern gentlemen use to fashion national identity. In effect, Ellen reduces Southern masculinity to the realm of the symbolic, and by bearing symbols of the gentleman, she acquires an agency prohibited to her. More than simply appropriating symbols of the white man, however, Ellen appropriates symbols of white men that are already, strangely, in her possession: she takes ownership of her white skin and redesigns its cultural meaning. Where Southern rhetoric of nationalism absorbs and mystifies even as it dispossesses blackness and womanhood, Ellen explodes Southern manhood by literally de-mystifying it: she embodies it during the escape and exposes its social props in so doing.

Out of this spectatorial encounter between the fabricated subject of Ellen's white masculinity and the viewing subject constituted by manufacturing, an apprehension of material complicity in Ellen's passing may result. Perhaps distraught over the image of the North being overrun by black women contriving to pass as white men, the anxious viewer is urged to reconsider his own relationship to the principals of manufacturing that make such passing possible. What this viewer reacts against is not so much the discovery of an unknown idea but the forced acknowledgment of a repression, as in Freud's notion of the Uncanny or *unheimlich*, "which is familiar and old-established in the mind and which has become alienated from it only through the process of repression."[44] If an Uncanny spectatorship is produced it would suggest that the fear of the manufactured whiteness of Southern black labor migrating North may be a "surmounted" belief written into the very structure of Northern capitalism itself.

Evidence for such fears of industry's threat to masculine identity

abounds in canonical antebellum literature. Behind these fears lies a regional threat posed by the Southern states "manufacturing" of slave bodies, a parallel not lost on the cutting perspicacity of *Punch* cartoonists (fig. 3.4). As we have seen, the fear that machines could transform people into objects, for instance, resonates in *The House of the Seven Gables*. Echoing Hawthorne's caution for the railway, Thoreau famously accuses mechanized transportation of reversing the status of the makers and the made in his quip, "We do not ride on the railroad; it rides upon us."[45] Emerson accuses the railroad of disturbing the essential separation of humanity from the realm of commodity artifice, saying it "makes man a chattel, transports him by the box and ton."[46] Broadening the indictment against mass transit, Emerson makes a connection between the construction of identity and commodity objects: "Man is made as a Birmingham button."[47] Here, Emerson limns with cautionary disdain the gentleman as a metonymic reduction (like the gentleman Ellen appears to be), having become the mass-produced object that fastens him together. In these examples, industrialization impinges upon a racial order threatening to come unbuttoned amidst ever swifter correlations of white passengers and passers, placeless cargo and chattel.

Conclusion: Seeing the Mulatta Mimic

In its un-gendering of the mulatta, the engraving reinforces the axiom that national power is disembodied; it is bodily invisible and spatially unbounded. At the same time, however, the masculine japes of both image and text are specifically regional. The image stages Southern masculinity as a composite of subaltern identities (despite its elision of them) and points ominously toward corresponding fluctuations in a Northern arrangement of identity. In other words, the image redefines the valence of threatening otherness, displacing it from the feminine and the black onto regional difference—Southern masculinity.[48] In this viewing context, the picture becomes a libidinal map for white viewers on which to project the fear that Northern masculinity is also appropriable. And although, in protective response, the picture may stimulate the fantasy that Northern society can annex any undesirable body, it only does so while promising to eradicate the trace of that body, particularly its generative capacity to reproduce undesirability. Masculinizing the mulatta screens out what would otherwise function as an index of plantation rape. However, as the caption always recalls, this is not really man. In its incompleteness as a representation of masculine whiteness, as with the colonial mimic, Ellen's appearance offers the viewer *"a subject of a difference that is almost the same, but not quite."*[49]

As terms like "black" and "white" and "woman" unravel under the

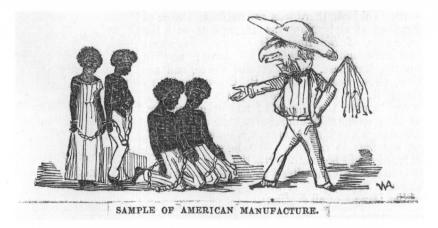

SAMPLE OF AMERICAN MANUFACTURE.

Figure 3.4. From *Punch* 20, 1851

weight of their disruption in the image, so too does language itself suffer a kind of descriptive impoverishment, failing to fix the person of Ellen Craft within the visual field. Yet, like William, a supervisory caption always attempts to reign in the meaning of Ellen's disguise. However resistant the image is in its singular visual representation of the disguised Ellen Craft without a male attendant, it also celebrates the erasure of visual signs of gender and race difference as it engrafts masculine visual signs onto a text (Ellen Craft as the subject of the caption) that is marked as feminine. In this way, the deceptive self-transformation that the image accomplishes reasserts the normative privileges of the propertied, white male. The image of Ellen Craft in disguise therefore subsumes meanings incompatible with dominant ideologies.

Scrutinizing the image of Ellen Craft through the lens of colonial mimicry brings the relationship of the engraving and the caption into sharper focus. If colonial appropriation, as Bhabha contends, "depends on a proliferation of inappropriate objects that ensure its strategic failure, so that mimicry is at once resemblance and menace," then surely the caption is a kind of "inappropriate object" that ensures the "strategic failure" of Ellen's disguise.[50] The caption accomplishes what no Southern customs official was able to do: it discovers the contraband body beneath the charade of race and gender privilege. Appearing to belong to both groups, slave and enslaver, Ellen Craft's protean identities—enhanced by the binary workings of the image and caption—disrupt the Manichean logics by which nineteenth-century America defined national identity, gender, and race.

The reappraisal of dominant modes of seeing is integral to the narrative, and the climax registers a central ambivalence in this form of authority. The bell-ringing scene exposes a tension in antebellum America's bureaucratic

order produced by the twin requirements of ensuring the mobility of privileged subjects and protecting private property. Both narrative and image affirm that the ability to envision white masculinity (especially in peril of detainment) overrides the ability to legally document or verify it. Ellen's image intimates that the white male needn't feign an identity to achieve domestic security, but remains the imagined standard of unimpeded, unadulterated, and nationally protected identity, even when failing to produce proof of that privileged status. Although the planter Ellen Craft pretends to be cannot write and thus cannot underwrite his presumed status through any means apart from the visual, the authenticating power of proximity to blackness nonetheless ensures Ellen's resemblance to patriarchy. The verifying power of blackness in proximity is precisely what threatens to dismantle the myth of white superiority, suggesting that racial privilege depends more upon difference and the appurtenances of domination than on essentiality.

The use in seeing the engraving given within the narrative is tied to a scene of harrowing filial disintegration, wherein William suffers helplessly against the heartless, irrational market-driven forces that separate him from his sister and make seeing her useless. Like William Wells Brown and Frederick Douglass, William Craft inscribes his narrative with a traumatic memorial to displaced foremothers and sisters dropped into slavery's abyss and attempts to invest value in seeing and remembering these figures. William links himself both to the particular degradations suffered by female counterparts and to their metaphorical restoration through representation. And like Douglass in particular, William attributes use value to ways of seeing that are contrary to those practiced by dominant culture. William's seeing forces viewers and readers of Ellen's passing to become aware of the complex and contradictory assumptions inherent to acts of racial gazing. His narrative reserves a superiority of vision for the black male, who flaunts an ability to pierce the subterfuge of the surface and invests value in seeing black femininity—particularly when such value is at a minimum for white observers. As a result, both Douglass and Craft indicate an alternative set of scopic assumptions exclusive to black men, a way of looking that reverses established modes of seeing. Even so, this exclusive prerogative of black men's looking does not affect the engraving when viewed apart from the narrative. Regardless of the control function of the caption, which can only stabilize the meaning of the engraving temporarily, the use in seeing Ellen Craft—as a white man, as a white-black woman become white man, or as a white-black woman posing as a feminine white man—is to achieve a form of looking that abjures decidability.

PART 2
STILL MOVING

Revamped Technologies of
Surveillance

4

Panoramic Bodies: From Banvard's Mississippi to Brown's Iron Collar

They touch our country, and their shackles fall.

WILLIAM COWPER

Literally meaning an "all" encompassing "view," the panorama flourished throughout Europe and America in the early decades of the nineteenth century. Split between entertainment and instruction, panoramic exhibits afforded viewers the illusory experience of unlimited viewing, using elaborate gimmicks to create a sense of movement through history and space. Typical panoramic views rarely focused on bodies, preferring sweeping historic battles, faraway landscapes, and sundry wonders of the modern and ancient world to representations of the individuated human form. With the sensational rise of abolitionism, however, this preference in the panoramic medium for the magnitude of place over the spectacle of the body would find uneasy resolution in several antislavery panoramas that, regrettably, no longer exist in their entirety. The textual descriptions of these now lost panoramas, however, do remain and challenge those of us concerned with the cultural effects of antebellum racial display to develop ways of approaching artifacts primarily meant for visual consumption through verbal narratives originally intended to be read or heard. Thinking through ekphrasis, in other words, this chapter examines William Wells Brown's panorama of slavery for its revision of landscape conventions and iconographies of race. As we shall see, Brown recodes the technology of the panorama to magnify bodies otherwise occluded in its typical cultural operations.[1]

In a landmark effort to extend the global impact of abolitionism, Brown's *Original Panoramic Views of Slavery* of 1850 registers disaffection for the minimization of slavery found in several of the medium's most celebrated

examples. Rather than simply reversing or exchanging popular icons of na-
tional and natural sublimity with abolitionist imagery, Brown's panorama
exploits the same principles of immediacy, synchronic totality, and ency-
clopedic didacticism that helped make its contemporaries highly celebrated
spectacles in England and America. Yet in order to revise what he saw as the
"mildness" characterizing the treatment of slavery in other panoramas, his
Views engage directly with the tactile field of sensory experience that these
others prohibit, encouraging physical contact between British audiences
and the material instrumentality of slavery's vicious operation in the lives of
midcentury American bondsmen and women.

Shuttling between the few illustrations of the panorama that survive
and the descriptive narrative distributed at the time of exhibition, I want to
show how Brown's aesthetic does more than simply subordinate panoramic
investments in romantic conceptualizations of nature and nationalist em-
blems to highlight the trials and triumphal escapes of slaves. It evacuates
the signifying antagonism between the verbal and the visual to interpose
a material object, an iron slave collar, shown at the end of every exhibition.
As with "The Virginian Slave," the production of an alternative artifact oc-
casions the performance of a kind of fleshing, whereby Brown defuses the
impetus in seeing to reduce slave subjectivity to the status of object, even
one charged to trigger the masochistic sympathies of audiences conditioned
to do so by abolitionism. Materializing a caesura in the ritual movement
spectators are invited to practice during panorama exhibits, the iron collar
becomes a counter-technology of still movement. It stills the frenetic spatio-
temporal rhythm of gazes concatenated by physical markers of movement
in panoramic scenery and driven by nascent consumer and tourist practices
that organize the scene of the panorama exhibit. And it moves viewers, on-
tologically relocating the perceptual relation of the view so as to tactically
encompass the viewer (for whom looking alone is suddenly inadequate to
the task, literally, at hand). Interposing a vexed materiality onto the visual
field that conjures even while boldly failing to produce the maternal body,
the iron collar cathects disruptions of media, memory, mobility, and mater-
nality endemic to panoramic subjects.

Subjects of Panorama and the Panoramic Subject

In *The Panorama: History of a Mass Medium*, Stephen Oettermann con-
nects the origin of the panoramic form to a number of commercial, artistic,
and cultural convergences. Irish-born Robert Barker's patent of the pan-
orama in 1787 indicates that the medium was as much associated with art as
with technologies of industrial invention. Late eighteenth-century interests
in tourism and landscape coincided with artistic practices for depicting spa-

tial grandeur through the manipulation of perspective, vanishing points, and horizon lines. According to Oettermann, early pictorial experiments with spatial expansionism by way of this play with the horizon resulted in an upsurge of ocular entertainments, allaying anxieties of urbanization, class polarization, and empire: "For the bourgeois citizen of Europe, hope seemed to be located at the horizon. For no matter where he looked closer to home, he could see only the daily struggle to survive, the pervasive discontent, and political persecution. The horizon was the line that separated bleak reality from glorious possibility."[2]

Likewise, Bernard Comment identifies the panorama as the pivot point whereat mass entertainments turn from romantic representations to illusions that anticipate twentieth-century modes of alienation. In *The Painted Panorama* he asserts that the "panorama was a response to a particularly strong nineteenth-century need—for absolute dominance" and describes the social and political implications of London's most popular works. Among these were the Barkers' Leicester Square panoramas *View of the Fleet at Spithead* (1793) and *Battle of Aboukir* (1795), as well as the Burfords' (father and son antecedents of the Barkers) exploded views of Pompeii (1824) and their depictions of Mont Blanc, Rome, Benares, Macao, Kabul, and Damascus.[3] As part of a desire to escape the alienating pressures of mass culture, Comment argues, viewers participated in constructing an "imaginary situation" with respect to space. Sovereignty and dominion over collective areas and foreign locales of imperial occupation were experienced through the conventions of theatre (with the panorama's built stage and modular lighting), art (with its manipulation of perspective), and travel (with its observation platforms and emphasis on escapism).[4]

The typical showing required a special building, often situated along a city street and configured as a "round or polygonal construction about 50 to 60 feet high and 90 to 110 feet in diameter, with a dome or conical roof that was often . . . surmounted by a decorative tower."[5] Oettermann goes on to describe the histrionic architecture of the rotunda's interior: its winding stairs lead expectant viewers through a darkened hall, an interzone that protracted entry to the sight and strategically divided urban confinement from the illusory spaciousness contained within the small building. Importantly, visitors were constrained from venturing too close to the painted canvases that depended from the circular walls of the rotunda by means of rails or ramps surrounding the platform.[6] An emergent practice of urban culture, the panorama followed commercial procedures for disciplining visitors, corralling and isolating them before a "spectacle"[7] in directive paths not unlike those of the museum, sideshow, or circus. The panorama thus located romantic escape as an interior dimension of the city.[8]

If the nostalgia and natural majesty of the panorama's vistas often op-

posed capitalism and urban social arrangements, its methods of exhibition were altogether congruent with them. Parallel figural operations of substitution, or surrogacy, and supplementarity were central to the panoramic form. In the words of Scott B. Wilcox, "The panorama supplied a substitute for travel and a supplement to the newspaper."[9] Fashionable among the elite and leisured classes at first, panorama-going became a phenomenon attracting mass audiences of mixed income and social status by the close of the century.[10] References to the audiences of panorama exhibits in midcentury periodicals mention the "middle and humbler classes" and analyze the possible educative effects of such spectatorship upon them.[11] That the form would have a necessary impact on the way its viewers saw the world and themselves therefore was an assumption explicit to the medium.

In London, Paris, and Boston, the panoramic rotunda and its displayed images promised mass audiences a transcendent release from the chaotic perceptual demands of the city space. As a circular, continuous, and frameless image, the panorama placed emphasis on a "synchronized totality" that situated the spectator at a point of command over the view.[12] In contrast to the opacity of the urban landscape, then, the panorama represented a spatial paradox, allowing unlimited visual access to pastoral, exotic, or historic expanses while physically limiting viewers in relation to the scene, each other, and the outer world of the city.[13] Whereas depictions of political turmoil common to European panoramas generally failed in the United States, as Comment notes, pastoral representations proved "more attractive [to Americans] than the nationalist fervor of Franco-English battles."[14] From the 1830s to the 1850s, American audiences swarmed moving panorama exhibitions housed in theatres and reception halls to see local landscapes reflected ostentatiously on an "extremely long canvas attached to two cylinders [that] slowly unreeled in order to simulate a journey . . . usually made on water."[15] These moving panoramas supported a dominant narrative of national progress and, in the process, plotted the natural progression of this narrative onto icons of rivers, buildings, ships, and roads. Particularly in the panoramas of the Mississippi vogue (not all of them "moving" panoramas), temporality in concert with space naturalized political agendas that asserted the expansion of trade and transportation.[16] One of the most popular examples of this vogue, John Banvard's *Mississippi from the Mouth of the Missouri to New Orleans,* fraudulently reported dimensions of six kilometers.[17] Before finding a permanent home in London's Egyptian Hall in 1848, where William Wells Brown may have had the opportunity to study its scenes, the exhibit successfully toured Boston and New York.[18] With its sensuous magnification of landscape detail and ornamental use of slave labor, the Mississippi panorama became the problematic call that would elicit Brown's corrective response.

Slave Representation and Landscape in the Mississippi Panoramas

Scant visual evidence remains of the spate of Mississippi panoramas that enjoyed great appeal in America and London during the mid-nineteenth century.[19] Still, John Egan's moving panorama of the rituals and habitat of Native Americans has survived, evidencing the objectification and uniformity characteristic of representations of African Americans in the genre. Like most panoramas, this one drew on the public's association of innovations in science with those of spectacle. A guide, often a learned expert, regaled visitors with encyclopedic facts, anecdotes, and theoretical speculations.[20] In Egan's panorama (fig. 4.1), for example, an expert ethnologist, Dr. Dickinson, lectured viewers on the archeological and religious implications of an indigenous burial mound as they observed scenes of African Americans engaged in the labor of excavation.

The progression of this panorama rehearses chronological, spatial, and cultural typologies, moving from the tranquil indigenous family, to conflicts with settlers, to the eventual demise of indigenous populations and their troubling connection to lands they once occupied. A conjunction of European and African American efforts literally dig up the remains of native life.[21] According to Comment, Egan's panorama and the thematic trajectory it constructs "would appear to have been inspired by studies made by the anthropologist Dr. Montroville to restore features of Native American culture,"[22] but this restoration depends heavily upon a scientific affirmation of native extinction contradicted by the panorama's culminating scene. A familiar racial distribution of labor helps to organize the scene's representation of the Indian burial mound in profile. In the center between middle ground and fore, the cross-section of the mound with its rows of recumbent skeletons anchors the signification of the surrounding figures and implies their purpose. Around the base of the mound, black men work in unison at the task of excavation. Although their shovels are in assorted postures of motion, they are attired uniformly in striped shirt, blue pants, and brown shoes, with facial features as rigidly generalized and interchangeable as their dress. They are most likely slaves but perhaps freedmen, given the geographical liminality of this Southern Ohio portion of the Mississippi. Nearby and closer to the foreground are evenly distributed pairs of white-suited men, their authority as the intellectual force behind the process signaled by the pages they hold in reference to the mound. Paper thus opposes spade in the visual hierarchy of power. Significantly, the scene has no overseer in it. Absent the third iconic term of the whip in this focalization of spade and paper, the scene fantastically imagines the volitional participation of the

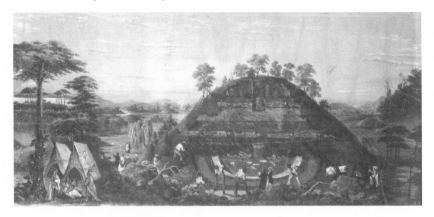

Figure 4.1. John J. Egan, *Panorama of the Monumental Grandeur of the Mississippi Valley*, ca. 1850. Courtesy of St. Louis Art Museum.

black laborer. Egan's arrangement of racial subjects visually encodes black inferiority and corresponds with Albert Boime's studies of the iconographic exclusion permeating nineteenth-century depictions of whites and blacks. In these visual and spatial allegories of dominance, conventional geometric patterns such as the "pyramidal envelope" are deployed as much for ideological as for aesthetic purposes, since they consign minorities to prostrate, marginal, or subordinated positions in extremis to whites.[23]

Egan's compositional division of racial labor complements the panorama's division of domesticity, women, natives, and even viewers—all of whom are in different proximities to the exhumation process. Congregated white figures who observe the labor provide targets of identification for spectators. As such, the panorama flatters its viewers. Acts of watching are elevated to a level of crucial participation in a nationally motivated and historic endeavor. Mixed-gender groupings assert the reproductive viability of whites and natives; yet for the black worker, by "droning" contrast, there are only men.[24] Implicitly managing fears of black reproductivity, interchangeability reduces blacks to automata and banishes them from the domain of the domestic.[25] For Egan's viewers, therefore, the panorama furnishes optic proof of the vanishing Indian, the supremacy of Anglo intellect, and the perpetuity of black labor.

Dual investments in the allure of the primitive and the record of its eradication also characterize John Banvard's popular Mississippi panorama. References to Native Americans locate the sublime desolation of the geographical beginnings of Banvard's Herculean effort to convey the magnitude of the river on a canvas incredibly touted to be over three miles long. A description written to accompany the panorama enshrouds the genesis of both the artwork and the river with the gradual removal of the indigene:

the numerous tribes of savages that now roam upon [the Mississippi's] borders; the affecting and imperishable traces of generations that are gone, leaving no other memorial of their existence, or materials for their history, than their tombs, that rise at frequent intervals along its banks; the dim, but glorious anticipations of the future;—these are subjects of contemplation that cannot but associate themselves with the view of this river.[26]

As in Egan's imagery, even majestic nature, symbolized here by a river that in turn equates to the country itself, cannot but participate in memorializing and thus reassuring the extinction of a population that elsewhere appears "numerous." Savagery thus initiates the viewer's journey along the river that terminates with the glory of New Orleans urbanism. But at its incipience near the falls of St. Anthony, Banvard's heroic river follows the current of the country's mythic origins in contemporary patriotic re-tellings (of which this panorama certainly is one), where "there is not a civilized inhabitant on its shores, if we except the establishment of Indian traders, and a garrison of the United States" (24). Given the celebration of the public commerce of the final scene in New Orleans, we must certainly make such an exception. For in Banvard's reconstruction of the teleology of American exceptionalism—constellating the river, the country, and the burgeoning canvas that celebrates both—civility emerges as the commercial by-product of an arduous propinquity with the primitive, the latter sloughed off as a Herculean effort of ritualized spectacle on a national and international scale.

The international significance of Banvard's gargantuan painting hinges on an anecdote used to advertise the exhibit and explain its origin: the penniless and fatherless Banvard, though hailing from a formerly aristocratic French family, reads a foreign author's infuriating assessment of America's artistic lacking despite an abundance of natural inspirations. In chauvinistic revenge, Banvard supposedly sought no financial reward for his undertaking, being "actuated by a patriotic and honorable ambition, that America should produce the *largest painting* in the world" (14). To represent this feat as one of paramount national concern, the *Description* begins with the panorama's unanimous approval on the part of Massachusetts governor Briggs and several members of the House and Senate, who offer as resolutions the panorama's magnificence, accuracy, and national commendation:

> *Resolved,* That as Americans, it is with emotions of pride and pleasure we commend this splendid painting, and its talented artist, who, by its production, has reflected so much honor upon himself, and upon the country of his birth, to the favorable consideration of the admirers of the fine arts, and of all others, who, under the influence of a commendable patriotism, cherish a disposition to encourage native genius and enterprise. (6)

To prepare his vaunted stroke of one-upsmanship against foreign de-
tractors of American genius, Banvard undergoes trials of physical transfor-
mation and hardship. Somehow, hardship engenders a minuteness of obser-
vation so incredible that the same *Description* that begins with the applause
of politicians ends with the sober testimonials of experienced river boatmen
authenticating Banvard's details. Hunting and trapping his food, Banvard
describes the way his skin became "as tawny as an Indian's, from exposure
to the rays of the sun and the vicissitudes of the weather" (15). The struc-
ture of his narrative of transformation from wilderness-bound jeremiad
to rags-to-riches success story echoes that of the country: the exceptional
visionary with democratic ideals sets out to achieve a feat of unimaginable
scope; inspiring contact with physical majesty ensues, but its articulation
requires momentary abjection in identification with savagery, the domain
of America's natural inspiration. The resurrection of Banvard from savage
to redeemer of American genius gains poignancy in the icon embossed on
the *Description*'s cover—the heraldic crest of the once esteemed Bon Verd
clan from France. Accordingly, the triumph of American genius in the face
of European criticism facilitates a private reclamation of aristocratic glory.
We shall witness a similar rhetorical move through pictorial turns of one-
upsmanship in Brown's panorama, where the natural world that Banvard
identifies with in order to heroically shed through representation mirrors
Brown's appropriation of the natural world, whose likeness is so esteemed
in Mississippi panoramas, to signify the injustices visited upon the bodies
of slaves.

The grounds for Brown's resistance to the mild treatments of slavery
in typical American panoramas most likely derive from the conventional
entwinement of the pastoral and the black body. In Banvard's *Description*,
movement through antebellum political and geographical space, from wil-
derness to the pastoral, corresponds with a shift in sightings of natives to
"Negroes" working on various plantations. The association of collective
slave labor with preliminary clues of a more recognizably Southern land-
scape enlists black bodies as "signifiers of white America's pastoral fanta-
sies."[27] The slave pastoral begins in Banvard's *Description* at President's Is-
land and glimpses of "fine cotton plantations, with the slaves working in the
cotton fields" (32). Nature ameliorates but also maps the plantation's stark
racial architecture of power: "see the beautiful mansions of the planters,
rows of 'negro quarters,' and lofty cyprus trees, the pride of the Southern
forests" (32). A partitioning of stateliness and squalor reproduces the high
contrast of the panorama's formal composition, creating a chiaroscuro of
social landscape diverted finally by the pastoral interest in foliage. Mansion
and cabin, no matter how potentially divisive as national subjects, recede

as backdrop to the cypress, an indisputable subject of regional pride and implied international curiosity. This pattern of spotlighting the "gloomy grandeur" of the trees and moss continues throughout the description, until nature's tranquil visual interest collides with the specter of slave violence in a macabre fusion of scenery and superstition.

The scene entitled "Bayou Sara" encompasses the disturbing cultural work of the pastoral and provides a representative test case for the kind of mild treatment of slavery that prompted Brown to deliberate action. Spotted briefly between the "[r]omantically situated" (34) Fort Adams, a memorial to the late president, and the "romantic looking" Prophet's Island, so named in memoriam of "Wontongo, an Indian prophet" (35), "Bayou Sara" offers a commemoration based on anonymity and substitution. The solemnity of historic patriarchy and the empty superstition of the displaced indigene link to the atmospheric residue of slave bodies. Even the syntax of the descriptions suggests an interconnection of these disparate monuments. In its entirety, the entry reads:

> BAYOU SARA,
> By moonlight. A short distance above this town stands an old dead tree scathed by the fire, where three negroes were burnt alive. Each of them had committed murder: one of them murdered his mistress and her two daughters. After passing Bayou Sara, the traveler will see some very beautiful cliffs, called the . . . (35)

And then we are syntactically rushed along the course of the river to the White Cliffs overlooking the weird foreboding of a native island burial site. But we are also encouraged—at least by the repetitive force of the term "romantic"—to examine the unsubtle difference in effect created by the "romance" of Bayou Sara.

For if mention of a former president and a native seer memorializes the justice of a historical conflict entombed elsewhere in the panorama's emphasis on the primitive as a bygone vestige of national origin, then the bayou calls forth an altogether unresolved question of national crime and punishment. The (in)justice, as with the Christian crucifixion story, centers on the crime of only one of three murders burnt alive. The scathed tree remains as a testament to what, we are encouraged to remember, was a just punishment meted out to execrable villains. Yet there is a lacuna in this legend, itself an aporia of a larger injustice. We are only told about the incriminating circumstance of one of the murderers, who curiously killed three slaves. The victims within the warrant for the egregious execution number the same as the supposed villains whose fierce justice visually transfers to the scathed tree. The charred trunk reassures the viewer of the certainty of the murderers' immolation and the Manichean logic of its necessity. Explanation of the

other two murders is an irrelevance in excess of the charming anecdote. The criminality of the other two, like the brutality of their victims' demise, is left to be associated with blackness alone.[28]

It is not difficult to imagine with what anger and pain a former slave would react to such a strategic imbrication of justice and slavery, where viewers are led to trust that punishments fit the crimes among a dangerous, self-destructive slave population, but only when masters intervene. Just as the grave marker of the native prophet, the island that now bears his functional name—Prophet's Island—gently replaces genocide with a romance of historical displacement, the name of this scene also implies an amelioration of slave mutilation. "Bayou Sara" replaces the anonymity of the murderer whose narrative justifies the execution as well as those whose crimes go unmentioned with the name of the presumed victim.

Memory thus becomes a central concern in Banvard's panorama, and its inclusion of the indigene along with the slaves may create some ambiguity in the political meaning of the landscape, a maneuver some critics have ascribed to nineteenth-century writers and artists who sought to veil their skepticism of national political agendas of expansion and enslavement.[29] But even as the lives symbolized along the banks of the river take on allegorical status and compel viewers with a sense of history, perhaps even to question history, they do so only for a moment. The composition of the piece and the gimmicky verisimilitude of its presentation urge a spectatorship of amnesia. The Mississippi consequently becomes a twisting mausoleum of iconic national bodies symbolized and then quickly obscured by such natural correlatives as islands, trees, and cliffs. These disappeared bodies are supplanted further by a nominative principle that renders their extinction functional (Prophet's Island) and retributive (we can only assume Sara is the restored name of the murdered mistress). The geographical ordering of scenes according to the physical properties of the river takes on a narrative plotting that also sets in motion a literal abridgement, both a concatenation and a curtailment, of official national history and folklore.

Brown's retort will draw on and redefine the pastoral, turning the boats, buildings, and bucolic harmony of the Mississippi panoramas into an organizing grammar for articulating slavery's injustices. The modal mobility associated with the river panoramas stalls out in Brown's, where the relentless urge to forget transmutes into a governing edict to linger and remember. Accomplished through subtle mechanisms of policing the gazes of spectators, Brown's panorama ultimately collapses the verbal-visual antagonism of the panoramic altogether by interposing an iron collar worn by one of the subjects illustrated in his view. Before examining the effects of this interjection of the material onto the spectacle, let us first establish its causes and purported intentions.

Brown's Panoramic River of Slavery

According to William Farrison, Brown began exhibiting his *Original Panoramic Views* in late October of 1850 at Newcastle-upon-Tyne.[30] Around the same time, Brown published an exhibition pamphlet entitled *A Description of William Wells Brown's Original Panoramic Views of the Scenes in the Life of an American Slave*. There are several curious tensions at play on its title page. For one thing, this is the only page with an illustration, that inevitable image of antislavery, the profile of the kneeling slave with shackled arms upraised in sanctimonious beseeching. What appears to be a tropical palm tree marks the otherwise decorative and nondescript foliage of the background. In the foreground beside the figure lies a stick with a tethered whip-like tassel whose braids correspond with the shackles. The rest of the forty-page text unfolds devoid of pictures in an ekphrastic effort to restage and perhaps even upstage the twenty-four larger-than-life illustrations it was meant to attend. The second tension is somewhat more obvious. A quotation from the Declaration of Independence appears under the heading of "fiction," and under the heading of "fact" there is a line from Cowper: "They touch our country, and their shackles fall." The Declaration is renamed to include the national tag of "American" Independence so as not to miss the by-then clichéd contrast in abolitionist discourse between the United States and England. The latter is a land of freedom; the former, a corruption of democracy.

Furthermore, in the copy of the *Description* owned by the American Antiquarian Society, Brown has inscribed the pamphlet to Samuel May, Jr. Significantly, he refers to himself abstractly as the writer: "With Writers [*sic*] Regards." To call himself the writer, however, quickly resolves the conflict in roles inherent to Brown's position as both the designer of the views, the life model of their depictions, and the writer who describes them. Herein lies a clue to Brown's process of visual signifying. As writer, he attempts to take control of the visual medium's tendency toward the debasement of African humanity, the erasure of African gender or amplification of sexuality, and the petrifaction of African spatial and temporal presence. Initially in the preface, however, Brown authorizes his role as expositor of the *Views* in terms of his dissatisfaction as a spectator of the enormously popular *Panorama of the River Mississippi*. Shocked by its "mild manner" in treating slavery, Brown attributes to his panorama the same evidentiary function of telling the truth about slavery amidst a crowded American scene of spurious and dissimulated representations that he elsewhere attributes to his own narrative of escape.[31]

Although the connection to popular landscape panorama may seem

evident, the relation Brown posits between his *Panoramic Views* and landscape is surprisingly more central than we might first imagine. Brown fashions himself as a sort of curator of slave illustration in discussing the scenery gathered in preparation for the panorama: "After considerable pains and expense, I succeeded in obtaining a series of sketches of beautiful and interesting American scenery, as well as of many touching incidents in the lives of Slaves."[32] Why does Brown mention the scenery sketches first? If as with antislavery literature the purpose of the work is primarily political—to "hasten the downfall of the greatest evil that now stains the character of the American people" (iii)—then why emphasize the beauty and interest of the implicitly unstained American landscape?

Speculating possible answers leads to an interrogation of the panorama's cross-purposes, its rhetorical allegiances divided between fiction and history, entertainment and arousal, a duality that characterizes much of Brown's unique form of quasi-polemic resistance tactically softened but also subtly complicated by convention. For as we shall see, Brown's *Views* are as much an application of the aesthetic principles of the conventional Mississippi panoramas as they are a condemnation of them. Even if he projects onto the screen of the popular landscape panorama an emphasis on the slave body, the landscape preoccupations of the Mississippi panoramas reverberate throughout. In Brown's panorama, signifying the unproblematic beauty of the landscape accentuates the problematic brutality that the American panorama often veils. His view reverses the visual field of the typical Mississippi panoramas, making their espoused icons of boats and buildings, flora and fauna, signal univocally the trials and triumphs of the black body.

As a whole, the *Views* described in the exhibition pamphlet rehearse familiar spatial, rhetorical, and affective tropes of abolitionism. Their sequence generally conforms to an eschatological teleology of death and resurrection as pitiable slave subjects move from spaces of moderate treatment in Virginia to forced marches, separations, auctions, and imprisonment in ironic proximity to iconic structures of freedom such as the White House and the ship *Old Ironsides* (views 3–6). Thereafter, progress through the *Views* matches the geographical movement of the archetypical slave as well as the narratological plot of the typical slave narrative.[33] Brown's emplotment may be inventoried in the following way: through New Orleans ports and the Calaboose (7–8), to an ethnographic profile of different plantations and slave funeral rites (9–11), to the autobiographical testimony of scenes from Brown's life (12,17) and similar scenes recounted in his narrative on slave torture and romantic stories of escape (13–16), to another direct reference to Brown's narrative about a boat fire on the Mississippi near St. Louis (17), which pivots the trajectory toward escaped male slaves attempting to recapture lovers and mothers (18–21), to scenes referencing Eliza's escape (20)

and George's heroic shootout popularized in *Uncle Tom's Cabin* (22), which Brown extends to include another boat scene of a violent battle between freedom-seekers and slavecatchers (23). The final view, of course, flatters the spectator with a paean to the genuine freedom that awaits fugitives resurrected upon British soil, the true space of freedom for the slave.

Beyond these exhaustive plot affinities with slave narrative, the *Description* demonstrates a unique preoccupation with boats, buildings, and bodies. If there is another kind of story of slavery in the panorama than those enshrined in abolitionist literature, it may well be found in the transformative nature of architecture and ships to circumscribe, transport, yet also signify the slave body as a cipher of progress and possibility. Such icons as the Calaboose, a central edifice in New Orleans for the confinement and display of slave bodies, and the USS *Constitution,* or *Old Ironsides*—a celebrated frigate engaged in key battles of the War of 1812—converge with other buildings and ships to concentrate and deflect the viewer's survey of the slave's body.

A cornerstone of rising American maritime power, *Old Ironsides* even became a popular song in 1830 with words by Oliver Wendell Holmes and music by William Lardner. Renditions of the ship's indestructibility came to signify the nation's claims to nautical hegemony and contributed to the growing fervor for westward expansion. And just as sentiments of frontier trailblazing romanticize while denying the trail of expelled indigenes, so too does the patriotic furor surrounding frigates like the *Constitution, Constellation,* and others mystify national maritime investments in the transportation of enslaved cargo and the products of enslaved labor. Brown highlights the contrast between patriotic myths of supremacy and the wretched byproducts of its unimpeded exercise in the lives of slaves by doubling the USS *Constitution* with another kind of boat, the Erie Canal boat he had commandeered for a time during his final years in slavery. The abstract, global fame of the former ship is undercut by the intimate, local trafficking in slave transport and escape that happens around the latter vessel and others of its kind. For example, in his tendentious attack of the American government's duplicitous embodiment of liberal republicanism, Brown posits a symbolic polarity in the third and fourth views between the capital as a locus for public demonstrations of sympathy for French republicanism in 1848 and as a hub for the sale and exchange of slaves. The White House and concourse of speech-makers vie against the slave pens with shackled slaves in the fourth view, which directly incriminates the slave dealers of the firm of Franklin and Armfield. Still, it is not so much the slave dealer but the government that the *Description* derides: "This view presents to us one of the numerous Slave 'pens' at the city of Washington. Many of them belong to the government of the United States, and are let out to persons who wish to deal in

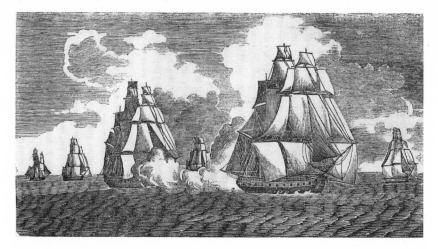

Figure 4.2. "Escape of the Constitution from a British Squadron" from *American Naval Battles*, 1848

human beings. The government also grants licenses to any person who may wish to engage in this nefarious traffic" (9).

Significantly, then, in the following two views, the panorama illustrates a series of ships in port. In the fifth, Brown describes three vessels: the first two, the *Creole* and the *Pearl*, were seized heroically by their slave cargo en route to auction blocks in the Deep South; the third, the schooner *Franklin*, appears in the foreground and "is bound for the Southern Slave-market of New Orleans, or Charlestown, South Carolina" (12). Although the sequence from background to fore summons the possibility of freedom, it does so only by emphasizing the infrequency of rebellion on the part of a population of slaves rendered en masse as passive subjects of the same historical forces of commerce that the panorama reflects in its organizing sense of narrative urgency. Indeed, the success of the *Pearl*'s freedom-seeking mutineers drowns in grammatical nondisclosure while the inevitability of the last schooner completing its trip with slave cargo obediently intact finalizes the view. This strategy of description thus kindles in the viewer a likely sense of hopelessness precisely in its initial celebration of hard-won freedom.[34] The viewer thus segues to the next view metaphorically on board the *Franklin*, borne thrillingly but also tragically toward sights south.

However, the next view briefly provides a temporal narrative pause, drawing the perspective outward from the interior of the city to encompass Washington and its port, now dominated by the USS *Constitution*. Here, the *Constitution* signals the degradation of democracy in the face of slavery. At the same time, Brown may have been relying upon his audience's

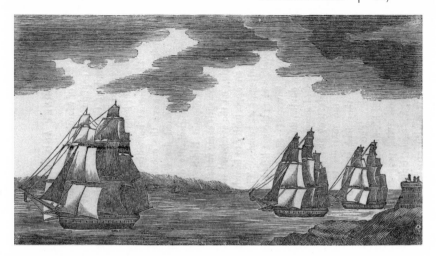

Figure 4.3. "Constitution's Escape from the Tenedos and Endymion" from *American Naval Battles,* 1848

familiarity with the popular iconography evoked by the ship in its singular representation. Engravings of the *Constitution* stress not its martial power but its evasions of certain defeat. Indeed, many such engravings of the *Constitution* bear titles whose nautical use of the term "escape" does little to dampen the strange resonance they have with the titles of the views (figs. 4.2 and 4.3). To enforce a viewing pause on the ship, a national icon associated with military power and now, strangely, the fugitive, Brown may have been charging this scene with the same aesthetic of body replacement that structures his forays into the visual field at the Crystal Palace. The escaping body of the slave, its triumphal iconicity as an object incarnating a national will to power by escaping domination, infuses the visual pause on the *Constitution.* Rather than merely replacing one with the other, the ironic relation of ship and slave escape suggests a palimpsestic aesthetic metaphorical of fugitive vision. The image of the *Constitution* as a national icon endorsing slavery remains the ground of a palimpsest, ghosted over with a hovering set of connoted images, not just of other (slave) ships central to slave history but of the ship-become-slave as well. Regardless of the ancillary meaning of the ship, in terminating the sense of movement endemic to the American panorama popularized by Banvard through this visual pause, Brown's panorama suggests both its debt and difference from the convenient restlessness of the Mississippi panoramas. Indeed, rather than a seamless viewing experience, *Original Panoramic Views* orchestrates its images according to narrative logics and thereby facilitates a halting conflict in gazing relationships.

"We Have Now Before Us . . ." Gazing at and Gazed at in Brown's Views

The instrumentality of conflicted gazing relations in rendering Brown's critique of landscape mythologies imbues the first view of the panorama. In this opening scene Brown introduces the viewer to the "mildest" form of slavery, a Virginia plantation system of agricultural, tobacco-based labor auspiciously bereft of an overseer, where slaves work and the "master goes occasionally into the field and looks after them" (7). What is most intriguing about this description of the illustration is that it comes a full six paragraphs after a non-illustrative disquisition on the variegated historical, economic, and political tensions that frame the scene, forces that appear beyond the diegetic space of the scene captured in the visual text.

This preliminary catalogue of contexts invites and defers a purely visual processing of the view. We are given a brief history of Virginia slavery, an explanation of the Fugitive Slave Law, sociological data on the lifespan of slaves and the resultant economic motive that metaphorizes slaves as so many units of crop: cultivated in Northern slave states for later consumption via the fatal hardships of labor in more Southern slave states. Before having the immediate visual design put into words, Brown's *Description*, and by extension the performative role of the tour guide that it scripts, must instruct the viewer on how to see and how to know what is being seen—in short, instructing on how to see historically by illustrating domination. Even as the text insists that history and context precede immersion in looking, the visual scene nevertheless must formally deny such proscriptions.

It is this staging of visual text frontloaded but also simultaneous with verbal context that brings us closer to Brown's intervention. He erects the image and parades it before viewers in order to transcend it dramatically for the sake of something else. The image is thus always a kind of deictic utterance, an antiphon of "this" requiring information extraneous to it for a fuller understanding. Still, images appear alongside the audio space of the spoken text, available for multiple and contradictory significances beyond the attempted seizure of meaning on the part of the *Description*. The impossibility of stability in the field of vision prods the ekphrastic impulse to seize semantic control of the image via the text and through the performance. The autobiographical dimension, or better, the autobiographics of the role presumptively allotted to Brown as the tour guide of the *Views* and speaker of the *Description* manages the referential excess produced in the gaps between *Description* and "View" similar to the control functions analyzed in William Craft's narrative and the caption in chapter 3.

We might demonstrate an example of this mediation ascribed to per-

formance in Brown's panorama by returning to the first view.[35] A familiar complex of gazes structures the scene framing master and slave, viewers and viewed. After the six paragraphs of deferred identification of the ostensible surface of the view, Brown finally names what the view manifestly represents: "The Slaves in the View now before us are at work in a Virginia tobacco-field" (6). The break from context to reportage calls the representation forth, bringing the slaves temporally into the viewer's field of vision—"now before us"—from a region where they could not yet be entirely discerned. Although these figures may have been on view throughout the recital of their political significance to the scene, the use of real-time narration in describing their appearance in the view relates the spectacle, as with most panoramas of the period, more to the aesthetic protocols of theatre than to those of painting or illustration. It is as though Brown wants viewers to feel suddenly the weight of their gaze upon the figures and to see the illustrated figures as having a sense of mobility. This further instruction in viewing is positioned as carefully in the *Description* and is as profound in its wording as the opening introduction to material seeing.

I have already suggested that a unique chain of subject-object linking and unlinking occurs in this view particularly but throughout the panorama generally, becoming the theoretical signature of Brown's style of antislavery staging. Subtle pronominal shifts in this passage help to maneuver the spectator through various kinds of gazing roles. As noted, the collective of panorama spectators emerge from the narrator-guide's initiatory "now before us," and get supported after describing the slave-dealer on horseback and the owner with the line, "Here we see Slavery in its mildest form" (6). However, this shared ascription of public viewing dissolves in the final paragraph when the diffuse gazing entity of the "we" and the "us" shifts abruptly to the isolate: "You will observe, by the way in which the Slaves before you watch the Slave-trader, that they fear he may succeed in purchasing some of them from their present owner" (7).

The dynamic complexity of this situation and its many kinds of looks and looking relations deserve careful parsing. First, there is the former mass spectator, the "we" whose glimpse of slavery and a corresponding mass of slaves begins the descriptive component of the view. Then there are two (for now) master looks: the one benign and paternal, the master who "looks after" slaves; and the other more sinister scrutiny of the absent overseer or the slave-dealer, whose gaze is never mentioned directly in action, except for the tragic effects of its desirous scrutinizing. Thirdly, there is the terrified look of the slaves as they "watch the Slave-trader" while (fourthly) being observed by "you," a suddenly individuated spectator whose gaze has been thus directed (fifthly) by another kind of master gaze effected by the narrator-guide's mandate to notice—"you will observe."

While spectator-consumers, like the panorama spectator or the slave-trader, become indirect targets of tactical slave gazes, the slaves remain in a state of ontological coalescence as they merge from unknowing objects of another's gaze to knowing subjects surreptitiously returning the look to slave dealers within the diegetic space of the illustration and to slave spectators without. These panorama viewers, with whom we must identify even as contemporary critical readers addressed by the *Description* and the view, move toward an increasingly restricted position of surveillance characterized by a sudden insularity. It is from this cut-off space that we metaphorically disembark from the visual altogether, as the illustrated forms of the panorama catalyze a more complex performance of utterances, explanations, and commands. The panorama conditions a space of performance where the visual and the verbal intersect a pedagogical site of instruction and resistance. In this heterogeneous performance, what opposes the mildness of the Mississippi River panorama is an overwhelming control of optical consumption.

A meaningful transition in the structure of the viewing experience defines Brown's method of directing gazes. Viewing within each section of the panorama is often initiated by a general intake of the scene as it confronts a mass spectator subjectivity. "We have now before us . . ." regularly begins such moments of broad, seemingly unrestrained viewing of the scene as a whole. Thereafter, the grammatical logic of Brown's narration invariably parses the mass subject, forcing viewers to experience enforced voyeurism in isolation. For example, in View the Second Brown declares, "On the right of you, you see a woman who will not go on" and later "You readily recognize" (7). Similarly in View the Third the viewer moves from "We have now arrived" to "You will observe" (8). Only rarely does the agent of scopic control, here embodied in Brown's narrator-guide, allow the viewing subjects of his pronominal creation grammatical free-play in the ambiguities of a passive construction, as with View the Fourth's "It will be observed" (10). The general pattern throughout stages the viewer as a mass subject while panning, to utilize cinematic terms, but as a private voyeur while zooming, making bodily presence seem thrillingly adjacent to those illustrated. Thus, the spectator is strategically engulfed and alienated by the sights surveyed, at once a part of a collective viewership and severed from the illustration (becoming what we might call the synecdochic viewer). The viewer is also a part of a part, or the metonymic viewer of a representation that frames more than the illustration: it also frames the viewer as a passive subject of an authoritarian master gaze.

Indeed, Brown directs viewers with an imperative urgency that authorizes how viewers access not just vision but also its correlatives of temporal and spatial positioning. A striking feature of Brown's voice in the *Descrip-*

tion is its clever marking of time, emphasizing immediacy as an essential component of the panoramic. Take, for example, the repeated use of such terms as "now" or "readily" in the transitional directives. They indicate the change of visual information, from one view to another, one detail to another. Thus Brown's panorama, like its generic antebellum cousins, explodes with a simulated infinitude of space, but the description adjoins to this spatial simulation a trickery of time. For there is not just one prevailing order of "nowness" in the anaphoric intoning of "now before us" that begins so many of the views but many subsets of now.[36] There is the now that turns focus from one view to another, a now predicated on the new, and a now that accompanies the ultrafocal command to observe details from amidst the chaos of details that a viewer without Brown or his *Description* could alight upon. Moreover, part of what registers the collective—now before us—is the nowness of this sudden shift to an intake of the new view, while a subsequent marker of temporal immediacy is established in the dangerous privacy of the metonymic as an urge to particularize among many random sights in any illustration. Hence, the particular visual detail corroborates the grammatical turn to a particularizing and particularized viewer.

Through orchestrated verbal directives, expatiations, and asides, Brown aspires to a role of regulation in the foregoing examples tantamount to William Craft's captioning of Ellen's frontispiece image. In one sense, the publicity that is always allied to the visual becomes a stage for more of Brown's enunciatory self-making. While his performance controls the image, to some degree, there remains in the visual that which cannot be accounted for in words alone. Out of the immediacy of visual apperception, a shared reality is produced, a coming into focus, as it were, of objects seemingly made present through representation for the audience during moments of collective witnessing. Of course, this collective context, if it was felt by spectators at all, is also partly an effect of Brown's rhetorical address. Nevertheless, it is in that spectral relation between viewer and view, always triangulated by the directive context of Brown's spoken or written description, where a fugitive vision manifests. There the abolitionist object supreme, a conjuncture of slave body and testimony, looks back from the scene of objecthood. There the object looks back, vitiating the autonomy of the gazers and, by degrees, suggesting an uncomfortable insularity, not simply in the self disconnected from others, but of the self, disconnected from the ideological and discursive expectation of abolitionist evidence, synthesized, as Dwight McBride incisively makes clear, in the conjoint production of slave body and testimony: "The slave is the material—the real, raw material—of abolitionist discourse. The slave is the referent, the point, the very body around which abolitionist discourse coheres and quite literally 'makes sense.'"[37] Drawing attention to pictorial slave bodies and borrowed and fictionalized testimony, Brown

draws but also diffuses attention to his own. It is through this alienation that Brown, in his practice, posits an alternative theory of looking relations to that espoused by Banvard. The result is a lesson in seeing with an ulterior pedagogy—to retard the subjective mobility of the gaze fostered elsewhere in American iconography and culture, in depictions of buildings, boats, and bodies. Far from conveying such lessons through image alone, however, Brown's *Views* intensify the alienations of the spectator in the intertext of words and image, a merger eventually exploded by the introduction of the iron collar.

Extant Illustration of Brown's Panorama

Discussing the rhetorical effects of the *Description* is, of course, only part of the story. The larger picture of Brown's panorama becomes visible in scrutinizing illustrated details that, unfortunately, no longer exist in their entirety. Nevertheless, a few of the views do survive and an examination of their interrelation with textual description further reveals the intricacies of Brown's engagement with and resistance to conventions, both of the panorama and of slave narrative.

The first existing illustration of the panorama from View the Twelfth is a popular set piece of antislavery iconography, the slavecatcher's hounds in vicious pursuit of the pitiable runaway. Taken from the illustrated edition of the *Narrative of William Wells Brown* (1849), Brown announces its significance to be based on its self-reflexivity: "the first scene in which the writer is represented in this Panorama" (19). An inclusion of the artwork's designer within the design, the depiction fittingly shows the fugitive captured by the very tree that affords him temporary safety (fig. 4.4).

Conventional principles of contrast structure the composition. The slave configures a statuary pose in comparison with the animated dogs and horse rider, positioned, in contrast, to accentuate their mobility. Yet the immobility of the slave does not have the same neutralizing effect as in the runaway slave advertisement where the wooden stance negates the presumption of flight. Here, the slave's placidity and kneeling profile recall Josiah Wedgwood's beatific slave (from the antislavery seal), except that this scene dramatically contextualizes such beseeching. The rigid calm of the slave depicted here connotes prayer. That he connotes the forces of light is suggested by the coloring of his clothes, mirroring the clouds in the sky and that central splash of light in the middle ground. Nevertheless, the forces of darkness have so trapped him as to make even prayer futile.

The slave's precarious seat of liberation on the extreme edge of the branch prefigures imminent collapse. The left curve of the gnarled trunk counterbalances and thus stabilizes the figure's position, but the totality of

The author caught by the bloodhounds. (See p. 21.)

Figure 4.4. From View the Twelfth of *Description* and *Narrative of William Wells Brown*, 1849. Manuscripts, Archives and Rare Books Division, Schomburg Center for Research in Black Culture, The New York Public Library, Astor, Lenox and Tilden Foundations.

the scene suggests the impossibility of escape and the totality of the slave's circumscription by captivating elements of the composition. Below him are the dogs, obvious tools for capturing historic slave bodies and, less obviously, iconic tools for captivating the readers and viewers of antebellum slave escape, linking the narrative of escape to contemporaneous traditions of frontier, picaresque, and romance adventure. Indeed, there must have been enough cultural interference attached to the scene of the slave-chasing dog that permitted it to be emblazoned on such domestic items as flatware and dinnerware.[38] But while the dogs are a central component of the subgenre of the slave-catching scene, these particular dogs are neither the focus nor the immediate cause of the slave's peril. Rather, the approaching slave-catcher on horseback fixes the slave's line of sight. Therefore, in spite of the caption, announcing the author to be "caught by the bloodhounds," and the foreground depiction of the animals stretching along the tree trunk excited to confiscate their prey, the dogs do not, in toto, encode the slave's terrifying capture. Ironically, those details of the composition most associated with the slave's reprieve delineate the certainty of his confinement.

The totality of the slave's subjugation configures even the display of the tree, the one design element that seems to promise freedom. The slave's perch, although affording him "a safe position in the tree but a few minutes" (*Description* 20), demonstrates restriction in the exaggerated upturn of its

terminal branches. Unnaturally twisted in this way the branches imply the vertical bars of a prison. Moreover, the circular inset of the image as a whole pinions the slave below its domed field of diegetic space; it is only within this circle of representation that the slave's imagistic story may unfold. Deepening the pathos, only the left side of the tree whereon the slave finds ephemeral safety breaks this diegetic boundary, jutting out toward the framing space of observation partly inhabited by the presumed viewer of the scene, whose exemption from the scene and the imminent apprehension it denotes contrasts with the slave's ineluctable position. As with many visuals geared to court the pity and purse of the sympathetic viewer, this one frames the subjugation of the slave with the unimpeachable freedom of the empowered viewer.

A related illustration that survives pictures the arrest of Brown and his mother, coming near the end of Brown's narrative just before his final escape to freedom in the nineteenth view of the panorama. The previous view shows the climactic escape of the heroic fugitives Leander and Matilda; the victorious and no doubt adventurous "representation of [them] on horseback, and of the men in pursuit" (32) follows Leander's triumphant thrusting aside of all impediments to their goal to flee American soil for Canada. In stark contrast then is the view of Brown and his mother, with its terrifying disregard for the domestic sanctity of the slave family as three slavecatchers and a dog surround fugitive mother and son. The emotional epicenter of the image (fig. 4.5) pinpoints Brown, whose posture of urgent retreat verifies the outrage of an ideal viewer.

A number of associations organize the scene's allegory of the denial of freedom with respect to issues of race and gender. The forlorn resignation of the mother and her slight stoop, blank look, and arms pinned as though heavy at her sides coincide with her position of enclosure within the central density of the image area. That she stands wearily beside the horses opposes the scene of Leander and Matilda's mounted escape, which, we can only assume, must have existed in a state of visual simultaneity with this one in the panorama's presentation. If Matilda's beloved femininity impelled Leander's brute overthrow of her oppressors, then the mother's passivity in this scene signals an actual failure of circumstances recorded here in "as close a representation of that scene as the writer could make it" (32). Significantly, this autobiographical scene implies a breach in the gender ideals satisfied in the earlier, presumably fictionalized scene of Leander's valiant defiance and Matilda's less explicit feminine "valor," constituted by a vulnerability that has been protected.

While the figure of the mother embodies an excess of mythic loss—of freedom, gender, perhaps even humanity—Brown's figure encodes the possibility for restitution. Her docility beside the horses acquires a bestial

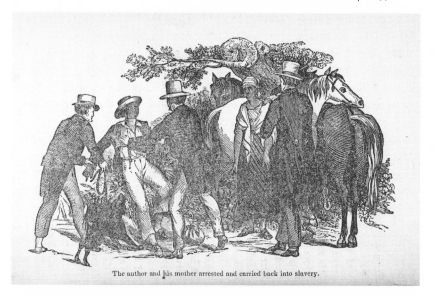

The author and his mother arrested and carried back into slavery.

Figure 4.5. "The author and his mother arrested and carried back into slavery," *Narrative*, p. 72. Manuscripts, Archives and Rare Books Division, Schomburg Center for Research in Black Culture, The New York Public Library, Astor, Lenox and Tilden Foundations.

quality, an altogether inhuman indifference to her own incapacitation. The mother and the three horses crowd around the base of a tree whose uppermost branches defy any semblance of upward ambition, curling strangely so as to present a nearly horizontal ceiling that encumbers the figures below. The light and dark contrasts of the composition associate the dark horse and the course display of its posterior with the three slavecatchers. They too only expose their backs to the viewers, while the slaves' bodies are given a lighter tint and positioned to face the viewer. This ascription of humanity, however, in the face of its profanation only heightens the tragic sentiment of the scene. According to a sentimental logic that privileges the expression of emotion, Brown's figure accrues sentimental authority.[39] He evinces a protest to this molestation of masculine rights to maternal protection so emphatically that he seems on the verge of falling down over its annulment at the hands of the slavecatchers. If the first extant image of Brown in the tree serves to index the instability of natural spaces of protection, which threaten collapse under the cumbrous weight of the slave's urgent need for untenable safety, then here it is again Brown whose collapsing figure references the impossibility of security on any natural ground within a post–Fugitive Slave Act America.

The third and final extant image from the panorama (fig. 4.6) repeats and subtly varies the thematic pattern of the slave family's thwarted efforts

to escape the political and domestic blight of slavery. In View the Fourteenth, the panorama provides an extensive citation of the narrative of Henry Bibb. Here Bibb escapes with wife and child to a "dark wilderness, many miles from any house or settlement," and they are soon attacked by "a gang of blood-thirsty wolves" (23). They draw so near that the terrified group is able "to see their glaring eyes and hear their chattering teeth" (24). Like the now lost image of Leander riding off with Matilda, this scene of Bibb with raised Bowie knife captures the heroism of black masculinity to protect his dependents in the face of overwhelming opposition and likely defeat. Unlike the former images, however, this one draws less on the theoretical libertarianism of American politics than on the visual iconography of American frontier folklore and adventure. Rather than bloodhounds, this scene foregrounds the natural predatory obstacle of the wolves. Instead of the proximity of the city and slavecatchers, those implied agents of civil protections afforded only to whites, this scene pictures the family beyond the pale of civilization. As Brown comments: "This description gives us some idea of what an American fugitive Slave has to endure in making his escape from Slavery" (24). Even as this struggle between archetypical man and beast overlays an anachronistic state of nature onto the plight of the slave family, the contemporary imagination had long associated America, including its developing urbanism, with the frontier. There, icons of savagery abound to contest the incursion of American males whose masculinity is, in part, constructed by virtue of such conflicts. As commentators of Bibb's narrative have observed, black masculinity usurps the exclusive position held by the patriarchal frontiersman and relocates the terms of the conflict with the wilderness as one of domestic survival and a search not for new lands of freedom but for any.[40]

One interesting effect of Brown's reference to Bibb is a grounding of the image, which may have had only a generic connection to the particularity of Bibb's narrative. Indeed, as Marcus Wood convincingly argues, many of the illustrations accompanying the narrative are taken from a general pool of stereotypes from which antislavery writers and editors selected visual representations. This plate of the wolves, for example, crudely reworks an anonymous scene typical to abolitionist literature of a slave family running from slave-catching dogs, so that, according to Wood, "the plate does not show Bibb and Malinda at all but some generic approximation of a scene of runaway apprehension."[41] However, for our purposes, where and how Bibb's publication illustrates its text is less important than Brown's editorializing of the image for his panorama. A glaring omission appears in Brown's selective references to Bibb's description of the scene with the wolves. The panorama description quotes Bibb in two parts: the first ends with the danger-

Figure 4.6. From *The Life and Adventures of Henry Bibb*, 1849, p. 125. Manuscripts, Archives and Rare Books Division, Schomburg Center for Research in Black Culture, The New York Public Library, Astor, Lenox and Tilden Foundations.

ous nearness of the wolves; after five asterisks, the second part explains how Bibb must resort to a Bowie knife for his family's defense. In this repackaging, Bibb speaks directly as the figure in an image, which may otherwise generically represent "runaway apprehension," as Wood asserts. Taken by themselves, the haphazard and crude etchings that escort slave narrative texts weakly conjoin verbal and visual referents. Yet, as Brown's panorama shows, *intertextual* practices of cross-referencing often made it so that the narratives rarely were taken by themselves. The correspondence between Bibb the speaker of the prose and the illustrated bearer of the knife results from Brown's excision of passages in Bibb's narrative, which postpones the heroism of the scene and qualifies its projected masculinity by way of an expansive contemplation on the existence of God.

At the moment of encounter, the wolves and the family they threaten give way in the mind of the protagonist to phenomenological brooding. Departing from the masculine hero type that Brown eventually makes of him in the panorama, the Bibb of the narrative seems more akin to the figure Brown strikes when prostrated before the slavers who recapture him and his mother. The omitted voice of Bibb's narrative wallows defenselessly: "My little family were looking up to me for protection, but I could afford them none."[42] Bibb, more than other male slave narrators, discusses the slave's domestic bonds as a liability that hampers his recourse to masculine self-disentanglement, not just from slavery, but also from its ancillary attachments.

To examine what makes these passages anathema to Brown's purpose in the panorama requires a consideration of their rhetorical and thematic difference from the pattern of slave family scenes established by Brown.[43]

Far more than venting doubt, Bibb recounts in these omitted passages the trial of separating cognition from imagination and memory during a moment of crisis. In an anaphoric eruption of the initial phrase "I thought" counterbalanced by the refrain "of his," Bibb takes incremental stock of the religious hypocrisy of a deacon sympathetic to slavery, while listing the material and symbolic possessions of slaveholding authority:

> I thought of Deacon Whitfield; I thought of his profession, and doubted his piety. I thought of his hand-cuffs, of his whips, of his chains, of his stocks, of his thumb screws, of his slave driver and overseer, and of his religion; I also thought of his opposition to prayer meetings, and of his five hundred lashes promised me for attending a prayer meeting. I thought of God, I thought of the devil, I thought of hell; and I thought of heaven and wondered whether I should ever see the Deacon there.[44]

Repetition of the phrase "of his" entwines Bibb's cognitive descent into an exploded moment of terror with an inventory of the owner's possessions, those sanctions and accoutrements of slavery that render an act of prayer on the threshold of doom unavailable to him. Literally, Bibb represents himself in the scene just prior to its depiction in the act of remembering such possessions of mastery instead of attempting to embody mastery himself. Crippling thoughts of the master's possessions including the very God he would pray to are thus shown to constitute the slave's consciousness. In this way, Bibb's narration of the scene foregrounds slavery as a total conditioning of his own experience of masculinity, structuring the limits of his apprehension of life, death, and any glimmer of realms beyond them while mediating his sense of having any masculine provenance that he could mobilize.

By omitting this existential hesitancy, Brown reconstitutes Bibb as the iconic embodiment of the heroic runaway and closes the gap between what Bibb at first seems incapable of doing and what he eventually does in a state where consciousness, memory, and imagination implode. While the reader of Bibb's narrative is led to believe that this rhetorical effect of stream of consciousness is meant to realize his disorienting horror, Bibb follows the passage with self-reflexive exposition that undercuts this presumed exaggeration for the purpose of verisimilitude, attributing it instead to an authorial fascination that conflates memory and imagination:

> The reader may perhaps think me tedious on this topic, but indeed it is one of so much interest to me, that I find myself entirely unable to describe what my own feelings were at that time. I was so much excited by the fierce howling of

the savage wolves, and the frightful screams of my little family, that I thought of the future; I thought of the past; I thought the time of my departure had come at last.[45]

The cause of tedium that Bibb apologizes for is confused, split between or confounded by two viable temporalities. There are the emotions of "that time" of the wolves' "fierce howling" that are difficult to describe but in straining to overcome this difficulty have resulted in the tedious but accurate onrush of questioning. In this other temporality of writing, Bibb struggles, despite tedious attempts, to describe the feelings "at that time." His interest in the latter instance springs from a failed effort of imagination and language to account for the memory of excited emotions; the tedious eruption of existential doubt is an admittedly inaccurate reflection of the time but manifests a concomitant fidelity to his feelings regarding authorship as a stylized negotiation with the irretrievable.

It is precisely this authentication of the unnarratable event that Brown suppresses in his citation of Bibb. Brown redeems and simplifies the subject position accorded to black masculinity in Bibb's narration, so that the taking of the knife and defense of the domestic becomes an automatic and available response. The remediated Bibb in Brown's citation presents a more culturally legible countertype to racist representations of the slave's emasculation. Brown's Bibb creates a more comfortable fit for the event, description, and image to hang together. In Bibb's narrative, the traumatic moment gets emblazoned elsewhere in culture as a snapshot of the slave's embattled resumption of agency, which makes the slave's automatic embracement of agency difficult not just to see or say, but also to remember or imagine as well.

Materiality, Collar, and Collapse

Visually mapping slavery not as a sequence but as an eruption of embodied execrations to the nation's aspirations of democracy, Brown's panorama responds to and disrupts the famed Mississippi panoramas and their subtle restitution of the slaveholding South as the veritable seat of antebellum civilization. More than the sequential logic of either verbal narrative or that of the moving panorama, the simultaneity made possible by the arrangement of Brown's views, always contiguously present alongside one another, provides new relationships between and among familiar tableaux of slavery prominently showcased for the popular imagination in abolitionist cultural production. In the *Original Panoramic Views,* successful vehicles bear fugitive couples to freedom even as neighboring journeys of fugitive families stall out before impasses; hollers of victory combine with the fierce

howling of slave-catching dogs; here black masculinity valiantly seizes arms to withstand oppression, and there it yields in meek surrender. As an alternative to the linear format that reduces slavery to events plotted over time, the panoramic exchanges the binaric (either–or, this–then that) model of representation for one that privileges inclusiveness and totality. Utilizing this mode, Brown's panorama creates a portrait whose variety and contrast refute Banvard's one-dimensional view of the nation as no more than a pastoral collection of the genera and species of "sights" only vaguely haunted by the bodies, histories, and politics vital to Brown.

Yet, perhaps because of Brown's special gift for spectacle, the panoramic mode is left neither intact nor consistent. For even if the views allow for promiscuous observation, the oration reflected in the exhibition pamphlet often strictly directs the audience, guiding them as auditors, regardless of their viewing penchants, through elaborate narratives that only minutely, in some cases, acquire depictive consonance with the views they adjoin. Viewers must stand before a scene listening and waiting before coming to understand how the lengthy story fits with the view. During these moments of ekphrastic disjuncture, as Brown procrastinates in attaching narrative to image, the exhibit works to subvert further the monological narration practiced in the more popular views his panorama meant to challenge and correct. In Egan and Banvard's panoramas, the description rarely digresses to narration, as though the image accompanies a larger story that exceeds the frame of the depicted subject, but in Brown's panorama, the reverse is the norm, as narrated events so exceed their relation to the illustrated scenes as to compete for artifactual centrality.

A startling example of this tension between illustration and narration comes near the end of the view that precedes Bibb's citation. Here, neither story nor scene sufficiently references the trials of slavery, which materialize in a physical set of shackles for panorama goers to inspect. View the Thirteenth piques abolitionist sympathy and viewer identification by recounting the deceitful practice of tanning a white boy and thereby artificially imparting the warrant of dark skin onto a body compelled, as a result, to enslavement. Adopting the anecdote from George Bourne's *Pictures of Slavery,* Brown informs viewers of the socially constructed dehumanization consequent to racial essentialism and the system of slavery, leaving the boy now grown to maturity racially unrecognizable: "He was a genuine nondescript; neither of the white, Indian, or African species of man" (22). Like the Salome Miller story Brown reports in *Clotel*—of the little German girl who is enlisted into slavery through the depiction of slavers—the boy is later rescued by whites who had known him earlier. Yet this tale, cited at length in the beginning of the description, provides merely an anecdotal backdrop for the view, which shows "two men in the act of tanning a white boy [. . .

and a] Slave in the foreground of the view, at work with a spade in hand, [who] is much abused and is addicted to running away; and, to prevent this, an iron collar has been put upon him" (22–23).

A familiar reference in abolitionist literature, the iron collar (fig. 4.7), was commonly used to curb slave escape, mark particular slaves as flight risks, and identify slaves after escape. To prove the frequent practice of affixing this three-horned implement onto slaves, Theodore Dwight Weld in *American Slavery as It Is* (1839) provides several runaway slave advertisements attesting to the abundance of the collar's use as well as slave testimonials and reported incidences involving the collar. One in particular recalls the circumstances of Brown's melodramatic iron collar:

> There was lately found, in the hold of a vessel engaged in the southern trade, by a person who was clearing it out, an iron collar, with three horns projecting from it. It seems that a young female slave, on whose slender neck was riveted this fiendish instrument of torture, ran away from her tyrant, and begged the captain to bring her off with him. This the captain refused to do; but unriveted the collar from her neck, and threw it away in the hold of the vessel. The collar is now at the anti-slavery office, Providence. To the truth of these facts Mr. WILLIAM H. REED, a gentleman of the highest moral character, is ready to vouch.[46]

In Brown's panorama the collar occurs in a view entitled "Tanning of a White Boy." Although it begins by corroborating a cited textual authority ("The writer was personally acquainted with a white boy in St. Louis, Missouri who was taken to New Orleans and sold into slavery"), the description meanders away from its titular object of focus and purported illustrative intent to enlarge upon the distress of an indisputably black slave. Unfit for romantic rescue, this figure wears a collar that both tragically marks and ensures his thwarted agency. Yet the tragedy of this slave is not a part of the earlier historical record, or the citation, or even the eyewitness testimony; he is rather an imaginary (imaged) figure who gains the semblance of humanity through a spiraling process of association, from tanning, to spade, to collar. From here, the scene invests the collar with the iconic function to yoke together an unruly entanglement of fiction, image, historic events, and cited anecdotes, as it moves to focus on background figures, "a woman and a girl chained together" (23).

Repeating the motif of successful escape for the slave couple, the narration explains how the woman was stowed away on a steamer by a long lost fiancé, a "free coloured young man" (23) who was also the steward. They travel to Cincinnati, then Canada and freedom. The final sentence of the description reads: "The collar worn by this woman at the time of her escape, was given to the writer in the summer of 1843, and can be seen at the close of each exhibition of the Panorama" (23). The collar thus completes a cir-

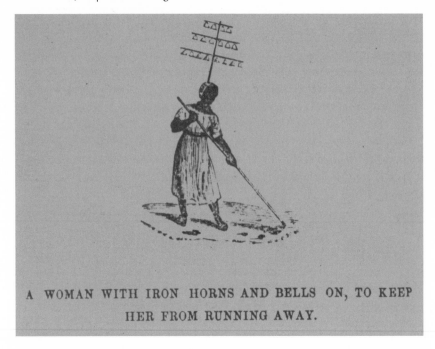

A WOMAN WITH IRON HORNS AND BELLS ON, TO KEEP
HER FROM RUNNING AWAY.

Figure 4.7. Collar with Bells. Photographs and Prints Division, Schomburg Center
for Research in Black Culture, The New York Public Library, Astor, Lenox and Tilden
Foundations.

cuit of transference—from tanned white boy, to collared slave, to chained
woman, to freedom—and now to the viewer, invited to scrutinize the mate-
rial object. Brown's report that he actually has the collar in his possession
also functions as incentive midway through the exhibition for viewers to
complete the spectacle with a sense of anticipation. A need is created by his
promise to see the real collar, carved out by an implicit suggestion of the
incompleteness of the scene and its associated words; the collar satisfies this
generated desire to hypostasize slavery through metonymy as it heightens
panoramic effects of immediacy and imminence. Like the collar, the slave
body dimly reflected in the views carries a potent charge, if not of objectiv-
ity, than of object-ness, a thing that attests to events represented, whether as
fact or fiction, pictures or words.

What remains curious, however, is the manner by which the collar gains
this power in the conjunction of the described picture and the narrated
events bridging history and fiction. No mention is made of the final woman
as wearing the iron collar in the description until the last sentence. She is
said to be chained to another girl, at first, and this may be a depiction of the
two linked via the collar, but in the description of her work and stow-away,

we get no more reference of her having the collar "at the time of her escape." And while the significance of the actual collar is linked to this woman who wore it, she is merely a background figure in the image, where the black man's middle-ground collar would surely be more pronounced, as is the description's unambiguous ascription of a causal, physical relation to him and "the iron collar [which] has been put upon him" (23).

Interestingly, close attention to the display and description of the iron collar (fig. 4.8) can tell us a great deal about the status of visuality at this historical moment. The collar is an object intended to be consumed—no longer merely for its image-value, but for narrative inclusivity, a supermechanism of intertextuality that produces a physical space in which the consumer of abolitionist spectacle enters into the diegetic realm of the narrative. What more effective instrument than the collar to conscript viewers into a circuit of transference that relays the unbridled remainder, the uncontainable excess of the spectacle to the terminus of the spectator? In the process there appears another kind of simultaneity, one that interlinks in metadiscursive and diachronic relation the disparate elements of the exhibition, including its contents, constructs, contexts, and now also its conscripts.

Drawing the viewer in as another text of the panoramic "assemblage," the collar also raises questions about the spectator as subject.[47] Is there an implied transformation of the social order in Brown's panorama that moves beyond those typically associated with the panorama, such as its exhibitionary complex? What social formations are enabled as a result of the combination of panoramic technologies of representation and the supplementary, anomalous space of material inspection produced by the iron collar? One way of answering these questions is to trace the impact of the panorama as a technology of identity formation, and Brown's divergence from its conventional operation. Jonathan Crary delimits the nineteenth-century's restructuring of the bourgeois subject as proceeding from the invention of photography. Crary explains the origin of the camera as an extension of the painter's camera obscura. In this way, Crary persuasively argues, panoramic images, like daguerreotypy, justified Enlightenment-based ways of seeing, reinforcing visual codes elaborated in classical painting, such as monocular vision and perspectives asserting a unified, singular point of view, later invalidated by cinema.[48] The perpetuation of these codes in a nineteenth century overrun with commodified images creates a new kind of viewing subject, Crary's "observer-consumer," whose sense of the world remains undisturbed despite its increasing representation as simulacra.

Brown's intervention in the panorama helps us to bring even finer distinctions to Crary's model of spectatorship. We might say that a monocular experience structures the presumed viewer's encounter both within the views of the panorama and without—in the presentation of the iron collar.

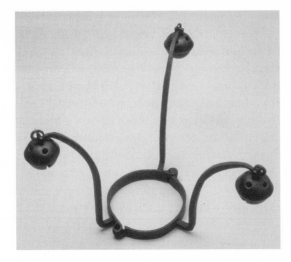

Figure 4.8. Slave Collar, "with three tall extensions with hanging brass sleigh bells. Made to be worn by an unruly slave, ca. 1830–1860." Courtesy of Louisiana State Museum.

It would not be difficult to imagine how viewers crowding around the object, or even touching it, could in doing so augment their sense of a world arranged to enfold their continuous, singular perception of it. Nor is it difficult to read the exhibit's material production of the collar as a commercial strategy designed to ground tensions already produced by the exhibit's combination of verbal and visual mediation in the cold, hard reality of an object of enslavement. The links between masochistic voyeurism and antislavery sensationalism converge around the collar. Even as it makes real those horrifying practices of bondage illustrated in the panorama, its dramatic presentation threatens to replace political awareness with prurient awe. The collar rewards viewers not for moral reorientation or for awakened commitments to social justice but, tautologically, for being viewers, for having bought and consumed a spectacle of slavery that now culminates by reinforcing the most fundamental assumption of the panoramic: the illusory sensory equivalence of vision and touch.

Yet this supposedly artifactual object vacates the particular bodies it no longer *apprehends*—in all senses of the word. The collar becomes the material residue of an incomplete performance, a nominal ending but not an end. As a material signifier, it effects a tactile presence of so powerful an icon of slavery that one may say its production at the end of an exhibit built on illusion and resemblance becomes a form of over-presence. Yet, taken alone, this presence finally signifies an overwhelming absence, for the collar manifests the invisibility of the black body whose presence it symbolically conjures but physically eradicates. I repeat Dwight McBride on the import the presence of the slave body has to the rhetorical coherence of abolitionism: "The slave is the material—the real, raw material—of abolitionist dis-

course. The slave is the referent, the point, the very body around which abolitionist discourse coheres and quite literally 'makes sense.'"[49] Refusing to produce this body threatens the collapse of abolitionist narrative, refusing to substantiate the desire for the material body. Even its form indicates lacuna more than substance. The collar's contrary operations of invocation and erasure, constitution and evacuation, recall the Mississippi panorama's memorial gestures of marking out the terrain of marginal identity while covering over the historical specificity of the reference by sentimentalizing and sensationalizing landscape. Correspondingly, at the same time that the collar signals the absence of the enslaved black body, it also registers the salient absence of the exhibit to ground its meaning.

As an information technology, the panorama bridges perceptual and experiential modes of knowledge dissemination. Brown intervenes in this process, separating but also heightening his viewer's sense of experiential contact with the representation. He seems to be opening up panoramic representation to strategies of disruption and defamiliarization used to speak back to Hiram Powers. While the collar seems to be outside of the visual and aural registers of the exhibition, it is introduced as part of the work, thus procedures of panoramic consumption may yet reduce its materiality, making it an object produced primarily for visual consumption. We might then ask whether this triumph of the ocular brings with it an endorsement of racializing logics of empiricism that the panorama attempts to discredit.

By inviting aestheticization and inspection, the collar is drained of any threat to the hegemonic social condition in which it is exhibited. Contrary to depictions of the passive slave, the collar visually concludes the exhibition in a way that forecloses white placation and paternalism. Though Brown allows his British audience to preserve for themselves a self-conception of moral superiority during the exhibition, the collar at the end suggests the lasting, unchanging status of domination without direct reference either to dominated or dominator. Its message, lifted out of narrative causality and connection, seems aimed precisely at those who witness domination, implicating them in its continued operation. Thus, the collar collapses the traditional paradigm of oppressed and oppressor, powerfully condensing the factuality of oppression.

At the end of the exhibit, the collar (or, shackle) recalls the one that begins it, at least in the *Description,* with the epigram—"They touch our country, and their shackles fall." Flattery thus resolves itself in obligation. Britain is the space not of the slave, who is immediately free upon arrival, but of the fallen shackle, which metaphorically studs the shores of the nation marking the entry of American slaves in memory of a fallen state surpassed. Yet, it remains a material legacy of early British involvement in the triangular trade as well as a reminder of the need for British society to replace the collar

with material forms of support for current slaves—stripped of their obdurate trappings as slaves and now in need of new social accoutrements. More significantly, the collar—fallen from ex-slaves and metaphorically dropped into the hands of British citizens—represents a transferal of property and of obligation. It is no longer the slave's yoke to wear, but the Briton's. Through its expulsion of the slave body, the lone collar binds North American slavery to Victorian viewers, in the process fusing market cultures of spectatorship with implied rhetorics of Christian charity and national superiority.

Removing the slave body from possible objectification, Brown obviates the pitfalls of even sympathetic representations of the slave that shield the bondsman from conventional gazes of compassion or entertainment, but yield him up to a gaze of abjection. The gaze Brown's final tactic courts must imaginatively produce the neck and body to fit the dreaded instrument. If the model of history espoused by the expansionist Mississippi panoramas is progressive, then that of the *Original Panoramic Views* is a revisionist form of cyclical history brought to life through an experience of ironic simultaneity. The developmental narrative of freedom's attainability beyond American borders uneasily coexists beside its alternative in the perpetuation of bondage for which the iron collar becomes an emblem. Ultimately, its presence forecloses the possibility for a personal identification with American national history on the part of Brown, the now liberated because expatriated ex-slave, and consequently invalidates that redemptive vision of history permeating Romantic antebellum literature.

Amidst growing public trust in race science, Brown combated white supremacist associations of degradation and blackness by highlighting the social conditions that erroneously confer upon those who are slaves the semblance of being essentially suited to slavery. In Brown's re-circuitry of the affective charge of slavery, revulsion is wired to the instruments of domination, as opposed to the visible difference of the dominated. To Brown, the chain and the collar, rather than black skin, are the proper emblems of the degradation that enslavement brings about.

Coda

The prescience of Brown's retooling of the technology of the panorama may find evidence in Harriet Beecher Stowe's *Uncle Tom's Cabin*, which presumes a readerly gaze analogous to that of the experienced tourist or panorama enthusiast:

> The traveler in the south must often have remarked that peculiar air of refinement, that softness of voice and manner, which seems in many cases to be a particular gift to the quadroon and mulatto women. These natural graces in the

quadroon are often united with beauty of the most dazzling kind, and in almost every case with a personal appearance prepossessing and agreeable.[50]

An apolitical fantasy structures such scenes prepared for the tourists' gaze, extracting the physical land from the material history and conflicts that make its viewing available for mass consumption. Of course, this fantasy also harbors an expansionist agenda that is still explicit in its panoramic, seemingly boundless or frameless presentation. Throughout *Uncle Tom's Cabin,* Stowe invokes this type of looking, but revamps it by adding an ugly frame around pretty pictures and thus maintaining a lightly caustic narratorial tone whenever discussing the events pictured in the text from the point of view of the Northern tourist. For example, when visiting Southern estates, Stowe's narrator laments that the novitiate viewer

> might be tempted to dream the oft-fabled poetic legend of a patriarchal institution, and all that; but over and above the scene there broods a portentous shadow—the shadow of *law.* So long as the law considers all these human beings, with beating hearts and living affections, only as so many *things* belonging to a master,—so long as the failure, or misfortune, or imprudence, or death of the kindest owner, may cause them any day to exchange a life of kind protection and indulgence for one of hopeless misery and toil,—so long it is impossible to make anything beautiful or desirable in the best regulated administration of slavery.[51]

Even the form of the passage rhetorically invokes the motif of expansiveness so often associated with the panoramic imagination upon which such romantic, history-less perspectives are partly based, but the ugly frame of the law inserted here cuts up the scene's pretty abstractions, grounding the otherwise groundless landscape of pretty things in the shamefully dehumanizing politics that sustain it. Stowe's ironic play with the word "things" also makes the process of slave-market capitalism complicit with Northern practices of tourism and corresponding acts of panorama-going that Brown redirects through engineered moments of stasis and through the interposition of the iron collar. Stowe's insinuation that the view produced by the Northern tourist or reader cannot be trusted to reflect the whole picture, disciplined as it has been by the depoliticizing mechanics of the panoramic imagination, echoes Brown's machinic revisions of the panorama and anticipates Harriet Jacobs's critique of visuality. Jacobs's too is preoccupied with the productive absences of the visual field, particularly its occluded frames of socio-juridical and material relations, which Stowe's narrator, like so many slave narrators, whose voices and experiences are bowdlerized to create that persona, is only too happy to impose.

5

The Mulatta in the Camera: Harriet Jacobs's Historicist Gazing and Dion Boucicault's Mulatta Obscura

> [P]art of the power of some writing by black women is its transformative poten-
> tial [to] replace the dominant discourse's obsession with the visual black body
> with a perspective that privileges touch and other senses. They are engaged in a
> project of re-imagining the black female body—a project done in the service of
> those readers who have inherited the older legacy of the black body as despised,
> diseased, and ugly.
>
> FARAH JASMINE GRIFFIN, "TEXTUAL HEALING"

For Linda Brent, narrator of Harriet Jacobs's *Incidents in the Life of a Slave Girl* (1861), the "project of re-imagining" entails a battle for survival waged in terms of spectatorship.[1] Hidden in her garret Brent becomes an unseen observer of her treacherous master Dr. Flint and writes letters postmarked from the North to make him think she has escaped.[2] As with the other narratives explored in this study, *Incidents* focuses upon the slave's manipulation of verbal and visual texts in order to occupy a hybrid position disruptive of the binary of slavery and freedom. A protean subject of surveillance, Brent postpones the status of slave within the darkened space of a garret by becoming a seeing subject. The garret that Jacobs conveys through metaphors of the camera obscura affords invisibility from plantation systems of optic domination via a one-inch diameter peephole.[3] Like Ellen Driscoll's installation, *The Loophole of Retreat* (fig. 5.1), I want to explore Jacobs's twinned thematics of visuality and embodiment, how domination through and retreat from visibility map onto the historic entrapment of the raced and gendered body, and how liberatory possibilities for self-representation result from appropriative re-domestications of technologies of seeing.

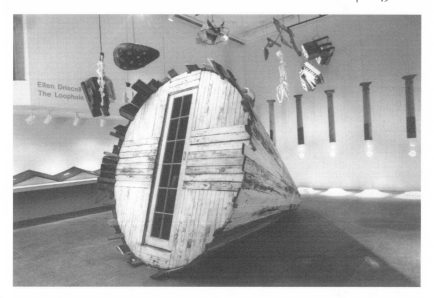

Figure 5.1. The Loophole of Retreat (1991–1992). Wooden cone, 12 mixed media objects on motor, 7 columns with shadow pictures 13' L × 8' diameter. Courtesy of the artist.

Congruent to this inscription of the mulatta as a function of the technology of the camera is Dion Boucicault's five-act drama, *The Octoroon; or, Life in Louisiana,* first performed in 1859. Along with its melodramatic transformation of Zoe, the octoroon, into salable property, the play positions race in significant relation to a technologically fortified system of surveillance. A daguerreotype conveniently delivers the optic proof necessary to unravel the central plot twists and restore plantation order. After M'Closky, a scheming overseer, slays a clever young slave named Paul, who poses unaware in front of another overseer's camera, social equilibrium follows a lynch mob's discovery of the incriminating plate. Parallels to this subplot of sudden discovery come in the auctioning of Zoe, hitherto presumed to be white by George, an uninitiated white suitor. The camera obscura acts as a preservative of white justice, reflecting truth in a nebulous social order overcome with disingenuous appearances. In the play, the reflective properties of the daguerreotype and the auction block sustain hegemonic truths in the face of parallel subterfuges, avaricious murder, and miscegenation, whereas in *Incidents,* the camera's stabilizing properties are only activated once the mulatta occupies its interior.

My argument builds on Barbara Rodriguez's perceptive analysis, which sees Driscoll's solicitation of participant-viewers to hide within the *Loophole* installation as a complement to Jacobs's textual gestures of self-concealment.[4] However, I want to trace a different historical complementarity

here of the mulatta and the camera. This pairing of topos and techne in such texts as the American version of *The Octoroon* and *Incidents* sutures contrary antebellum reading pleasures.[5] As I will show, narratives of miscegenation, progress, and technological surveillance cohere according to a racialized logic of reflection that slave narratives presumably verify even today. Fundamental to Driscoll's inspiring sculpture and the affect it induces is, at the very least, a conflict of desire and knowledge. That the desire to know risks affirming the desire to possess becomes an organizing principle of Driscoll's *Loophole*. Nearby arrangements of Jacobs's text (cover pages stretched in an accordion shape, blanketed over with felt, and with apertures cut into them showing tiny maps of the North Carolina plantation where Jacobs lived) tantalize viewers with the implication that the historic verities of pained slave experience are already mediated. They are repossessed, as it were, according to properties of exchangeability inherent to slave objectification.

The presence of the daguerreotype and the vicissitudes of its relation to the mulatta form the basis of my inquiry here. This chapter investigates Jacobs's characterization of the garret as a third space of representation, a material one that mirrors and revises the position of the conventional reader as well as reigning antebellum notions of vision, then under reconstruction in light of technological advancements in daguerreotypy. And, as we shall see, the space actualized in the garret is never simply a condition of being nor an abstraction, but a place of representation operating according to a particular and indeed peculiar mechanics. Like the discursive space that intersects the camera and the mulatta in Boucicault's play, it records a crisis of relations exacerbated by technologies of hidden surveillance. What Foucault says of the panopticon—that it renders power automatic and decentralized—easily extends to the functioning of the camera but applies to the mulatta only through potentializing analogy, whereby we begin to discern the inter-implication of vision and race with systems of law, love, and liberty.

Labors of Love: Historical Vision versus Sentimental Gazing

Incidents subverts the reader's affective recourse to a particular kind of sentimental reading, which overlooks material history, by denying the possibility of fellow-feeling between narrator and reader. More than simple assertions of counteridentification, however, Jacobs facilitates during such authorial interventions a process that Judith Butler terms "disidentification": "the experiences of misrecognition, this uneasy sense of standing under a sign to which one does and does not belong."[6] Rather than conceptualiz-

ing Jacobs as proponent of or opponent to the dominant ideologies of "true womanhood" ascribed to her readers, an emphasis on disidentification enables a critical sensitivity to the complicated ways in which Jacobs and her narrator highlight simultaneous relations of similarity and difference between the slave woman and her genteel reader. According to Butler, disidentification may be construed as a propitiatory narrational strategy because it proposes "a site of disarticulations" that breaks subjects free from oppressive social mechanisms demanding a repetition or miming of conventional codes of identification.[7] For Jacobs, several expressions of disidentification deal specifically with sentimental looking practices. For example, in a passage typical of the narrative's overall preoccupation with spectatorship, Jacobs courts but then checks her readers' reflexes of pleasure, suffusing a sight of loving connection between master and slave with bleak reminders of historical caste and economic exploitation:

> I once saw two beautiful children playing together. One was a fair white child; the other was her slave, and also her sister. When I saw them embracing each other, and heard their joyous laughter, I turned sadly away from the lovely sight. I foresaw the inevitable blight that would fall on the little slave's heart. I knew how soon her laughter would be changed to sighs.[8]

Beneath the superficial harmony of the girls' interaction, Brent glimpses an ensuing rift created by their asymmetrical relations to racial hierarchy. Hazel Carby astutely describes the materialist proclivities of Brent's narration, which "repeatedly emphasizes the overwhelming determination of material differences in structuring the lives of women, regardless of either biological relation or emotional attachment."[9] Less clear in Carby's account, however, is the way in which these motifs of material difference are structured according to metaphors of vision and manifest in scenes of looking. After all, as Boucicault's play makes clear, material differences are often belied by appearances, particularly when optic assessments are steeped in appearances culturally coded to trigger romantic affect.

The play is brilliantly consistent in dramatizing this perverse coupling of labor and love, of economic with romantic desire—anxieties over which the mulatta had come to signify in a burgeoning literature of the period. Such couplings are suggested to be the cause of the plantation's turmoil; the judge's love of his slave preceding Zoe's birth is like the judge's fancy for Scudder, a photographer-overseer whose equipment proves useless; likewise there is the widowed mistress's futile love for her slaves as surrogate children who can make old age a comfort; all of which is similar to the other unworkable types of love running throughout the play: the partnership of slave and Indian in Paul and Whanotee (also miscegenative whether viewed

erotically as a type of marriage or as a filial relationship), or the masochistic metaphor Scudder uses to convey Zoe's beauty ("If she ain't worth her weight in sunshine you may take one of my fingers off").

But although desire can err by embroiling itself within the field of economy, the camera is a purist device, decoupling the appearance of things from the idea of them, as in the actual contour of a nose from its owner's more favorable consciousness of it. As Scudder boasts, "The apparatus can't mistake" (ii. 14), no matter how disagreeable the truth is that it renders. In contrast to the opening scene of Act II, in which Scudder sets up the camera and takes a shot of Dora (a belle with designs on George) with his self-developing liquid, a subsequent scene involves Zoe working as Dora's agent to solicit George's love, while George, still being misunderstood by Zoe, confesses that he can "think of nothing but the image that remains face to face with [him]; so beautiful, so simple, so confiding" (15). Captured during these scenes of obfuscated and interrupted confession and deceptions both conscious and unwitting is a lesson on the arbitrariness of truth, its various bases steeped in contingencies.

At the end of this scene, George offers to Zoe perhaps the most exaggerated example of the commingling of love and labor repudiated by Jacobs: "the wealth I covet is the love of those around me—eyes that are rich in fond looks, lips that breathe endearing words; the only estate I value is the heart of one true woman, and the slaves I'd have are her thoughts" (ii. 15). These lines register the fatal inability of the Southern imaginary to independently conceptualize desire, labor, and the plantation space. The image of Zoe that George both sees and invents mitigates her material situation as a component of the property that his speech perilously metaphorizes as a negative standard of love's greater value. Of course, such pronounced subordinations of property and social valuations to romantic idealism are essential to melodrama, which tautologically proposes a countercapitalist mode of vision only insofar as that vision absorbs rather than debunks systems of property and accumulation into sentimental rhetorics still freighted by those same systems.

Through a preoccupation with looking relations, Jacobs critiques simple sentimentalisms that eliminate race and class. For the purposes of my argument, sentimentalism may be heuristically defined as a mode of literary discourse whose authority lies in evoking and transforming both the body's sensations as well as the political meanings attached to them, thereby identifying the body as a site of affective and political struggle.[10] According to Bruce Burgett, codes of literary sentimentalism pose an "intersubjective understanding of self-other relations [which] locates personal and political life as neither opposed along lines of private and public, nor identical to one

another."[11] Yet Jacobs draws on this organizing gesture of sentimentalism as explained by Burgett—its partial fusion of the personal and the political—to indict an implicit racial divide separating black subjects from white readers. Rather than repudiate sentimentalism's mystification of the political and the affective, Jacobs highlights the fantasy of such material elisions demonstrated by Boucicault's George. In diverting the sentimental gaze from effacing social differences between pictured subjects, Jacobs redefines the way bodies come to have meaning in pictorial contexts and how they are constructed for public consumption. In this way, *Incidents* precludes a central effect of racist gazing—"abstraction of the body from its social environment."[12] Throughout this chapter, therefore, whenever discussing the particular form of sentimentalism denounced by Jacobs, I am neither referring to sentimentalism as a tradition nor as the discursive strategy commonly described by scholars of the genre, which seeks through affect the politicization of the body.[13] Rather, I use the term to describe what for Jacobs seems to encompass a strain of ahistorical false consciousness that depoliticizes bodies and imbues both proslavery and abolitionist ways of seeing slaves as centerpieces of affect—whether of suffering or of interracial harmony.

In her critique, Jacobs implicates everyday acts of looking as ideological. Instead of focusing on the immediate affections of the interracial playmates, Jacobs exercises a mode of seeing that synthesizes temporalities, bringing a discordant future to bear down upon the accords of the present. This sort of foresight is very much embedded in history, insofar as "history" denotes a record of material relations.[14] Applying historical vision to the scene becomes the antidote for the amnesia that sentimental pictures induce. However, it is with effort that the narrator disregards the affective force of the scene, particularly its mystification of social relations, melting them away in the heartwarming spectacle of interracial affection. The most effective means of demystification for Jacobs involves framing the scenes she observes with temporal simultaneity. From this critical vantage, the present joy of the interracial girls cannot account for their different relation to material history, nor can it obliterate the outcome of that difference. Nevertheless, the pull of affective sight is so strong that even the knowing observer denies its enthralling poignancy with difficulty. In turning "sadly away," Jacobs acknowledges the seductive power of pictures, that dangerous allure of seeing the girls' interaction detached from history. Yet simply restoring an occluded history does not always disable a picture's ahistorical effects.

It is in the narrative's treatment of the slave mistress that true womanhood, as a universal category available to women of the leisured classes, dissolves as a source from which principled historical vision may spring:

> Mrs. Flint, like many southern women, was totally deficient in energy. She had
> not strength to superintend her household affairs; but her nerves were so strong,
> that she could sit in her easy chair and see a woman whipped, till the blood
> trickled from every stroke of the lash. (10)

Instead of posing the mistress descriptively as an object of the reader's optical scrutiny, Jacobs's method of characterization concentrates on the mistress's visual practices: the dissonance between what the mistress sees unfeelingly and what she fails to see.[15] Although the mistress cannot oversee her household, she plays overseer to slave punishment. Two spaces of domesticity are thus counterpoised in this ironic commentary on the mistress's "nerve." On one level, there is the place of the house, which requires all of those facets of micromanagement that the languid mistress fails to satisfy—overseeing the cooking, cleaning, and maintenance of the main plantation house. On another level, there is the plantation, or more aptly, the extended plantation system. In this broader domestic space of authority, Jacobs asserts that the mistress satisfies her role entirely by dint of surveillance, presiding over the agony of slaves with merciless nonchalance. Powerlessness in the former kind of domestic space, Jacobs implies, does not entail powerlessness in the latter. Forasmuch as the mistress has nerve to oversee the oppression of her slaves and thus play manager of public authority, she lacks the nerve to manage the immediate, private demands of domesticity. Throughout *Incidents,* Jacobs evokes a disturbing relationship between the enervated, sadistic spectator position of the mistress and the reader who takes no account of her privilege.

Typically, male-authored slave narratives dramatize a similar combination of voyeurism and sadism, but *Incidents* differently situates the slave viewer to the scene of slave abuse. In the whipping of Aunt Hester, for example, Douglass remains perceptually sensitive to but physically invisible within the scene of abuse. Closeting himself in a nook so that he cannot be seen, Douglass voyeuristically takes part in a primal scene familiar to readers of the slave narrative, who occupy a parallel position of withdrawn scrutiny. Witnessing the dynamic between abusive father-master and abused aunt-mother-slave not only makes the young Douglass keenly aware of his position as a slave for the first time but also facilitates identification more with the master than with the slave.[16] As I have suggested in chapter 2, during Douglass's entry into "the blood-stained gate, [of] slavery's hell,"[17] blackness is drawn in equivalence to feminine, abject corporeality and bodily subjection, while white masculinity denotes inviolable authority. Combined with the portrayal of other molested and battered women, such as Henrietta, Mary, and Henny, Aunt Hester's whipping sediments a general

image—what Douglass calls "a most terrible spectacle"—of slave women as *abjective* correlatives of slavery's inhumanity.[18] Douglass emphasizes his role as eyewitness to brutality in order to martial literary authority, but as the narrative progresses this self-representation gradually shifts so that the older, emancipated Douglass recounts scenes of cruelty as "pure voice."[19]

Instead of inscribing Linda Brent solely as witness, Jacobs renders her narrator as a voice of reportage. A quality of removal and distant witnessing underscores many of the scenes of slave torture recorded in Brent's life story, as seen here:

> Dr. Flint ordered him to be taken to the work house, and tied up to the joist, so that his feet would just escape the ground. In that situation he was to wait till the doctor had taken his tea. I shall never forget that night. Never before, in my life, had I heard hundreds of blows fall, in succession, on a human being. His piteous groans, and his "O, pray don't, massa," rang in my ear for months afterwards. . . . I went into the work house next morning, and saw the cowhide still wet with blood, and the boards all covered with gore. (15)

In satisfying the genre's conventional representation of the slave body as a spectacle of abject victimization, this scene readjusts the narrator's (and thus the reader's) conventional relation to that spectacle. As in William Wells Brown's *Narrative,* Jacobs's text introduces the slave narrative trope of bodily mortification in a scene that exempts the narrator from having to be an eyewitness. As an alternative, Linda Brent becomes an ear-witness to the cruelty, but gives visual verification to the horror when she sees the blood-stained cowhide after its use. The "gore" on the boards makes palpable the abolitionist theme that the domestic spaces of slavery are saturated with immanent and immediate violence, creating an architecture that is literally buttressed with blood. Yet Jacobs's emphasis on hearing rather than seeing diverts the reader's gaze from the subjected captive body, allowing the tortured slave a measure of humanity commensurate with mind rather than body. The slave's words detached from and instead of his body become the sole medium through which the narrator vicariously apprehends his anguish.

In Jacobs's scene of abuse, moreover, the instrument of torture is *removed* from the master's body. The sound of relentless flogging alone expresses the master's cruelty, punctuated only after the fact of the torture by a visual inspection of the cowhide and the blood. These post-spectacle signs visibly index the master's power as an immanent violence that circumscribes Linda. More than treating her narrator or others as victimized spectacles, Jacobs establishes the scene of abuse as a secondary but tangible peril, for which the eavesdropping slave—like the reader—feels pity with-

out simultaneously viewing the subjected slave as pitiful. The aural scene of slave abuse proleptically metaphorizes tactics of covert observation that Brent will resort to while in the garret.

Unlike typical male slave narrators who begin with graphic punishments visited upon the bodies of slave women, Jacobs introduces her readers to slavery as an injustice not of torture but of hypocrisy, as a relation founded upon broken contractual obligations. Jacobs sardonically ventriloquizes plantation ideologies when explaining the attitudes of the master class toward her family members, culminating her dignifying biographical portraits of them with stark reminders that the grandmother amounts to nothing more than a "valuable piece of property" (9), or the father, though suddenly dead, need not be attended to—"he was merely a piece of property" (13). Brent experiences such hypocrisy when she is not set free as expected at the death of a mistress who was always kind to her and taught her to "love thy neighbor" because, as Brent reasons, "I was her slave, and I suppose she did not recognize me as her neighbor" (11). Such dismissals underscore the slave system's perfunctory gesture of extending familial or foster status to the slave while ultimately subscribing to the slave's juridical status as merchandise, "for, according to Southern laws, a slave, *being* property, can *hold* no property" (10).

A central corollary to this principle of slave commodification in the face of empty or indeed rapacious intimacy between masters and slaves manifests in ocular valuations of slaves as things. From the perspective of the master class, the common link of Brent's grandmother's labor as nursemaid for children both white and black does nothing to bridge the legal gap separating these children. Although a single source of maternal nourishment connects the children of the plantation, such labor is elided from the view of owners, who consequently view the slave nurse as a machine, indistinguishable from the very milk she provides: "These God-breathing machines are no more, in the sight of their masters, than the cotton they plant, or the horses they tend" (12). That the slave woman remains the milk-machine for white and black children alike allows the white plantation mistress to escape this reduction to the product of her labor. As Mary Ann Doane has concluded with reference to modern technological experiments with human reproduction, while motherhood, broadly conceived, may be seen as that which loops femininity into scientific and mechanical discourse as a type of machinery, "it is also that which infuses the machine with the breath of human spirit."[20] In *Incidents,* the mechanization of slave women's labor is primarily an effect of the master class's optical orientation toward the slave as chattel. For white owners, seeing seems to be as much about a willed blindness toward the customary and secretive production of slave babies as it is about the marking of slave bodies.

Master Vision and the Mulatta at Auction

The tragic mulatta is considered by critics to be largely a construct of white female abolitionism, entering the popular consciousness often in sensational and negative relation to true woman ideals. The trope became a durable symbol throughout the nineteenth century and well into the twentieth, of a gendered status corrupted by a taint of admixture that nullifies the chastity available to white women. Moreover, the mulatta also signifies, as a juridical and scientific touchstone of ambiguity, a figure whose indeterminacy menaces legal and rational discourses that seek to stabilize her vexing indecipherability. As a plot device, the mulatta is either a racist hero of white purity or degree zero racial fluidity. She is either victim, a sign of the oppressive practices that produce her and thereby complicit with them, or trickster, wreaking havoc upon the racial order by unraveling myths of white purity and exposing the culture's inability to imagine interracial subjects despite its hypocritical investments in conditions conducive to their reproduction.

A remarkable example of the enigmatic and contradictory dictates enshrouding slave ontology as it takes distorted shape from within the permissible limits of the master class may be found in an opening speech of Boucicault's play. Here the elderly slave Pete threatens to kill the thronging black children he adores with a touch of irony, minstrel humor, and prolepsis. When he assures the interloping scion George, newly arrived from European gallivanting, that "dis ere property"—meaning the children— "wants claring; dem's getting too numerous round: when I gets time I'll kill some on 'em, sure!" Pete, in effect, invites the audience to imagine the slave as a wildly replicating, obstructing presence in need of pruning and termination. Entangled in the image of slave children who wander through the play never uttering an individual word are metaphors of expansionism and manifest destiny: the slave children are at once foliage, a property of landscape and frontier, and indigenous others, living threats to the stability of civilized plantation life. This image of slave children en masse as "black trash" is like the illustration of the live oak and the creeper plants that suck dry its strength, which the "good" Northern overseer Salem Scudder offers his counterpart, M'Closky, the "bad" overseer—twin biological threats to the preservation of an existence that is both sanitary and sane, civilized and ordered. Sentiment and comedy seem the intended effects based on the later clues that such extreme expostulations are spuriously felt by Pete, however realistic and legally sanctioned such acts may have been for Southern slaveholders. Perhaps more disturbing than this moment of irony is the succeeding intertextual invocation of Stowe's beloved Topsy in Pete's similar remark

that these children "nebber was born at all; dey swarmed one mornin' on a sassafras tree in the swamp: I cotched 'em; dey ain't no count. Don't believe dey'll turn out niggers when dey're growed; dey'll come out sunthin else" (I.i). This image of a forbidden tree of origin in a fallen garden encapsulates a central conflict of the plot. Just as Zoe is initially taken for white by George, which tragically seals her fate by insinuating her in a prohibited circuit of desire and legal replication, the children are imagined to dissimulate their origins as well, envisioned as teeming insects that begin in the backwaters of the Deep South plantation in the un-arable but prodigious zone of the swamp, the Southern frontier, with its own unlikely couplings of race and justice.

The fantasized birth of the slave children described by Pete as swarming around the sassafras tree gives rise to an ominous prediction about their development: "Don't believe dey'll turn out niggers when dey're growed; dey'll come out sunthin else" (I.i). Therefore, to see the slaves as beings of dramatic evolution is to propose an ontology of blackness that runs counter to slavery's economics and its demand that the slave's transmissible and transmutable essence remain a measure of monetary and labor value rather than of physical or exomorphic possibility. Yet this vision of slaves as having fugitive bodies always in transition, becoming other than what they are, is not simply the idiocy of a quixotic buffoon, but the utterance of a wise fool who, as in Shakespearean drama, establishes the play's central theme and orients the audience obliquely to it. The vagaries of race, of origins and teleological becoming, are the play's central concern, and subset to it are issues of law, visuality, and truth.

We might say that the camera is positioned by the play as partner to the mulatta trope in that, like the mother of Zoe, Scudder's photographing "took the judge's likeness and his fancy" (I.p.5), insinuating itself at the heart of the plantation's operations like Scudder's other inventions, despite their ineffectuality. Not very different from the intimate coupling of master and slave, technology and plantation labor prove to be an unprofitable if quaint experiment in amalgamation. One could go so far as to see the connection as perverse, in the sense that Zoe's presence both strains and makes visible the domestic ideology of the plantation through Mrs. Peyton's pathetic emotional investment in the slaves and tolerance of Zoe, an unproductive attachment to goods and labor that may explain Terrebonne's insolvency. But although Zoe's presence visually underscores the Southern myth of slavery as an extended family between white patriarchs and black servant classes, to the repatriated interloper, George, her lack of visual acknowledgment on the part of others is noticed by him as unusual, especially given her radiant beauty. After Mr. Sunnyside's entrance and greeting to Mrs. Peyton and George, the latter remarks, "They do not notice Zoe.—(Aloud)

You don't see Zoe, Mr. Sunnyside" (i.6). George's assumption of Zoe's purity turns on the joke of vision; though she looks white, she is not, and this one drop's worth of difference is the amalgam that ruins the whole. His conventional diffidence in remarking upon her physically while in her presence is thought to be funny by Sunnyside and others for whom the mulatta body permits—and perhaps even invites—objectification. The perverse commingling in this scene ironically results from George's unknowing ascription of feminine honor to one denied such virtue.

Similarly, in *Incidents* Jacobs exposes how the slaveholder's ideological conceptualization of the slave as a familial asset coheres through public spectacles of generosity, which belie the slave's ultimate status in the public eye as a material asset. Negotiating this contradiction is shown to be a source of frustration for Dr. Flint, as he is forced to conceal his private exploitation of slaves who have gained symbolic value within the white community as embodying that ideology of the extended family so precious to Boucicault's Mrs. Peyton. Slaves who fall into this partial zone of public protection, such as Linda Brent's grandmother, must bargain for privileges by threatening to become exactly what they are—commodities—and thus arousing community interest by revealing the mitigating ideology of plantation familiarity as a sham. With an altogether different valence from Zoe's descent to the auction block, Bent's grandmother strategically utilizes the spectacle of the auction to flaunt her commodity status and thereby parade Dr. Flint's avarice to the community. Wary of publicizing his double-dealing, Dr. Flint designs to sell the grandmother "at a private sale" (14), even though freedom was promised to her by a previous owner in exchange for upstanding service. As a countermeasure, the "very spirited" grandmother decides to willingly submit herself to the spectacle of the auction block, since, as Jacobs reports, "she was determined the public should know it" (14). When shocked onlookers exclaim "Shame! Shame! Who is going to sell *you,* aunt Marthy?" (14), her use of the commercial publicity inherent in her status as an exchangeable object succeeds in shaming Dr. Flint and models a tactic of defiance that Brent will later employ.

If auction block publicity in *Incidents* betrays proprietary malfeasance, in *The Octoroon* it merely points to widespread instabilities of legitimacy. Rather than mediating communal expectations of order, as with Marthy, Zoe becomes a ritual scapegoat, absorbing communal panic over the tardy rehabilitation of vanished regimes of the law and the father. Zoe's unexpected slave auction comes about when the villainous M'Closkey engineers a scheme to prove that she was never legally manumitted. He sets in motion a claim upon the Terrebonne estate and all of its attendant property, culminating in her spectacle upon the block. The disappearance of Paul, the murdered slave, coincides with the complication of Zoe's condition and

eventual sale. Both events come to embody rifts in the social fabric of the community, requiring the impromptu creation of specialized, regulatory publics meant to repair those social rifts: the slave bidders, who awkwardly negotiate policies for bidding that somehow remain in flux during the auction, and the lynch mob gathered to find Paul's murderer.

That commodity fetishism structures these efforts to remedy the social verges on redundancy given the slave plantation setting. For as we know, any monolithic singularity of meaning that attaches to the iconic message is a projection of market relations. The notion that appearance reveals inner essences is a verdict that also guarantees investments in commodity relations. Ambiguity in appearance, as in the law, makes possible the exchange of the body as a form of currency, a token that may enter into public circulation as a vehicle for the redemption of value. It is still rather curious how forcefully the play fetishizes the remedial objectivity of images. A "fantastic form of a relation between things"[21] in the lynch mob's discovery of the daguerreotype and in the exhibition of Zoe transfers the disrepair of plantation governance to a condition of solvency. The fetishistic value of Zoe's image as a tragic commodity envelopes with ambiguity the crisis in labor relations that spawns her sale. Even beyond the Peyton household, this crisis lurks as the subtext of Pete's strange origin story of slave children or in the hybrid border relations posed by Paul and Wahnotee, who share a mishmash language and often roam through the swamp instead of the countryside's more public routes. The unspeakable and the unreadable crisis of slave production finally gets resolved when technologies of panoptic control take over where absent patriarchs, legal documents, and fallible human insight and sight have failed. Take, for example, the unreadability of Zoe to George. Although George immediately takes for granted her whiteness, or racial non-exchangeability despite her gendered capacity to circulate as a promiscuous object of male attraction—Zoe is in fact fractionally African and thus wholly re-enslavable even while being (at the start of the play) legally free. According to the telos of the one-drop rule, Zoe's origin in slavery guarantees the possibility of her return. Her body, the site of a legal, structural, and phenotypic ambivalence, can be used to redeem and thereby stabilize socioeconomic crises that transpire in the domestic networks surrounding it.

The tragedy of Zoe's hidden blackness, according to the logic of the plot, is that it spoils the legitimate consummation of desire. The white men who love her cannot make sacrifices for her so long as she is constituted by a system designed to cash out the value of her exchangeable though paradoxically white-looking body. Indeed, it bears notice that each of the three men in the play who vie for her affection are not natives of the plantation system and each avers that he would make sacrifices for her but cannot. M'Closkey declares that he would marry her if only the law would allow it. He later

vows to give up his animosity toward the Peytons, somehow willing to over-
come his class resentments to allow her to save them, to be their heroic mar-
tyr if only she would relent to his affections. Other would-be propitiators,
George and Scudder, go so far as to wish themselves exchangeable that they
may take her place upon the auction block: George proclaims, "I will sell
myself, but the slaves shall be protected" (iii.21); Scudder's words are far
more melodramatic—"I wish they could sell me! I brought half this ruin
on this family, with my all-fired improvements. I deserve to be a nigger this
day—I feel like one, inside" (iii. 24). These moments of desperation heighten
the terrible futility of resolution, uncomfortably positioning the audience to
feel relieved upon Zoe's death, if only because such unthinkable sacrifices
may be put out of mind. Still, a psychological residue, a ghost of suggestion,
hovers around Zoe's sale, inciting spectators to imagine beside her the white
male lovers who would join her if they could; but such a partnership is, of
course, rendered perverse in the play. The proper place for the male rescuer
of Zoe is on the other side of the block, bidding for her purchase; and yet,
this too is a morally compromised position in the play as it is occupied by
villain and hero alike.

In Jacobs's narrative too members of a master class in regulatory cri-
sis are far more variegated than uniform in their treatment of slaves. There
are those like Dr. Flint, who directly and cruelly abuse slaves and falsify
contractual obligations; those like the grandmother's and Linda's prior
mistresses, who position their slaves as intimate attendants; and then there
is that ambiguous public to whom the grandmother's self-spectacle is ad-
dressed. The response of this public master class is characterized in aural
rather than visual terms, as the "Many voices" (14) who declaim her deter-
mined stance upon the auction block as "no place for *you*" (14). While the
grandmother ascribes to this public a conscientious role to remember the
slave's loyal service and to uphold verbally exchanged obligations between
master and slave, Jacobs finally makes this public complicit in widespread
acts of forgetting the slave's humanity in her recourse to unveil material
relations covered over by systems of economic marginalization in both the
North and South.

That the public is rendered as pure voice associates it with the disem-
bodied subject position of the hypothetical reader or spectator, in whose
view the external world becomes nothing more than an object of specta-
cle as with Boucicault's audience. In Jacobs's auction block scene, two im-
portant connections arise. One is between disembodied subjects (like the
crowd or the reader of the narrative) and acts of forgetting slave labor and
denying material history (an amnesia facilitated by technology in the play).
The other is between embodied figures like the grandmother and acts of
counter-memory—efforts to oppose the dominant culture's denials and

blind spots. Rhetorical strategies of aurality contribute to Jacobs's sustained critique of disembodied spectators and their complicity with those systems of injustice that they seem merely to view. The whites who assemble as spectators of the grandmother's slave auction, however, are not the only public represented in *Incidents*. Jacobs alters the unmarked status of the viewing public when she includes within its abstract number the figure of the slave mother, who mediates sympathy for the slave while serving as a stand-in for the ideal, though impossible, reader-observer.

Describing the return of her escaped uncle bound in chains, Brent sets up a spectacle whose viewing public is neither unified nor disembodied, for it conceals the mother whose affective gaze unravels the male slave's fragile performance of masculinity:

> I saw him led through the streets in chains, to jail. His face was ghastly pale, yet full of determination. He had begged one of the sailors to go to his mother's house and ask her not to meet him. He said the sight of her distress would take from him all self-control. She yearned to see him, and she went; but she screened herself in the crowd, that it might be as her child had said. (21)

Rather than the general viewership of the text's reading audience or the specific perceiver embodied by Linda Brent, the concerned mother plays the role of the intimate observer, whose scrutiny, if consciously perceived by the slave, undoes his defiant relation to the scene in which he is made a spectacle. The sight of the mother's sight, in other words, plays heckler to his enactment of masculine agency, and his compromise to become an exhibit of insurrection gives way as the maternal gaze, like the language of the paternal slaveholder, subsumes the discourse of power with that of the personal. In discussing Sawyer's hurt feelings over the escape of Jacobs's uncle, his beloved slave ("I trusted him as if her were my own brother"), Lauren Berlant notes the tidy contrast between Sawyer's "language of personal ethics" and Jacobs's "language of power": "she looks to political solutions, while his privilege under the law makes its specific constraints irrelevant to him."[22] Subjects of privilege, in other words, require that the history of differential power be suppressed, while a consciousness of subjection requires such history to be made public. We might recall, by way of example, that moment during Zoe's auction when the white men who love her exclaim their wish to be sacrificed on the block in her place, denying history through a radical fantasy of material equivalence. This is the threat hinted at throughout the play. It is not that a white man could love the invisibly black slave, but that in doing so he would place himself upon the auction block, submitting to enter his body into a spectacle system relied upon to exclude it even while exposing the racial essences of others as a function of exchangeability and property relations.

Representations of slave abuse found in *Incidents* depend upon enlisting readers to play the role of screened-off mothers in the crowd, a sentimental viewing public that watches and feels for the slave as an object of cruel spectacle but that does not publicize its own acts of spectatorship as in Boucicault's drama. The gender dynamics of this rerouting of the terms of the spectacle, however, reveal an interesting complication. Repeatedly, the narrative foils the sentimental consumption of the male slave body by offering the woman, or the mother, as the site of the reader's identification. In such instances, readers are constituted as a sympathetic public, containing so many screened-off mothers in its otherwise anonymous midst. And yet, the public's gaze is never suggested to be automatic proof against maltreatment in *Incidents* and Jacobs often demonstrates the great pains Linda takes to solicit the community's preventative scrutiny. For example, when she is assigned to carry out errands while aggressively pursued by Dr. Flint, Linda notes that temporary safety lies in the sight of the public: "By managing to keep within sight of people, as much as possible during the day time, I had hitherto succeeded in eluding my master, though a razor was often held to my throat to force me to change this line of policy" (29). Remaining within sight of anonymous others yields the same kind of defensive reassurance that publicity holds for the grandmother during the auction block scene. However, when that public becomes a crowd or mob—a cruel public—the prospect of relative security is replaced by increased hostility.

In her description of a mob attack, Jacobs weaves together the text's threads of remote observation, auditory imagery, and criticism of mass public racism:

> Towards evening the turbulence increased. The soldiers, stimulated by drink, committed still greater cruelties. Shrieks and shouts continually rent the air. Not daring to go to the door, I peeped under the window curtain. I saw a mob dragging along a number of colored people, each white man, with his musket upraised, threatening instant death if they did not stop their shrieks. Among the prisoners was a respectable old colored minister. They had found a few parcels of shot in his house, which his wife had for years used to balance her scales. For this they were going to shoot him on Court House Green. What a spectacle was that for a civilized country! A rabble, staggering under intoxication, assuming to be the administrators of justice! (56)

Under the assumed rights of the military to intervene on civic affairs, the drunken soldiers take hostage innocent African Americans who are described by Jacobs primarily in auditory terms. Indeed, the "[s]hrieks and shouts" of the assaulted blacks produce in the white soldiers an irritation that spurs the mob's desire to kill. Individuality in the mob is limited to designations of whiteness and weaponry. The phrase "each white man, with

his musket upraised" is the only indication of specificity. Throughout, the soldiers are indistinct and plural, a "they" that agglutinates by the end of the passage into a "rabble." Although "colored people" initially comprise an undifferentiated series of discordant voices, biographical specificity arises with the "respectable old colored minister" and the exculpatory circumstances of his unjust arrest. Here again Jacobs narrates historical contingencies absent from the spectacle. Seeing the shot without knowing its innocuous purpose, the soldiers, we are led to presume, falsely impute insurrectionary motives to the minister and epitomize the superficial vision castigated throughout *Incidents*.

As in prior examples, Jacobs also presents Linda Brent as a secret observer of the mob. She plays the screened mother in the crowd as well as the eye of God appropriated from the proslavery minister's litany, which uses the chiding refrain of "Although your masters may not find you out, God sees you; and he will punish you" (58) to discipline slaves, whose infractions are captured by an ever watchful deity partial to the master. Jacobs turns this concept of the panoptic eye of judgment back around to inspect the injustices of white racism as an embodied spectator. Her position is embodied because of the physical emphasis of her peeping "under the window curtain" and, more importantly, because of the fear she admits to while spying. Linda's fear "to go to the door" underscores her own marked status, which mirrors that of the prisoners. Herein lies the narrative's embedded critique of the reader's position as spectator: if the reader takes up a disembodied, transcendent, empirical position in relation to the scenes Brent describes while huddled in fear behind doors or cramped and gasping for air in the garret, then a disturbing correlation arises between the comfort of the reader and the "nerve" of the master class. *Incidents* therefore requires that readers disassociate the technology of narrative from that of the camera obscura, which abstracts viewers from the scenes they survey.

Investing in and Divesting from the Camera Obscura Economy of Vision

A popular model for explaining and representing vision from the Renaissance to the early period of the nineteenth century, the camera obscura (fig. 5.2) typified bourgeois humanism. According to Jonathan Crary, it was the "dominant paradigm through which was described the status and possibilities of an observer."[23] It organized the act of vision so as to ensure that the observing subject could perceive the optical truth of an external world while remaining invisibly sheltered within the chamber of the camera. As Crary explains, "the camera obscura performs an operation of individu-

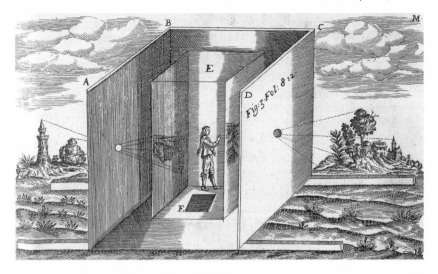

Figure 5.2. Camera Obscura, Athanasius Kircher, 1646

ation; that is, it necessarily defines an observer as isolated, enclosed, and autonomous within its dark confines [and is thus] a figure for both the observer who is nominally a free sovereign individual and a privatized subject confined in a quasi-domestic space, cut off from a public exterior world."[24] With its ability to "decorporealize vision," the camera obscura facilitates perception not of the actual world but of a mechanically magnified reflection of it projected onto a screen within the camera. The figure inside the box does not see the exterior tower behind him, only its ambient reflection projected on the screen. In mediating vision the apparatus enhances perception, at least to an early modern worldview, since the perceiver remains cognizant of but not subject to the external world.

As Ellen Driscoll's installation makes clear, Jacobs undergoes a similar withdrawal from the observed external world as the camera obscura observer. Vision in the "quasi-domestic" garret is monocular, restricted by the one-inch diameter peephole in the wall. The hybrid space of the garret collapses categories of gender, as many critics of *Incidents* have noted, and allows Jacobs's narrator to fluctuate in her self-representation between the encumbered mother and dependent granddaughter, who is unable to physically escape the place of her subjection when it overlaps that of kinship, even as she becomes the embattled combatant of plantation authority. As Sidonie Smith, echoing others, puts it, "Jacobs/'Brent' eschews the representation of herself as the isolato, self-contained in her rebellion, figuring herself instead as dependent always on the support of family and friends, particularly her grandmother."[25] According to Smith, Jacobs's placeless vision enables *Inci-*

dents to "probe, unconsciously and consciously, certain gaps in those conventions, certain disturbances in the surfaces of narrative."[26] The conventions to which Smith alludes are those that *Incidents* appropriates overtly, such as the seduction novel, domestic fiction, male slave narrative, biblical tropes, picaresque narratives, and the spiritual narrative. But I would add to this catalog those pseudoscientific and metaphysical narratives of vision invoked by the camera obscura, which Jacobs also seems to be unconsciously appropriating. Those narrative conventions having to do with sovereign seeing and withdrawn observation still linger in the antebellum imagination and their durability attests to the ways in which such obsolete models of transcendent subjectivity continued to promise some measure of resistance for marginal subjects.

As a revamped camera obscura, the garret allows Brent to remain invisible while surveying the landscape that grounds her social and juridical subjection, and, as with the camera obscura observer, this invisibility becomes a pre-condition for an ideal type of viewing. *The Octoroon* dramatizes this ideal when those searching for the disappeared Paul find the daguerreotype plate that reveals his murder. The photo image records the historical act in process as a fait accompli. To Scudder and the others assembled who read it, the image registers indexically what the photo must only connote, the murder of Paul by M'Closkey. Although showing an incomplete act, the image, like the legality of frontier lynching that it reinforces, serves as irreproachable evidence, a surveillance that is taken as impartial judgment and so dangerously imparts this residue of impartiality to frontier justice. Members of the lynch mob are enlisted as overdetermined interpreters of the image, anchoring what they see deductively in what they purportedly know it to mean already. In this translation, perceived objects instantaneously transmute into condemnatory evidence.[27] Although Douglass celebrates the medium in "Pictures and Progress" as a bearer of democracy, the order that photography helps to re-establish in Boucicault's play is anything but democratic.[28] At the heart of the play's vehement denial of M'Closkey's aggressive economic mobility is a repressive nostalgia for patriarchal aristocracy, as benevolent as its replacement conglomeration of lower and working-class male agents are ethically skeptical. Luckily, though, the camera saves the vigilantes from their own legal pessimism and racist motivation to kill the ostensible and convenient suspect—the falsely accused Whanotee—who no less conveniently takes the burden of executioner off their shoulders by hunting down and killing M'Closkey with tomahawk upraised in the play's final scene. By this logic of proxyism, Wahnotee's killing must be seen as Boucicault no doubt intends it, as a structural equivalent to Zoe's self-killing; both of these unstable, unallowable figures from the porous margins

create but also imbibe threats to the patriarchal master class that they finally annul through violent self-removal.

By contrast, in Jacobs's narrative, the ideal of unseen viewing involves acknowledging legacies of defiance against the master class, particularly represented by the slave father. The correspondence between invisibility and black masculine confrontations with patriarchy derives from two consistently drawn associations in *Incidents*—the absence and thus un-observable character of fathers and the revolutionary spirit of black men, which gives rise to their absence—whether through flight or extermination. The scene where Linda visits her parents' graves and decides to flee in order to protect her own children sheds light on these associations and their importance to understanding Jacobs's complex revision to Enlightenment practices of vision based on the camera obscura.

At the gravesite, the narrative offers another proleptic metaphor of the garret, another moment of the mulatta's interjection into the machinery of a space of quasi-abstracted vision not unlike that of the camera obscura. "As I passed the wreck of the old meeting house," Linda Brent explains, "where, before Nat Turner's time, the slaves had been permitted to meet for worship, I seemed to hear my father's voice come from it, bidding me not to tarry till I reached freedom or the grave" (93). At this turning point Jacobs intervenes on a masculine tradition of slave rebellion by championing motherhood "as the source of courage and conviction," since the decision to flee is based on a consideration of the "the doom that awaited [her] fair baby in slavery."[29] In this way, Jacobs refocuses the female slave's relation to a legacy of a suppressed black paternal order.

The description of the meeting house implies that the legacy of the slave father is not something antithetical to that of the mother, but a related, albeit differently contextualized, strategy of defiance that can be operationalized within domestic structures. Although the meeting house has been abandoned, undoubtedly at the direction of white male authority figures terrified by the example of Nat Turner, Jacobs reanimates it, domesticating it as well as the famous slave rebel who personifies its reactionary aims by touching both with a kind of maternality—here articulated, in part, through the absent father. Jacobs's narrative so refurbishes this outwardly forlorn symbol of slave rebellion as to make it functionally operative: a successful meeting does take place here, as the twin spirits of Nat Turner and Linda Brent's father impel her to escape. Adumbrating the situation of the garret, this scene imagines the father haunting an abandoned structure and wielding disembodied agency in the form of an auditory hallucination that imparts the will to defy slavocratic authority. Here, Linda figuratively enjoys the disembodiment promised to the camera obscura spectator by iden-

tifying with her father, a mystified absence of revolution. As in the fugitive visions summoned forth by other slave narrators, the moment of re-fleshing in Jacobs instigates a reconstructive re-ordering of the visual field, as she decides to become, like the camera obscura operator, an unseen agent of vision and, like the father, one who battles invisibly with the master class.

To be sure, the combat of *Incidents* unfolds around scenes of looking, wherein an altered version of the camera obscura observer (the fugitive female slave) yields surprising reversals of the slave system by visually capturing her would-be captor.[30] Describing her "Loophole of Retreat" through martial metaphors, Jacobs characterizes her narrator as a vigilant sniper awaiting her public target from a secreted location:

> Opposite my window was a pile of feather beds. On the top of these I could lie perfectly concealed, and command a view of the street through which Dr. Flint passed to his office. Anxious as I was, I felt a gleam of satisfaction when I saw him. Thus far I had outwitted him, and I triumphed over it. Who can blame slaves for being cunning? They are constantly compelled to resort to it. It is the only weapon of the weak and oppressed against the strength of their tyrants. (82)

A common set of gendered binaries (private/public, domestic/market, fixed/open) comprises the spatial dynamics of Jacobs's loophole. The text portrays Linda's vantage point, with its featherbeds retooled to serve as an observation deck, as an undetectable domestic enclosure and juxtaposes it against Dr. Flint's office, his public sphere headquarters in the marketplace. While Linda is rigidly circumscribed by and bound to her place of detection, the space associated with Dr. Flint is only the path leading to his office—not the structure itself. Turning the tables on the master, Jacobs reconfigures the spatial fixity associated with the feminine and the domestic to triumph over the master's seemingly unfettered mobility. The moment Linda experiences a "gleam of satisfaction" upon seeing the master from the loophole registers her awareness of the possibilities in a counter-offensive of seeing. It is here that she recognizes the power of a fugitive vision, one that reverses the expected social arrangements of race, property, and apperception in order to capture not just the master, but the slave system, as a perceived object removed from the seeing subject within the camera obscura.

Perhaps the most intriguing aspect of Jacobs's interrogation of vision is her infusion of the auditory onto the visual during key scenes of remote observation. Part of Jacobs's revamping of the camera obscura involves this transformation of the unseen look-out post into an auditorium from which visual perception is impeded and thus superseded by listening. Such a transformation has gendered implications in that it shifts emphasis from autonomous, invasive watching to intersubjective, receptive listening. How-

ever, the acoustic veracity of Brent's perception is compromised by another "vision"—a sort of return of the repressed sentimental—as her anxieties regarding her children give rise to auditory delusions that finally manifest in visual terms. Commingling gothic motifs of eerie music and ghostly apparitions, the following passage elucidates how the aural dimensions of the "loophole of retreat" supplant the visual and cast suspicion upon the credibility of Brent's perceptual faculties.

> And now I will tell you something that happened to me; though you will, perhaps, think it illustrates the superstition of slaves. I sat in my usual place on the floor near the window, where I could hear much that was said in the street without being seen. The family had retired for the night, and all was still. I sat there thinking of my children, when I heard a low strain of music. A band of serenaders were under the window, playing "Home, sweet home." I listened till the sounds did not seem like music, but like the moaning of children. It seemed as if my heart would burst. I rose from my sitting posture, and knelt. A streak of moonlight was on the floor before me, and in the midst of it appeared the forms of my two children. They vanished; but I had seen them distinctly. Some will call it a dream, others a vision. I know not how to account for it, but it made a strong impression on my mind, and I felt certain something had happened to my little ones. (87)

This scene bears out Crary's claim that mid-nineteenth-century interest in anatomy so corporealized vision as to disqualify the credibility of disembodied vision. According to Crary, extensive antebellum interest in the physiology of optic sensation contributed to the demise of the camera obscura as the apotheosis of vision because the operations of the human eye were regarded as subject to chimerical deviations produced by a range of extra-perceptual factors like the emotional duress and sleepless worry overtaking Linda in the above passage.[31] As the ironic song permeates the garret it mutates into an aural chimera of precisely that which makes it ironic: the children without whom Linda cannot feel at home, the children whose existence under the constant threat of sale makes "no place" within slavery's domain "like home."

Jacobs's reference to the popular song seems intended to recapitulate a generic indictment of American hypocrisy found in many antebellum slave narratives.[32] It subtly questions the sentimental patriotism and regional attachments fostered in nationally prized cultural texts or events—whether the Constitution, Fourth of July, or "Home, Sweet Home"—that exclude the alienations of the slave. The context of the song's intrusion upon Brent's vigilant post resonates with the song's maudlin lyrics: "An exile from home, splendor dazzles in vain, / Oh, give me my lowly thatched cottage again." Measuring the slave woman's unfathomable distance from a nationally es-

poused trope of "home," Jacobs subtly alienates her readers from any ahistorical appreciation of the lyric's seemingly neutral celebration of place.

The transformation of "Home, Sweet Home" into the moaning of children is not the only fantastic alteration that occurs in the scene. The acoustic illusion mutates again, transforming into a mirage within the chamber carried along a "streak of moonlight." Coupled with the music and Linda's heart-rending anxiety for her children, the moonlight functions in a manner comparable to the screen of the camera obscura. It captures within the garret an image of an external reality not seen firsthand by the observer. This is a sophisticated revision of the classical model, however, as Jacobs disturbs the separation of vision from other perceptual faculties guaranteed by the camera obscura while craftily proving Crary's argument that the quirks of anatomy and emotion play havoc with the truth-claims of vision. What Linda Brent thinks she sees in this moment no longer determines what can be known truthfully about the external world. Hence, Jacobs's appropriation of the camera obscura decouples the assumed relationship between knowledge and vision.

And the maintenance of this relationship is precisely the melodramatic stakes or cultural work of Boucicault's play, which proposes a more conservative, yet markedly complex, adjacency of its camera and mulatta. The play demonstrates the entangling clash of emerging visual architectures for imaging race, gender, region, and class with older models of social arrangement and literary tropes designed to ensure the split between self and other, white and black, right from wrong, civil from savage. Sharing center stage with the characters is the play's focalization upon the conceptual stand-off between two distinct yet interrelated ways of ordering identity. The mulatta becomes intertwined with the camera as a new technology for the visual display not of the coherence but of the fissures in social and legal arrangements and in presumed truths of identity, justice, and domesticity whose appearances change when surveyed through the lens of these alternative seeing machines.

The mulatta in *Octoroon* becomes a seeing machine on par with the camera, just as stabilizing as the camera and just as committed to uphold middle-class patriarchal subjectivity—sacrificing herself though many men would want to take her place upon the auction block. In the auction scene, for example, Zoe stands, from one perspective, as an inappropriate object of exchange. We know she does not belong there, not by race but by law. We are allowed to be insiders to a legal truism, working at times like the camera as a mechanism for establishing irrefutable truths about social enigmas. However, a figure like Zoe cannot pass as a lady despite looking like one when knowledge of her origin attaches to her body; at the same time, the

camera operates as a rescue agent of transcendent truth, even though it cannot provide anything more than a detailed reflection of the surface of things in the absence of cultural knowledges or narratives of origin. The truth the camera lays bare rescues only one part of the plot and cannot be relied upon to solve the play's primary crisis involving Zoe's interracial and therefore enslavable identity.

While the daguerreotype would have suggested to contemporary viewers of the play those hallmarks of early photography that are by now commonplace in scholarship of visuality and the antebellum period—technological innovation, optic proof, and deific vision—this particular apparatus and its user come equipped with their own unique series of associations. Indeed, Scudder is a transplanted Northerner, a failed inventor of gadgets who has set his daguerreotypes aside to try his hand at overseeing a New Orleans slave plantation only to fail in that line as well, though without much to mar his brash Yankee honesty, as is the case with his nemesis and moral counterpart, M'Closkey. The camera has been a vehicle not for truth but for profit, a fixed device that takes a while to snap a sometimes unflattering because unembellished likeness of its subjects. And while the chemical process of the camera may be an innovation, it is not so complex that Paul the precocious slave and victim of the play's plantation scandal can't figure it out simply by watching it done a few times. Despite the Indian's fear of the instrument as a type of gun as well as his false conclusion that it in fact kills his friend Paul rather than M'Closkey, the camera does finally serve as deus ex machina, sealing the real murderer's fate. As a result, the honest Northerner brings to the South more than the sensational allure of technology in the camera; in it he brings a form of deific vision that retributively exhibits covert injustice for public viewing, even when committed against the least protected of the plantation's dramatis personae. Thus the addition of the camera heightens the play's central conflict of the fugitive visibility of race and the fatal consequences of mistaking miscegenated for pure, white for black, marriageable for untouchable.

But the camera is also presented in relation to another exercise in visual scrutiny that likewise lays shrouded in a form of injustice rendered invisible and ambiguous for being buried in the past and practiced behind the closed doors of plantation domesticity. The interracial union of Zoe's white planter father and black slave mother seems obliquely referenced in the negative space of the camera's glamorous role in this play. Playing opposite to the daguerreotype's vivid manner of translating an unseen and lurid crime into a public spectacle is the very body of the octoroon Zoe's white skin, upon which is etched a haunting portrait of slavery's tangled genealogies and the specter of violent rape that the mulatta always signifies. In spite of the slave

mistress's love for Zoe and unusual tolerance for her husband's illicit desires, the camera attempts to provide an alibi for slavery's unnatural connections.

Just as the nightmarish mechanics of the plantation economy affirm a white domesticity while exploiting black women as sites for the reproduction of both slavery and whiteness, so too does the camera assert two opposing objectives at once. At first, Scudder's posing of Dora before the camera renders domestic femininity as a site of consumption and the reproduction of leisured white privilege. But then the rowdy partnership of Paul and Wahnotee interrupt this seeming innocent use of the camera, parodying Dora's posing while asserting the impossibility of Paul as a sitter for the daguerreotype. Nor can Wahnotee embody the role of the daguerreotypist, a role that ironically was advertised as open to just about anyone during this period. Indeed, even aside from the play's insistence upon the automatism of the camera, daguerreotype equipment was routinely touted as requiring no specialized operator. In a long-running ad from New Orleans's *Daily Picayune* of 1843, for instance, daguerreotype equipment appeared for sale alongside ads for private salon artists. The mechanical apparatus and a set of instructions substitute for the artist and the salon, though not to be taken as different from the cultural and economic category that such fine art establishments make possible.

The analogy of operator to owner is an interesting one, for it likens Zoe not to the machinery but to the image, the plate produced by the automatic camera. By extension, Wahnotee, the proximitous operator manqué, and Scudder, the inventor, may be seen as partialized owners of the resulting photo image, just as the dead plantation patriarch, Judge Peyton, bears a ghostly and ambiguous ownership over Zoe. The camera is the perfect device for implying the wish that the octoroon's reproductive origin be blurred in relation to the white father since agency is dispersed in the automatic, mechanical, even magical reproduction of nature and external reality in the machine. Northern technical innovation thus gives the alibi to Southern perversions of labor reproduction once fantastically sloughed off onto Old Pete's swarming trees.

Conclusion: The Garret as an Obscurer Camera

Having engineered the hoax of a successful escape, Brent attains a supervisory command over the grounds of her life in slavery. In the garret she inspects slavery's physical demesne, political workings, and primary actors without breeching the limits of a space that blurs distinctions between confinement and sanctuary, womb and tomb. Neither one nor the other, nor

even simply an in-between space, the garret becomes a third space of representation wherein the distinctiveness of the categories it mediates break down. There, notions of freedom and slavery are recontextualized, redefined according to different orders of knowledge. For instance, freedom for Brent in the garret is more than simply the opposite of slavery. Within the third space, freedom never signifies anything so absolute as independence or opportunity, but rather a complex of contradictory relationships involving sexual self-determination, maternal sovereignty, proximity to ancestry, as well as surveillance despite invisibility and survival despite the most ascetic of privileges.

A crossing and recrossing of gender boundaries structures Brent's retreat, as she takes up a position commensurable to that of the absent father and, as I have made clear, engages in a form of combat with Dr. Flint. The letters deployed from this position, which would seem to make such masculine defiance possible, situate Linda—at least in the mind of Dr. Flint—at the same runaway boundary zone to which her brother and uncle once retreated. The very same escape that Jacobs inscribes in the earlier passages of the narrative as a possibility for male slaves hardened to abandon family members is finally achieved by the female slave, but in a dramatically altered form. Indeed, it is only through a trick of representation, the deceit of the letters, that Brent occupies this escape zone. This is not to argue, however, that Brent's hybrid role as both masculine combatant and as entrenched female dependent leaves these original gender categories intact. One need only recall her later deception garbed as a male to recognize the way that the experience in the garret unhinges conventional gender and race markers.

As though mobilizing the garret into a portable prosthetic, Brent assumes the role of a fugitive passer. Costumed as a black male sailor, with her face deliberately made darker, the masquerading Linda Brent comes into contact with, Mr. Sands, the father of her children, without so much as attracting the slightest notice from him. Now intermingling with those whom she had only been able to spy on from a hidden distance, Brent remains invisible—at least insofar as her identity as Linda Brent has been rendered unrecognizable by the costume. Blackface drag, in this context, reprises for Linda the security features of the garret without its insufferable fixity. The slave girl is just as enclosed within the faux skin of the black seaman as she was immured in her grandmother's garret. Her experience in the latter, we are led to believe, informs her decision to practice the former. To engage invisibly with the throng of the plantation thoroughfare, Brent decides to practice another form of self-enclosure, not within a domestic architecture so common that it escapes the notice of passers-by, but within a public, anthropomorphic equivalent: the black male laborer.[33]

While sentimentalism corrects the solipsism of the camera obscura's transcendent and disembodied form of vision by placing political emphasis on the body, in *Incidents* Harriet Jacobs refutes a very particular form of sentimental looking relations that does not, one that ironically takes on qualities that Crary aligns with the camera obscura. The conventions of sentimentalism that Jacobs attacks in *Incidents* rigidly define systems of visual consumption that produce observers, much like the camera obscura, "fitted for the task of 'spectacular' consumption."[34] But whereas this modern observer is mobile and able to consume an unending series of commodity-like images sundered from any point of fixed reference, Jacobs's is not. Modeled by Brent's confined and cyclopean vision while in the garret, Jacobs's observer is bound to politically charged physical spaces. In *Incidents,* the picture sentimentally construed nullifies cultural and material difference. Jacobs situates her perspective in real space and in relation to systemic mappings of power. Her text organizes visual experience as potentially duplicitous in that it leaves out the body. In essence, Jacobs recasts vision so that the private history of the captive body's subjection by and exclusion from dominant models of visualization—epitomized by sentimentalism's 'lovely sights'—can be made public.

Yet just as the narratee of "lovely sights" is debarred from looking without simultaneously apprehending unruly material phenomena, so too does Jacobs reassert her position as observer as *part* of the exterior world represented in her observation through the peephole. Within the garret, she becomes part of what she sees without. The body is never fully abandoned in these garret acts of observation. Thus, the subsequent paradox of Jacobs's appropriation of the camera obscura is that she posits an embodied observer within a viewing context generally associated with detaching observation from the body, maintaining the objectivity of the sovereign observing subject, and "escaping from the latent opacity of the human eye."[35]

Photography affords new possibilities for tangibly seeing identity, those genealogies of communities and phenotypic markers of association and exclusion that the mulatta disruptively confounds. The body of Zoe in this sense is unphotographable as it resists the allegedly transparent truth of the surface. And yet the play fantasizes that the racial depths of her tricksterish amalgamation were somehow readable at the surface, only it is a surface that requires greater magnification than ordinary daguerreotype lenses provide. The camera in the play is a wonderful arbiter of one type of justice, but an outsider to the secrets of the racial surface that any Southerner seems to know already and that make up the judicial problems of another kind of crisis of interpretation—one that the camera cannot solve. But the play is rather silent about this contradiction of tropes, the camera versus the mulatta—who wins in upending and reinstating social order? In the play

the triumph of the one remains only in epiphenomenal rather than causal relation to the destruction of the other.

In Boucicault the camera shows the incompatibility of optic objectivism in the fugitive interpretive zone of the slave South; as with the letter of the law, there is little need or use for such a transparency-truth machine when the surfaces of things in the South are not allowed to speak for themselves but require background, history, or access to originary moments in order to be legible. And yet the iconic message of the daguerreotype reveals a regulatory function of surveillance rooted in precisely the temporal reconstitution of a mythological past—as with the octoroon's conception.[36] This reconstitution may thus suggest the pornographic quality of the trope of the mulatta and the reason for the camera alongside her image in further signifying a titillating function. As a bodily sign, Zoe too conjugates disparate modalities of time and space: her very complexion because unusual and sensational conjures up in the light of the present the act of miscegenation that has created her, and more importantly, others like her, in the very dark and brutal corners of the imaginary plantation—imaginary because still a place of voyeuristic safety for the white Northern gaze which so often sought to venture there during this period.

But along with titillation and the promise of a prurient gaze of power that penetrates the concupiscent scene of the mulatta's conception, the trope of the mulatta, particularly when paired with that of the camera as seeing eye of judgment, also may have induced in audiences a phantasmatic sense of surveillance—a permanent social visibility which not even proof of whiteness can prove against. In this way, the camera and the mulatta come together to form a composite machine for sustaining power relations through acts of seeing and being seen. Together they become a kind of "architectural apparatus," a panopticon, assuring the "automatic functioning of power" by instating acts of surveillance that are ultimately self-disciplining for all those who witness the permanent political effects of their social repositioning.[37]

6

Throwing Identity in the Poetry-Pottery of Dave the Potter

Some people's emanations are very strong, some people create themselves afresh outside of their own body. This is not fancy. If a potter has an idea, she makes it into a pot, and it exists beyond her, in its own separate life. She uses a physical substance to display her thoughts. If I use a metaphysical substance to display my thoughts, I might be anywhere at one time, influencing a number of different things, just as the potter and her pottery can exert influence in different places.

JEANETTE WINTERSON, *ORANGES ARE NOT THE ONLY FRUIT*

In an age of dazzling simulacra, we might be amazed at the success of a slow-paced, low-tech television show like PBS's *Antiques Roadshow,* which pauses to appraise the minutia of craft objects from the past. With its episodic presentation of average Americans armed with some apocryphal collectible or heirloom, whose inconspicuous attributes get translated into historical narratives about their process of production and usually alarming market value by experts, the show blends the intellectual drama of an archeology dig with the cupidity of a game show all while reinforcing the durable cultural work of the American Dream. Just about anyone, the show seems to promise, may be in the possession of a treasure passing itself off as that old lamp or ashtray collecting dust in the attic. All that's needed is proof of rarity to translate the white elephant into a cash cow. Beyond its materialization of bygone knick-knacks and its fascination for putting a price tag on history, the show indirectly fuses the visual spectacle of the historical object—as the camera lingers over appraised wares—with the verbal narrative of the appraiser's evaluation.

Program #505 of *Antiques Roadshow* (premiering February 5, 2001) included an antique emblematic of the show's ritualized intermingling of the verbal and the visual. The ash-glazed earthenware jug that Shannon origi-

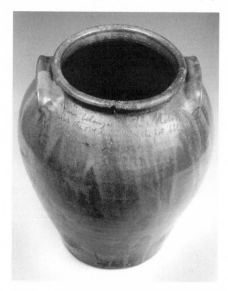

Figure 6.1. Typical jug by
Dave the Potter, 1840.

nally bought for $60 turned out to be so "fantastic" that stodgy appraiser
J. Garrison Stradling dubbed her "one lucky Charlestonian." After having
Shannon recount her precarious acquisition of the piece (she first sold it but
was then convinced by her wiser mother to buy it back just minutes after
originally making the sale), Stradling estimated the jug (fig. 6.1) to be worth
approximately $6,000. The appraiser further related that it was made by a
slave artisan named Dave, who worked in Edgefield, South Carolina, during
the 1840s and 1850s, and wrapped up by saying, "Everybody talks about the
best pieces of South Carolina pottery being made by Dave the Slave."

Although Stradling, when taking note of the words etched on the side
of the jug, explained that Dave was unusual in being a slave artisan who
could write, he did not venture an interpretation of the exceptional size of
the signature or date. Nor did he offer more than a cursory elucidation of
the caveat emptor quotation etched onto the side of the jar—"L.M. says this
handle will crack." Stradling only paused to (mis)identify L.M. as Dave's
"employer," Lewis Miles, without specifying that Miles was also Dave's
owner and master. In the television show's journey toward decoding hidden
market values, the writing on the jar is a matter not to be questioned but ex-
plained. As far as Stradling and the producers of the show were concerned,
the writing scrawled on the piece is just that, writing meant to be read. Like
the unbroken handle and the glaze that gives the jar its glossy patina, the
writing is simply another clue to be assimilated unquestioningly into the
appraiser's finalizing narrative about the history, and thus the value, of the
piece.

But there is more to "read" in the writing on the wares of Dave the Pot-
ter than the words themselves (although even they deserve added attention).
The letters and words can only be fully interpreted in relation to the style in
which they are incised, and both the appearance and the meanings we as-
sign to the writing are further related to the appearance of the craft object
that literally and metaphorically grounds them. In addition to the various
ways we can position the texts of Dave's multivalent creation, dually made
up of the three-dimensional object and writing, we must also account for
the historical contexts that frame the piece. There is its representational
relationship to slavery—which the television show is more than willing to
oversimplify in naming the crafter "Dave the Slave"—as well as to systems
of ownership and appropriation, which the show seems to disavow in refer-
ring to the slave master Miles as an "employer."

The same lasting integrity of the jar that underwrites its value for the
lucky Shannon also presents a challenge to the quoted prediction of Lewis
Miles scratched onto its surface. The handle, it may be discerned, has not
cracked despite the employer-master's inscribed warning. What does crack
under the weight of Dave's iconoclastic production, however, are our pre-
sumptions about slave speech within the antebellum South. Despite his po-
sitioning in a slave system designed to disenfranchise him, Dave's written
pronouncements seem to perform unexpected agency. How is it that this
enslaved potter is not silenced within the normally mute system of craft pro-
duction? What sort of identity does participation within this system allow
Dave? Taking this particular jar as a test case, does the ironic pronounce-
ment attributed to the master show Dave to be resisting or succumbing to
slavocratic authority?

From one angle, we might read the inscription as a dutiful report of a
possible weakness in the object for sale. Citing the master, Dave humbly
recedes from view as the master is allowed to speak directly to the potential
buyer. "Buy at your own risk," Lewis Miles warns us, with a gracious and
proprietorial smile, "and don't expect any refunds." But from another angle,
we might note that even if the above interpretation were valid, it is not the
master but Dave who does the reporting. He, the maker of the object and the
signer, whose name appears grandly on the side of the jar, attributes to the
master the presumption of a flaw that is contradicted by the continuing so-
lidity of the object's construction. From this angle, the flamboyantly signed
creator "Dave" has set up the master to fail, having the master's words dis-
proved by an eyewitness account of the jar itself. When interpreted in this
light, Dave becomes legible within similar scripts surrounding figures like
Frederick Douglass. Out of the combined testimony of the text and the pot,
Dave rehearses a narrative of romantic individualism and African Ameri-

can exceptionalism, resistant to dominant authority even while working within its purview.

Although this resistant identity may seem to overtake any more humble manifestations of the potter that we can read into the inscription, we must be careful not to rush to judgment, since there is yet another important context to be factored into our interpretation—that of the date and signature. Despite being much larger than usual, the signature and date are important components in the production code accompanying most ceramics produced for sale in the antebellum market, and their appearance here confirms Dave's conformity to more basic forms of expression. Though stylishly large, the presence of the date and signature also show Dave to be working within an established potter's tradition.

Just how we might read the conjunction of visual and verbal fields in his pottery as a correlate to Dave's own complex amalgamations of identity is precisely the question that this chapter raises. But in order to fully explore what Dave's multimedia works allow him to do, we must first move beyond reductive appraisals of the verbal and visual dimensions conflated in his pieces. I hope the example from the *Antiques Roadshow* makes clear that privileging any one of the many fields or axes of discourse on which Dave's works may be plotted, whether it be that of market value, historical context, verbal meaning, or visual appearance, cannot do justice to the complex intermingling of these fields that any of Dave's pieces ultimately achieves.

As we have seen, Dave invokes the master narrative of literacy in order to subtly undermine it by counterposing it against an alternative mode of representation. The master's admonition regarding the handle, for instance, comes to us in the form of writing that functions as an ironic caption. But its truth value is subverted by the fact of the jar's evident cohesion. Thus the master's narrative as well as the master's discourse of writing is invalidated by the contravention of an alternative mode of representation: the visual field. In a sense the master's words function as an extraneous adornment to the piece, but the piece alone would not be complete without this subtle argument about the master's inadequacies written onto its surface. As a result of these tensions in representation, the identity attributable to Dave undergoes a process of splitting, a form of displaced identification Homi Bhabha identifies as responsible for creating ambivalence in colonial discourse: "Splitting constitutes an intricate strategy of defense and differentiation in the colonial discourse."[1] According to Lin Zou, Bhabha's notion of the split subject presumes that resistance for subaltern or slave subjects derives from the very act of self-examination and contradictory self-representation: "In Bhabha's model, the critical agent has to make itself split, and so turn itself into a subject that is not located in its linguistic self or attached to any

concrete belief."[2] In his pottery and poetry, Dave becomes a critical agent through a process of splitting. He is not simply the slave crafter who reports his master's warning but also the creator of the object upon which the truth value of the warning depends. Through literacy Dave encourages readers to become skeptical of the meaning of words alone as well as the authority that underpins them.

In the interplay of the verbal and the visual, therefore, Dave coalesces in various and contradictory locations of identity. Over the course of this chapter, I shall argue that there are four key reference points for mapping Dave's splitting. He is represented as an agent and an object of literacy (written communication), spectacle (looking relations and the social power that regulates them), his signature, and the materiality (shape, size, design) of the artwork itself.

These four reference points may be clarified in the following ways. Through literacy Dave characterizes himself as a disenfranchised, yet resistant, subject of dominant discourses. While the production coding incised upon the pieces gives the slave crafter a limited voice, Dave's inscriptions allow a wider range of voices, enabling the slave to become more than a subject of commodification. In the writing on the jars, Dave positions himself variously as a member of the Edgefield community, an ironic commentator, a whimsical aphorist, and a performer of racialized speech. However, Dave's position of prominence within the craft markets of Edgefield simultaneously indicates the flexible appropriation of his work by dominant Southern culture. Partially a derivative of literacy, the second point of reference for locating Dave is as an authorized viewer of his own crafts, as documented by the *Roadshow* piece. By creating a conflict between dominant and alternative modes of valuation, as in the discrepancy between the owner's caution and the fact of the jar's durability, Dave's position as spectator of himself and his crafts destabilizes traditional assumptions about slave visibility and market power. Thirdly, the signature elevates Dave to a kind of celebrity status within the antebellum South. Instead of making him a subject of contractual negotiation—the function of ordinary signatures—Dave's first-name signature is a paradox. It acts as a material emblem of his status as a commodity, but also points to his lauded role as a creator of commodities. And finally, Dave represents himself as the faintly traceable origin of a series of surrogate bodies comprised by the jars. Offering a modification to Henry Louis Gates, Jr.'s, claim that literacy is the primary means of escape from the slave's condition of being imprisoned in the body, Dave uses hybrid representations to multiply the symbolic bodies associated with the tragically embodied slave, and uses his inscriptions to highlight the triumph of the material object over the grip of the master.

Beyond acts of multiple self-positioning, Dave's emphasis on making and unmaking links his work to that of slave narrators. As we shall see, many of Dave's pots take readers back to the commodity's moment of creation and center on the clay's boiling, or *bilin'* as Dave calls it. During these moments of bilin', Dave stages himself as the arch creator of commodities, though still a commodity himself. Through this process, Dave's works accomplish the same association of blackness with humanity that slave narrators sought through literacy and print technology, yet Dave achieves this ascension to empowered status through the commodity form. By making his pots metaphorically boil again, Dave enables made objects to signify as if they were unmade. As a result, the authorial subjectivity produced in Dave's work resembles the figure of ontological transformation that Douglass strikes when he focuses his readers' attention on the way the slave becomes a man. Furthermore, the impact of Dave's toggling between slave and master, commodity and creator, threatens to deconstruct assumptions regarding the integrity of whiteness in a manner similar to the slave Uncanny discussed in relation to the Crafts. If Dave can become an elite sort of commodity object by making and unmaking other commodity objects, then on what ground can subjects be differentiated from objects? The same instabilities in the construction of whiteness triggered by viewing Ellen Craft's engraving rise up in Dave's work, blurring distinctions necessary to the maintenance of race difference.

Aside from accounting for Dave's hybrid self-manifestations, my analysis also attends to the interplay of historical contexts that shape Dave's work and complicate our understanding of its place within a wider discourse of slavery authored by slave narrators. Mobilizing another fugitive vision in the interstices of writing, seeing, signing, and making, Dave's pots raise many of the same critical questions addressed in other chapters. In particular, they highlight the tensions of interpretation that result when a repressively circumscribed identity is represented over and against dominant discourses (craft tradition, ethnography, pseudoscience, the law, slave advertisements, minstrel songs, plantation novels, abolitionism)—all of which compete to represent the slave experience as well as the slave subject.

The History of African American Ceramics

Discourses on the history of African American ceramics have risen from somewhat myopic beginnings. Textual artifacts formerly considered too exceptional to be included in histories predicated on representativeness, such as Dave's work, have been largely ignored. Additionally, much of the early work done in African American craft history has focused on con-

structing a canon. In *Afro-American Folk Art and Crafts* (1983), the vener-
able folk art historian William Ferris laments the dearth of primary textual
evidence in nineteenth-century African American pottery:

> In respect to the potter's craft, very little historical information on Black par-
> ticipation in the Southern ceramic tradition has as yet surfaced; indeed, when
> compared to the North, not much has been published on Southern folk pottery
> in general. It would appear . . . there were never many Blacks involved in the
> making of folk pottery in the South, and that the work of those few does not
> have a distinctly racial quality, much less an African ancestry.[3]

Here Ferris voices his insistence on a form of scholarship motivated by what
Gates has famously dubbed "race and superstructure" historiography, which
privileges the unearthing of artifacts with recognizably Afrocentric traits.[4]
Nevertheless, Ferris helpfully calls attention to a problematic absence of
scholarship surrounding slave ceramic folk arts from the South. But instead
of offering a clarion call for revisionist academic explorations, he hastily
eternalizes this dearth in number ("there were *never*") and this lack of racial
authenticity as somehow essential to the nearly mass-produced nature of
antebellum pottery. Of course, at the time of its publication Ferris's seminal
work was finally establishing an academic foundation for African Ameri-
can folk art as a subject of study in general, and we need not fault him for
failing to incorporate exceptions to the rule of highly regularized pots that
were daily produced and offered for sale in the Edgefield district of South
Carolina.

This historic center of ceramic production is mentioned by John Vlach
in *By the Work of Their Hands* (1991) as a recuperative exception to the defi-
ciencies Ferris laments when trying to construct a pottery tradition among
black artisans freed or enslaved.[5] In Edgefield, while walking by one of the
district's many potteries in the 1840s, one would find produced for sale an
assortment of alkaline-glazed stoneware: jugs, bowls, vases, storage ves-
sels, dining and cooking wear. As items used for practical purposes, these
wares, as Vlach informs us, are "mostly utilitarian in function and in form";
mostly, that is, until we come across another exception to the rule of ce-
ramic uniformity, Dave the Potter: "Yet in the case of Dave the Potter, the
only slave to sign and date his works, we have evidence of a deviation from
normal practices."[6] As clues to "alternative possibilities in design and ex-
ecution," these unique pots are important anomalies to Vlach because of
their "gigantic size" (some were as large as forty-four gallons) and for their
"rhymed couplets."[7]

Perhaps because Dave the Potter is an exceptional artisan working
within a district that is also an exception to the dearth of artifacts seen in

the rest of the antebellum South, little more is said about him. Vlach only briefly mentions the potter and does not enlarge upon the significance of the unique and evocative inscriptions of poetry found on the pottery. Like Ferris's, Vlach's study lays important academic foundations for folk traditions but does not elaborate on the particularities of its objects of scrutiny. Vlach's scope "looks beyond Edgefield,"[8] as Jill Beute Koverman justly remarks in *I Made This Jar,* the first extended study of Dave the Potter. But if Vlach's contextual focus is too broad to assess Dave's unique pots, Koverman's edited collection of archeological, historical, and literary essays is perhaps too narrow. While the essays individually contextualize the pots both historically (the secessionist politics of the town of Edgefield) and thematically (as emblematizing issues of apocalypse, freedom, and literacy), they do not work to elaborate the palimpsestic and multivalent poetry of Dave and his pots, nor do they consider them through critical frameworks sensitive to issues of racial identity and spectacle, which, as will be pointed out, the pots arouse.

Regardless of its sometimes overly narrow focus, however, traditional scholarship on African American art usefully presents a profile of the conditions affecting artisan production under slavocratic regimes in the South.[9] Combined with a critical interest in interpreting the visual meanings of such artifacts, this scholarship helpfully illuminates the modes of production under which objects like Dave's pottery were created and thus obviates one pitfall of much of the scholarship currently being done on visuality, which proposes an ungrounded subject of pictorial representation. Instead of simply applying theories of spectacle and embodiment to Dave the Potter's work as though it may be viewed from an ahistorical, unifying frame of reference, we must first examine the material conditions affecting his production and examine the ways in which his wares were organized for public consumption.

Dave and the Conventions of Edgefield Pottery

The figure I've been calling Dave the Potter was also known as Dave the Hive. He is said to have worked as a typesetter for a pro-Unionist newspaper, *The Hive,* where he may have also learned to read and write. John A. Burrison provides some important information regarding the Potter's biography, noting that Dave

> spent his adult years in the service of Abner Landrum, when he must have learned the potter's craft. During the same period he served as typesetter for the two newspapers Landrum published, the South Carolina Republican and, later, The Edgefield Hive.[10]

The fact that Dave's pots flaunt lines of poetry attributable to him—"I made this" boasts one jar, "Making This Jar—I Had All Thoughts" begins another—may seem astonishing, given the typical injunctions against slave literacy. Throughout the South laws forbidding the literacy instruction of slaves were passed most likely as a result of rebellions in the 1820s, which exacerbated widespread fears of insurrection. North Carolina legislators justified such interdictions, reasoning that literacy "has a tendency to excite dissatisfaction in [slaves'] minds, and to produce insurrection and rebellion, to the manifest injury of the citizens of this State."[11]

Although Dave the Potter rebelliously transforms the functional craft object into an "event" of speech, it would be peremptory to overemphasize the potter's literacy as unique. Burrison goes on to make two important qualifications regarding Dave's literacy: first, that South Carolina "did not make it illegal to teach slaves to read and write until 1837" and second, that Landrum's *Hive* was ill received by the notoriously fiery Edgefield folk because of its Unionist views. Nor is Dave the only literate slave potter of interest to scholars. Burrison adumbrates the biography of a Georgian named Bob Cantrell, who like Dave worked largely among white free artisans and did not learn his craft through apprenticeship, as was customary for white potters, but "learned it while assisting . . . white potters" as is most likely the case with Dave.[12]

Because many African American crafters were forced to work outside of organized craft traditions, their work often departs from this tradition. Some critics have taken this logic one step further, racializing that difference and setting up its effect as an essence. The preponderance of personal style—many of the storage jars bear Dave's signature in grand, flowing cursive script—and the originality of construction in Dave's pots foreground performativity and spontaneity, qualities that some critics purport to be fundamental to African American cultural production, as do Sidney Mintz and Richard Price here:

> Within the strict limits set by the preconditions of slavery, African Americans learned to put a premium on innovation and individual creativity; there was always a place for fads and fashions; "something new" . . . became something to be celebrated, copied, and elaborated.[13]

Alternatively, other critics have described this propensity for a focus on personal style as essentially intuitive. Robert Farris Thompson mystifies the origins of those very elements of an art work that seem beyond the ken of disciplinary understanding, archival verification, or logical inference. Thompson justifies his reading of the multiple, polyrhythmic patterning in African-influenced textiles by reasoning that "it would be irresponsible not to attempt to sharpen awareness of [the] staggered and suspended pattern

in some forms of African cloth by reference to off-beat phrasing of melodic accents in music, or in dance."[14] But while Dave the Potter's work expresses these patterns and accents, it also exceeds them in exciting ways.

This brings us to the question, just how does Dave's work compare with that of his contemporaries? Let us return to our imaginary tour of Edgefield's stoneware vessels to picture one of Dave's jars suddenly appearing among rows of greenish jugs, which seem metaphorically to be "speaking" nothing at all in their construction other than their value as functional objects and their participation in a commodity system based upon the exploitation of slave labor. Upon closer scrutiny, we observe that most of the ceramics possess markings—far more mechanical codes than those of Dave's works perhaps, but forms of writing nonetheless—indicating the pottery where the vessel was produced, sometimes initials, and often a date. Dave's jars, therefore, are not unusual in having incised messages about their point of origin. Stephen T. Ferrel's research explains that the practice of inscribing pots was part of a local tradition popularized in Edgefield, a point confirmed by Burrison, who adds that the folk pots often possessed, in addition to documentational writing, evidence of "applied faces or inscribed poetry."[15] Beyond laying out some necessary history concerning the composition of the indigenous ceramics of the district, Burrison makes a claim for Edgefield as the pioneering center of alkaline glazes. Its pottery of

> mainly jugs and food-storage jars ornamented with white and dark brown slips (liquefied clays) under green to brown alkaline (wood-ash or lime based) glazes, represents a distinctly local tradition in that its features are combined in a way unknown elsewhere, suggesting the transition from English slip decorated, lead-glazed earthenware to the alkaline-glazed stoneware that was emerging as the norm for the Deep South in the early nineteenth century. Indeed, just as significant for American ceramics historians as Edgefield District's spectacular products is the likelihood that in this section of the Carolinas, alkaline glazes, later diffused through the Deep South, were first developed.[16]

There is no doubt that the achievements of antebellum Southern handicrafts preponderantly were due to the skilled labor of black slaves, whose masterful but cheap work fomented rivalry from poor Southern whites. In "The Ante-Bellum Negro Artisan" W. E. B. Du Bois examines the response of Charles Lyell, a propertied Georgian slaveholder, who clearly exhibits a bias of personal interest in supporting the contractual rights of slave artisans against the growing animosity of white workers agitating for legal prohibitions on slave contracts. According to Lyell, the opposition of Southern white laborers and mechanics proves "that the blacks are steadily rising in social importance in spite of slavery, or to speak more correctly, by aid of that institution."[17] Using the labor conflict to provoke sectional division

over abolition, Lyell suggests that the North, "if they really desired to accelerate emancipation," would treat black workers with as much respect as demonstrated by the success of black artisans in the South.[18] In addition to being caught between the scorn of poor whites and the greed-inspired accolades of slave owners, the elite class of slave artisans, Du Bois explains, was "free in everything but name only [. . . they] acquired property, reared families and often lived in comfort."[19] That the slave artisan enjoyed special privileges is confirmed by James Newton, who determines that many slave artisans could read and write besides enjoying special benefits: "they received better clothes; more food; and were extended special privileges."[20]

In antebellum South Carolina, a slave craftsman with Dave's extraordinary skill would ascend to a social position commensurate with that of free blacks, attaining, as Du Bois reasons, a de facto freedom. Especially in urban centers such as Charleston, black skilled crafters enjoyed a greater degree of freedom than plantation slaves, and though not technically free, occupied a liminal caste between free blacks and slaves, earning them the designation of "quasi-slave" by historian Marina Wikramanayake.[21] As an accomplished craftsman, Dave probably would have shared in the privileges available to quasi-slaves such as hiring out their own time, entering into contracts despite growing legal restrictions, and living at a distance from masters. Although living in semi-rural Edgefield, Dave may have lived in a manner not unlike the urban quasi-slave craftsman, who "worked independently, or for an employer, [with] the slaveholder receiv[ing] a commission on the slave's earnings."[22]

Apart from the documentational production coding typical to Edgefield jars, which indicate the date and the producer's initials, the following jar coded "Lm July 31 1840" by Dave (fig. 6.2) may have distinguished itself from the pieces surrounding it by the discernible skill of its production as well as the less discernible couplet of autobiographical poetry incised just under the wide lip of its spout:

> Dave belongs to Mr. Miles
> wher the oven bakes & the pot biles

Departing from jars commonly found in the antebellum market, this one gives biographical information relating to the ownership of its producer and thus puts the reader-buyer into dialogue with the commodity-jar's creator, a dialogue that speaks via fugitive and contraband inscriptions (i.e., slave signature and poetry on an unusually large craft object) along conventionally mute pathways of exchange. But our "speaking" creator-crafter and the central voice or subject position we assign to him must be analyzed still further to capture the hybrid complexities of Dave's expression of selfhood.

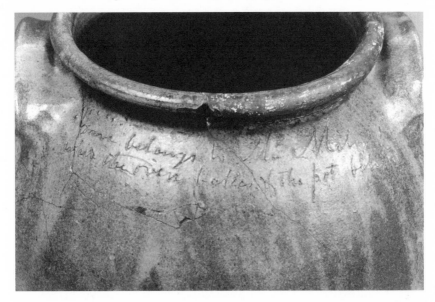

Figure 6.2. Detail of 1840 Vessel. Courtesy of The Charleston Museum, Charleston, South Carolina.

As we shall see, the authorial subjectivity communicated in the multiple forms of writing on the jars construe Dave as a conglomeration of differently positioned identities.

Reading for Multiple Forms of Dave

While Dave is at once the author and creator of his jars, he is also often a subject represented within the couplets incised upon them. By moving back and forth from a literary reading of the words in the couplet to a visual analysis of the way the words in the couplet appear, we may begin to identify a number of contradictory positions occupied by Dave. In the example given above (fig. 6.2), identity is not simply expressed verbally, but relationally as well. In this section I will analyze the ways in which Dave's multimediated jars position Dave as both fixed and fluid, working humbly beneath and defiantly above the master, Lewis Miles. Here again, the visual dimensions of the jar, the typeface of its writing as well as its signature, vie against any simple reading of the jar's verbal component. As a result of this self-splitting, Dave represents himself as both deferential and resistant to systems of dehumanization and commodification. To explore this contradiction, let us begin with Dave's conformance to proslavery discourses.

In the above-cited couplet the self-textualizing potter announces himself to be, like his jars, a commodity, located in a region whose landmarks—

"wher the oven bakes & the pot biles"—conjure images of the pottery where the jars begin and the kitchen where the jars are destined to go. The speaker emerges not just in relation to his owner, as a belonging, but to the tools of his trade as well. The couplet foregrounds an equation between persons and things; Dave locates himself structurally alongside the "oven" and the "pot" and thus defines himself in metonymic relation to the master's machinery. This connection between the place and tools of production reinforces a grim historical equality with which many whites viewed slave crafters and artisanal fixed capital. For example, Peter Wood points out that in Southern periodical advertisements it was customary for well-skilled slaves to be lumped in with the wares when places of trade such as shops, mills, and factories were put up for sale.[23] This principal correlation with the appliances of his craft establishes a subjected identity for the Dave who appears as the speaker of the couplet.

The typeface design of the incised names of Dave and his master within the couplet further position the potter as diminutive and powerless compared to the master. But before investigating what is revealed in the way the names are incised, it is important to recognize the multiplicity of figures represented in the poetry-pottery signified by the word "Dave." Indeed, the creator "Dave" is conveyed through the production initials accompanying the pot in small, precise letters apart from the "Dave" *within* the couplet, who is partly embodied in the typographical attributes of the word, its size, shape, depth, and consistency of incision. Both of these Daves are dwarfed by the master's larger name. The contrast becomes clear when we compare the indistinct typography of the couplet's "Dave" to that of the owner's name. As if to illustrate a sense of distance implied in the name, the lettering of "Mr. Miles" is conspicuously elongated. The twin peaks of the "M" in Miles extend to a significant height, forming an angular zenith artfully counterbalanced by the generously spaced and curvilinear forms at the base of the letter. Opposing the breadth of the master's name is the faint, squat lettering of the potter's. With its final "e" reduced to a miniature loop and the capital "D" scarcely legible, hardly taller than the other letters, Dave's name contains letters that seem to be kerned together. In representing his own name through the process of kerning, a typographical technique in which the spaces between letters are so reduced as to make the letters appear to overlap, the potter may be differentiating the owned, compressed, and compromised "Dave" from both the grandiloquent "Dave," whose signature explodes with colossal distinction on the sides of many of the jars, and the workaday "Dave," whose name appears in legible, squared forms next to the *abbreviated* initials of the master. Therefore, the couplet of this particular jar reverses the typographical personalities usually assigned to Dave and Mr. Miles in most of Dave's work, as the lettering of the former takes on

a foreshortened humility more typical to that of the latter, the stamp-like "LM" of the jar's production information.

Another way that we might read this jar and its couplet as conforming to the logic of slavery is by contextualizing the apparent control over the creation of the jar allowed to Dave by the master in terms of the region's policies of slave management at the time. The potter's seemingly unusual control of his work may actually show Dave to be the beneficiary of an established tradition of strategic leniency and faux partnership extended to slaves in South Carolina after the 1820s as a means of forestalling slave rebellions.

A state-wide custom of allowing slaves limited forms of private ownership may account for the dramatic autonomy evidenced in Dave's work. Larry Hudson, Jr., explores the opportunities available to slaves working under South Carolina's task system, which allowed them to stabilize family units and even to acquire private land and goods in their spare time: "An ability (and willingness) to execute their work assignments in the public world efficiently gained the slaves more time to spend working their gardens and increased their 'living space.'"[24] In a task-based organization of labor, slaves had to complete pre-set "tasks" for the master's livelihood (typically between ten and twelve hours of work) before being able to tend to their own allotments, mainly at night. That the task system had become routine throughout the state of South Carolina reflects its effectiveness as a form of ideological labor control. "Throughout the state," Hudson reports, "masters used a task system to a greater or lesser degree, and, whenever possible, they allowed their slaves a small piece of land to plant for their own use."[25] Providing such concessions to an enslaved workforce enabled masters to maintain control by inducing the slave to envision his or her prosperity as being inextricably allied to that of the plantation.

Manufactured within such a climate of nominal labor trade-offs and cozening incentives, Dave's work reflects the task system's balance between public productivity and private enterprise. Like the plantation slave's garden, the writing on Dave's pots, his couplets and signature, comprises a self-directed output of labor sanctioned by the corresponding plenitude of his pots, which, like the plantation slave's fieldwork, represents public labor completed at the behest and for the primary benefit of the master. Extending the analogy, we might read the "small piece of land" that Dave metaphorically cultivates for his own use as the face or wall of the functional craft object, a normally non-arable tract of land on which he plants private markers of ownership, tilling self-interest and egoistic fame. Of course, this agricultural metaphor cannot fully account for the intermingling of media in Dave's poetry-pottery, since these complexities of form resist any simple prying apart of the clay from the couplets. For just as the flowing signature

on the pots readily announces Dave's aberrant will-to-fame, so too does the enormity and skilled design of the vessel—especially when we consider that earthenware of such a size and with particular glazes would just as immediately disclose Dave the Potter's craftsmanship to the knowledgeable viewer even if his name were absent. Although Dave leaves his imprint on each pot in multiple and unique ways, he does so within the artisan's equivalent of the task system, in which what seems to be self-benefiting labor ultimately benefits the system that enslaves him.

Despite this evidence of Dave's subjection and conformity, it is not difficult to find evidence of his resistance to hierarchical ideologies of slavery. While the potter's status seems to be minimized by being equated to the tools of production, the couplet of the "Dave belongs . . ." pot also indirectly minimizes the status of the owner. Aside from having the dignifying titles of family name and "Mr." (in contradistinction to the potter's abridged surname), "Mr. Miles" is given rhetorical shape and substance in the couplet by being rhymed with the anomalous word "biles," a variation of "boils." Perhaps a vernacular distortion, "biles" finalizes the web of ownership that the speaker finds himself in and, in a slippery way, returns rhetorical control to Dave, who is hereby able to incorporate the signified body of his master into the fixed capital of the pottery works itself. Dave does not necessarily belong to Mr. Miles the man, the couplet suggests, but to Mr. Miles a locationally specific entity, an abstracted place housing the active tools of oven and pot. Thus, Dave diffuses Miles's legal ownership by making him the linguistic equivalent of the pottery works, which Dave in turn takes ownership of by stylizing the action of the pot. In the couplet the pot is at once a meta-reflexive signifier, referring to the *material* pot upon which the word "pot" is written, and an abstraction that exists before the moment of sale, an *ideal* pot, as yet unmade, which continues to accrue value in the liquefaction of its "biling."

The ideal pot that "biles" relates significantly to the action of the material pot that becomes the ground of the couplet's writing. Given the general use of the term "bile" as an important fluid governing digestion and emotion, one may wonder as to the implications of attaching a verb like "biles" to an object eventually meant to store grain. Following this reading, the pot figured in the couplet as well as the larger one being read take on somatic features beyond those ordinarily attributed to ceramic vessels. Constructed as a kind of stomach, a container of bile and an index of a present-tense effusion of emotion, the jar that biles may reference anger toward the work at the pottery, perhaps in response to Mr. Miles's ownership. After all, it is ironic that while the couplet doles out two active verbs to pottery tools it only assigns a transitive verb to such a prolific potter-creator as Dave. By

association Dave may be seen as baking and biling, but by direct reference alone, he merely belongs.

One effect of encoding his handiwork with writing is that it provides Dave multiple spaces in which to perform self-splitting. As both psychic protection and projection, this splitting allows Dave to separate a sense of himself as a master craftsman (signature) from that sense of himself as someone else's property (the diminutive Dave in the couplet), and to present himself as the esoteric sum of these discordant identities. The splitting found in the writing of his pots furnishes a canny merging of dissident politics with dutiful labor, wherein Dave intimates a politics of resistance against his condition as a slave in the very act of completing his mandated task as one. The resistance I read into Dave's heterogeneity of selfhood coheres with Stuart Hall's assertion that representations of "cultural identity," as systems of flux and process, erode racist assumptions.[26] Presumably, within the culture of Dave's clientele, blackness is viewed as essential, unchanging, and homogenous. But like Hall, Dave espouses through his performance of variegated selves a notion of identity as "a matter of 'becoming' as well as 'being.'"[27] The differently positioned Daves found on the jars lead to a break from racial absolutisms and imagine slave selfhood as capable of embodying such contrarieties as slave and master. Just as commodity objects and dominant subjects are culturally sanctioned to be both themselves and more than themselves simultaneously, Dave exercises a strategy of selfhood that accounts for contrary and diverse locations of identity and, as a result, gestures toward resistance.

In representing himself as a split subject, inhabiting contradictory social positions, at once deserving of respect and exercising mastery, at once chattel and muted, Dave the Potter realizes a type of resistance that Paul Smith imagines as "the possibility of resistance through a recognition of the simultaneous non-unity and non-consistency of subject positions."[28] Such splitting achieves resistance insofar as colonial discourse, the rhetoric of the master class, insists upon the singular rigidity or essentialism of slave identity, as Bhabha notes here: "Splitting constitutes an intricate strategy of defense and differentiation in the colonial discourse. Two contradictory and independent attitudes inhabit the same place [. . .] This results in the production of multiple and contradictory belief."[29] According to Bhabha, splitting is the mechanism of displacement by which colonial discourse is disarticulated and its totalizing attempts to narrowly define the subaltern undone.

Dave's splitting elicits a correspondence with slave narratives in that it offers resistance to the complex demands placed upon the slave's submission to the expectations of a white audience. Dave exudes the same sophistica-

tion of complex resistance that William L. Andrews points out in narratives that repudiate objective autobiography, "which demanded that a black narrator achieve credence by objectifying himself and passivizing his voice."[30] Dave's work revalues the assumption that "passivizing" signifies submission to white expectations, however, since the enslaved potter cannot throw off the mantle of passivity so safely as Douglass, but neither does he don that mantle exclusively in self-representations of consistently split subject positions. Thus, in splitting selfhood into the opposing but similarly public textual spaces of professional mastery (signature and jar/pot) and objectified chattel (verse), Dave gestures to the elastic, dialogic nature of his represented identity as irreducible, non-essentialist, and indeterminate.

More than simply rejecting the singularity of subjected identity, however, Dave's work also presents Mr. Miles (LM) multiply, thus demonstrating a comprehensive turn away from binaries such as slave-owner, black-white, and self-other. Like the primordial clay Dave describes as fungible even after becoming a finished pot, identity, as implied in his work, is a transformational product, marking changeable positions of difference rather than stable culminations of being.

The materiality of the ceramics complicates the theory of identity signified in Dave's work even further. For still another Dave is represented in the action of the jar other than the presumed speaker and maker—the Dave of the jar itself. Though it would be absurd to assume that customers would mistake the potter's signature for a whimsical name for the jar, it would not be extravagant in a semiotic analysis to speculate about the effects of considering the jars as bearing Dave's name as if it were their own. Indeed, the name appears so dominantly across the vessels that the signing seems to reproduce a naming ritual. In giving his work his name, the potter is doing more than simply recording his creations as his own or grandly taking possession of them; he is imparting them with the sign of his identity and rejoicing in their dissemination as vicarious experiences of freedom. Although a thorough investigation of the ramifications of this linkage between the jar as surrogate body and the signature is beyond the scope of this chapter, it is important to note here the connection between the indisputably owned body of the central speaker and the more mercurial kind of owned body of the jar. If Dave does not fully escape the status of an owned thing in his writing, perhaps he exchanges one type of commodity status as a captive for another type embodied in the jar.

The couplet of the "Dave belongs . . ." jar links the speaker, the jar, and ultimately the reader in a system of depersonalization and ownership. At any moment of reading, what is most striking is that the jar has any ornamental writing at all, let alone that the writing is executed quite brazenly by a literate slave whose witty couplets often rewrite the scene of produc-

tion-consumption as a moment of communication, a rebellious act of writing and reading. That he would take up the pen at all places Dave in the company of those whom critics today might call "techno-rebels." Harryette Mullen proposes that if we view slave narratives as "interracial collaborative textual productions made possible by the sharing of the technology of writing," then the genre may be seen to anticipate "the technological grafting of white body and black soul through the mechanical synchronization of filmic image and soundtrack" technology of the twentieth century.[31] Dave's work is no less prescient as it appropriates the colonizer's technology and uses it to insinuate the slave crafter in the market through an insertion of writing. Henry Louis Gates, Jr.'s, *The Slave's Narrative* continues this connection between literacy and technology, thoroughly tracing the origins of the tautological prejudice that justified slavery on grounds of the slave's "natural" illiteracy. Gates argues that literacy "was a commodity [slaves] were forced to trade for their humanity."[32] Retooling the very technology of scientific discourse in his combined use of writing and pottery, Dave empowers the device of the signature to do the phantasmatic work of projecting an abstract, literate, and civilized humanity. Hence, Dave's signature functions as a supplement to the drama already observable in the potter's traditional grammar of shape, size, and design.

Perhaps another way to conceptualize Dave's production is as a fusion of two modes, work and play, often seen separately in Western culture, but synthesized in creolized slave works. Sterling Stuckey clarifies this synthesis: "Coming from cultures in which work and art were united so completely that any notion of art for art's sake lacked meaning, Africans in North America created while working, as they had done before . . . slave creativity helped ease the pain of labor than might otherwise have been intolerable."[33] Dave's self-aggrandizing play in the salience of his signature and the wit of his verse recalls the work ethic expressed by ex-slave craftsmen in their personal narratives, as when James W. C. Pennington speaks poignantly about his devotion to blacksmithing:

> I had always aimed to be trustworthy; and feeling a high degree of mechanical pride, I had aimed to do my work with dispatch and skill; my blacksmith's pride and trade was one thing that had reconciled me so long to remain a slave. I sought to distinguish myself in the finer branches of the business by invention and finish.[34]

Alternatively, the fusion we find in Dave's jars recalls the African-based ritual as well as practical purposes of jars and clay pots in slave life, uniting sacred and secular domains. Teresa N. Washington argues that while pots were common tools of domesticity, they became spiritual vehicles when upended to catch the "sounds of worship," or when filled with water: "The

water and the pot, then, were not only tools of sympathetic conjure used to keep the word contained among the supplicants and away from the oppressor's ear, but they were also used to send the requests swiftly to the Orisa and the spiritual realm."[35]

Notwithstanding the brutal exploitation of the slave system, Dave's work similarly accentuates resistance to alienation, but it simultaneously draws attention to the alienating conditions conspiring to make the slave artisan no more than a cog in the machine of commodity production. Like Pennington's pronouncement of his "blacksmith's pride," many of Dave's couplets underscore the artisan's investment not so much in the object itself, but in the process of its creation. While the commodity object (the material pot or jar) can be owned by a consumer, the message borne upon it often alludes to Dave's creative labor as a private investment that is both greater in value than the object and, more importantly, unavailable for purchase, exploitation, or, in many cases, even comprehension.

One fifteen-gallon jar, which recently broke auction records when it was bought for $83,600 on December 2, 2000, offers an example of Dave's strategic mystification of his own labor (fig. 6.3). One side of the rim bears the following production information: "LM Jan. 30, 1858—Dave," with the initials both indicating Lewis Miles as Dave's owner and naming the eponymous place of production, which somewhat attenuates his ownership of Dave. On the other side of the rim appears the following couplet: "Making This Jar—I Had All Thoughts / Lads & Gentlemen—Never Out Walks." Here again, the potter focuses on a time period before the market, taking the reader back to the moment of the jar's creation. This is a temporality at odds with the market, since it is here that the clay symbolizes possibility, a zone of productivity not determined by the demands of the consumer or owner, and entirely within the control of the crafter. We might gloss the couplet as saying that the fecundity of Dave's imagination can never be outstripped by the patriarchal aristocratic classes designated by "lads" and "gentlemen," who may be Dave's superiors, owners and clientele, but never his equals in the realm of creative production. This anterior realm of pure possibility—this place of biling, as it were—paradoxically emblazons on the commodity object the taunt that the jar itself is less valuable than its maker, and that, despite the maker's status as property, his access to a region of pure possibility far exceeds that of the master class to which he is subject. In the couplet, the effect of Dave's reference to his creative genius in making the pot excludes the consumer, if only implicitly, from this prior condition of abstract value.

Through his writing, Dave contributes to the mystification of his labor, but not in the traditional Marxist sense, whereby workers and consumers are distanced from labor through systems of commodity fetishism. Rather, Dave's poetry records directly onto the commodity object the satisfaction

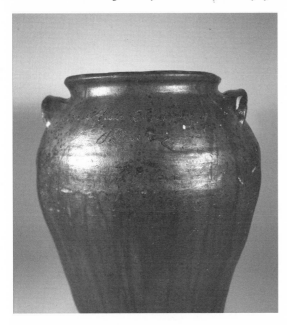

Figure 6.3. 15-Gallon
Jar, 1858

he takes in his own productivity, making the commodity bear the trace of the artisan's relationship to his labor in his own words. The rhetorical force of this record, as in the "I made this" or "Making this pot" examples, celebrates the potter-poet's creative relation to his labor but mystifies this relation for the consumer who is imagined by the couplets as existing outside of this productivity. Therefore, this record of Dave's labor before the clay becomes an object or a product resists alienation.

But the fact that this resistance is in the form of poetry, and in a style that would have been recognized as "Negro" or Gullah at that, leaves Dave's lyrical manifestos against alienation open to another kind of objectification. Indeed, the appropriation of Negro expression was a staple form of commodification throughout antebellum America, thanks largely to the practice of minstrelsy. Therefore, it would be more accurate to conceptualize Dave's poetry as a potentially subversive message that prioritizes slave labor and excludes white consumers from taking full possession of that labor conveyed in a medium regularly associated with the debasement of slaves. Although some of the poetry on Dave's work boldly resists alienation and therefore challenges the exploitative conditions of its production, it does so in a language that is congruent with those conditions.

However, the appropriable nature of slave dialect does not dampen entirely the resistance it can be made to achieve in every context. The social circumstances of the period precluded a transparent language of militant revolution among slaves. If neologisms like "biles" or defamiliarizing us-

ages like "out walks" were to operate subversively, they did so only under the reassuring cover of nonsense, a semantic register commonly attributed to slave speech by whites liable to view the slave as more inept than savage—if only to repress lingering fears of Vessey's thwarted rebellion. Even so, the nonsense of dialect possesses revolutionary potential. As Peter Wood explains, while a command of proper English offers obvious advantages (eavesdropping on important news, for example), a mastery of "bad" English could be just as useful; employing a language unintelligible to white oppressors provided slaves with "effectual elements of resistance."[36]

A few of Dave's jars directly confront the ideologies of the Southern market and capitalism without the mitigating use of the vernacular. For example, one jar of August 22, 1857, teases, "I made this jar for cash / though its called lucre trash." Waxing moralistic, Dave presents a practical yet shockingly honest attitude toward material gain, contrasting the message of the earlier jar in which the crafter derives a value not reducible to market relations from producing the jar. Similarly, another jar of 1840 admits, "Give me silver or either gold / though they are dangerous to our soul." Implicated in a plantation economy based essentially around a rich planter aristocracy, these jars preach a surprisingly hard-nosed materialism not unlike that of Frederick Douglass's *Narrative,* in which the slave rails against the economic backwardness of the planter class as he cultivates for himself a traditionally Northern, even Franklinesque, posture of industriousness. But there is more going on in these verses than candid admissions of economic motivation.

Dave's verses cited above invoke, profess, and subtly critique market relations. Dave's profession of greed (another jar pertly claims "Cash Wanted") presumes the overpowering ideological drive of acquisitiveness over Christian virtues of frugality, modesty, and sharing. His verse trades on the hypocrisies of his clientele as it references commonplace aphorisms moralizing against greed only to boldly reject them in favor of avarice. As a result, his cheeky frankness relies on reader-consumers to acknowledge the immoral, exploitative motivations driving market relations. In effect, by whimsically noting his own failure to obey conventional morality, Dave's couplets flaunt the hypocritical exaltation of monetary demand over social standards and religious ideology. Hence, the couplets have less to do with the creator's greed than with the hypocrisy of the culture for which the jar is marketed, and by extension they implicate the double standards underwriting the exploitation of slave labor. Ironically, however, it is this very quality of greed in consumers that would presumably inspire them to buy such a contumacious commodity object. The sale of such an object provides evidence for the durability and flexibility of the market to appropriate and

commodify that which would be considered antithetical to other social institutions such as the law, religion, or slavery.

To be sure, Dave's avowals of monetary gain are rebellious in a number of ways. First, South Carolina legally forbade slaves to participate in the cash economy, despite widespread practices of slaves bartering, hiring out their time, and even selling excess crops in an underground economy. Legally, slaves were viewed as bearing commodity value but were not permitted to be bearers of currency. These jars, therefore, display for public scrutiny an unlawful desire. Second, the jars signify on other domestic commodity objects adorned with Christian epigrams (pillows, wall hangings, quilts, etc.) and thus threaten to invade a space pristinely outfitted with unvarying bulletins of female resignation, chastity, and contentment with unruly messages of self-aggrandizement and the rejection of conventional moral codes.

But no matter how subversive we interpret these jars to be, they still point to the antebellum Southern market's appropriative capacity to accommodate Dave's anomalous works. Even when they do not bear mitigating dialect, these vessels do bear Dave's signature, which works in two contrary ideological directions at once. It registers the slave's ability to possess individuality, literacy, and skill in spite of proslavery ideologies proclaiming slaves to be incapable of them. Moreover, the signature also potentially tamps down any trace of resistance, writing it off as the weird but amusing genius of the slave craftsman, whose difference from other crafters, whether in the look or attitude of his wares, only heightens their market value and thus profits the master all the more. The very same catch-22 that rises up to squash the potential resistance of slave narrative ultimately sponsored and closely monitored by white abolitionists frames Dave's work. Before exploring the ways that Dave's signature complicates his relation to commodity and subject status, let us now turn to a comparison between Dave's work and antebellum slave narratives.

Dave and the Slave Narrative Tradition

The slave laborer was almost never meant to be individuated or identifiable in the finished products of the plantation economy. Likewise, the slave craft worker was not expected to identity himself in the process of production. Despite having access to resources beyond that of the field worker, he could not, in most cases, impress the finished product with a signature since most commodities—from decorative metal works and cabinetry to pottery and textiles—were engineered by teams of workers often owned by the same man. The owner's rather than the slave's name identified the company, which, as in the case of the Lewis Miles pottery, absorbed the collective

identity, labor, and profit of de-individuated workers under one patronymic insignia. A distinction therefore must be made between production codes, which may include marks designating the identity of particular workers, and signatures, which aestheticize or make conspicuously visible the written name of a creator. While many slave crafters recorded their labor through production codes, few did so through signatures. In signing his pots Dave radically affirms the uniqueness of his identity and simultaneously defies those market conventions that typically reserve signatures for works of high art rather than utilitarian commodities. Because the large pot type that Dave is most famous for constructing was a functional object, the identity of its producer—whether slave or free, white or black—was considered inconsequential. Disrupting this portrait of business-as-usual in the plantation economy, Dave's works blur generic categories between craft and art. And, as we have seen, they also blur boundaries between the visual and the verbal, challenging the very conceptual models of inquiry we might use to analyze them.

However, there are unsettling implications in celebrating Dave's foundational uniqueness and outspokenness in the face of the servility and reticence of "ordinary" slaves. Imputing to Dave the special status of an iconoclast runs the risk of perpetuating the masculinist bias overshadowing some of the revisionist history of nineteenth-century African American culture. Critics such as Deborah White and Deborah McDowell have voiced suspicion over the masculine inflections inherent to much of the rhetoric surrounding mid- to late twentieth-century attempts at establishing a black tradition. Setting out to replace the Sambo myth of the male slave, many black male scholars countered with what McDowell describes as "the myth of the male slave as militant, masculine, dominant, and triumphant in both private and public spheres."[37] Given the unusual expressiveness of Dave's jars, it is all too easy to frame him in triumphant terms; however, such a perspective loses sight of the incompleteness and intrinsic ambivalence of his gestures of resistance. While the following sections expound upon Dave's negotiation of the crafter's customary reticence—his hybrid affixing of the signature onto the commodity—they shall also expose the transitory nature of his resistance and thereby avoid establishing him as an unproblematic forefather of slavocratic defiance. Rather than positing Dave as a paragon of slave bravado in the masculine tradition, the final section of this chapter sets him in relation to a kind of ascension to subject status through the commodity associated with feminine, often fictional figures like Aunt Jemima.

As amalgams of pottery and poetry the pots play trickster to genre and thus require a critical apparatus able to bring together what at first glance seems to be two sets of incommensurable symbol systems, writing and pottery. A thorough analysis of Dave's work must explicate those strands of in-

terconnectivity that link the pots to similar cultural representations embedded within the context of slavery. And while there is a relentlessly growing body of socio-historical work excavating a wide array of nineteenth-century slave culture, very little of this type of scholarship makes authoritative claims about hybrid slave expressivity. What makes Dave's works "hybrid" goes beyond their blending of words and clay to include their combination of contradictory discourses. For example, a signature designates an artwork to have cultural and not functional value, while a pot or a jar normally indicates the reverse: connoting an object that is physically used and handled. Writing, on the other hand, construes a symbol system that opposes the primacy of touch associated with functional objects. Dave's pots blend two types of value and symbol systems normally regarded as antithetical and thus constitute an "assemblage"—Gilles Deleuze and Félix Guattari's word for something that is both a technical instrument as well as a text, something "simultaneously and inseparably a machinic assemblage and an assemblage of enunciation."[38] Seeing Dave's jars as assemblages foregrounds the way that the textual or ennunciative capacities of Dave's ceramics are inseparable from their functional uses. This means approaching his wares not just as functional artifacts within a genealogy of crafts but as cultural objects that bespeak and speak back to the social conditions in which they were produced, consumed, and used.

Assemblages like Dave's often fall outside of the focus of survey historiography bent on exploring the representative. How then shall we analyze the hybrid effects of Dave's work? If we consider some of Dave's verses as primarily self-referential in their modes of address, then we may benefit by reading them as, among other things, moments of antebellum African American autobiography, or more precisely, as slave narratives in miniature. Indeed, the works of Dave the Potter propose a variety of significant parallels to slave narratives, and counterposing Dave's hybrid poem-pots against them sheds new light on many central concerns of slave narrative scholarship. The most obvious similarity is an underlying tension between private disclosure and conformity to generic convention, which requires a balance between autobiographical uniqueness and ethnographic typicality. This tension plays out in the conflicting demands of the market. While the conventions of slavery demand that Dave produce functional storage jars for the profit of his master, his jars add a dimension of personal style, a particularity that accrues value—both in the antebellum market as well as in current auction circuits—primarily because of their divergence from the norm. Likewise, early slave narratives evince similar limiting pressures to suppress particularity in favor of representative aspects of the slave experience. The role of the abolitionist sponsor and the parochial discursive limits placed upon slave testimony correspond with the role played by the

slave master and the market demands for generic crafts for sale. The lasting commercial interest in Dave's unusually vocal productions attests to a contradictory consumer demand within the antebellum Southern craft market for work that blends the ethnographic spectacle of representative artifacts of slavery with the autobiographical, performative spectacle of personal disclosure related to abolitionist publishing.

The fact that Dave's potentially subversive expressions, so like those found in the abolitionist press, were made public within the South amends assumptions about the overwhelming silence of antebellum slaves in the South. Jeannine DeLombard claims, for example, that abolitionism frequently positions the South as a space of silence as well as violence for the slave, since the slave was excluded from juridical forums and debarred from testifying against the master.[39] Dave's work forces an awareness of the contingency of the slave's silence in the South as his jars testify against the master by proxy. Although slaves were legally forbidden to indict masters, Dave's ceramics enunciate that which he cannot, accomplishing a radical reversal of the staging of mastery that was endemic to the maintenance of slavocratic authority. Saidiya Hartman claims that in the slaveholding South "the exercise of power was inseparable from its display [and that] representing power was essential to reproducing domination."[40] Masters regularly staged scenes of power in order to constitute their authority through such performances. By contrast, my reading of Dave's couplet incised on Dave's *Roadshow* jar, with which I open this chapter, demonstrates how the master's authorial intrusion into the pot's construction ultimately proves the master's ineptitude and reserves for the slave both artisanal and rhetorical mastery. Dave alone knows just how much would break the handle. He fashions himself to be a master of approaching (but not quite crossing) thresholds of rupture and excess. But for all of this jar's brashness in casting the official master in a negative light, it may also be read as proof of the slave's exploitable value. What master needs to know the potter's craft so thoroughly when he can own a potter like Dave who could do the work for him?

Aside from disputing authority, Dave's works echo slave narratives in meditating on the ruinous effects of the Diaspora and disconnection from community. An example of Dave's diasporic aesthetic occurs on a remarkable storage jar dated 1857. On one side of the jar we read, "I wonder where is all my relation," and do not find our answer until turning the jar, where we arrive at the displaced response, "Friendship to all and every nation." In the process of reading this couplet in the round, the jar is transformed into a model of the globe as the arrangement of words offers a graphic metaphor of the dispersal of bodies queried in the couplet. It is the circular positioning of the couplet—its rhetorical structure—that answers the opening question, not the supplied response. Significantly, the response circumvents the

question of lost relations by invoking, rather saccharinely, the harmonious image of transnational community. The idea that Dave, despite being an African slave, can find comfort in his universal belonging to the global community could have been seen as congruent with the popular poetic voice of Christian sentimentalism, but must have also seemed almost frighteningly ironic for a member of a violently dislocated group to express on a jar in one of the most fiery regions of secessionism of the South. Read another way, the couplet emblematizes how Dave's immediate relations get lost in the gap, recoverable only by being abstractly redefined. And because the couplet here is designed according to a horizontal rather than a vertical arrangement, nothing other than the slightly larger space separating "I" from "nation" prevents us from reading the much more bolder statement: "Friendship to all and every nation I wonder where is all my relation." In this configuration, the opening platitude and the unity it proposes dissolve to insignificance under the tragic weight of the speaker's musing. As with so many other couplets, irony acknowledges the emptiness of aphoristic rhetoric. More importantly, the meaning of the words (the verbal dimension of the assemblage) cannot be deciphered apart from the physical (visual and haptic dimension).

This last point is central because a consideration of Dave's work further revises scholarly assumptions regarding the status of visuality in the antebellum period. According to Jonathan Crary, before the explosion of commodity culture in the nineteenth century, vision was organized around metaphors of touch: "But in the nineteenth century such a notion became incompatible with a field organized around exchange and flux, in which a knowledge bound up in touch would have been irreconcilable with the centrality of mobile signs and commodities whose identity is exclusively optical."[41] But Dave the Potter's works refuse the "subsumption of the tactile within the optical" that Crary claims to be a consequence of the antebellum market's explosion of commodities.[42] Tactile reading of the pots is a prerequisite to reading the writing upon them. For example, the integrity of the *Roadshow* jug's handle can only be partly deciphered by sight. Indeed, the owner's reported caution invites prospective buyers to physically test the handle's durability. Less obvious is the circumnavigating language of the Diaspora pot, whose gap in the round requires either a tactile turning of the object or a physical circulation of the observer.

A reading of physical gaps or marks also becomes a crucial tool for slave narrators who inscribe the lash marks recorded upon their own bodies as authentication of the veracity of their narratives. In the most famous example, Douglass pauses his retrospective narration in order to engage in a haptic reading of his own body: He places the pen that writes the narrative in the authorial present upon the wounds inflicted in the narrated past. The

202 | *Still Moving*

pen measures not just the lasting proof of Douglass's experiences in slavery written upon his body, it also measures the temporal gap between the event of his injury and its representation in writing. The effect in the narrative, of course, dissolves this temporal gap, making it seem as though the wounds of the feet are palpably re-inflicted by the pen that resurrects the past. Similarly, Dave's gap on the Diaspora jar physically represents a temporal break in representation, a gap that links to ancestral absence, memory, and the limits of representation. Haptic and optic modes of perception or knowledge are indissolubly combined in Dave's oeuvre, as in the case of Douglass's pen, in order to represent that which cannot be conveyed in language alone. For Dave as with Douglass, language references a time-space that opposes the immediacy of tactile communication, of touching the gaps and wounds of slavery.

As evidenced by the Diaspora jar, Dave's work carries on the double-voiced cultural work of slave religion as seen by Eugene Genovese in that it sustains African impulses among slaves on one hand, while offering reassurances to whites of the docility and acculturation of blacks, on the other: "The black variant of Christianity laid the foundations of a protonationalist consciousness and at the same time stretched a universalist offering of forgiveness and ultimate reconciliation to white America."[43] Alluding to the tragic mass dislocation of Africans in America, this couplet provides the best evidence for treating the entire collection of Dave's writings as potential engagements with his enslaved condition in writing, shrouding these engagements with linguistic and sentimental indirection.

Dave's strategic use of indirection points up another similarity to slave narratives. While both slave narratives and Dave's work superficially champion a politics of slavery in keeping with their sponsors, they also momentarily break away from these discursive models to criticize not just slavery but dominant white culture as well. Examples from slave narratives are numerous, but Dave's participation in such criticism is, not surprisingly, more shielded. We can, for example, infer an embedded critique of oppressive ownership systems in the self-splitting demonstrated in the "Dave belongs to Mr. Miles" jar. This piece thematizes a struggle for self-authorship, which becomes for Andrews and other slave narrative scholars a central trope of the genre. Similarly, the implied exposure of Christian hypocrisy in the verses flaunting the slave's greed correlate, in effect if not in address, to Douglass's excoriation of racially motivated inconsistencies in American moral doctrine North and South. And finally, the instrumentality of literacy in elevating the slave to the status of a speaking subject emerges in both works in concert with the visual field as yet another, though less commented upon, avenue toward agency for the antebellum slave. Although a historical curiosity, Dave's "speaking jars" may expand our understanding of the effects

and limits of literacy for those engaged in the project of self-emancipation, especially when we position literacy in tandem with techniques of visual self-representation, such as illustration for slave narrators or, in Dave's case, creation in the plastic arts and in the use, reproduction, and dissemination of signatures.

The Paradox of the Slave Signature

As in slave narratives, Dave's construction of personhood depends upon manipulating different fields of representation. The kind of personhood produced in such acts of manipulation, therefore, is more textual or discursive than essential. William L. Andrews offers this advice for describing the authorial presence referred to in nineteenth-century slave narratives: "Because the ontology of autobiography is so problematic, it seems to me more fruitful to treat the form more as a complex of linguistic acts in a discursive field than as the verbal emblem of an essential self uniquely stamped on a historical narrative."[44] While Andrews stresses the fallacy of misinterpreting the represented or discursive self for the "real" historical entity, or essentially mistaking persona for person in slave narratives, his urging that we heed the distinction of the represented self is made even more complicated by the special circumstances of Dave's art: his signatures seem to "stamp" an essential self onto a commodity object. And yet, closer examination of the implications of Dave's grandiose signature finally unravels the authenticity of the subjectivity signaled by the name.

Especially when decoded in their own time, the jars and the messages they contain must have garnered the approval of white authority. In spite of their dissident overtones, the jars would not have been permitted to exist if not for the profit of their white masters. Hence, even when the subjectivity conveyed by the writing on the jars seems inimical to the master's authority or to white dominance, the resistance available in such expressions is always already compromised from the moment of inscription. Indeed, Dave's mercurial self-representation, his simultaneous acceptance and defiance of oppression, exemplifies a conundrum of discursive power familiar to scholars of slave narrative and other literatures of minoritized subjects forced to appropriate dominant systems of representation. It would be hasty, however, to give in to hermeneutic cynicism and augur that neither for Dave do the master's tools destroy the master's house. The signatures on Dave's works do reference a boldly individual slave identity, but it is one that is finally appropriated by the process of production as a trademark. Thus Dave's polysemous jars are both endorsements of the system and emblems of its subversion, both a testament to the allowable latitude of the slave system and a critical exception to its practices.

Theorizing what effects the signatures on these jars have in terms of Dave's relation to dominant systems of slavery and commodity production indirectly refocuses our assumptions about the primacy of literacy in attaining subject status for nineteenth-century African Americans more generally. Rather than momentously signifying his transition from commodity status to personhood, as with Douglass's shedding of the name Bailey, the signatures on Dave's jars draw attention to the impossibility of attaining authority outside of the agency of the commodity form. Dave uses his pots in the same way that ex-fugitives used the abolitionist press, as a commercially valued text on which to attach evidence of ontological equality in a form legible to dominant white culture. In the same way that many slave narratives were published alongside supplementary legal documents bearing the slave's signature, for Dave the commercial jar becomes a kind of supplementary document circulating his will to being in the Southern public sphere of the market.

The signature also operates as an index to the jar's temporality, inscribing "history onto the utilitarian."[45] However, the historical veracity of the real Dave may only be conceived of as a trace in the signatures left on his works, as suggested by deconstructionist criticism which has discovered a capacity for temporal ambiguity in signatures.[46] The crux of the matter for the deconstructionist is that the signature promises to signify a paradox, something that earmarks a pure, singular event, but also something that can be repeated. The singularity of identity that Dave achieves through his deployment of the signature makes the pureness of the moment in time when he signed the pot even more tangible since we can touch the tool marks of his signing on the finished product. Moreover, the repeatability of Dave's signature may be witnessed by the uniform appearance of the name on a number of pieces. But while Dave's signatures flaunt his access to this literate practice of signing in order to represent himself as a transcendental subject in writing, they do so in a way that also seems to curiously flaunt an awareness of the signature's partiality, its impossibility of ever being able to reproduce a pure, unrepeatable event.

I take this detour through deconstruction to consider how Dave's signature relates to the supposedly "pure" event it coincides with, the making of the commodity. Many of Dave's couplets indicate his preoccupation with the making and unmaking of the pot or jar and render Dave as both maker of commodities and as a commodity himself. Like the deconstructionist's notion of the signature, which creates a false replication of a pure event that is by definition incapable of being repeated, Dave engages in a process of referring repeatedly back to a moment of making, when the commodity object is yet unmade. This bilin' moment also precedes the demand for anything having to be signed. It is a moment not of production but of producing, and

as such, it lays stress on the process that gives rise to the jar as much as to the signature. Prior to the existence of a signed Dave, the bilin' moment makes irrelevant Dave's coming to terms with himself as a commodity in the process of commodity production.

A parallel may be drawn between Dave the Potter's fascination for making and unmaking and Douglass's metadiscursive commentary on the function of the sections within his narrative, where in the first section we see how a "man is made into a slave," and the next shows the reverse. In both cases, the slave seems to urgently desire ontological realization, to undergo personhood as though identity itself was but a process of manufacturing. James Olney argues that slave writing involves an ontological realization through literary self-production, through the replacement of a void or a discursive nothingness with a material text. Olney interprets the manner by which Frederick Douglass signs his narrative ("I subscribe myself") as a moment of self-textualization, of becoming a something from nothing:

> The ability to utter his name, and more significantly to utter it in the mysterious characters on a page where it will continue to sound in silence so long as readers continue to construe the characters, is what Douglass' *Narrative* is about, for in that lettered utterance is assertion of identity and in identity is freedom—freedom from slavery, freedom from ignorance, freedom from non-being, freedom even from time.[47]

We may extrapolate from Dave's signature a similar moment of the slave's actualization in light of Olney's celebration of Douglass's achievement of transcendent subjectivity through literacy. According to Olney, "The portrait and the signature . . . like the prefatory and appended letters, the titular tag 'Written by Himself,' and the standard opening 'I was born,' are intended to attest to the real existence of a narrator."[48] If "real existence" refers to a singular entity, however, the signature accompanying Dave's jars does not necessarily function in a comparable manner. Whereas Douglass's signature may function to index a real existence in keeping with privileged Euroamerican assumptions, Dave's surname-less, ornamental signature functions to reveal the slave's distance from the privileged norm of existence.

Houston Baker, Jr., offers a different theory of the signature, one perhaps more sensitive to the broken family ties and object status of the slave. The signatorial X, according to Baker, marks the space at the end of the traditional Blues song, inviting the listener to access and appropriate the central identity of the Blues singer as a commodity.[49] Thinking about the jars as commodities that bear a name upon them relates to products in our own time. The name on a "Tommy Hilfiger" sweater, for instance, accrues an extra-commercial value outside of its immediate circulation in a material system of exchange. This is the value that seizes the name as it circulates

in a cultural economy beyond the usual discursive restrictions prohibiting black participation in the "public sphere." Like a logonymic product, one that bears a name, Dave's signature not only gestures toward sign, in a precarious attempt to substitute logos for corpus or the written word for the material body, it also becomes signage—conferring upon "Dave" the same symbolic capacity invested in the owner, Lewis Miles, to name the greater corporation. As a logotype, the name is evacuated of its function to nominate an individual at all. Indeed, the anxiety raised by the radical inscription of this master-artisan and slave-poet onto the craft object is placated as the signatorial Dave discursively stamps itself with authority—not through the assertion of individuality, but through the power of the commodity form.

Conclusion: Bilin' and Trademark Identity

Dave's pots stage a complex, double-edged intervention on the commodity form. On one level, they allow Dave to mystify himself and his labor, mobilizing a kind of self-abstraction through the commodity as Dave becomes a trademark. This process of achieving a sense of personhood through commodity fetishism is similar to Lauren Berlant's interpretation of the character of Delilah from *Imitation of Life*. Having a photograph of her face emblazoned on boxes of pancake mix transforms Delilah, according to Berlant, into "a living trademark" and a "racial hieroglyph." To Berlant, Delilah "can pass through American culture because she has given her body over to its representation of what her subject position is."[50] In other words, Delilah partly escapes embodiment by becoming a racist caricature of a Mammy (her subject position) on a mass scale. Despite the obvious humiliation sustained in such a representation, the trademark identity functions as a prosthetic body that shields against additional denigration. Similarly, Dave transforms himself into a logo, symbolized by his sizeable incised moniker. This signatorial logo or trademark replaces the pained body of the exploited slave laborer with the prosthetic body of the commodity itself, or as Berlant puts it, with the "image of safety and satisfaction commodities represent."[51] In this way, Dave becomes both icon and laborer. As icon, Dave ascends to a state of publicity that does not make his pained body visible, and he enmeshes himself into the commodities he produces. At the same time, the writing on the jars frequently restores to view the Dave who labors, and thereby intervenes in the process of commodity fetishism, precluding the labor from being written out of the consumption of his works. Different from the classic scene of capitalist consumption, Dave's works insist upon making his labor visible.

We might expound these two competing gestures observable in Dave's

work by referring to Marx's intriguing example of the dancing table. To il-
lustrate the principle of commodity fetishism Marx tells about an ordinary
table that becomes extraordinary—it begins to dance. The "wooden brain"
of the table, according to Marx, is filled with "grotesque ideas," one of which
is to dance. Although the commodity is an empty and dead thing, it appears
to dance as if it were alive, as if it were a natural, living organism. The danc-
ing of the table is a mask that conceals the labor that produced the table as
well as the oppressive social conditions under which that labor operates.
According to Marx, the commodity conceals concrete, living labor, trans-
forming it into an abstract and mediated form. Commodity fetishism cov-
ers over the appropriation of labor that is inherent to commodities. Labor
is thus alienated from the commodity. The commodity only seems autono-
mous, as though it bears meaning apart from the real social conditions that
bring it into being. As a result of this masking, commodities appear to have
meaning only in relation to other things, not people or social relations. This
is the heart of Marx's term "reification," when the relation between things
mediates the relation between people, or agents acting within a bourgeois
capitalist social order. "The language of commodities—like all languages
for Marx—is a language of bodies. But capitalism abstracts from these bod-
ies, from the specific use-values and the laboring bodies which produce
them."[52]

A profound denial of the living labor that goes into the production of
commodities leads to reification. Marx employs the dancing table to allego-
rize how commodities seem to do all sorts of magical things, but never be-
speak the living labor that produces them. Reification also makes it possible
for commodities to become a rout to self-abstraction, as Berlant contends
with regard to the character of Delilah. Abstraction is a style of embodiment
that seeks to cast off the visible body and to disengage one's public identity
from the historical facts and socio-cultural circumstances that frame the
racialized body.[53] Just as Delilah's trademark, fashioned after Aunt Jemima,
turns away from the pain of slavery and yields an amnesiac effect that cre-
ates national solidarity through consumption, so too does Dave's trademark
negate white guilt for slavery by offering an image of protected, legitimated,
and even enfranchised slave labor, however superficial. His trademark, in
part, functions as a salve ameliorating the moral burdens facing the slave-
holding South, spuriously justifying the peculiar institution as capable of
nurturing the artisanal and artistic agency of the slave.

Apart from indirectly apologizing for slavery, Dave's work persistently
draws attention to the scene of production, encouraging the consumer
through the writing on the ceramics to reflect not only on the process of
labor—of making the jar or pot—but also on the social conditions of the
laborer. According to Marx, fetishism arises because the commodity hides

its history in order to appear as something natural. Two important aspects of history are hidden in the commodity: the labor that went into its production and the social relations figured by that labor. The table dances in order to appear as an autonomous subject, neither a product of labor nor a marionette made to dance by the work of unseen others. But Dave's commodities are built in such a way as to unveil this normally hidden history of production.

Rather than dance like Marx's table, which hides its production, Dave's jars seem to boil again. They bring reader-consumers back to a time before the commodity was a physical thing, before it was wholly made. I distinguish Marx's dance from Dave's boiling—or biling—in that Dave's work uses the ineluctable properties of fetishism, "which attaches itself to the products of labour as soon as they are produced as commodities,"[54] in order to reveal, not simply transcend, the history and social relations underpinning the commodity's creation.

In conclusion, many of Dave's jars present two kinds of hybridity: the one literal, the other much more abstract. On one level, the jars conjoin two systems of representation, pottery and poetry, clay and writing. Although they are functional objects, they are also literary texts containing several types of writing ranging from the metaphorical to the declarative. Seeming to work at cross-purposes with the production codings or those couplets where Dave acknowledges his captive status, the signature celebrates a highly visible, uniquely vocal identity. At the same time, however, the signature also establishes Dave's status as not beyond Southern commodity culture but firmly within it. The enlarged signature demarcates the ceramic object as a singular creation fabricated by a creator, yet the lack of family name in the signature emphasizes the extent to which norms of artistic authority rest upon the exclusion of those who, by virtue of what Orlando Paterson calls the "natal alienation" of slavery, bear no family name. Rather than decommodify himself through discourse, as with the abolitionist slave writer, Dave effects a hypercommodification, representing himself as a trademark identity, a special kind of commodity. The theme of bilin' in his writing points toward commodity creation as a site of potential power, where the slave wields tactile control over the system of production to which he is otherwise bound. Instead of marking a transition from commodity to human status, as in Douglass's *Narrative,* Dave's jars—to riff on Douglass— seem to say, "Now you will see how a thing can turn nothing into something, and back again."

Conclusion

[V]ision too has a range. Only at very great distances are the things it gives us pure things, identical to themselves and wholly positive, like the stars.

<div align="right">MAURICE MERLEAU-PONTY, THE VISIBLE AND THE INVISIBLE</div>

During the antebellum period, the range of vision associated with slaves—seeing them, being seen by them, seeing as them—comprises a phenomenology of possession and desire routinely displaced by figures of death, distance, and difference. These figuralizations achieve their most popular and perhaps memorable fruition for the nineteenth-century reading public in Stowe's *Uncle Tom's Cabin.* The preponderance of optic metaphors surrounding Little Eva's deathbed anticipate the concomitant dominance of visual representations devoted to this scene in the decades following the novel's publication. In contrast to the image saturation of the poignant mise-en-scène—"The eye could turn nowhere without meeting images of childhood, of beauty, and of peace"—Eva remains a grounding object of our viewing, a voyeuristic target of scopic availability and arrest, in whose moribundity the meanings aroused by the tantalizing image objects that surround her find resolution. That her "eyes never open" guarantees us the freedom to look without having our look returned. Unable to look back, Eva transforms into a quasi-living centerpiece of the touching objects of commingled innocence and vulnerability around her, the not-yet-object who appears an object already. Stowe sacralizes objectifying vision through Eva's affecting death, equating it to Christian faith, particularly when her father, St. Clare, implores her to report her dying vision, "O, Eva, tell us what you see!"[1] If articulated, St. Clare presumes, deathly sight may have the power to mitigate the eventual absence of the child, imparting faith and transcendence in its place and suggesting, finally, that the transference of another's vision may yield salutary abstractions from immediate pain and suffering.

Wedded to its sacral function, therefore, the kind of vision adumbrated in this scene also poses a semantic challenge, giving rise to crises of description and interpretation. In what is significantly an adaptation of the mass, Eva instructs others on how to receive her curl—a transubstantiation of her angelic vision—explaining how to look at it and see something beyond it, how—in short—to engage in acts of sacrosanct vision that the characters and the reader will need to understand the novel's eschatology. In desiring transcendent vision, St. Clare, who while despising the "THING" of slavery—its essential disburdening of his labor onto an unpaid substitute—still seeks a form of spiritual surrogacy in the agencies of his mother, child, and finally Uncle Tom, all moribund and in states of socio-juridical powerlessness in comparison to himself. Following Eva's death, as St. Clare reads the Bible with Tom, the very same capacity to satisfy the bereaved patriarch's need for vision transfers to the slave, who seems to experience reading in much the same way as the angelic child, as a form of a priori revelation:

> "Tom," said his Master, "this is all real to you!"
> "I can jest fairly *see* it Mas'r," said Tom.
> "I wish I had your eyes, Tom."[2]

Of course, St. Clare's wish troublingly overlooks the legal reality that, as the master, he does in fact have Tom's eyes. Wanting access to the slave's presumed spiritual superiority of vision, which innocently realizes that which is invisible to rational discourse, St. Clare epitomizes a fantasy of slavocratic possession. What St. Clare wants restored to him, in other words, is already in his possession insofar as we allow the corporeal connotation of the slave's eyes to subsume the metaphor of the slave's sight. Having her Christian cynic return to the fold of the faithful through the vision of Uncle Tom, Stowe reinscribes a fungibility of vision that the slave is called upon to impart throughout abolitionist rhetoric, at the level where body and metaphor intersect, to sustain a proxyism of suffering that redeems a Christian economy of salvation. St. Clare's recollection of his mother's credo in this scene, "if we want to give sight to the blind, we must be willing to do as Christ did . . . and *put our hands on them*,"[3] reinforces the presumed hierarchy underwriting such acts of missionary zealotry: the white faithful are positioned as having a store of "sight" to give to those essentially positioned as lacking it, the "blind." According to this maternally inspired vision of white aid, the Christian is only debarred from attaining Christ-like status by desire (he or she must first want to give sight) and by detestation, a loathing of the blind, the black, and those marked by a frightful lack of that which the privileged hold in abundance.

This book has sought to trace out the dynamics of another, never wholly separate, dimension of slave sight. Indeed, the reader of Frederick Doug-

lass's second autobiography transacts with St. Clare's wish to see bereaved and absent maternality through the slave's eyes, but the proffered glimpse metaphorically breaks the glass that showcases the mimetic expectation and sentimental directive of such an impulse to see with a force that echoes in William Wells Brown's similar negation of illustration. For the slave, these ex-slave authors suggest, a different orientation toward the matrifocal unknown obtains and in turn alters the media called upon to conjure it. The mother restored equates to a temporary performance of impermanent legibility, flickering at a threshold of matrices where inscription, citation, connotation, depiction, and memory conjoin and give way. The phenomenological contours of a vision adequate to the twin demands (desires) of evoking a subjectivity that is culturally visible only as object and ennobling the self through that evocation without reducing the remembered subject to objecthood is, by necessity and negotiation, a fugitive vision.

The concern of this book has been to examine African American productions of visual fugitivity. A fugitive mode of performance defers the raced and gendered hegemonics of the antebellum visual field, recording the unspeakable and unseeable trace of a subjectivity not yet become, not quite fleshed out, for an American audience of so many St. Clares desperately wanting to see with the eyes of the idealized and martyred slave, but recoiling, we can only presume, at prospects seen through the eyes of the retributive slave. Whether through citation to an unexpected portrait, appropriation of traditional visual technologies, or proximity to illustration, the intertexts of *Fugitive Vision* require a critical sensibility open to an aesthetics based on experiences of oppression that challenge a hermeneutics of accessibility, rationality, and correspondence. This challenge to find meaning in the non-correspondences and irrational interference posed by an archive of illustrations seemingly as fixed as the fugitive icon applies as much to the contemporary critic as for the ex-fugitives studied here, who inscribe alternative kinds of vision in textual, temporal, and perceptual sites of intersection.

The theme of mobility is useful for articulating what moves there in that space between—for talking about what moves out from that intertextual space, what movement gets us there, and what is moving and meaningful about it. That there must be, as for St. Clare, an affective payoff, however, moved so many of the figures studied here to sentimental apostacies and textual games of hide-and-seek, boldly *failing* to produce the expected violence of the slave body and thus refusing the mechanics of debasement and vulnerability that leave blackness prone to a hostile essence of hypervisibility. Mobilizing technologies usually conscripted to affirm the binaries of domination, these writers and artists complicate the axiom that accords racial blackness with hypervisibility. At sites of intertextual performance, a

hypo-visibility arises. The etymological apposition of "hypo" derives from two related connotations, one referring to that which lies beneath appearance; the other, referring to the agent in photography that fixes an image.

If the pictorial instates a temporality of stasis, it does so only insofar as viewers disavow the eerie threat of movement superordinate to physical properties of time and space, which many critics of American literature have noted in the writing of the period. The hauntings emanating from portraits of subjectivities suppressed in history but somehow fixed psychically to wreak havoc upon the living may resonate with the period's investments in corralling indigenes and slaves into a pictorial space of identity, safely but not fixedly occupying a remote existence of incomplete presence. It is not so much that hypo-visibility gives subjectivity to these oppressed images of bodies, but that it is in the fixing and unfixing of encounters with the pictorial, the image, and the visible that the ideological forces that conspire to surmount the Other's body come movingly into view, even if, and most particularly when, the rational logics of reflection, mimesis, and illustration's supplementarity to speech and literacy seem drastically collapsed in the process.

The hypo-visibility of slave subjectivity mapped in this study subtly alters the predictable bodily erasures, appropriations, and compensatory embrace of the sonic in opposition to the hostilities of the visible. Throughout, my aim has been to refine the view, expressed by Lindon Barrett in the following way, that African Americans, by and large, invest in sonic cultural production rather than the scopic, "because African Americans are . . . disbarred from meaningful participation in the sense-making activity of vision [and] are confronted with vision as a hostile realm of significance."[4] Less a disagreement with than an enlargement upon Barrett's thesis, this study poses the trace evidence of nineteenth-century African American visual participation in a sense-*un*making activity of vision. Unmade in the material interstices of visual and verbal signification in the jars of Dave the Potter or in the iron collar, a post-postscript of Brown's panorama, is the presumption of bodily presence in African American performances of slave subjectivity even in the face of (the giving face to) the obdurate materiality of that body.

In *Blackness and Value,* Barrett reminds us of the temporal distinctions separating the "obdurate materiality" of timelessness and transcendent, pure materiality: "In the deposition or designation of the transcendent, one claims pure time and approximates notions of God and notions of the 'civic' power of God. Opposingly, timelessness in space is the antithesis of God *and of the voice.* Timelessness in space marks pure materiality and . . . is the reality of the unanimated, or dead body."[5] If the pictorial normally instantiates the timelessness of dead and obdurate materiality, then what we have

observed here is the way that image mediates a reanimation that approximates the purity of time–space of maternality in memory and performance, without necessarily jettisoning, covering over, or replacing the trace of materiality and timelessness. A paradoxical overlaying of values incommensurate with the either- or semiotics of dominant culture inheres in all of the virtual moments and material texts discussed here, from Douglass's Ramses picture, to the ringing bell of the Crafts' narrative that tolls Ellen's reentry from narrative into the signifying domain of the frontispiece, to the diasporic jar of Dave the Potter. This is not to say, however, that these moments eschew the acoustic aesthetic of vocality. Elaborating on African American privileging of the acoustic over the condemnatory realm of visuality, Barrett writes, "In the view of the dominant culture, grotesque African Americans and their cultural influence undertake productions of value *without the site (sight) of value,* and much of these productions has to do with resourcefully relinquishing the sight (site) by which they are condemned."[6]

There remains, nevertheless, an overlooked and understudied impulse in the cultural production of nineteenth-century African Americans, both a relinquishment of dominant mobilizations of sight and a recuperation of an alternative, repressed mode of vision—seldom designated as pure sight, untinged by various other modes of expression to be sure, yet primarily conceptualized in terms of a visual experience. The hypo-visibility produced in the works of writers and artists in these pages, in other words, does not wholly "forgo the acknowledged significance of site (sight)," that Barrett maintains to be a prior condition for "an Other production of value."[7] As the preceding chapters indicate, the sub-visible and temporarily fixed visualization of "an Other production of value" often occurs in ways that demonstrate the ideological menace that Barrett's parenthetical phrasing assumes, and that visualization unsettles for a nineteenth-century audience that which I and Barrett's other critical readers may take for granted. The perilous merger of sights as sites is the upshot of much of the intertextual activity celebrated black writers take up in the antebellum period, to posit perception as a location of culture. To see, for these writers, is to collaborate with memory, experience, and identity in accessing a field of meanings both articulate and ineffable that do not propose completeness. Rather than dialectic, this relation encompasses Merleau-Ponty's notion of a "hyper-dialectic," which respects "the plurality of the relationships and what has been called ambiguity" in the movements and meanings it encloses.[8] The primordial faith that animates Merleau-Ponty's later critique of the phenomenology of perception articulated in his earlier writings coincides with the historical gestures, intertextual attempts at intersubjectivity, and formulations of fleshing (or recomposing a body that reduces neither to object nor subject) that appear throughout this book. For Merleau-Ponty, the no-

tion of flesh designates a new orientation toward carnality and perception, such that consciousness and reality enfold and diverge according to "chiasm" or processes of reversibility. An imminence construes the relationship between the seer and the seen, self and other, organizing sensation, seeing, and touching into a type of being without affirming positivism, "without ceasing to be ambiguous and transcendent."[9] Thus, to engage in fugitive vision is to strike ontological and epistemological compromises. It is to see for, as with Tom, that which can be articulated for a predominantly white abolitionist readership, as well as to see as difference itself, as both slave and what W. E. B. Du Bois would later refer to as the veil, the material (or historical in the case of Harriet Jacobs) mediation that divides epistemology according to the color line. The fugitive relation posed between self-textualized black writers and the textuality of the slave mother or connectivity to the slave masses eventuates a dialectic that does not propose the completeness of its polar terms.

NOTES

Introduction

1. Carroll, *Word, Image, and the New Negro*, p. 28.
2. Silverman, "Fassbinder and Lacan," pp. 272–301.
3. A related paradox is suggested by the position of the running figure. The cumbrous triangular forms created by the appendages and rearward density of the figure anchor the fugitive in a scene of frozen motion. Wood, *Blind Memory*, p. 93.
4. Gates, *Figures in Black*, p. 17.
5. For a detailed overview of abolitionist iconography and commodity culture, see Lapansky, "Graphic Discord," pp. 204–206.
6. Moten, *In the Break*, p. 7.
7. Aside from Mitchell, Mieke Bal's visual poetics inspires my discussions of the interferences posed by the play of verbal and visual signification. Bal, "Visual Poetics," pp. 135–150.
8. Mitchell, *Picture Theory*, p. 163.
9. Gates proposes the status-through-literacy argument compellingly in *Figures in Black*, pp.14–24, while Baker argues for the significance of commodity renegotiation and the "economics of slavery" in *Blues, Ideology, and African-American Literature*, pp. 23–31.
10. Lacan, "The Eye and the Gaze," in *Four Fundamental Concepts*, p. 73.
11. Silverman, "Fassbinder and Lacan," pp. 289–290.
12. Sanchez-Eppler, *Touching Liberty*, pp. 8–9.
13. Spillers, "Mama's Baby," pp. 65–81.
14. In particular, Hartman argues that the "fungibility" of the slave's body, to stand in for the desires, expressions, and sentiments of another, reinforces rather than undermines the exchange principle of chattel slavery. Hartman, *Scenes of Subjection*, p. 21.
15. Moten, *In the Break*, p. 14.
16. Moten, *In the Break*, p. 183. hooks, *Black Looks*.
17. Moten, *In the Break*, p. 184.
18. Ibid., p. 185.
19. See note 9.
20. Crary, *Techniques of the Observer*, p. 9.
21. Andrews, *To Tell a Free Story*, p. 36.
22. The quote refers to the essay by Toni Morrison, "Unspeakable Things Unspoken."
23. Holland, *Raising the Dead*, pp. 5–7.
24. Hartman, *Scenes of Subjection*, pp. 36–48.
25. Henderson, *Scarring the Black Body*, p. 39.

26. Ibid., p. 38.

27. For a contemporary analysis of the mother-son relationship, see O'Reilly, "In Black and White."

1. Racing and Erasing the Slave Mother

1. Douglass, *Narrative*, p. 13.

2. Gates, *Signifying Monkey*, p. xxiv.

3. Douglass, *My Bondage*, p. 55.

4. Samuel Morton, George Gliddon, Josiah Nott, and James Van Evrie are among the most notable American School ethnographers.

5. Fabian, *Time and the Other*, pp. 111–112.

6. In the autobiography and ethnography of this period, the first is always predicated on the latter and vice versa; to say then that there is an ethnographic impulse in all autobiography is tantamount to saying that there is a reciprocal autobiographical anxiety in all ethnography. According to Mark Neumann, a modern anthropologist, the ethnographic impulse has been characterized by "the gaze outward . . . At worlds beyond [our] own, as a means of marking the social coordinates of a self." On the other hand, Neumann notes that the autobiographical impulse "gazes inward for a story of self, but ultimately retrieves a vantage point for interpreting culture." Neumann, "Collecting Ourselves," p. 173.

7. Andrews, *To Tell a Free Story*, p. 231.

8. Spillers, "Mama's Baby," p. 80.

9. Kaja Silverman, drawing from the work of Laura Mulvey, Lacan, Foucault, and others, discusses the difference between look and gaze in a critique of masculine subjectivities in film (*Male Subjectivity at the Margins*, p. 130). The gaze is far more Draconian than the look, and often takes the form of surveillance. The gaze is clinical, objectifying, voyeuristic, and sadistic. It often feminizes (or "de-phallusizes") its optic subject, placing specularized (gazed at) bodies within a narrative of punishment. As in Foucault's critique of Bentham's Panopticon, the gaze is beyond subjectivity, working without agency. In other words, the black body in antebellum America would construct a colonizing gaze even if there were no whites present; the colonizing gaze is such an intrinsic component of an imperialist culture that it operates without particular individuals appropriating it. But this book will not need to venture into such ontological perplexities since I will be working only with gazes that are appropriated by particular agents. The look, on the other hand, emanates from a particular subjectivity, from a desiring subjectivity. Desire in this sense alludes to Lacan's meaning, which always intimates a lack. Instead of constructing an object, the look constructs a focal point that directs desire. Unlike the gaze, the look can be turned back, the look-ee can return the same look to the look-er, so the power dynamic of looking is far more protean than that of the gaze. What is most important in the difference between the look and the gaze in this book is that the look can pretend to be a gaze; it can essentially pass itself off as a gaze, which is precisely what Douglass does in his use of the picture.

10. Fredrickson, *Black Image in the White Mind*, p. 35.

11. Knox, *Races of Men*, p. 15.

12. Ibid., p. 162.

13. Ibid., p. 163.
14. Douglass, "Claims of the Negro," p. 295.
15. Nott and Gliddon, *Types of Mankind,* p. 69.
16. Ryan, *Womanhood in America,* p. 143.
17. Pratt, *Imperial Eyes,* p. 7.
18. Douglass, *My Bondage,* p. 13. Hereafter, citations to this text appear in parentheses.
19. Douglass, *Narrative,* p. 12.
20. Ibid.
21. Baker, "Autobiographical Acts," p. 103.
22. Douglass, *Narrative,* p. 13.
23. Ibid.
24. Smith, "Performativity," p. 18.
25. Spillers, "Mama's Baby," p. 80.
26. McDowell, "In the First Place," p. 46. Deborah White makes a similar point in asserting that "the male slave's 'masculinity' was restored by putting black women in their proper 'feminine' place." White, *Ar'n't I a Woman,* p. 22. Furthermore, Valerie Smith has argued that the slave narrative—like Western autobiography in general—is a masculine genre; its emphasis on "rugged individuality, physical strength, and geographical mobility [. . .] enshrines cultural definitions of masculinity." Although Douglass attacks racist ideologies that shape relations in the South as well as the North, his texts, according to Smith, leave intact and indeed depend upon equations of manhood and power. Smith, *Self-Discovery and Authority,* pp. 34, 20.
27. Smith, *Self-Discovery and Authority,* p. 353.
28. Olney, "'I Was Born,'" p. 50.
29. See Stepto, *From Behind the Veil.*
30. Casmier-Paz, "Slave Narratives," p. 98.
31. Dorsey, "Becoming the Other," p. 435.
32. Ibid., p. 447.
33. Brown, *Domestic Individualism,* pp. 1–2.
34. Brawley, "Frederick Douglass's *My Bondage and My Freedom,*" p. 120.
35. Ibid.
36. Ibid.
37. Walker, *Moral Choices,* p. 253.
38. Fleischner, *Mastering Slavery,* p. 3.
39. Prichard, *Natural History of Man,* p. 157.
40. Andrews, "The Novelization of Voice," pp. 23–34.
41. The term "signifyin(g)," usually spoken in the vernacular without the final "g," is a mode of parody or repetition, what Gates calls the "trope of tropes" in African American literature, and in this context it refers to Douglass's punning, mimicking, appropriating, and calling attention to the modes of authority and citation practiced in ethnographic discourse.
42. Bakhtin, *Speech Genres,* p. 93.
43. Slote, "Revising Freely," p. 24.
44. Douglass, "Claims of the Negro," p. 298.
45. Walker, *Moral Choices,* p. 254.
46. Moses, *Afrotopia,* p. 15.

47. Gates, "The Blackness of Blackness," p. 291.

48. Frantz Fanon refers to "epidermilization" in *Black Skin, White Masks* (11) as a form of internalization; it occurs when colonized subjects internalize the inferiority that their skin color difference signifies to colonizers or to dominant culture.

49. Nott and Gliddon, *Types of Mankind*, p. 52.

50. Quoted in Theriot, *Mothers and Daughters in Nineteenth-Century America*, p. 23.

51. Ibid, p. 24.

52. Saartje Baartman, known as the "Hottentot Venus," was put on display for European audiences, who were voyeuristically fascinated by Baartman's buttocks. bell hooks quotes Sander Gilman's conclusion that "by the eighteenth century . . . the black female body [became] an icon for black sexuality in general" (*Black Looks*, p. 62).

53. Taylor, *Journey to Central Africa*, p. 70.

54. Douglass, "Claims of the Negro," p. 299.

55. Martin, *Mind of Frederick Douglass*, p. 5.

56. Ibid.

57. Ibid., pp. 3, 58.

58. Ibid., p. 97.

59. Ibid., p. 95.

60. Foster, *Witnessing Slavery*, p. 78.

61. Andrews, "Towards a Poetics of Afro-American Autobiography," p. 81.

62. For an illuminating cultural history of Egyptian nationalist iconography, that by the late nineteenth century and early twentieth routinely portrays Egypt as a woman, see Baron, *Egypt as a Woman*, pp. 57–81.

63. Smith, "Performativity," p. 21.

64. Castronovo, "'As to Nation, I Belong to None,'" p. 258.

65. In his reading of Otto Preminger's film *Laura*, Lee Edelman (*Homographesis: Essays in Gay Literary and Cultural Theory*) theorizes that the facelessness of objectified figures is inherent to the very impulse to construct narratives; accordingly, the face becomes a trope for narrativity itself. Though he specifically refers to the homosexual, his analysis may be extended to the black mother for our purposes. Edelman argues that catechresis is "the site at which the assumption of meaning confronts the disfiguring force of figuration" (238), and claims that meaning resides only in "the fictional face with which we dissimulate the contingency, the randomness, or the facelessness of experience" (225). Douglass's mother represented oddly in the Ramses illustration thus may be a figure who creates the face of facelessness that Edelman argues is necessary for narration. I will take up the issue of the face as a trope specific to African American theories of narration later in this chapter.

66. Dorsey, "Becoming the Other," p. 445.

67. See Leverenz, Sundquist, Dorsey, Baker, and Andrews.

68. Prichard, *Natural History of Man*, p. 71.

69. Douglass comments sarcastically on ethnography's failure to find European hair textures in Egyptian images in "Claims of the Negro": "their hair was far from being of that graceful lankness, which adorns the fair Anglo-Saxon head. But the next best thing, after these defects, is a positive unlikeness to the Negro" (296).

70. Knox, *Races of Men,* p. 152.
71. Ibid., p. 161.
72. Douglass, "Claims of the Negro," p. 298.
73. Nott and Gliddon, *Types of Mankind,* p. 67.
74. Ibid., p. 191.
75. Ibid., pp. 262, 263.
76. Douglass, "Claims of the Negro," p. 299.
77. Ibid., p. 299.
78. Ibid.
79. Ibid.
80. Quoted in Hinks, *To Awaken My Afflicted Brethren,* p. 182.
81. Sterling Stuckey in *Slave Culture* notes that the Reverend J. W. Pennington is listed as a witness in the marriage between "Frederick Johnson [Douglass] and Anna Murray" (223).
82. Pennington, *Text Book,* p. 6.
83. Stocking, *Race, Culture, and Evolution,* p. 49.
84. Stanton, *Leopard's Spots,* pp. 33–34.
85. Moses, *Afrotopia,* p. 44.
86. Ibid., pp. 47, 44.
87. Prichard, *Natural History of Man,* p. 143.
88. Gates, *Figures in Black,* p. 101.

2. Looking for Slavery at the Crystal Palace

1. duCille, *Coupling Convention,* p. 18.
2. Spillers, "Mama's Baby," p. 80.
3. Ibid.
4. William Farmer identifies among the party Mr. and Mrs. Estlin of Bristol, and a lady friend, Mr. and Mrs. Richard Webb, of Dublin, and a son and daughter, Mr. McDonnel, Mr. and Mrs. Thompson, and their daughter, Miss Amelia Thompson. Quoted in Still, *Underground Railroad,* p. 374. For more on the political influence of these figures on Brown, see Farrison, *William Wells Brown.*
5. The letter is reprinted in its entirety in Still, *Underground Railroad,* p. 375.
6. Ibid.
7. Ibid.
8. Ibid., p. 374.
9. Quoted in Farrison, *William Wells Brown,* p. 186.
10. For a discussion of Estlin's censorship of the "breeding" passage in Douglass's *Narrative,* see Fisch, *American Slaves in Victorian England,* pp. 3–5.
11. Henderson, *Scarring the Black Body,* p. 37.
12. Kasson, *Marble Queens and Captives,* p. 55.
13. Quoted in Yellin, *Women and Sisters,* p. 107.
14. Ibid., p. 100.
15. Quoted in Still, *Underground Railroad,* pp. 375, 376.
16. Yellin, *Women and Sisters,* p. 122.
17. Using J. L. Austin's classifications from *How to Do Things with Words,* we

might refer to Brown's speech act as a self-referential performative, though not necessarily as an assertion. For more on slave narratives and speech-act theory, see Andrews, *To Tell a Free Story*, pp. 23–25, 104–105.

18. Farrison, *William Wells Brown*, p. 186.

19. Johnson, *Mother Tongues*, p. 70.

20. Krier, *Birth Passages*, p. 8.

21. Ibid., p. 13.

22. Johnson, *Mother Tongues*, p. 60.

23. Foucault, *Power/Knowledge*, p. 85.

24. Quoted from "A User's Guide to Détournement," www.bopsecrets.org/SI/detourn.htm.

25. Marcus, *Lipstick Traces*, p. 168.

26. Quoted from "A User's Guide to Détournement," www.bopsecrets.org/SI/detourn.htm.

27. According to William Farmer, Brown's performance did not yield the desired effect—"Not a word, or reply, or remonstrance from Yankee or Southerner" (quoted in Still, *Underground Railroad*, p. 376). A single American male removed the cartoon from the exhibit area but remained silent when questioned by the abolitionists. See also Yellin, *Women and Sisters*, pp. 119–123.

28. Kasson notes that even when the sale of the sculpture was discussed in antebellum periodicals with observable unease, references to the sculpture's contemporaneous similarity with American slavery were rare. Kasson, *Marble Queens and Captives*.

29. The latter image (fig. 2.5) first appeared as the frontispiece of Lydia Maria Child's *The Fountain* (1835), bearing the caption, "Engraved by P. Reason, a Colored Young Man of the City of New York, 1835."

30. Farrison, *William Wells Brown*, pp. 136–137.

31. Brown, *Description of Original Panoramic Views*, p. 1.

32. Farrison, *William Wells Brown*, p. 172.

33. Ibid., p. 173.

34. The India Route Panorama is discussed by Richard Altick in *Shows of London*. He concludes that "the displays of savages appealed to what was becoming a more and more openly and aggressively displayed aspect of the English character, its complacent assumption of racial supremacy" (279). See also Nancy Osgood's "Josiah Wolcott: Artist and Associationist," which discusses the commissioning of Josiah Wolcott, a Brook Farm community member, to construct a panorama for Henry "Box" Brown called "Mirror of Slavery" in 1849–1850. As will be discussed in more detail in chapter 4, information regarding Brown's "Original Views" and its composition is scarce. "Moving panoramas," or "moving dioramas," were successful forms of spectacle during the 1840s, translating the exploits of empire and Manifest Destiny onto gargantuan canvases typically covering vast expanses (American painter John Rowson Smith toured Britain in 1849 with a "four-mile painting" of the Mississippi River). For more on the history of panoramas, see Oettermann, *Panorama*.

35. Spillers, "Mama's Baby," p. 67.

36. Brown, *Narrative of William W. Brown*, p. 15. Hereafter, citations to this text appear parenthetically within the chapter.

37. Charles Ball's *Slavery in the United States* (written with the help of Isaac

Fisher, an amanuensis) begins with an extended citation of a newspaper article, an excruciatingly vivid exposé of burning slaves alive, which serves to verify and fore-shadow the ensuing autobiographical accounts of torture.

38. Bergner defines herself as part of a "second wave" of Douglass criticism that shares a critical framework based on feminist-Lacanian psychoanalysis. (Deborah McDowell, Jenny Franchot, Valerie Smith, and George P. Cunningham are men-tioned as part of this second wave.) According to Bergner, the whipping of Hester shapes Douglass's Oedipal identification with white male culture, making Captain Anthony less rival than object of desire. Bergner, "Myths of Masculinity," pp. 241–260.

39. Lawal, "The African Heritage of African American Art and Performance," p. 43.

40. Stowe, *Uncle Tom's Cabin,* p. 45.

41. Ibid., pp. 45, 44.

42. Ibid., p. 45

43. Ibid., p. 47

44. For more on whiteness as denoting both materiality in the body and abstrac-tion from the body, see Wiegman, *American Anatomies,* pp. 21–42, and Dyer, pp. 8–14.

45. Benston, "Facing Tradition," p. 99. For more on prosopopoeia, see Miller, *Illustration* and DeMan, "Autobiography as De-facement."

46. Benston, "Facing Tradition," p. 99.

47. Ibid., p. 100.

48. Rodriguez, *Autobiographical Inscriptions,*" p. 4.

49. Barrett, "Hand-Writing," p. 322.

50. Benston, "Facing Tradition," p. 104.

51. Ibid., p. 101.

52. Ibid.

53. Sorisio, *Fleshing Out America,* pp. 8–9.

54. Ibid., p. 9.

55. hooks, *Talking Back,* pp. 42–43.

56. Huffer, *Maternal Pasts, Feminist Futures,* p. 3.

57. Quoted in Yellin, *Women and Sisters,* p. 110.

58. Ibid., p. 99, endnote 1.

59. See Wallace, "Variations on Negation," pp. 69–75, and Johnson, *World of Dif-ference,* pp. 166–171.

60. Gates, *Figures in Black,* p. 168.

61. For more on the ocular mask, see Gates, *Figures in Black,* p.170.

62. Spillers, "Mama's Baby," p. 80.

3. The Uses in Seeing

1. The image of Ellen Craft in disguise recontants significations incompatible with dominant ideologies. Diana Fuss makes the important point that identification springs from the same conceptual model of identity as colonial imperialism, and so must be seen as always in some way a concession to that colonial order rather than a purely radical act of resistance. For a postcolonial theorist like Homi Bhabha (*Loca-*

tion of Culture), mimicry is not a tactic of colonial redress but a condition of colonial address. It fortifies rather than subverts colonial power and, as Fuss explains, it "operates as an emphatic instrument of political regulation, social discipline, and psychological depersonalization" (Fuss, "Interior Colonies," p. 24). After explaining Fanon's theory of identification, particularly how the Imperial Subject forces racialized subjects to mime a representation of alterity that the Imperial Subject has already created for them, Fuss poses a significant question about the political value of mimicry: "What then, is the political utility of mimesis for the colonized, when mimesis operates as one of the very terms of their cultural and political dispossession under colonial imperialism?" (24). Although many feminist critics, as Fuss points out, distinguish mimicry from masquerade in that the first entails a deliberate performance of a role while the latter characterizes an unconscious assumption of a role, many postcolonial critics do not explicitly ascribe so much countermanding power to mimicry. Fuss describes mimicry as a "parodic hyperbolization" of a role, and masquerade as a "nonironic imitation" (20). For Bhabha, as for my purposes with Ellen Craft's image, it is in the slippage where mimicry slips into mockery that colonial power is disputed.

2. McCaskill, "Introduction," pp. vii–xxv; Garber, *Vested Interests*; Lott, *Love and Theft*.

3. The point I am making here is simply that tragic mulatta narratives, although always staging a contextual reversal of identity, do not necessarily challenge patriarchal codes of identity and may in fact work to preserve them. In confronting the absurdity of the color line, they also subtly endorse the racial and gendered separation of social privilege. For more on the way tragic mulatta narratives underscore patriarchal relations of power, see Mullen, "Optic White." Mullen defines the "media cyborg" as a product of the technological grafting of black soul onto white bodies, which recycles the thematics of passing, assimilation, miscegenation, and invisibility found in tragic mulatta novels. According to Mullen, assimilation always entails a production of whiteness: "assimilation is unimaginable without miscegenation, whether sexual or mechanical-cybernetic: assimilation equals whiteness produced from the resources and raw materials of blackness" (77). In the image of Ellen Craft as a white male and its accompanying caption, which affirms Ellen to be a "Negro" woman, we also get a re-assemblage of racial identities that is technologically created through the process of illustration and periodical publication. In support of Mullen's observations that "assimilation is unimaginable without miscegenation" and that "assimilation equals whiteness" (77), the image signifies at least three kinds of miscegenation: first, the presumed rape that creates Ellen Craft and determines her physical ability to pass as white; second, the visual effect of Ellen's disguise, her "assimilation" of whiteness; and three, the miscegenated nature of the visual text. While it celebrates "Negro" agency, the engraving performs this gesture within the publication circuits of leading abolitionists, a force of Northern elites helping to "assimilate" fugitives— or, to use Mullen's language, to help make them seem more "white." Moreover, in viewing the antebellum slave narrative as a media cyborg technology, we should note that the process of miscegenation does not correlate to Mullen's late-capitalist media trope, based on whites in commercials lip-synching to music recorded by blacks. The effect is a sheen of whiteness with an interiority that is invisibly produced by blackness. In many of the antebellum slave narratives that were obviously written by

sponsors or editors, as with Charles Ball's *Slavery in the United States,* the narrative voice is marked as white, by dint of its pedantry. Such texts invite readers to scientifically experience the minutiae of daily life in slavery, as if the narrative had suddenly introjected an empiricist white sensorium into the body of a black slave. The result is an eradication of interiority altogether, replaced by a white narrative sensibility that is emotionally blank but encyclopedic on all matters dealing with agriculture. If the late twentieth-century media cyborg describes a whiteness whose interiority is produced by having technologically assimilated black singing, the nineteenth-century version of it that tropes through slave narratives is a whiteness whose interiority is produced by having technologically assimilated black sight.

4. Foucault, "Technologies of the Self."

5. Farrison, *William Wells Brown,* pp. 136–137.

6. From the cover blurb of McCaskill's edition of *Running.*

7. Craft, *Running a Thousand Miles,* p. 12; hereafter cited parenthetically.

8. In carnival, M. Bakhtin claims, "What is suspended first of all is hierarchical structure and all the forms of terror, reverence, piety, and etiquette connected with it—that is, everything resulting from sociohierarchical inequality or any other form of inequality among people (including age)." Bakhtin, *Problems of Dostoevsky's Poetics,* pp. 122–123.

9. In using the term "Uncanny," I am speaking not only of repressed or surmounted anxieties but also of a potentially purgative recognition of socially constructed norms and binaries, such as those that presume the inevitable separateness of race and gender categories. This application of Freud's Uncanny shares a critical agenda with feminist critics, such as Susan Linville (*History Films, Women, and Freud's Uncanny*) who interprets the Uncanny as a progressive agent for interrogating nostalgic ideals of gender and nation.

10. Part of what constrains the rhetorical nature of many slave narratives written between the 1830s and the 1860s is the editorial "assistance" provided by abolitionist amanuenses. According to Marion Wilson Starling, "[d]oubt as to the trustworthiness of the slave narrative may be expected [. . .] particularly when the autobiographer is in need of editorial assistance." Starling, *Slave Narrative,* p. 221. As a result of intrusive editorial control, few antebellum narratives include "expressive" speech acts, thereby constituting the slave less as person than witness. See Andrews, *To Tell a Free Story,* pp. 84–86.

11. Gates, *Figures in Black,* p. 17.

12. According to Michael Warner, the "principle of negativity" defines the propertied white male of Enlightenment America's public sphere as an abstract unit of disembodied citizenship. Privileged citizens consequently bear a negative relationship to embodiment, which debars women and minorities from participation in the public sphere. What sustains the citizen subject's power then is an ability to abstract from the body, which in turn explains the value of print as a means to such discorporation. Warner, *Letters of the Republic,* p. 42.

13. Gates, *Figures in Black,* p. 19.

14. Barrett, "Hand-Writing," p. 319.

15. Foreman, "Who's Your Mama?" pp. 505–539.

16. Bland, *Voices of the Fugitives,* pp. 152, 154.

17. Heffernan, *Museum of Words,* pp. 7, 1.

18. Lauren Berlant suggestively distinguishes between the white icon—the normative white person, presumed not to be of African descent—and the white hieroglyph—a light-skinned person who is of African descent—in "National Brands/ National Body," p.110.

19. Barrett, "Hand-Writing," p. 325.

20. Bhabha, *Location of Culture*, p. 88.

21. De Quincey, "On the Knocking at the Gate in *Macbeth*," p. 393.

22. Christian, *Black Women Novelists*, p. 22. For more on the political uses and effects of passing narratives, see Fabi, *Passing and the Rise of the African American Novel*; Raimon, *"Tragic Mulatta" Revisited*; and Carby, *Reconstructing Womanhood*.

23. Lindon Barrett sees these moments in which the illiterate Ellen pantomimes the assumed power of writing afforded to whiteness as exposing the materiality of the white body, "the most highly valued point of interpretation or writing" as opposed to the black body, which is always assumed to stand outside of language and signification. Barrett, "Hand-Writing," p. 330.

24. Carby, *Reconstructing Womanhood*, p. 89.

25. Hawthorne, *House of the Seven Gables*, p. 261.

26. Millington, *Practicing Romance*, p. 149.

27. In Kawash's usage fugitivity names a liminal space observable in many slave narratives (she specifically analyzes those of Henry "Box" Brown, Bibb, and Jacobs) wherein one is neither slave nor free, neither "property of another nor propertied in the self." Kawash, *Dislocating the Color Line*, p. 80. I quibble with the application of the term to Ellen since her whiteness provides her with agency-effects comparable to being propertied in the self, particularly in light of Cheryl Harris's definition of "whiteness as property," a historically integral determinant of social relations. Harris, "Whiteness as Property."

28. Trachtenberg, "Seeing and Believing," p. 474.

29. Ibid.

30. Ibid.

31. Pietz, "The Problem of the Fetish, I," p. 9.

32. By "embodied presence" I mean to denote that which is signified by the apparent body through a witnessing of the flesh, and to oppose that which is signified through an abstraction of the body.

33. Andrews, *To Tell a Free Story*, p. 213.

34. Ibid., p. 213.

35. McCaskill, "'Yours Very Truly,'" p. 520.

36. Bland, *Voices of the Fugitives*, p. 145.

37. McCaskill, "'Yours Very Truly,'" p. 520.

38. Ibid., p. 517.

39. W. J. T. Mitchell defines ekphrasis as "an exploration of the tradition of verbal description of works of visual art. The typical ekphrastic text might be said to speak to or for a semiotic 'other'—an image, visual object, or spectacle—usually in the presence of that object. The point of view of the text is the position of a seeing and speaking subject in relation to a seen and usually mute object." Mitchell, "Narrative, Memory, and Slavery," p. 201. For more on ekphrasis, see Heffernan, *Museum of Words* and Krieger, *Ekphrasis*.

40. Closure refers to the way readers of two sequential panels of narrative art or

graphics must fill in the gap between them, in time or space, in order to make sense of the sequence. It is the process by which we ascribe wholeness to disconnected units of narrative art. McCloud, *Understanding Comics,* p. 67.

41. Norton, *Alternative Americas,* p. 105.

42. Gilroy, *Against Race,* p. 127.

43. McClintock, *Imperial Leather,* pp. 352–356.

44. Freud, "The Uncanny," p. 363. Freud traces the groundwork of the Uncanny back to infantile, but thereafter repressed, experience. And yet, this is also the problem with Freud's theory, in positing that the Uncanny results exclusively from repressed infantile experience. However, he does acknowledge a secondary set of uncanny feelings more useful to our purposes here, which is based on the strange return of what he calls "surmounted" primitive belief structures: "we have *surmounted* these modes of thought; but we do not feel quite sure of our new beliefs, and the old ones still exist within us, ready to seize upon any confirmation" (370–371).

45. Thoreau, *Walden,* p. 81.

46. Quoted in Norton, *Alternative Americas,* p. 33.

47. Emerson, "English Traits," p. 437.

48. Inherent to the cultural construction of whiteness, fantasies of sloughing off negative identity attributes onto a racial other so as to experience completeness as a form of shuttling between racial essences occurs frequently in nineteenth-century American literature. Janet Gabler-Hover usefully examines the topoi of white women who temporarily take on qualities associated with black women in postbellum Southern literature as a revisionary means of sustaining Edenic fantasies of the South. By inverting this process of racial exchange, slave narratives published abroad or in the North may have contributed to the race and gender plasticity that simultaneously reduces and redeems Southern whiteness. See Gabler-Hover, *Dreaming Black/Writing White.*

49. Bhabha, *Location of Culture,* p, 86; emphasis in the original.

50. Ibid.

4. Panoramic Bodies

1. Some critics and art historians have argued that the panorama represented essential American ideologies of envisioning landscape. See, for example, Born, "The Panoramic Landscape" and Novak, *Nature and Culture,* pp. 18–33.

2. Oettermann, *Panorama,* p. 18.

3. Comment, *Painted Panorama,* p. 19. According to Comment, the vogue of the Leicester Square panorama was replaced by the Colosseum, "whose popularity lasted until the end of the 1850s, when it in turn gave way to the exotic panoramas (Rome, Paris, the Lake of Thun) and, more particularly, the new attractions on offer at the Crystal Palace" (28).

4. Ibid., p. 8. For more on the conventional affinities of panoramas and other arts, see Oettermann, *Panorama,* chap. 1.

5. Oettermann, *Panorama,* p. 51.

6. Comment, *Painted Panorama,* p. 7.

7. Here and throughout the chapter I use the term "spectacle"—derived from Guy Debord and others—to denote a type of entertainment as well as a resultant

form of reification located in the visual field. According to Debord borrowing from Marx, as capital accumulation results in an overwhelming alienation, the net effect is a distancing of the individual from all but representation, and in light of an increasing dispossession there is an accompanying compensation in an excess of surrogate experience through spectacle-driven entertainments such as the panorama. See Debord, *Society* and Jay, "From the Empire of the Gaze to the Society of the Spectacle: Foucault and Debord," in *Downcast Eyes*, pp. 381–434.

8. For a comprehensive treatment of a variety of British spectacles from the sixteenth to the nineteenth century, see Altick, *Shows of London*.

9. Wilcox, "Unlimiting the Bounds of Painting," in Hyde, *Panoramania!* p. 37.

10. Ibid., p. 39.

11. Ibid., p. 40.

12. Comment, *Painted Panorama*, p. 108. Comment further hypothesizes this semblance of transcendence from the specific demands of the urban spatial order in relation to the curious rise of panoramas of particular cities exhibited to spectators who lived in those same cities and who were thus "able to re-appropriate the town which, when they were in it, always gave them the impression that they were lost" (136).

13. Bernard Comment characterizes the panorama's "paradoxical status" as one of its defining features as "an enclosed area open to a representation free of all worldly restrictions," which affords viewers a "way of regaining control of sprawling collective space" (8).

14. Ibid., p. 56.

15. Ibid., p. 63.

16. For a discussion of the temporalization of space in American landscape painting, see Miller, *Empire of the Eye*, pp. 82–87. An insightful discussion of the cultural significance of the moving panorama may be found in Miller, "The Imperial Republic," pp. 265–435.

17. Comment, *Painted Panorama*, p. 63. For more on the tradition of the Mississippi River panoramas, see McDermott, *Lost Panoramas*. On the linkage between expansionism and the symbol of the river, see Seelye, *Prophetic Waters*.

18. Kathryn Grover suggests an alternative panoramic influence on Brown in Caleb P. Purrington and Benjamin Russell's *A Whaling Voyage Round the World*, which was unveiled in New Bedford in December of 1848, and speculates that "it seems likely that it was still on view when Brown was in New Bedford the following April." Grover, "Fugitive Slave Traffic and Maritime New Bedford," p. 31, footnote 28.

19. Scott B. Wilcox notes that aside from "a few notable exceptions, such as John Vanderlyn's 1819 panorama of Versailles," the scarcity of surviving panoramas has thwarted the scholarship necessary to ascertain the form's full worth in shaping nineteenth-century ways of seeing and imaginary inclinations. Wilcox, "Unlimiting the Bounds of Painting," in Hyde, *Panoramania!* p. 13.

20. As Scott B. Wilcox demonstrates in examining newspaper reviews of panoramas, the exhibits were widely valued pedagogically for their accurate dissemination of information about the material world. Ibid., p. 36.

21. For more on the representation of Native Americans in art, see Vickers, *Na-*

tive American Identities and Stephanie Pratt, *Native Americans in British Art 1700–1840.*

22. Comment, *Painted Panorama*, p. 172.

23. Boime, *Art of Exclusion*, p. 17.

24. For a thorough discussion of the interrelation of slavery, visibility, and gender, see Spillers, "Mama's Baby," pp. 65–81, and Wiegman, *American Anatomies*, pp. 43–78.

25. The panorama audience's acceptance of racialized forms of labor helps to contain the eruption of raced and gendered bodies that appear in a media normally dedicated to the erasure of human particularity and the celebration of an imperialist dominance over nature. As Mary Louise Pratt has shown, the panorama conventionally invokes a monarchic subject who projects a psychological fantasy of domination during encounters with the imperial frontier. Pratt, "Scratches on the Face of the Country."

26. Anonymous, *Description of Banvard's Panorama*, p. 22. Hereafter, citations to Banvard's *Description* will be noted parenthetically.

27. Boime, *Art of Exclusion*, p. 91.

28. On the intermingling of race and criminality, see Davis, "Race and Criminalization."

29. For more on the use of ambiguation as concealment for political skepticism, see Abrams, *Landscape and Ideology in American Renaissance Literature.*

30. Farrison, *William Wells Brown*, pp. 174–176.

31. Because of a general dearth of published materials and extant illustrations related to panoramas of the period, very little is known about other ex-fugitive slaves who remained in England giving lectures and touring with panoramas succeeding the strengthening of the Fugitive Slave Law in 1850. C. Peter Ripley notes the epiphenomenal popularity of Henry "Box" Brown's panorama, which also reflected his peculiarly sensational escape via the postal system, and the panorama of J. C. A. Smith, about whom almost nothing remains in evidence. Ripley, *Black Abolitionist Papers*, p. 191.

32. Brown, *Description of Original Panoramic Views*, p. iii. Hereafter cited as Brown's *Description* and followed by parenthetical page numbers.

33. On the generic tendencies of the antebellum slave narrative, see Andrews, "The Performance of Slave Narrative in the 1840s," in *To Tell a Free Story*, pp. 97–166.

34. For more on slave ship rebellion, see Montesinos, *Slumbering Volcano.*

35. By performance, I mean it here in both the traditional sense, from J. L. Austin, that Brown's verbal utterances affect the reception of the display, as well as in Judith Butler's sense, that the performative works according to a logic of iterability and is conditioned by social discourses delimiting its ritual possibilities and purposes for the construction of identity. It is through sustained repetitions, gestures, and ways of being that the illusion of coherence in identity manifests. Butler, *Gender Trouble.*

36. For an intelligent discussion of temporality and narrative painting, see Mitchell, "The Politics of Genre."

37. McBride, *Impossible Witnesses*, p. 6.

38. See Lapansky, "Graphic Discord."

39. For an insightful study of the intersection of abolitionism and sentimental masculinity, see Foreman, "Sentimental Abolition in Douglass's Decade."

40. For a thorough discussion of Bibb's narrative, domesticity, and generic influences, see Heglar, *Rethinking the Slave Narrative.*

41. Wood, *Blind Memory,* p. 127.

42. Bibb, *Narrative of the Life and Adventures,* p. 124.

43. See Heglar, *Rethinking the Slave Narrative* and Andrews, *To Tell a Free Story,* pp. 151–160.

44. Bibb, *Narrative,* p. 126.

45. Ibid.

46. Weld, *American Slavery as It Is,* p.75.

47. It is at this point that Brown readjusts the panorama from medium to assemblage, making it both a technical apparatus as well as a technology of identity, or what Deleuze and Guattari explain as both a "machinic assemblage and an assemblage of enunciation." Deleuze and Guattari, *Thousand Plateaus,* p. 504.

48. The revolution in visuality carried out by a combination of the market and technology, according to Crary, gives rise to "a new valuation of visual experience: it is given an unprecedented mobility and exchangeability, abstracted from any founding site or referent." Crary, *Techniques of the Observer,* p. 14.

49. McBride, *Impossible Witnesses,* p. 6.

50. Stowe, *Uncle Tom's Cabin,* p. 54.

51. Ibid., p. 51.

5. The Mulatta in the Camera

1. Griffin, "Textual Healing," p. 521.

2. Extending analyses focusing on Jacobs's use of literacy and feigned letters from the North, I pursue the concomitant effect of Jacobs's manipulation of the visual field in this chapter. For more on literacy and Jacobs, see Yellin, "Written by Herself"; Berlant, "The Queen of America"; and Carby, *Reconstructing Womanhood.*

3. The camera obscura is an optical device epitomizing the Renaissance ideal of disembodied observation that persisted well into the antebellum period.

4. Rodriguez, *Autobiographical Inscriptions,* p 50–95.

5. A version of the play staged in Britain ends happily in interracial marriage; American versions end tragically with the deaths of major characters.

6. Butler, *Bodies That Matter,* p. 219.

7. Ibid.

8. Jacobs, *Incidents in the Life,* pp. 28–29. Hereafter, citations to pages will be made parenthetically.

9. Carby, "'Hear My Voice, Ye Careless Daughters,'" p. 69.

10. *Incidents* emphatically isolates that tension inherent to sentimental looking relations between "feeling" and "code," which, according to Bruce Burgett, "was intended to sharpen the emotional effect on the sensitive reader who, presumably, experienced the same conflict within herself." Burgett, *Sentimental Bodies,* p. 16.

11. Ibid., p. 84.

12. Ibid., p. 16.

13. Perhaps the best-known argument that opposes Ann Douglass's claim that

nineteenth-century sentimentalism merely sanctioned patriarchal minimizations of women and women's roles is Jane Tompkins's *Sensational Designs*. Post-Tompkins scholarship, which discusses sentimentalism's emphasis on the politics of affect and the body, albeit according to a different ideological paradigm than male-authored discourse, includes Armstrong, *Desire and Domestic Fiction*; Herbert Ross Brown, *Sentimental Novel in America*; Cherniavsky, *That Pale Mother Rising*; Cott, *Bonds of Womanhood*; Harris, *19th-Century American Women's Novels*; Kelley, *Private Woman, Public Stage*; Merish, *Sentimental Materialism*; and Noble, *Masochistic Pleasures of Sentimental Literature*.

14. Jacobs's preoccupation with material history and the way that the past mediates observations of the present relates to Marxist conceptions of "fore-history." Walter Benjamin states that repetition does not exist for the material historian "because the moments in the course of history which matter most to [her] become moments of the present through their index as 'fore-history,' and change their characteristics according to the catastrophic or triumphant determination of that present." Benjamin, *Arcades Project*.

15. Hazel Carby argues that Jacobs unmasks the contradictions of ideal womanhood when applying them to Southern mistresses, who invariably fall short of its dictates: "The qualities of delicacy of constitution and heightened sensitivity, attributes of the Southern lady, appear as a corrupt veneer that covers an underlying strength and power in cruelty and brutality." Carby, "Hear My Voice, Ye Careless Daughters," p. 70.

16. For more on Aunt Hester's whipping, see Bergner, "Myths of Masculinity," and McDowell, "In the First Place," pp. 192–214.

17. Douglass, *Narrative*, pp. 14–15.

18. Ibid., p. 5.

19. DeLombard, "'Eye-Witness to the Cruelty,'" p. 246.

20. Doane, "Technophilia," p. 166.

21. Marx, *Capital*, p. 165

22. Berlant, "The Queen of America," p. 560.

23. Crary, *Techniques of the Observer*, p. 27.

24. Ibid., pp. 38–39.

25. Smith, "Resisting the Gaze of Embodiment," p. 101; see also Andrews, *To Tell a Free Story*, pp. 253–258, and Foster, "In Respect to Females."

26. Smith, "Resisting the Gaze of Embodiment," p. 101.

27. As in all cases of anchorage, the restriction of floating meanings is also ideological, banishing other possible signifieds the instant it attaches to them. In this case, we might wonder about the connotative counterreference in the image of the absent Indian, also counterintuitively anchored as the not-operator of the operator-less daguerreotype—a sort of logical imputation of agency denied—and the posture of the white man with tomahawk, or white man become savage, which is likewise denied as an abstraction and limited to the special wickedness of M'Closkey. See Barthes, "The Rhetoric of the Image," in *Image Music Text*, p. 39.

28. Douglass, "Pictures and Progress."

29. Carby, "Hear My Voice, Ye Careless Daughters," pp. 75, 92.

30. Critics have argued that the garret metaphorizes Jacobs's struggle to find discursive as well as physical sanctuary in the antebellum United States. For Bruce

Burgett, the martial connotations of the term "loophole of retreat" signify "that the boundary between public and private is a battleground that transects Jacobs's body. The garret becomes a strategic position in her struggle to publicize the structural asymmetries that both underlie *and* belie nineteenth-century liberalism as a political ideology." Burgett, *Sentimental Bodies,* p. 138.

31. Crary argues that between 1810 and 1840 there occurs "an uprooting of vision from the stable and fixed relations incarnated in the camera obscura" (*Techniques of the Observer,* p. 14). While Crary argues that the new observer produced by this revolution in visuality becomes more mobile and exchangeable and is abstracted from any site or reference, Jacobs intervenes on this abstraction, grounding the viewers of her scenes in her own bodily experiences.

32. Originally written by the American John Payne to accompany the music of British composer Henry Bishop for the opera *Clari, or the Maid of Milan* in 1823, "Home, Sweet Home" quickly became one of the century's most renowned songs, sweeping America in printed song sheets and routinely performed by traveling minstrel troupes as well as the acclaimed Jenny Lind, who sang it for President Lincoln. Soon to be a favorite pastime for weary soldiers on both sides of the Civil War battlefield, the song takes on an eerily literal meaning for Brent in the garret, for whom there is no place like a home at all. For more on the history of "Home, Sweet Home," see Clarke, *Rise and Fall.*

33. As Lauren Berlant has argued, this passing critiques the gendered division of American citizenship: "He [Sands] has the right to forget and to not feel, while sensation and its memory are all she owns. This is the feeling of what we might call the slave's two bodies: sensual and public on the one hand; vulnerable, invisible, forgettable on the other." Berlant, "The Queen of America," p. 556.

34. Crary, *Techniques of the Observer,* p. 19.

35. Ibid, p. 50.

36. Barthes elaborates on this temporal function:

The type of consciousness the photograph involves is indeed truly unprecedented, since it establishes not a consciousness of the *being-there* of the thing (which any copy could provoke) but an awareness of its *having-been-there.* What we have is a new space-time category: spatial immediacy and temporal anteriority, the photograph being an illogical conjunction between the *here-now* and the *there-then.*

See "The Rhetoric of the Image," *Image Music Text,* p. 43.

37. Foucault, *Discipline and Punish,* pp. 198–199.

6. Throwing Identity in the Poetry-Pottery of Dave the Potter

1. Bhaba, *Location of Culture,* p. 132.
2. Zou, "Radical Criticism," p. 10.
3. Ferris, *Afro-American Folk Art,* p. 33.
4. In "Preface to Blackness: Text and Pre-Text," Gates mounts a critique against interpretive practices that fail to sufficiently treat the literary work as a linguistic

event deserving of close reading. Gates's injunction that the primary aim of criticism is the "deconstruction" of sign systems instead of the reconstruction of a priori meanings pertains to Ferris, whose lament regarding the shortage of observably Afrocentric Southern folk art nevertheless presumes what knowledge such artifacts would bestow. In other words, Ferris seems, to me, to already know what he is looking for and thus may fail to spot mutations of Afrocentricity in existing works, such as Dave the Potter's.

 5. Vlach, *Afro-American Tradition.*

 6. Ibid., p. 33.

 7. Ibid., p. 33.

 8. Koverman, *I Made This Jar,* p. 20.

 9. Much of the scholarship on slave crafts has tended toward the important, if sometimes narrowly framed, work of investigating linkages between craft objects and African influences. In a now famous passage explicating the tragic dimensions of the diaspora, eminent African American historian E. Franklin Frazier succinctly articulates the cultural conditions facing the displaced African: "Through force of circumstances, [slaves] had to acquire a new language, adopt new habits of labor, and take over, however imperfectly, the folkways of the American environment" (Frazier, *Negro Family,* p. 21). According to traditional historical renditions of African cultural evolution in the Americas, slave culture became a repository of syncretisms—amalgamations of native African customs and the "new habits of labor" mentioned by Frazier—and so the major task facing the twentieth-century scholar working within the new field of African American studies was to reestablish the connections to Africa that centuries of slavery and oppression had obliterated or ignored. Melville Herskovits, an early pioneer of anthropology who was inspired by Franz Boas's postulations that racial differences are socially and culturally constructed, termed these surviving syntheses of African and European folkways "Africanisms." As a result of Herskovits's rather convincing argument, which Wilson J. Moses lauds as definitive of African American scholarship despite Frazier's rejection of Herskovits's central thesis that black Americans are essentially an African people (Moses, *Afrotopia,* p. 235), a great majority of the scholarly work done on early African American art and craft has been pressed into the service of unearthing such Africanisms in eighteenth- and nineteenth-century artifacts. David Driskell's emphasis on examining early slave works primarily for their expression of Africanisms is not atypical of much of the scholarship devoted to slave crafts such as Gullah baskets, the ironwork of Southern cities, the woodwork in Carolina houses, cemetery markers, pottery, and quilting. Driskell finds in the surviving decorative arts of slaves in colonial America "a synthesis of the distinct characteristics of African craftsmanship and iconography with the art of the majority of culture" (Driskell, *Two Centuries,* p. 12). Following in this train of methodological and interpretive prerogatives, John Vlach updates Herskovits's study of surviving strains of alternative, African cultural elements in basketry, musical instrument building, wood carving, pottery, boatbuilding, and blacksmithing: "Black artisans maintained their alternative sense of creativity only through working out a complex amalgam of cultural influences" (Vlach, *Afro-American Tradition.* p. 1).

 10. Burrison, "Afro-American Folk Pottery," p. 337.

11. Mississippi, for example, passed legislation forbidding the education of slaves or free Negroes in 1823; Louisiana, in 1830; North Carolina and Virginia, in 1831; and Alabama, in 1832.

12. Burrison, "Afro-American Folk Poetry," p. 335.

13. Mintz and Price, *Birth of African American Culture*, p. 51.

14. Thompson, *African Art in Motion*, p. 13.

15. Burrison, "Afro-American Folk Poetry," p. 336.

16. Ibid.

17. W. E. B. Du Bois, "The Ante-Bellum Negro Artisan," p. 179.

18. Ibid.

19. Ibid., pp. 177–178.

20. Newton, "Slave Artisans and Craftsmen," p. 235.

21. For another detailed discussion of the unique class position of the quasi-slave, see Wade, *Slavery in the Cities*.

22. Wikramanayake, *World in Shadow*.

23. Wood, *Black Majority*, p. 198.

24. Hudson, *To Have and to Hold*, p. xiv.

25. Ibid., p. 15.

26. Hall, "Cultural Identity and Diaspora,"

27. Ibid., p. 325.

28. Smith, *Discerning the Subject*, p. 118.

29. Bhaba, *Location of Culture*, p. 132.

30. Andrews, *To Tell a Free Story*, pp. 6–7.

31. Mullen, "Optic White," p. 84.

32. Gates and Davis, *Slave's Narrative*, p. xxviii.

33. Stuckey, *Slave Culture*.

34. Pennington, *Text Book*, p. 8.

35. Washington, *Our Mothers, Our Powers, Our Texts*, p. 77.

36. Wood, *Black Majority*, pp. 187–188.

37. McDowell, "In the First Place," p. 42.

38. Deleuze and Guattari, *Thousand Plateaus*, p. 504.

39. Jeannine DeLombard, "'Eye-Witness to the Cruelty.'"

40. Hartman, *Scenes of Subjection*, p. 7.

41. Crary, *Techniques of the Observer*, p. 62.

42. Ibid.

43. Genovese, *Roll, Jordan Roll*, p. 284.

44. Andrews, *To Tell a Free Story*, p. 23.

45. Jonathan Green, quoted in Koverman, *I Made This Jar*, p. 1.

46. According to Jacques Derrida in "Signature Event Context" the signatorial mark fallaciously promises to protract time or to defer its passage infinitely while unsuccessfully attempting to attest to the existence of a singular individual that is forever indicated by the "iterability" or repeatability of the signature:

> By definition, a written signature implies the actual or empirical nonpresence of the signer. But, it will be said, it also marks and retains his having-been-present in a past now, which will remain a future now, and therefore in a now in general, in the transcendental form of nowness . . . For the attachment to the source to

occur, the absolute singularity of an event of the signature and of a form of the signature must be retained: the pure reproducibility of a pure event. (328)

47. Olney, "'I Was Born,'" p. 54.
48. Ibid., p. 52.
49. For more on Baker's concept of identity entailed by the Blues, see *Blues, Ideology, and African-American Literature,* particularly the introduction.
50. Berlant, "National Brands/National Body," p. 125.
51. Ibid., p. 114.
52. McNally, *Bodies of Meaning,* p. 69.
53. Berlant, "National Brands/National Body," p. 111.
54. Marx, *Capital,* p. 165.

Conclusion

1. Stowe, *Uncle Tom's Cabin,* p. 428.
2. Ibid., p. 437.
3. Ibid., p. 410.
4. Barrrett, *Blackness and Value,* p. 217.
5. Ibid., p. 110.
6. Ibid., p. 50.
7. Ibid., p. 51.
8. Merleau-Ponty, *Visible and the Invisible,* p. 94.
9. Ibid., p. 214.

WORKS CITED

Abrams, Robert E. *Landscape and Ideology in American Renaissance Literature: To-pographies of Skepticism*. New York: Cambridge University Press, 2004.

Abzug, Robert. *Passionate Liberator: Theodore Dwight Weld and the Dilemma of Re-form*. New York: Oxford University Press, 1980.

Adorno, Theodor. *Aesthetic Theory*. Trans. C. Lenhardt. London: Routledge, 1984.

Altick, Richard. *The Shows of London*. Cambridge, Mass.: Belknap/Harvard University Press, 1978.

American Naval Battles: Being a Complete History of the Battles Fought by the Navy of the United States from Its Establishment in 1794 to the Present Time. Concord, N.H.: Luther and Roby, 1848.

Andrews, William L., ed. *African American Autobiography: A Collection of Critical Essays*. New York: Prentice Hall, 1992.

————. "The Novelization of Voice in Early African American Narrative." *PMLA* 105 (1990): 23–34.

————. *To Tell a Free Story: The First Century of Afro-American Autobiography, 1760–1865*. Urbana: University of Illinois Press, 1986.

————. "Toward a Poetics of Afro-American Autobiography." In *Afro-American Literary Study in the 1990s*, ed. Houston A. Baker, Jr., and Patricia Redmond. Chicago: University of Chicago Press, 1989. 78–90.

Anonymous. *Description of Banvard's Panorama of the Mississippi River, Painted on Three Miles of Canvas: Exhibiting a View of the Country 1200 Miles in Length, Extending from the Mouth of the Missouri River to the City of New Orleans; Being by Far the Largest Picture Ever Executed by Man*. Boston: John Putnam, 1847.

Armstrong, Nancy. *Desire and Domestic Fiction: A Political History of the Novel*. New York: Oxford University Press, 1989.

Austin, J. L. *How to Do Things with Words*. Ed. J. O. Urmson and Marina Sbisa. Cambridge, Mass.: Harvard University Press, 1962.

Baker, Houston, Jr. "Autobiographical Acts and the Voice of the Southern Slave." In *Critical Essays on Frederick Douglass*, ed. William L. Andrews. Boston: Hall, 1991. 94–107.

————. *Blues, Ideology, and African-American Literature: A Vernacular Theory*. Chicago: University of Chicago Press, 1987.

Bakhtin, M. M. *Speech Genres and Other Late Essays*. Trans. Vein W. McGee, ed. Caryl Emerson and Michael Holquist. Austin: University of Texas Press, 1986.

————. *Problems of Dostoevsky's Poetics*. Trans. Caryl Emerson. Minneapolis: University of Minnesota Press, 1984.

Bal, Mieke. "Visual Poetics: Reading with the Other Art." In *Theory between the Disciplines: Authority /Vision /Politics*, ed. Mark. A. Cheetham and Martin Kreiswirth. Ann Arbor: University of Michigan Press, 1990. 135–150.

Ball, Charles. *Slavery in the United States: A Narrative of the Life and Adventures of Charles Ball, a Black Man, Who Lived Forty Years in Maryland, South Carolina*

and Georgia, as a Slave Under Various Masters, and Was One Year in the Navy with Commodore Barney, during the Late War. New York: John S. Taylor, 1837.

Baron, Beth. *Egypt as a Woman: Nationalism, Gender, Politics.* Berkeley: University of California Press, 2005.

Barrett, Lindon. *Blackness and Value: Seeing Double.* Cambridge, UK: Cambridge University Press, 1999.

———. "Hand-Writing: Legibility and the White Body in *Running a Thousand Miles for Freedom.*" *American Literature* 69.2 (1997): 315–336.

Barthes, Roland. *Camera Lucida: Reflections on Photography.* New York: Hill & Wang, 1980.

———. *Image, Music, Text.* Ed. and trans. Stephen Heath. New York: Hill & Wang, 1977.

Benjamin, Walter. *The Arcades Project.* Trans. Howard Eiland and Kevin McLaughlin. Cambridge, Mass.: Harvard University Press, 1999.

Benston, Kimberly W. "Facing Tradition: Revisionary Scenes in African American Literature." *PMLA* 105.1 (1990): 98–109.

Bergner, Gwen. "Myths of Masculinity: The Oedipus Complex and Douglass's 1845 Narrative." In *The Psychoanalysis of Race,* ed. Christopher Lane. New York: Columbia University Press, 1998. 241–260.

Berlant, Lauren. "National Brands/National Body: *Imitation of Life.*" In *Comparative American Identities,* ed. Hortense Spillers. New York: Routledge, 1991. 110–140.

———. "The Queen of America Goes to Washington City: Harriet Jacobs, Frances Harper, Anita Hill." *American Literature* 65.3 (1993): 549–574.

Bhabha, Homi. *The Location of Culture.* New York: Routledge, 1994.

Bibb, Henry. *Narrative of the Life and Adventures of Henry Bibb, An American Slave* (1849). Ed. and introduction by Charles Heglar. Madison: University of Wisconsin Press, 2000.

Bland, Sterling Lecater, Jr. *Voices of the Fugitives: Runaway Slave Stories and Their Fictions of Self-Creation.* New York: Greenwood, 2000.

Blassingame, John W. *The Slave Community: Plantation Life in the Ante-Bellum South.* Rev. ed. New York: Oxford University Press, 1979.

Boime, Albert. *The Art of Exclusion: Representing Blacks in the Nineteenth Century.* London: Thames and Hudson, Ltd., 1990.

Bontemps, Arna, ed. *Five Black Lives; The Autobiographies of Venture Smith, James Mars, William Grimes, the Rev. G. W. Offley, [and] James L. Smith.* 1st ed. Middletown, Conn.: Wesleyan University Press, 1971.

Born, Wolfgang. "The Panoramic Landscape as an American Art Form." *Art in America* 36 (1948): 3–4.

Brawley, Lisa. "Frederick Douglass's *My Bondage and My Freedom* and the Fugitive Tourist Industry." *Novel: A Forum on Fiction* 30.1 (Fall 1996): 98–128.

Braxton, Joanne M. *Black Women Writing Autobiography: A Tradition within a Tradition.* Philadelphia: Temple University Press, 1989.

Brown, Gillian. *Domestic Individualism: Imagining the Self in 19th-Century America.* Berkeley: University of California Press, 1990.

Brown, Herbert Ross. *The Sentimental Novel in America, 1789–1865.* New York: Oxford University Press, 1989.

Brown, William Wells. *A Description of William Wells Brown's Original Panoramic Views of the Scenes in the Life of an American Slave, from His Birth in Slavery to*

His Death or His Escape to His First Home of Freedom on British Soil. London: Charles Gilpin, 1850.

———. *Narrative of William W. Brown, an American Slave. Written by Himself.* Boston: Antislavery Office, 1847; London: C. Gilpin, 1849.

Burgett, Bruce. *Sentimental Bodies: Sex, Gender, and Citizenship in the Early Republic.* Princeton, N.J.: Princeton University Press, 1998.

Burrison, John A. "Afro-American Folk Pottery in the South." In *Afro-American Folk Art and Crafts,* ed. William Ferris. Boston: G. K. Hall, 1983. 332–353.

Butler, Judith. *Bodies That Matter: On the Discursive Limits of "Sex."* New York: Routledge, 1993.

———, *Gender Trouble: Feminism and the Subversion of Identity.* New York: Routledge, 1990.

Carby, Hazel V. "'Hear My Voice, Ye Careless Daughters': Narratives of Slave and Free Women before Emancipation." In *African American Autobiography: A Collection of Critical Essays,* ed. William L. Andrews. Upper Saddle River, N.J.: Prentice Hall, 1993. 59–76.

———. *Reconstructing Womanhood: The Emergence of the Afro-American Woman Novelist.* New York: Oxford University Press, 1987.

Carroll, Anne Elizabeth. *Word, Image, and the New Negro: Representation and Identity in the Harlem Renaissance.* Bloomington: Indiana University Press, 2005.

Casmier-Paz, Lynn A. "Slave Narratives and the Rhetoric of Author Portraiture." *New Literary History* 34 (2003): 91–116.

Castronovo, Russ. "'As to Nation, I Belong to None': Ambivalence, Diaspora, and Frederick Douglass." *American Transcendental Quarterly* 9 (1995): 245–260.

Cherniavsky, Eva. *That Pale Mother Rising: Sentimental Discourses and the Imitation of Motherhood in 19th-Century America.* Bloomington: Indiana University Press, 1995.

Child, Lydia Maria. *An Appeal in Favor of That Class of Americans Called Africans.* Boston: Allen & Ticknor, 1833.

Christian, Barbara. *Black Women Novelists: The Development of a Tradition, 1892–1976.* Westport, Conn.: Greenwood, 1980.

Clarke, Donald. *The Rise and Fall of Popular Music.* New York: St. Martin's, 1995.

Comment, Bernard. *The Painted Panorama.* New York: Harry N. Abrams, 1999.

Cott, Nancy. *The Bonds of Womanhood: "Woman's Sphere" in New England, 1780–1835.* New Haven, Conn.: Yale University Press, 1977.

Craft, William, and Ellen Craft. *Running a Thousand Miles for Freedom: The Escape of William and Ellen Craft from Slavery* (1860). Introduction by Barbara McCaskill. Athens: University of Georgia Press, 1999.

Crary, Jonathan. *Techniques of the Observer: On Vision and Modernity in the Nineteenth Century.* Cambridge, Mass.: MIT Press, 1990.

Davis, Angela. "Race and Criminalization: Black Americans and the Punishment Industry." In *The House That Race Built,* ed. Wahneema Lubiano. New York: Vintage, 1998. 264–279.

Davis, David Brion. *Problem of Slavery in the Age of Revolution.* New York: Oxford University Press, 1975.

———. *Problem of Slavery in Western Culture.* New York: Oxford University Press, 1988.

Debord, Guy-Ernest, and Gil J. Wolman. "Methods of Détournement." Trans. Ken

Knabb. *Les Lèvres Nues* 8 (1956). Available on-line as "A User's Guide to Détournement," www.cddc.vt.edu/sionline/presitu/usersguide.html.

Deleuze, Gilles, and Félix Guattari. *A Thousand Plateaus: Capitalism and Schizophrenia.* Trans. Brian Massumi. Minneapolis: University of Minnesota Press, 1987.

DeLombard, Jeannine. "'Eye-Witness to the Cruelty': Southern Violence and Northern Testimony in Frederick Douglass's 1845 *Narrative*." *American Literature* 73.2 (2001): 245–275.

DeMan, Paul. "Autobiography as De-facement." *Modern Language Notes* 94 (1979): 919–930.

Derrida, Jacques. "Signature Event Context" (orig. pub. 1972). In *Margins of Philosophy,* trans. A. Bass. Chicago: University of Chicago Press, 1986. 307–330.

De Quincey, Thomas. "On the Knocking at the Gate in *Macbeth*." *The Collected Writings,* vol. 10, ed. David Masson. London: A & C Black, 1896–1897.

Doane, Mary Ann. "Film and the Masquerade: Theorizing the Female Spectator." In *Writing on the Body: Female Embodiment and Feminist Theory,* ed. Katie Conboy, Nadia Medina, and Sarah Stanbury. New York: Columbia University Press, 1997. 176–192.

———. "Technophilia: Technology, Representation and the Future." In *Body/Politics: Women and the Discourses of Science,* ed. Mary Jacobus, Evelyn Fox Keller, and Sally Shuttleworth. New York: Routledge, 1990. 163–177.

Dorsey, Peter A. "Becoming the Other: The Mimesis of Metaphor in Douglass's *My Bondage and My Freedom*." *PMLA* 111 (1996): 435–450.

Douglass, Frederick. "The Claims of the Negro Ethnologically Considered, an Address Delivered at Western Reserve College, July 12, 1854." In *The Life and Writings of Frederick Douglass,* ed. Philip S. Foner. New York: International, 1950. 2: 289–309.

———. *My Bondage and My Freedom* (1855). New York: Dover, 1969.

———. *Narrative of the Life of Frederick Douglass, An American Slave* (1845). New York: Norton, 1997.

———. "Pictures and Progress" (1861), In *The Frederick Douglass Papers,* vol. 3, 1855–63, ed. John Blassingame. New Haven, Conn.: Yale University Press, 1985. 452–473.

Driskell, David. *Two Centuries of Black American Art.* New York: Knopf, 1976.

Du Bois, W. E. B. "The Ante-Bellum Negro Artisan" (1902). In *The Other Slaves: Mechanics, Artisans, and Craftsmen,* ed. James E. Newton and Donald Lewis. Boston: G. K. Hall & Co., 1978. 175–182.

duCille, Ann. *The Coupling Convention: Sex, Text, and Tradition in Black Women's Fiction.* Oxford, UK: Oxford University Press, 1993.

Duffy, Dennis. *Marshall McLuhan.* Toronto: McClelland and Stewart Limited, 1969.

Dyer, Richard. *White.* New York: Routledge, 1997.

Edelman, Lee. *Homographesis: Essays in Gay Literary and Cultural Theory.* New York: Routledge, 1994.

Emerson, Ralph Waldo. "English Traits" (1856). In *The Portable Emerson,* ed. Malcolm Cowley. New York: Penguin Books, 1981. 395–518.

Fabi, M. Giulia. *Passing and the Rise of the African American Novel.* Urbana: University of Illinois Press, 2001.

Fabian, Johannes. *Time and the Other: How Anthropology Makes Its Object.* New York: Columbia University Press, 1983,

Fanon, Frantz. *Black Skin, White Masks.* Trans. Charles Lam Markmann. New York: Grove, 1967.

Farrison, William Edward. *William Wells Brown, Author and Reformer.* Chicago: University of Chicago Press, 1969.

Ferris, William, ed. *Afro-American Folk Art and Crafts.* New York: G. K. Hall, 1983.

Fisch, Audrey. *American Slaves in Victorian England: Abolition in Popular Literature and Culture.* Cambridge, UK: Cambridge University Press, 2000.

Fleischner, Jennifer. *Mastering Slavery: Memory, Family, and Identity in Women's Slave Narratives.* New York: New York University Press, 1996.

Foreman, P. Gabrielle. "Sentimental Abolition in Douglass's Decade: Revision, Erotic Conversion, and the Politics of Witnessing in *The Heroic Slave* and *My Bondage and My Freedom.*" In *Sentimental Men: Masculinity and the Politics of Affect in American Culture,* ed. Glenn Hendler and Mary Chapman. Berkeley: University of California Press, 1999. 149–162.

———. "'Who's Your Mama?' 'White' Mulatta Genealogies, Early Photography, and Anti-Passing Narratives of Slavery and Freedom." *American Literary History* 14.3 (2002): 505–539.

Foster, Frances Smith. "In Respect to Females . . .': Differences in the Portrayals of Women by Male and Female Narrators." *Black American Literature Forum* 15 (1981): 66–70.

———. *Witnessing Slavery: The Development of Ante-bellum Slave Narratives.* Westport, Conn.: Greenwood, 1979.

Foucault, Michel. *The Archaeology of Knowledge.* London: Tavistock, 1972.

———. *Discipline and Punish: The Birth of the Prison.* Trans. A. M. Sheridan. New York: Pantheon, 1979.

———. *Power/Knowledge: Selected Interviews and Other Writings, 1972–1977.* New York: Pantheon, 1980.

———. "Technologies of the Self." In *Technologies of the Self: A Seminar with Michel Foucault,* ed. L. H. Martin, H. Gutman, and P. H. Hutton. Tavistock, London, 1988. 16–49.

Franchot, Jenny. "The Punishment of Esther: Frederick Douglass and the Construction of the Feminine." In *Frederick Douglass: New Literary and Historical Essays,* ed. Eric J. Sundquist. New York: Cambridge University Press, 1990. 141–165.

Frazier, E. Franklin. *The Negro Family in the United States.* Chicago: University of Chicago Press, 1938.

Fredrickson, George M. *The Black Image in the White Mind: The Debate on Afro-American Character and Destiny, 1817–1914.* Middletown, Conn.: Wesleyan University Press, 1971.

Freud, Sigmund. "The Uncanny" (1919) in *The Penguin Freud Library Volume 14: Art and Literature.* Trans. and ed. James Strachey. London: Penguin, 1990.

Fuss, Diana. "Interior Colonies: Frantz Fanon and the Politics of Identification." *Diacritics* 24.2–3 (1994): 19–42.

Gabler-Hover, Janet. *Dreaming Black/Writing White: The Hagar Myth in American Cultural History.* Lexington: University Press of Kentucky, 2000.

Garber, Marjorie. *Vested Interests: Cross-Dressing and Cultural Anxiety.* New York: Routledge, 1992.

Gates, Henry Louis, Jr. "The Blackness of Blackness: A Critique of the Sign and the Signifying Monkey." In *Black Literature and Literary Theory,* ed. Henry Louis Gates, Jr. New York: Methuen, 1984. 285–321.

———. *Figures in Black: Words, Signs, and the "Racial" Self.* New York: Oxford University Press, 1987.

———. "Preface to Blackness: Text and Pre-Text." In *Afro-American Literature: The Reconstruction of Instruction,* ed. Dexter Fisher and Robert B. Stepto. New York: MLA, 1978. 44–71.

———. *Signifying Monkey: A Theory of African American Literary Criticism.* New York: Oxford University Press, 1988.

———, and Charles T. Davis, eds. *The Slave's Narrative.* New York: Oxford University Press, 1985.

Genovese, Eugene D. *Roll, Jordan Roll: The World the Slaves Made.* New York: Vintage, 1972.

Gilman, Sander. "Black Bodies, White Bodies: Toward an Iconography of Female Sexuality." *Critical Inquiry* 12 (1985): 203–242.

———. *Difference and Pathology: Stereotypes of Sexuality, Race, and Madness.* Ithaca, N.Y.: Cornell University Press, 1985.

Gilroy, Paul. *Against Race.* Cambridge, Mass.: Harvard University Press, 2000.

Goodman, Nelson. *Languages of Art. An Approach to a Theory of Symbols.* New York: Bobbs-Merrill Co., 1968.

Griffin, Farah Jasmine. "Textual Healing: Claiming Black Women's Bodies, the Erotic and Resistance in Contemporary Novels of Slavery." *Callaloo* 19.2 (1996): 519–536.

Grover, Kathryn. "Fugitive Slave Traffic and Maritime New Bedford: A Research Paper Prepared for New Bedford Whaling National Historic Park and the Boston Support Office of the National Park Service." September 1999, New Bedford, Mass. http://www.nps.gov/archive/nebe/research/grover.pdf.

Gwin, Minrose. "Space Travel: The Connective Politics of Feminist Reading." *Signs* 21.4 (1996): 870–905.

Hall, Stuart. "Cultural Identity and Diaspora." In *Identity: Community, Culture, Difference,* ed. J. Rutherford. London: Lawrence & Wishart, 1990. 322–337.

Harris, Cheryl. "Whiteness as Property." *Harvard Law Review* 106, 8 (1993): 1707–1791.

Harris, Susan K. *19th-Century American Women's Novels: Interpretive Strategies.* Cambridge, UK: Cambridge University Press, 1990.

Hartman, Saidiya V. *Scenes of Subjection: Terror, Slavery, and Self-Making in Nineteenth-Century America.* New York: Oxford University Press, 1997.

Hawthorne, Nathaniel. *The Blithedale Romance.* Boston: Ticknor, Reed, and Fields, 1852.

———. *The House of the Seven Gables.* Boston: Ticknor, 1851.

Heffernan, James A. W. *Museum of Words: The Poetics of Ekphrasis from Homer to Ashbery.* Chicago: University of Chicago Press, 1993.

Heglar, Charles J. *Rethinking the Slave Narrative: Slave Marriage and the Narratives of Henry Bibb and Ellen Craft.* Westport, Conn.: Greenwood, 2001.

Henderson, Carole E. *Scarring the Black Body: Race and Representation in African American Literature.* Columbia: University of Missouri Press, 2002.

Herskovits, Melville. *The Myth of the Negro Past.* Boston: Beacon Hill, 1941.

Hinks, Peter P. *To Awaken My Afflicted Brethren: David Walker and the Problem of Antebellum Slave Resistance.* University Park: Pennsylvania State University Press, 1997.

Holland, Sharon Patricia. *Raising the Dead: Readings of Death and (Black) Subjectivity.* Durham, N.C.: Duke University Press, 2000.

hooks, bell. *Black Looks: Race and Representation.* Boston: South End, 1992.

——. *Talking Back: Thinking Feminist, Thinking Black.* Boston: South End, 1989.

Hudson, Larry E., Jr. *To Have and to Hold: Slave Work and Family Life in Antebellum South Carolina.* Athens: University of Georgia Press, 1997.

Huffer, Lynn. *Maternal Pasts, Feminist Futures: Nostalgia, Ethics, and the Question of Difference.* Stanford, Calif.: Stanford University Press, 1998.

Hyde, Ralph. *Panoramania! The Art and Entertainment of the All-Embracing View.* London: Trefoil Publications, 1988.

Jacobs, Harriet (Linda Brent). *Incidents in the Life of a Slave* (1862). Ed. Nellie Y. McKay and Frances Smith Foster. New York: Norton, 2001.

Jay, Martin. *Downcast Eyes: The Denigration of Vision in 20th Century French Thought.* Berkeley: University of California Press, 1994.

Johnson, Barbara. *Mother Tongues: Sexuality, Trials, Motherhood, Translation.* Cambridge, Mass.: Harvard University Press, 2003.

——. *A World of Difference.* Baltimore: Johns Hopkins University Press, 1987.

Kaplan, Sidney. *The Black Presence in the Era of the American Revolution 1770–1800.* Greenwich, Conn.: New York Graphic Society, 1973.

Kasson, Joy. *Marble Queens and Captives: Women in Nineteenth-Century American Sculpture.* New Haven, Conn.: Yale University Press, 1990.

Kawash, Samira. *Dislocating the Color Line: Identity, Hybridity, and Singularity in African-American Narrative.* Stanford, Calif.: Stanford University Press, 1997.

Kelley, Mary. *Private Woman, Public Stage: Literary Domesticity in Nineteenth-Century America.* New York: Oxford University Press, 1984.

Knox, Robert. *The Races of Men: A Fragment.* Philadelphia: Lea & Blanchard, 1850.

Koverman, Jill Beute, ed. *I Made This Jar: The Life and Works of the Enslaved African American Potter, Dave.* Columbia: McKissick Museum, University of South Carolina, 1998.

Krieger, Murray. *Ekphrasis: The Illusion of the Natural Sign.* Baltimore: Johns Hopkins University Press, 1992.

Krier, Theresa M. *Birth Passages: Maternity and Nostalgia, Antiquity to Shakespeare.* Ithaca, N.Y.: Cornell University Press, 2001.

Lacan, Jacques. *The Four Fundamental Concepts of Psychoanalysis.* Trans. Alan Sheridan. New York: Norton, 1978.

Lapansky, Phillip. "Graphic Discord: Abolitionist and Anti-Abolitionist Images." In *The Abolitionist Sisterhood: Women's Political Culture in Antebellum America,* ed. Jean Fagan Yellin and John C. Van Horne. Ithaca, N.Y.: Cornell University Press, 1994. 201–230.

Lawal, Babatunde. "The African Heritage of African American Art and Performance." In *Black Theatre: Ritual Performance in the African Diaspora,* ed. Paul

C. Harrison, Victor L. Walker, and Gus Edwards. Philadelphia: Temple University Press, 2002. 39–63.

Leverenz, David. "Frederick Douglass's Self-Refashioning." *Criticism* 29 (1987): 341–370.

Linville, Susan. *History Films, Women, and Freud's Uncanny.* Austin: University of Texas Press, 2004.

Lott, Eric. *Love and Theft: Blackface Minstrelsy and the American Working Class.* New York: Oxford University Press, 1993.

Marcus, Greil. *Lipstick Traces: A Secret History of the 20th Century.* Cambridge, Mass.: Harvard University Press, 1990.

Martin, Waldo E., Jr. *The Mind of Frederick Douglass.* Chapel Hill: University of North Carolina Press, 1984.

Marx, Karl. *Capital: A Critique of Political Economy,* vol. 1. Trans. Ben Fowkes. London: Penguin, 1976.

McBride, Dwight A. *Impossible Witnesses: Truth, Abolitionism, and Slave Testimony.* New York: New York University Press, 2001.

McCaskill, Barbara. "Introduction: William and Ellen Craft in Transatlantic Literature and Life." In *Running a Thousand Miles for Freedom,* ed. Barbara McCaskill. Athens: University of Georgia Press, 1999. vii–xxv.

———. "'Yours Very Truly': Ellen Craft—The Fugitive as Text and Artifact." *African American Review* 28.4 (1994): 509–529.

McClintock, Ann. *Imperial Leather: Race, Gender, and Sexuality in the Colonial Contest.* New York: Routledge, 1995.

McCloud, Scott. *Understanding Comics.* New York: Kitchen Sink, 1993.

McDermott, John. *The Lost Panoramas of the Mississippi.* Chicago: University of Chicago Press, 1958.

McDowell, Deborah E. "In the First Place: Making Frederick Douglass and the Afro American Narrative Tradition." In *African American Autobiography,* ed. William L. Andrews. Upper Saddle, N.J.: Prentice Hall, 1993. 36–58.

McNally, David. *Bodies of Meaning: Studies on Language, Labor and Liberation.* Albany: SUNY Press, 2001.

Merish, Lori. *Sentimental Materialism: Gender, Commodity Culture, and Nineteenth-Century American Literature.* Durham, N.C.: Duke University Press, 2000.

Merleau-Ponty, Maurice. *The Visible and the Invisible.* Ed. Claude Lefort. Trans. Alphonso Lingis. Evanston: Northwestern University Press, 1968.

Miller, Angela. *The Empire of the Eye: Landscape Representations and American Cultural Politics, 1825–1875.* Ithaca, N.Y.: Cornell University Press, 1993.

———. "The Imperial Republic: Narratives of National Expansion in American Art, 1820–1860." Ph.D. diss., Yale University, 1985.

Miller, J. Hillis. *Illustration.* Cambridge, Mass.: Harvard University Press, 1992.

Millington, Richard H. *Practicing Romance: Narrative Form and Cultural Engagement in Hawthorne's Fiction.* Princeton, N.J.: Princeton University Press, 1992.

Mintz, Sidney W., and Richard Price. *The Birth of African American Culture: An Anthropological Perspective.* Boston: Beacon, 1976.

Mitchell, W. J. T. *Iconology: Image, Text, Ideology.* Chicago: University of Chicago Press, 1986.

———. "Narrative, Memory, and Slavery." In *Cultural Artifacts and the Production*

of Meaning: The Page, the Image, and the Body, ed. Margaret J. M. Ezell and Katherine O'Brien O'Keeffe. Ann Arbor: University of Michigan Press, 1994.

———. *Picture Theory Essays on Verbal and Visual Representation.* Chicago: University of Chicago Press, 1994.

———. "The Politics of Genre: Space and Time in Lessing's *Laocoon.*" *Representations* 6 (1984): 98–115.

Montesinos, Maggie. *The Slumbering Volcano: American Slave Ship Revolts and the Production of Rebellious Masculinity.* Durham, N.C.: Duke University Press, 1997.

Morrison, Toni. "Unspeakable Things Unspoken: The Afro-American Presence in American Literature." *Michigan Quarterly Review* 28 (Winter 1989): 1–34.

Moses, Wilson Jeremiah. *Afrotopia: The Roots of African American Popular History.* Cambridge, UK: Cambridge University Press, 1998.

Moten, Fred. *In the Break: The Aesthetics of the Black Radical Tradition.* Minneapolis: University of Minnesota Press, 2003.

Mullen, Harryette. "Optic White: Blackness and the Production of Whiteness." *Diacritics* 24 (1994): 71–89.

Neumann, Mark. "Collecting Ourselves at the End of the Century." In *Composing Ethnography: Alternative Forms of Qualitative Writing,* ed. Carolyn Ellis and Arthur P. Bochner. Walnut Creek, Calif.: AltaMira, 1996. 172–200.

Newton, James E. "Slave Artisans and Craftsmen: The Roots of Afro-American Art." In *The Other Slaves: Mechanics, Artisans, and Craftsmen,* ed. James E. Newton and Donald Lewis. Boston: G. K. Hall & Co., 1978. 233–239.

Noble, Marianne. *The Masochistic Pleasures of Sentimental Literature.* Princeton, N.J.: Princeton University Press, 2000.

Norton, Anne. *Alternative Americas: A Reading of Antebellum Political Culture.* Chicago: University of Chicago Press, 1984.

Nott, Josiah C., and George R. Gliddon. *Types of Mankind: Or, Ethnological Researches Based Upon the Natural, Geographical, Philological, and Biblical History: Illustrated by Selections from the Unedited Papers of Samuel George Morton, MD, and by Additional Contributions from Prof. L. Agassiz, LLD, W. Usher, MD; and Prof. H.S. Patterson, MD.* 7th ed. Philadelphia: Lippincott, 1855.

Novak, Barbara. *Nature and Culture: American Landscape and Painting, 1825–1875.* New York: Oxford University Press, 1980.

Oettermann, Stephen. *The Panorama: History of a Mass Medium.* Trans. Deborah Lucas Schneider. New York: Zone Books, 1997.

Olney, James. "'I Was Born': Slave Narratives, Their Status as Autobiography and as Literature." *Callaloo* 20 (1984): 46–73.

O'Reilly, Andrea. "In Black and White: African American and Anglo-American Feminist Theory on the Mother and Son Relationship." In *Mothers and Sons: Feminism, Masculinity, and the Struggle to Raise Our Sons,* ed. Andrea O'Reilly. New York: Routledge, 2001.

Osgood, Nancy. "Josiah Wolcott: Artist and Associationist." *Old-Time New England* (1998): 5–34.

Pennington, James W. C. *A Text Book of the Origin and History of the Colored People* (1841). Detroit: Negro History Press, 1969.

Pietz, William. "The Problem of the Fetish, I." *Res: Journal of Anthropology and Aesthetics* 9 (Spring 1985): 5–17.

Pratt, Mary Louise. *Imperial Eyes: Travel Writing and Transculturation.* New York: Routledge, 1992.

———. "Scratches on the Face of the Country; or, What Mr. Barrow Saw in the Land of the Bushman." In *'Race,' Writing, and Difference,* ed. Henry Louis Gates, Jr. Chicago: Chicago University Press, 1986. 138–162.

Pratt, Stephanie. *Native Americans in British Art 1700–1840.* Norman: University of Oklahoma Press, 2005.

Prichard, James C. *The Natural History of Man: Comprising Inquiries into the Modifying Influence of Physical and Moral Agencies on the Different Tribes of the Human Family.* London: N. Bailliere, 1848.

Proceedings of the Anti-Slavery Convention of American Women. New York, 1837.

Raimon, Eva Allegra. *The "Tragic Mulatta" Revisited: Race and Nationalism in Nineteenth-Century Antislavery Fiction.* New Brunswick, N.J.: Rutgers University Press, 2004.

Ripley, C. Peter. *The Black Abolitionist Papers,* vol. 1. Chapel Hill: University of North Carolina Press, 1985.

Rodriguez, Barbara. *Autobiographical Inscriptions: Form, Personhood, and the American Woman Writer of Color.* New York: Oxford University Press, 1999.

Ryan, Mary P. *Womanhood in America: From Colonial Times to the Present.* 3rd ed. New York: Franklin Watts, 1983.

Sanchez-Eppler, Karen. *Touching Liberty: Abolition, Feminism, and the Politics of the Body.* Berkeley: University of California Press, 1993.

Seelye, John. *Prophetic Waters: The River in Early American Life and Literature.* New York: Oxford University Press, 1977.

Sekora, John, ed. *The Art of Slave Narrative: Original Essays in Criticism and Theory.* Macomb: Western Illinois University Press, 1982.

Selzer, Linda Furgerson. "Reading the Painterly Text: Clarence Major's 'The Slave Trade: View from the Middle Passage.'" *African American Review* 33.2 (1999): 209–229.

Silverman, Kaja. "Fassbinder and Lacan: A Reconsideration of Gaze, Look and Image." In *Visual Culture: Images and Interpretations,* ed. Norman Bryson, Michael Ann Holly, and Keith Moxey. Hanover, N.H.: University Press of New England, 1994. 272–301.

———. *Male Subjectivity at the Margins.* New York: Routledge, 1992.

———. *The Threshold of the Visible World.* New York: Routledge, 1996.

Slote, Ben. "Revising Freely: Frederick Douglass and the Politics of Disembodiment." *Auto/Biography Studies* 11 (1996): 19–37.

Smith, Paul. *Discerning the Subject.* Minneapolis: University of Minnesota Press, 1988.

Smith, Sidonie. "Performativity, Autobiographical Practice, Resistance." *Auto/Biography Studies* 10 (1995): 17–33.

———. "Resisting the Gaze of Embodiment: Women's Autobiography in the Nineteenth Century." In *American Women's Autobiography: Fea(s)ts of Memory,* ed. Margo Culley. Madison: University of Wisconsin Press, 1992. 75–110.

Smith, Valerie. "'Circling the Subject': History and Narrative in *Beloved.*" In *Toni Morrison: Critical Perspectives Past and Present,* ed. Henry Louis Gates, Jr., and K. A. Appiah. New York: Amistad, 1993. 342–355.

————. *Self-Discovery and Authority in Afro-American Narrative.* Cambridge, Mass.: Harvard University Press, 1987.

Sorisio, Carolyn. *Fleshing Out America: Race, Gender, and the Politics of the Body in American Literature, 1833–1879.* Athens: University of Georgia Press, 2002.

Spillers, Hortense. "Mama's Baby, Papa's Maybe." *Diacritics* 17.2 (1987): 65–81.

Stanton, William. *The Leopard's Spots: Scientific Attitudes toward Race in America 1815–59.* Chicago: University of Chicago Press, 1960.

Starling, Marion Wilson. *The Slave Narrative: Its Place in American History.* 2nd ed. Washington, D.C.: Howard University Press, 1988.

Stepto, Robert B. *From Behind the Veil: A Study of Afro-American Narrative.* Urbana: University of Illinois Press, 1979.

Still, William. *The Underground Railroad.* Philadelphia: Porter & Coates, 1872.

Stocking, George W., Jr. *Race, Culture, and Evolution: Essays in the History of Anthropology.* Chicago: University of Chicago Press, 1982.

Stowe, Harriet Beecher. *Uncle Tom's Cabin* (1852). New York: Penguin, 1981.

Stuckey, Sterling. *Slave Culture: Nationalist Theory and the Foundations of Black America.* New York: Oxford University Press, 1987.

Sundquist, Eric J. "Frederick Douglass: Literary Paternalism." In *Critical Essays on Frederick Douglass,* ed. William L. Andrews. Boston: Hall, 1991. 120–132.

Taylor, Bayard. *A Journey to Central Africa.* New York: Putnam, 1854.

Theriot, Nancy M. *Mothers and Daughters in Nineteenth-Century America: The Biosocial Construction of Femininity.* Lexington: University Press of Kentucky, 1996.

Thompson, Robert Farris. *African Art in Motion.* Berkeley: University of California Press, 1974.

Thoreau, Henry David. *Walden* (1854). New York: Anchor Books, 1960.

Trachtenberg, Alan. "Seeing and Believing: Hawthorne's Reflections on the Daguerreotype in *The House of the Seven Gables.*" *American Literary History* 9.3 (1997): 460–481.

Vickers, Scott B. *Native American Identities: From Stereotype to Archetype in Art and Literature.* Albuquerque: University of New Mexico Press, 1998.

Vlach, John. *The Afro-American Tradition in Decorative Arts.* Cleveland: Cleveland Museum of Art, 1978.

————. *By the Work of Their Hands: Studies in Afro-American Folklife.* Ann Arbor: UMI Research, 1991.

Wade, Richard C. *Slavery in the Cities: The South 1820–1860.* New York: Oxford University Press, 1964.

Walker, Peter F. *Moral Choices: Memory, Desire, and Imagination in Nineteenth-Century American Abolition.* Baton Rouge: Louisiana State University Press, 1978.

Wallace, Michelle. "Variations on Negation and the Heresy of Black Feminist Creativity." *Heresies* 24 (1989): 69–75.

Warner, Michael. *Letters of the Republic: Publication and the Public Sphere in Eighteenth Century America.* Cambridge, Mass.: Harvard University Press, 1990.

Washington, Teresa N. *Our Mothers, Our Powers, Our Texts: Manifestations of Àjé in African Literature.* Bloomington: Indiana University Press, 2005.

Weld, Theodore Dwight. *American Slavery as It Is: Testimony of a Thousand Witnesses.* New York: American Anti-Slavery Society, 1839.

White, Deborah. *Ar'n't I a Woman.* New York: W. W. Norton, 1985.

Wiegman, Robyn. *American Anatomies: Theorizing Race and Gender.* Durham, N.C.: Duke University Press, 1995.

Wikramanayake, Marina. *A World in Shadow: The Free Black in Antebellum South Carolina.* Columbia: University of South Carolina Press, 1973.

Willis, Henry. *Specimen of Printing Types from the New England Type Foundary.* Boston: Dutton and Wentworth, 1834.

Winterson, Jeanette. *Oranges Are Not the Only Fruit.* New York: Atlantic Monthly Press, 1987.

Wolff, Cynthia Griffin. "Passing Beyond the Middle Passage: Henry 'Box' Brown's Translations of Slavery." *Massachusetts Review* 37.1 (Spring 1996): 42–44.

Wood, Marcus. *Blind Memory: Visual Representations of Slavery in England and America, 1780–1865.* New York: Routledge, 2000.

Wood, Peter H. *Black Majority: Negroes in Colonial South Carolina from 1670 to the Stono Rebellion.* New York: Knopf, 1974.

Wynter, Sylvia. "Sambos and Minstrels." *Social Text* 1 (1979): 149–156.

Yellin, Jean Fagan. *Women and Sisters: The Anti-Slavery Feminists in American Culture.* New Haven, Conn.: Yale University Press, 1989.

———. "Written by Herself: Harriet Jacobs' Slave Narrative." *American Literature* 53.3 (1981): 479–486.

Zou, Lin. "Radical Criticism and the Myth of the Split Self." *Criticism* 42.1 (2000): 7–30.

INDEX

Page numbers in italics refer to illustrations.

MICHAEL A. CHANEY is Assistant Professor of English at Dartmouth College, where he teaches courses on African American literature and culture, nineteenth-century American literature, and intersections of race and popular culture.